Urban Cinematics

Urban Cinematics
Understanding Urban Phenomena through the Moving Image

Edited by François Penz and Andong Lu

intellect Bristol, UK / Chicago, USA

First published in the UK in 2011 by
Intellect, The Mill, Parnall Road, Fishponds, Bristol, BS16 3JG, UK

First published in the USA in 2011 by
Intellect, The University of Chicago Press, 1427 E. 60th Street,
Chicago, IL 60637, USA

Copyright © 2011 Intellect Ltd

A catalogue record for this book is available from the
British Library.

Cover designer: Holly Rose
Copy-editor: Macmillan
Typesetting: Mac Style, Beverley, E. Yorkshire

ISBN 978-1-84150-428-5

Printed and bound by Gutenberg Press, Malta.

Contents

Introduction: What is Urban Cinematics?

François Penz and Andong Lu

> Our contemporary life as it is would be completely different if the 20th century had happened without the cinema – our habits, the way we look, what we do, what we think, would be different – our contemporary life now in the early 21st century is completely formed by the fact that the 20th century was the century of the moving image – the moving image changed our way of thinking, moving around and seeing things.
>
> Wim Wenders (2003)

Urban Cinematics stems out of a conference as part of a two-year Arts and Humanities Research Council (AHRC) grant entitled Narrascape, an international research network on 'Urban Narrative Environment' in the UK and China – a collaboration between the Department of Architecture in Cambridge and the School of Architecture at Nanjing University.

At a time when 50% of the world population lives in cities, 90% in the UK, there is an increasing number of city-related research programmes. But the particularity of our own research programme has been the belief that cinema and the moving image could provide us with the percept ual equipment to grasp the complexity of urban phenomena in line with Wim Wenders' poignant remark. Although it is a relatively recent academic discipline, there is a wealth of research in the area of cinema and the city. It has become well established and is respected academically, in architecture and design-related disciplines but also in film studies, cultural studies, visual anthropology, urban geography, literature, philosophy, language studies, art history, cognitive psychology, and no doubt is gaining ground in other fields too.[1]

However, the challenge here is for all those disciplines to find enough common ground to have a constructive and innovative dialogue. What this volume is attempting is not simply to create a framework whereby we juxtapose a range of disciplines where a dialogue takes place from the relative safety of everybody's field, without much venturing outside one's own discipline; that would be a multidisciplinary approach where the 'whole remains the sum of the parts'. What this book is proposing is an inter-disciplinary and transformational

approach where a new field emerges through the integration of more than one discipline. New possibilities emerge as new partners and new strands of knowledge partake in the discussion. And yet the dialogue is not necessarily easy in such a context as noted by James Hay:

> To study 'the cinematic' would involve considering the place(s) of film practices within an environment and their relation to other ways of organizing this environment, of organizing social relations into an environment. To consider cinema and cinema studies in this way would certainly be inter-disciplinary but would not assume that working across disciplines of knowledge and intellectual traditions is easy […]. (Hay 1997: 212)

Indeed, it is challenging to venture outside one's own domain but potentially particularly rewarding for disciplines pertaining to film studies to apply their knowledge 'outside the box', to the urban environment.

> What concerns me therefore is the tendency to see film practices […] as a discrete set of relations producing a 'cinematic subject' rather than understanding film as practiced among different social sites […] To shift strategies in this way would involve not only decentring film as an object of study but also focusing instead on how film practice occurs from and through particular sites – of re-emphasizing the *site* of film practice *as* a spatial issue or problematic. (Hay 1997: 212)

Hay proposes to re-discover, re-evaluate the film medium – the cinematic – at the place where it takes place, where it is being shot and constructed, the urban environment. And this is precisely what these chapters set out to do.

While an approach to studying cities must build on hard facts as the necessary backbone to any serious investigation, we believe that cinema provides complementary evidence of the 'soft' side of the city as coined by Raban (1974: 2): 'The city as we imagine it, then, soft city of illusion, myth, aspiration, and nightmare, is as real, maybe more real, than the hard city one can locate on maps, in statistics, in monographs on urban sociology and demography and architecture'. In other words, learning from the filmic spaces of the past may offer a more holistic approach to the understanding of cities in order to better anticipate the present, but also the future[2].

The Narrascape research project adopted a practice-based research approach using the moving image as proof of concept, staging a series of workshops both in the UK and China. This is a methodology that our research group, the Digital Studio for Research in Design, Communication and Visualization, has used for well over a decade. Our movie-making experiments test hypothesis steeped in the history and theory of the relationship between cinema, architecture and the city, and aim to inform the current debate on the use of digital moving images in architectural and urban design issues.

Of course, the practice of filming the city is as old as cinema itself with the very first images of Place des Cordeliers in Lyon screened to a fee-paying audience by the Lumière

brothers on 28 December 1895. To this day the city has been a long-lasting fascination for film-makers. Nanni Moretti, driving through Rome on his Vespa (*Caro Diario*, 1993), contemplates the idea of making a film of 'just of houses, panning shots of houses, Garbatella 1927, Olympic Village 1960 …'. Indeed, buildings are an attractive 'sitting target' for the roving camera, a natural décor waiting to be captured. And yet 'cinematographicity', a term coined by Bois (1989: 113) in his analysis of Eisenstein's style, involves a series of heart-searching decisions from the moment the camera is switched on and trained onto a street or a building: 'From *The Strike* on, Eisenstein had to find practical answers to the problem of how to film a building, how to transform it, from a passive setting of the action, into a major agent of the plot'. This concern is echoed by contemporary documentary film-maker Raymond Depardon,[3] commissioned by *La Fondation Cartier* in Paris to film and exhibit twelve world cities: 'the problem is: what do I film, who am I and how do I film? We have to go back to the foundation of cinema as did Murnau and Flaherty: observe and listen'.

But the act of filming the city is rewarding both for the film-maker and the urban environment. Indeed, through the framing process and the subsequent screening, even the most anonymous and banal city location will be transformed from an unconsciously recorded space – or naive space – to a consciously recorded space that becomes an expressive space. *Le cinéma est avant tout un révélateur inépuisable de passages nouveaux* [Cinema is primarily an endless revelatory medium of novel passages], noted Elie Faure (1934: 6). On the screen crystallizes a new dispersive system bringing together different strands, themes, scales, part cities, part human bodies. The moving image has the ability to reveal a new spatial and narrative structure, to challenge the traditional organization of the city as new geographies and new thematic connections may emerge. For film-makers this is hugely liberating, as if doing away from material culture, a new freedom is being afforded by the immaterial world of the moving image.

Film-makers's attraction to the city has been matched by numerous scholarly publications and several recent research projects. Books in this field include a fascination for the reconstructed city in the studio (Albrecht 1986; Neumann 1996; Bergfelder et al. 2007; Jacobs 2007; Sanders 2007), work on the modern, modernism and modernity in films (Charney & Schwartz 1996; McQuire 1997; AlSayyad 2006; Perry 2006; Pomerance 2006), utopian and dystopian cinematic environments (Coates et al. 2000; Prakash 2010), cinematic portrait of cities (Shiel 2006; Brunsdon 2007), phenomenological and semiotic cinematic approaches (Sobchack 1992; Gardies 1993; Pallasmaa 2001), cinematic mapping (Bruno 2002; Conley 2007) and many other categories. Indeed, there is a multitude of urban 'cinematics'.

Acknowledging the importance of theory in practice and practice as theory, a key aspect of this publication is to have a dialogue between moving image practitioners and academics in order to review the mechanisms by which cinema and the moving image contribute to our understanding of cities while at the same time addressing two key issues: how do film-makers make use of cities and how do cities exploit cinema? This broad inter-disciplinary exploration is organized around five sub-themes:

- City Symphonies: Montaged Urban Cinematic Landscapes
- Cinematic Urban Archaeology
- Geographies of the Urban Cinematic Landscape
- The Cinematic in the Urban
- Cinematic Urban Design Practice

There is a gradual progression in the way in which the chapters are laid out, with a very broad chronological approach essentially going from the historical to the digital, from the theoretical towards the application of the knowledge to urban practice. In particular, in the section on The Cinematic in the Urban, cinema moves out of the movie theatre into the city while in the final section it contributes to urban design in a new leap of faith.

Part I: City symphonies: Montaged urban cinematic landscapes

In the 1920s the fascination with the city as a complex phenomenon resulted in an unprecedented increase in moving-image works, which aimed at constructing composite cinematic poems that encapsulated the dynamics of the modern metropolis. Walter Ruttmann's *Berlin Symphonie of a Great City* (1927) and Dziga Vertov's *Man with the Movie Camera* (1929) are two key examples of rendering a synthetic, imaginary cinematic portrait of the city by dialectically juxtaposing and intertwining fragmented moving images of the urban landscapes by means of an extensive deployment of montage techniques. However, beyond such clear-cut examples, city symphonies remain an elusive genre to pin down, in part because there are very few publications on the subject, perhaps pointing to the difficulty in grasping the concept. This section is therefore a modest attempt at redressing this gap. 'Montage-based films without human leads where the city is the subject' is a rather convoluted but probably 'safe' definition of city symphonies, safe in the sense that it constitutes a non-controversial lowest common denominator. With the city as their subject, city symphonies not only represent the city as such, they also invent the city, enable its imagination and creation, and bring out the hidden, silent and invisible features of the city to public consciousness. The city symphony genre is a key piece of the urban cinematics jigsaw puzzle. In the 1920s they metaphorized[4] the emergence of the modern metropolis by eliciting crucial links on the screen. City symphonies give space to the urban space, allow the city to play and come forward, becoming both character and subject. One forgets how important a movement city symphonies were in its golden age, more like a tidal wave according to John Grierson (1933: 136) 'Of fifty scenarios presented by the tyros [young film-makers], forty-five are symphonies of Edinburgh or of Ecclefechan or of Paris or of Prague'. If we fast forward to the present, city symphonies are still being made today as, for example, with artist Sarah Morris's work as part of her artistic practice or as a vehicle for the urban romantic pop group Saint Etienne with *Finisterre* (2003), a film about London and *What have you done today Mervin Day* (2005) about the Lea Valley. City symphonies

still occasionally make headlines; for example, with Terence Davies's portrayal of Liverpool, *Of Time and the City* (2008). It has been described as a city symphony and yet it does not fit straightforwardly into the category. This is a key point as if every new city symphony is having to reinvent the genre.

In 1997 Helmut Weihsmann wrote one of the classic analyses of city symphonies with his chapter entitled *The City in Twilight: Charting the Genre of the 'City Film' 1900–1930* (Weihsmann, 1997). Here his writing complements his earlier effort by considering two films, *Berlin Alexanderplatz* (1931) and *Zazie dans le Métro* (1960). Both films are not usually referred to as city symphonies, and in that sense, Weihsmann contributes to extending and nuancing the genre. Crucial to his choice of films is their literary origin as he aims to 'link literature, modernity and urbanism to film aesthetics' together 'with the modern interpretation of city life' in order to propose a 'method, labelling it a cognitive model of "urban mapping" and architectural "reading"'. Parallel to this ambitious and original approach, Weihsmann uses *Berlin Alexanderplatz* and *Zazie dans le Métro* to highlight cinema's capacity at 'preserving or memorializing the historic past [...] as it provides for the transformation of that past and for becoming fiction and collective memory'. This echoes Roger Odin's three memory logics developed in Chapter 6.

In his chapter, Patrik Sjöberg appeals for a new discourse on contemporary documentary concerning the city and the site specific. He questions, within the context of documentary media, the lack of re-evaluation of the cinema–city discourse that is based upon early modern theories of Benjamin, Simmel and others. In that sense his writing complements admirably Weihsmann's analysis of early city symphonies by taking into account contemporary developments. Sjöberg pays special attention to the 'sensibility' of the city as the foundation of urban (cinematic) cartography. He argues that modern mapping based upon real-world observation (well connected with the *flâneur* and early city symphony) has been replaced, through the transitional theory of psychogeography, which approaches a conceptual mapping, by the postmodern 'neogeography' that is personal, mediated and cinematic. Acknowledging the contemporary highly mediated urban conditions, he introduces five 'conceptual panoramic viewpoints' pertaining to city documentary: the 'postmetroplis' and 'third space' of Edward Soja; the 'real cities' of Steve Pile; Lisa Parks' work on satellite imagery and Michael Bull's studies of the impact of portable personal stereo. These viewpoints also provide useful coordinates for thinking about urban cinematics.

Not many can evoke movies in textual terms as well as Thom Andersen. His voice-over script for *Los Angeles Plays Itself* (2003) is probably the best essay on the city of Los Angeles in the movies. This is now complemented by this chapter on his latest film, *Get Out of the Car* (2010). Andersen likes to think of his film as a city symphony, which is essentially devoted to 'billboards, advertising signs, wall paintings, building facades'. It is both a fascinating account of the process by which he came to make the film and the many stories and histories behind the images of the film itself. If a movie is the tip of an iceberg, then Andersen's essay is what's below the water, often murky water, in the case of Los Angeles and its endemic political failures at rescuing and conserving many crucial sites of memories. But Andersen

is not a *passéist* and, instead, advocates a 'militant nostalgia' and invites for a 'celebration of artisan culture and termite art'. *Get Out of the Car* and this companion essay reveal the city in a series of close-ups where most tourists would not look. It allows for a little-known Los Angeles to come forward, for a reading of the city 'against the grain to bring the background into the foreground'.

Part II: Cinematic urban archaeology

A cinematic archaeology of a city can potentially render visible the becoming of the modern city and its subsequent transformations since 1895. Such retrospectively longitudinal cinematic studies of cities are now possible through increasing the availability of archival material. Such an exploration of the filmic spaces of the past may enable historians, architects and urbanists to better anticipate the city of the future. Films have a remarkable capacity to resurrect a city's topography, which, together with its social and cultural context, is all too often folded away in maps of the past, as remarked by Andersen,[5] 'Bunker Hill was the most photographed district in Los Angeles, so the movies unwittingly documented its destruction and depopulation'. Recent films have been collaged out of such archival material, most notably *Los Angeles Plays Itself* (Thom Andersen, 2003) and *Helsinki Forever* (Peter Van Bagh, 2008), both films using essentially fiction films clips, while *Stroom* (Jord den Hollander, 2005) is exclusively made out of amateur film footage of Nijmegen. Crucially, the processes involved in cinematic urban archaeology exhume, unlock and preserve past memories. And, as an applied concept, it may have far-reaching implications for planning and urban regeneration purposes as well as for heritage and conservation.

In his chapter Nicholas Bullock is concerned with the way in which the film medium has been used, historically in particular, through a discussion of the work of Marcel Poëte, a key figure in the establishment of the new 'science' of urbanism in early twentieth-century France. Poëte believed in photography's ability to be the 'exact record of life', reminiscent of André Bazin's own view about *l'objectivité photographique* derived from the medium's automaticity in transferring reality. Following from a discussion on Atget's photographic recordings of Paris and its potential link to 'poetic realism', Bullock's main argument concentrates on Poëte's attempt to 'capture the essence of the modern city' with his film project, *Paris au Fil des Heures*. The unrealized project in the form of a long-lost script unearthed by Bullock, and aired in this volume for the first time, leads to considerations of 'scientific objectivity' and of the conjectural link of Poëte's project with the montage tradition of the city symphonies. Poëte's script is historically significant, the equivalent for urbanism to what Le Corbusier did with *Architectures d'Aujourd'hui* (Pierre Chenal, 1930), an attempt to communicate complex urban phenomena by means of the moving image medium.

Considering the city as a 'communication space' and using a 'sémio-pragmatique' approach, Roger Odin seeks to understand how the city makes use of cinema within the context of Saint-Étienne, from the 1920s to the present day. He highlights three very different

'logics': first, an educational one, which corresponded to using cinema as a propaganda tool both in Catholic and secular schools. Odin points out rightly that this was not only limited to Saint-Étienne; in fact, Bullock reminded us that by 1939 across France around 4000 16-mm projectors were operating in schools and churches, town halls and political clubs. However, Odin's second logic, branding, was concerned very directly with the city of Saint-Étienne. In 1980, faced with an unprecedented economic crisis, the communist municipality called upon the power of cinema by creating a film festival, in an effort to 'mitigate the psychological effects on the population and perhaps, while bringing back a national, even international, visibility to the city'. This strategy was abandoned by the next right wing municipality in favour of the creation of an amateur film fund, interpreted by Odin as a third 'memory-driven logic'. A cinémathèque was created as a 'lieux de mémoire', a place where 'archival space is transformed into sacred space'. Roger Odin's study of Saint-Étienne constitutes a unique single longitudinal retrospective study of how a city has used cinema in the most diverse and imaginative ways for educational, economic and identity purposes.

Murray Grigor sets out to compare and contrast Edinburgh's Old and New Towns. Grigor pays tribute to the tradition of the city symphonies in his witty account of *Sean Connery's Edinburgh*, a film shot in 1981. It has some elements in common with *The London Nobody Knows* (Cohen, 1967), namely the use of montage style and the resort to a well-known actor – James Mason in the case of London – as the *flâneur* guide, the device that pieces together the different part of the city. However, it has none of the bleakness of the London movie, partly because it was seen as way to promote tourism. If we refer to Odin's 'three logics' in the previous chapter, *Sean Connery's Edinburgh* is part of a logic of branding as well as propaganda. Yet, in this capacity to chronicle the bits of the city that disappear forever, it has also a value as 'site of memories', now part of Edinburgh's cinematic urban archaeology.

Mark Lewis's chapter constitutes a reflective piece of writing on his film-making practice and an illustration of cinematic mapping in terms of observing and documenting the city. Perhaps, unwittingly, Mark Lewis traces the transformation and abandonment of the modern movement in a sympathetic way. Poignantly, his films document modern buildings that are no longer standing, such as in *North Circular* (2000), or about to disappear, such as the Hendon FC ground and the Heygate estate. Alternatively, he evokes invisible memories of a glorious past, e.g. *Isosceles* (2007), as well as portrays the banal and everyday locations that are being transformed on the screen from anonymous spaces into expressive places. Lewis elicits with great clarity the motivations as well as the why and the how of nine of his movies.[6] At the heart of his interest is the world around him, and more specifically, 'the modern world of the city and how film can re-imagine how those forms might have been experienced when they were modern'. His films are short, between one and six minutes on average, and consists of a single uninterrupted shot, as if 'indexing a chunk of the world duration'. There are no characters and the point of view is that of 'the film camera as having a basic consciousness' whereby architecture can be conceived as a form of proto-cinema where Lewis imagines the elevated walkways of the Heygate estate as 'ready-mades

for cinematic dolly shots', echoing Calvino's notion (Calvino 2009: 8) of a *mental cinema* 'projecting images before our mind's eyes'.

Part III: The geographies of the urban cinematic landscape

Cinema may use cities in creative ways to reorganize the city spaces into narrative geographies where urban fragments are collaged into spatial episodes. The alternative to creative geographies is cinematic topographical coherence. Both approaches – used in montage as well as in continuity editing traditions – may give different readings of the city and have a different impact on our spatial perception. The use of creative geographies is one of the key principles of city symphonies, creating imaginary, artificial landscapes that exist only on the screen and where disparate physical locations construct a composite cinematic space through montaged manipulation of the urban terrain. A wonderful example of this principle is Vertov's *Man with the Movie Camera*, a collage of five cities. However, speaking of fiction films, Andersen[7] warns that 'like dramatic license, geographic license is usually an alibi for laziness. Silly geography makes for silly movies'. Indeed, the use and misuse of topography in film may impact on artistic as well as archival values. However, in the right hands, the creative geography notion can be rewarding and afford great freedom to a film-maker such as Rivette (1981: 12), 'There is one thing that I love [...] and that is to make two places to communicate when in reality they are situated at two opposite ends of Paris [...] Play with the real geography to create false topographies and sometimes the reverse too'. In planning and urban terms, when it comes to topographical considerations, the prevalent reference remains Kevin Lynch's book *The Image of the City* (1960). Lynch acknowledges the complexity of the urban fabric and our difficulty in grasping the 'image of the city'. He investigated the identity and structure of city images with a view to better grasp issues of imageability and legibility of the urban environment. Lynch's work is highly relevant in this section and it is not uncommon to consider his empirical studies on the geography of cities in relation to city films.

In his chapter Tsang mourns that 'documentary theory itself has been somewhat slow to respond to Vertov's challenge', whereby 'a single filmic space would involve twelve walls filmed by me [...] in different parts of the world'. However, he finds in Dutch film-maker Van der Keuken 'a visionary whose work anticipates current interest in human mobility' and goes some way in addressing Vertov's ploy. Using essentially one film, *Amsterdam Global Village* (1996), Tsang proceeds to demonstrate how Van der Keuken, a film-maker steeped in the documentary tradition, from Vertov and Vigo through to Jean Rouch's ethnographical work, was able to create a unique cinematic Amsterdam-centric view of the world. Van der Keuken seeks to create a 'new city where the act of walking around any street corner in Amsterdam would now bring him to a different culture'. By cutting back and forth between different parts of the world – often war-torn places – in contrast with a stable and peaceful Amsterdam, it pushes montage, the cinematic creative geography principles and the film medium, to its very limit. Overall, Tsang demonstrates how Van der Keuken's film brings

together discursive formations of a shared collective world, across different time zones and spaces, transcending physicality.

Celia Dunne interprets the different usage and implications of aerial shots in two Mexican urban films: *El Hombre de Papel* (1963) and *Don de Dios* (2005). Typically, aerial shots of cities offer a God's eye perspective belonging to the 'hard city' concept referred to by Raban, associated with a world of urban planning, density and statistics. By contrast, the on-the-ground shots allow for the 'soft city' to reveal the city of illusions and nightmares. It is this passage from 'hard' to 'soft', which Dunne investigates in her chapter within the Mexican context of the time. The aerial shots, when related to on-ground somatic narratives, provide a special kind of (filmic) cartography. Dunne sets these films against the historical condition of the modernization and globalization of Mexico City, and through a comparative study between them, shows that aerial shots can either 'support or disrupt prevailing conceptions of the city'.

Finally, in this section Andrew Otway concentrates on Jarmusch's *Night on Earth*, a film, which has a double association with city symphonies without, however, claiming to be one. The overarching structure of the film is a dawn-to-dusk portrait of five world cities, a world city symphony configuration. Furthermore, each city is introduced by a one minute city sinfonietta portrait. More specifically, Otway raises the important issue of 'wayfinding' as a particular type of urban navigation. In contrast to scientific map-making and map-reading, pre-scientific maps often incorporate wayfinding and its experiential narrative formations. In this regard, films about car journeys in cities may be considered as a special kind of mapping. Otway has focused his study on the link between wayfinding and the notion of everyday life. Through a close reading of three, out of five, taxi journeys in Jim Jarmusch's film *Night on Earth*, he shows that wayfinding, an often neglected urban experience (in fiction films), produces a compelling aesthetic of everyday life.

Part IV: The cinematic in the urban

We are at the beginning of an age of mediated space. Media have fundamentally transformed both our place-making for senses and our sense-making of places. Public space and private space, as perhaps never before, are so closely intermingled. The screen installation, an architecture of public intimacy, has moved into the urban and becomes, more and more, an everyday situation. This section considers this new phenomenon and focuses on the emerging urban practice of 'moving space' that synthesizes both cinema and architecture to create new urban situations, communicate urban narratives, as well as reconfigure human relationships with the built environment.

Doug Aitken's moving image work, *Sleepwalkers*, when it was projected onto the façade of Taniguchi's new MOMA building, produced an extraordinary urban/architecture situation. This situation blurs the traditional boundaries between architecture and film, between site-specific art and advertisement, between interior and exterior, between publicity and privacy.

It appeals for a theoretical reflection, which Alison Butler undertakes in this chapter. By carefully analysing the project and its peripheral discourse, Butler demonstrates the great potential of engaging cinema (with its distinctive power of narrative and intimacy) with urbanism, especially with the architecture within (and about) urban public space. As Butler suggests, architecture as public object and cinema as public event so readily lend themselves to the other that they could mingle in the necessary production of 'mediatized urban space', a subject that deserves further explorations and experiments.

Echoing Alison Butler, Janet Harbord and Rachel Moore examine two recent urban art installations that use film medium to transcribe historical message into new urban situations. They show that when the film enters the social milieu, in this case the art gallery and the street, it has the potential to become architecture, insofar as it transforms the immediate presence into mediated or mediatized urban experience. In particular, the street projection impacts on the image of the city and its legibility by becoming a new landmark, albeit an ephemeral one. Harbord's and Moore's careful analyses of the experience and meaning of the two cases promote a subtle sensibility towards the city as mediated or cinematic synthesis of past, present and future, an urban cinematics that the artworks have brought forth.

In the final chapter in this section, video artist Layla Curtis investigates the world of parkour through an art project commissioned by Westminster City Council, which had pioneered the use of parkour as a way of engaging young people in physical activity since 2006. However, what is novel in Layla Curtis's artwork is how she immortalizes the ephemerality of parkour by filming the traces left by the free-runners, fixing transient urban memories into the fabric of the urban environment. Parkour dramatizes architecture in a very interesting way – partly because it is inherently risky and therefore dramatic. It makes us notice elements of the urban landscapes that we would not normally pay much attention to; low walls, barriers, plinths, parapets – the unsung 'foot soldiers' of our everyday urban environment. As Curtis points out parkour has been popularized by TV documentaries and the film industry, notably through the films of Luc Besson. Originating from the French suburbs, this new form of urban flânerie took its inspiration from computer games (see, for example, the Ninja and Super Mario Bros series) where gamers chase each other across rooftops. Therefore, how it is filmed and reinterpreted by the camera is crucial – framing, cinematography and editing are key to a new interpretation of the city.

Part V: Cinematic urban design practice

This last section is devoted to new thoughts and exercises on practising cinematics in urban design. The focus is on how cinema could go beyond mere representation and enter the processes of design. Regarding cinema as a tool, rather than a medium, requires studies of its functionality, validity, mechanism, as well as the procedures of using it. 'Cinema' challenges the traditional disciplinary boundary of urban design by introducing a realistic attitude to reality, the dynamism of perception, and the narrativity of experience, among

others, and underpinning new tools and methods for the transforming profession to cope with contemporary urban issues.

Crucially, to introduce this section, Maria Hellström Reimer states that there is 'no real borderline between cinematic work, life rehearsal and live urbanity, the one constituting the raw material for the other'. She then goes on to reflect upon the relationship between cinema and urbanity from the viewpoint of bio-politics. She regards cinema as a political battleground between the cinema as institutional apparatus, with its power to immerse and subdue the audience, and the cinema as performative, life form of resistance. Acknowledging the playfulness inherent in the filmic construction of reality, she proposes a concept of the anagram, where one could substitute 'collage' as the metaphor of urban cinematics. The idea of 'anagram' incorporates the performative dimension of life and resists the projected authentic reality.

Marc Boumeester pursues 'videography's role in the exploration, registration and understanding of urban environments' as a method of cinematic mapping. Boumeester does so while reflecting upon the research programme conducted at TUDelft in this field. He examined three strata of mapping: gridding, zoning and fragmentation, the types of organizations of urban information based on which participants of the mapping exercises could be organized and connected. Drawing upon a series of experiments, Boumeester argues that while videography does not give an objective and complete mapping tool, it provides an authorial tool that maps the 'soft side' of the city. However, Boumeester questions the 'technified' version of the dérive, or a single piece of cinematic work (as a valid method of mapping); instead, he argues for a system of collective effort that could orchestrate a projected image of the city.

Wowo Ding begins her chapter by questioning the limits of the traditional method of mapping, which excels in recording 'the space of the city' yet falls short of showing 'the city in space'. As a practising urban planner, Ding intends to find an objective, working method that integrates the perceptual dynamism of people in space. This dynamism can be recorded by movement (temporal dimension) and by changing images. In this chapter, Ding proposed a mapping technique that is based upon vertical interface, as opposed to traditional plan-based mapping. The video camera plays a structural role in this method: it both includes a temporal dimension of space and secures the perceptual validity of the analyses of spatial forms. The camera stands for the 'vision sphere' of the human eye and helps to access the real-time formation of perceived space. Crucially, this chapter has introduced a potential application for the moving image into the domain of urban planning and design, contributing to the pending issues of perception and mapping of real urban space.

With regard to movie-making like architecture, as a process of 'design', 'expression' and 'communication' and anticipating the far-reaching consequences of digital media onto the world of architecture and urbanism, Maureen Thomas, proposes a practice-based methodology using the moving image as a way of understanding and communicating architectural design and urban phenomena. Using the example of a journey in space, her approach entails a narrative re-interpretation of Le Corbusier's concept of the architectural

promenade through Kevin Lynch's principles in order to derive a movie-making panoply, a screen 'grammar of space'. Thomas reveals with great clarity how the workshop participants learn to create dramatic developments while maintaining an architectural legibility through the use of landmarks, nodes and edges, thus gaining a spatial understanding acquired through the use of the camera and editing techniques. In effect, Thomas proposes a series of guidelines towards a new way, for architects and urbanists, of 'seeing' spaces and places by means of the moving image – a method from which one learns as much from the process of movie-making as from the results.

Our introduction constitutes the starting point for what is a complex multi-faceted relationship between cinema and the city, where there is no right, wrong or final answer, but a multitude of considerations made more intricate because of the interdisciplinary nature of the field of enquiry.

References

Albrecht, D. (1986), *Designing Dreams,* London : Thames and Hudson.

AlSayyad, N. (2006), *Cinematic Urbanism: A History of the Modern from Reel to Real,* London/New York: Routledge.

Bergfelder, T., Harris, S. and Street, S. (2007), *Film Architecture and the Transnational Imagination: Set Design in 1930s European Cinema,* Amsterdam University Press.

Bois, Y.- A. and Glenny, M. (1989), 'Sergei M. Eisenstein, Montage and Architecture', in Assemblage No 10, Cambridge Mass: MIT Press.

Bruno, G. (2002), *Atlas of Emotion: Journeys in Art, Architecture and Film,* New York: Verso.

Brunsdon, C. (2007), *London in Cinema,* London: British Film Institute.

Calvino, I. (2009), Six Memos for the Next Millennium, London: Penguin Books.

Charney, L. and Schwartz, V. (1996), *Cinema and the Invention of Modern Life,* Berkeley: University of California Press.

Coates, S. (2000), *Impossible Worlds,* Basel: Birkhäuser.

Conley, T. (2007), *Cartographic Cinema,* Minneapolis: University of Minnesota Press.

Faure, E. (1934), Ombres solides (Essais d'esthétique concrète), Paris: Edgar Malfère.

Gardies, A. (1993), *L'Espace au Cinéma,* Paris: Méridiens Klincksieck.

Grierson, J. (1933), 'Documentary (2): Symphonics', Cinema Quarterly, Spring.

Gunning, T. (2006), 'Modernity and Cinema', in M. Pomerance (ed.), Cinema and Modernity, New Brunswick, N.J.: Rutgers University Press.

Hay, J. (1997), 'Piecing Together What Remains of the Cinematic City', in D. Clarke (ed.), *The Cinematic City,* London: Routledge.

Jacobs, S. (2007), *The Wrong House: The Architecture of Alfred Hitchcock,* Rotterdam: 010 Uitgeverij.

Keiller, P. (2003), 'The City of the Future', in Penz, F. (ed) Screen Cities, City: Analysis of Urban Trends, Culture, Theory, Policy, Action, Vol 7, Number 3, Carfax Publishing, Taylor and Francis Group.

McQuire, S. (1997), *Visions of Modernity: Representation, Memory, Time and Space in the Age of the Camera,* Thousand Oaks (Ca): Sage Publications Ltd.

Neumann, D. (1996), *Film Architecture: Set Designs from Metropolis to Bladerunner,* New York/ Munich: Prestel.

Pallasmaa, J. (2001), *The Architecture of Image – Existential Space in Cinema*, Helsinki: Rakennustieto.

Perry, T. (2006), *Masterpieces of Modernist Cinema*, Bloomington: Indiana University Press.

Pomerance, M. (2006), *Cinema and Modernity*, New Brunswick, N.J.: Rutgers University Press.

Prakash, G. (2010), *Noir Urbanisms: Dystopic Images of the Modern City*, Princeton University Press.

Raban, J. (1974), Soft City, Re-edited in 1998 by London: Picador.

Rivette, J. (1981), 'Entretien avec Jacques Rivette', Cahiers du Cinéma, vol. 327.

Sanders, J. (2007), *Celluloid Skyline: New York and the Movies*, New York: Alfred A. Knopf.

Shiel, M. (2006), *Italian Neorealism: Rebuilding the Cinematic City*, London: Walfllower Press.

Sobchack, V. (1992), The Address of the Eye: A Phenomenology of Film Experience, Princeton University Press.

Webber, A. and Wilson, E. (eds) (2008), Cities in Transition – The Moving Image and the Modern Metropolis, London: Wallfower Press.

Weihsmann, H. (1997), 'The City in Twilight: Charting the Genre of the "City Film" 1900–1930', in F. Penz and M. Thomas (eds), Cinema & Architecture, London: British Film Institute.

Notes

1. The breadth and depth of interest across disciplines is vividly expressed in books such as *Cities in Transition – The Moving Image and the Modern Metropolis* by Webber (2008).
2. Paraphrasing Partrick Keiller in Keiller (2003).
3. In *Cahiers du Cinéma*, October 2008, no. 638, p. 17. Exhibition Reference: Depardon, R., *Villes/Cities/Stadte.*, Gottingen, Steidl Verlag and Paris, The Fondation Cartier pour l'Art Contemporain, 2007.
4. Paraphrasing Tom Gunning in Gunning (2006).
5. Voice-over commentary in his film *Los Angeles Plays itself* (Andersen, 2003).
6. Available online at <http://www.marklewisstudio.com/films2/TD_Centre.htm> Accessed 14 September 2010.
7. Voice-over commentary in his film *Los Angeles Plays itself* (Andersen, 2003).

Part I

City Symphonies: Montaged Urban Cinematic Landscapes

Chapter 1

Ciné-City Strolls: Imagery, Form, Language and Meaning of the City Film

Helmut Weihsmann

Introduction – the visual impact and shock of the metropolis

Ever since the beginning of cinematography in the early 1900s, film-makers of all film genres – fiction or documentary – have been fascinated with the topography and image of the modern metropolis. This is especially the case for Berlin and Paris, two imperialist capitals of enormous political and economical power and diversity, which are also the symbols for industrial progress of an extreme *laissez-faire* capitalism and free trade. The rapid growth of their populations, the drive for splendour, wealth and greed, the grand architecture and the diversity of city life, and multiple aspects or visions of modernity in these centres changed the structure of society and the urban landscape of world cities since the beginning of the twentieth century. Film and photographic images emphasized and characterized the urban landscape for its technical and civilized progress, thus celebrating the vigour, complexity and new form of the future metropolis with its resulting technological innovations and evolutions. New urban features, systems and networks appeared in communication, transportation, mobility and urban design, which very soon became an important inspiration for avant-garde writers, poets, critics, painters, film-makers and media artists alike. This new perception of a visionary and hybrid technopolis – alongside all the social and psychological changes that occurred – interacted with the notion of a modern environment of speed, production and efficiency, which fascinated early cinematographers.

The first examples of this kind of fanatic urban enthusiasm and filmic documentation in the form of actualities and short newsreels in the historiography of cinema were the short travelogues by the French cinematographers, the brothers Auguste and Louis Lumière as well as the innovative American engineer Thomas Edison and, of course, the remarkable German brothers Skladanowski of Berlin, who invented the *Bioscope* for depicting urban crowds. Already by the 1920s several pioneering and existing film portraits or city films, so-called *city symphonies* as they are now labelled by film historians, were probably the first artistic benchmarks for this unique kind of interest in the rising metropolis. With the advent of a combination of total urbanization, modernization and mass transportation, the cities themselves started rapidly changing their form and features, creating what German sociologist Georg Simmel defined in his classic essay *Die Großstädte und das Geistesleben/ The Metropolis and Mental Life* (Georg Simmel, 1903). Simmel wrote that modern urban life leads to the acceleration of one's nervous system (*Steigerung des Nervenlebens*), meaning that the experience of walking on the crowded streets in downtown Berlin at the turn of the century led to mental problems and even psychic illness, such as neurasthenia, nervousness

and hysteria. Walter Benjamin, on the other hand, described this *shock of the new* as a revolutionary act against the establishment (Benjamin [1936]/1999). And the Viennese architect and polemist Adolf Loos once proclaimed in his writings that his buildings are for people with modern nerves (Loos 1908). Despite Simmel's cultural pessimism (or scepticism) towards the Modern City and Joseph Roth's horrific fear of an anonymous and cold city (*Kälte der Grosstadt*), a generally negative attitude towards the modern metropolis shifted to the other extreme. Among intellectuals and artists, a neutral and objective standpoint towards the big city prevailed. The Marxist writer Walter Benjamin and his contemporary Berlin columnists Siegfried Kraucauer, Bernard von Bretano or Bela Bálazs saw in the dispersion and diffuse perception of reality the chance of liberation and hope for revolution by destroying the aura of the bourgeois artwork and its hoax for authenticity. Examples of this paradigm shift can be quoted from the daily newspaper articles of the journalists Bretano, Bálazs and Kracauer in Berlin.[1]

From verbal to visual

The vibrant and rhythmic pulse of the city had been the inspiration for countless artists, architects, poets, writers and film-makers since the beginning of Modernism at the turn of the century with the emergence of photography and cinematography. American writer John Dos Passos's claim to fame was that he apparently wrote the first modern novel influenced by the techniques and innovative perception of cinema and (parallel) montage in his legendary book *The Manhattan Transfer* (Dos Passos [1925]/1986). Dos Passos constructs a vivid and brilliant panorama of New York City as a great futuristic machine filled with motion, drama and human tragedies. Dos Passos was not very much interested in the individual lives of his characters, but rather in portraying them and their city Manhattan as a whole, a living organism. Jay McInerney states in his introduction to the novel that:

American individuals are processed by the economic machine of the city, like the new arrivals to New York described in the opening passage of the novel: men and women press through the manure smelling wooden tunnel of the ferry house at Battery Park, crushed and jostling like apples fed down a chute into a press. (McInerney [1925]/1986: 7)

From the very first pages of *The Manhattan Transfer*, one receives vivid images of the metropolis:

There were Babylon and Nineveh; they were built of brick. Athens was gold marble columns. Rome was held up on board arches of rubble. In Constantinople the minarets flame like great candles round the Golden Horn […] Steel, glass, tile, concrete will be the materials of modern skyscrapers. Crammed on the narrow island the million windowed

buildings will jut glittering, pyramid on pyramid like the white cloudhead above a thunderstorm. (Dos Passos 1925: 23)

Dos Passos swirls his readers straight into the centre of things, as his first main character of the novel, arriving in the city by ferry from a farm on Staten Island, asks for directions from his fellow passengers: 'How do I get to Broadway? [...] I want to get to the centre of things'. And someone answers his question on the street: 'Walk east a block and turn down Broadway and you'll find the centre of things if you walk far enough [...] Thank you sir. I'll do just that'. (Dos Passos 1925: 23)

As much as several crucial authors of modern literature – James Joyce, T.S. Eliot, Ezra Pound, Robert Musil, Louis-Ferdinand Celiné, and others were influenced by the means of montage and non-linear storytelling as in experimental film language, there are very difficult problems for film-makers in translating books – drama as well as fiction – onto the medium of a photoplay or a narrative movie. Most writers were enchanted with the energy and dynamics of a modern metropolis, and film-makers shared a common interest in charting the experience of the city on one's psyche and senses. Bioscopic and cinematographic explorations of urban space date from the very beginnings of cinema in form of an aperçu of urban life and Modernity. Most of the early avant-garde film collage and montage attempts to portray the dynamics of modern urban life and the future shape of the forthcoming metropolis, that is, Walter Ruttmann's prototype of a 'city-symphony' *Berlin, die Sinfonie der Großstadt/Berlin, Symphony of the City* (Walter Ruttmann, 1927) or the less-known reportage film on *Moskva/Moscow* (Mikhail Kaufman & Ilja Kopalin, 1928) by Dziga Vertov's younger brother Mikhail Kaufman, were of experimental quality due to the strong fascination with the new and expressive medium of cinematography and the new techniques of unchained camera and montage principles of *Kino Glaz* (camera eye). One of the fundamental aesthetic features of film as a new and experimental medium for artists, film-makers and architects was, of course, its novelty in creating fantastic images and movements of the camera as well as its possibilities of using décor; depicting or constructing space, which created intrinsic spatial realism. Especially one of the major Soviet film-makers and theoreticians Dziga Vertov (né Denis Kaufman) set new and basic standards in film-making with his lengthy film essay *Čelovek s Kinoapparatom/The Man With A Movie Camera* (Dziga Vertov, 1929), attempting to create a yet unseen, even visionary 'New Moscow' on the editing table as an imaginary filmic space and transforming it into a socialist utopian dream or metaphysical space. The poetic film poem *Manhatta* (Charles Sheeler & Paul Strand, 1921) or the futurist experiments *Velocità* (Pippo Oriani & Corrado D'Errico, 1930/1931) or *Stramilano* (Corrado D'Errico, 1929/1930) or some French *cinéma pur* examples, such as *Jeux reflets et de la vitesse/Play With Reflexions and Speed* (Henri Chomette, 1925) or the document *La Tour* (René Clair, 1928) on the Eiffel Tower are more lyrical, translucent, musical and impressionistic. Jean Vigo's film debut, his polemical film *À Propos de Nice* (Jean Vigo, 1930), sarcastically portrayed his hometown Nice in carefully selected shots and parallel montage sequences of dialectical quality. These few examples of film history should

give just a general idea that the actual physical and/or aura-derived fictional spaces of cities and architecture have a very long and continuing tradition in cinematography and visual media. It is now my intention in this chapter to suggest that there is an aura-related feeling of metaphysical space in film, which can be achieved through specific filmic manipulation and uses of physical space and metaphorical space.

Therefore, this chapter will focus on two classic movies from 1931 until 1960, in which tales and stories are situated and contextualized within important centres of Modernity, to prove that aura and film can not only match each other, but indeed go together and achieve an interesting synergy. My first example, *Berlin Alexanderplatz* (Piel Jutzi, 1931), is set in post-war Berlin very close towards the end of the democratic Weimar Republic; my other example is the funny farce *Zazie dans le Métro/Zazie in the Subway* (Louis Malle, 1960) portraying a gay and swinging Paris during the French *New Wave* period pre-1968. My intention here will be threefold: first to link literature, modernity and urbanism to film aesthetics in some exemplary cases of past and present; second to suggest, or even better, to make the connection between literary history and architectural theory with film aesthetics and history, and third and last, also to suggest the 'reading' of architecture and history in perceptual and constitutive experience, as content, form, social activity, subject matter and cognitive perception by cinematic methods and styles in film history and in the genealogy of city films or urban 'space operas'. Perception in architecture as well as in the *mise-en-scéne* of cinema is seeing and staging a narrative through the methods of gaze and space. A perceptual construction of cinema and/or a system of codes establishes a physical space relation or an *a priori* understanding between the viewer and the viewed, which can work as an architectural structural reading of one's environment and habitat. The strategy I propose, literary film narrative with the modern interpretation of city life, is also one that I use as a method, labelling it a cognitive model of 'urban mapping' and architectural 'reading'.

Narrative reading of the city

To begin with there is an objection: comparing a novel with its filmic adaptation is not necessarily legitimate, since they are completely different media. Literature and film are still considered to be basically incompatible. Cinema can parallel other art forms, but it need not stem from them, as Ralph Block puts it succinctly in his early article *Not Theater, Not Literature, Not Painting* (Block 1927). Again, some of the Russian formalists, French purists and German avant-gardists go so far as to argue against the inclusion of any literary values at all in the cinema. In 1929 German experimental film-maker Hans Richter noted in his pamphlet *Filmgegner von heute, Filmfreunde von morgen*: 'Film has inherently nothing in common with either novels or drama. These are based on the power of words, while film relies on the succession of optical impressions' (Richter [1929]/1968, my translation). Rhetoric, drama and psychology were considered by leading film artists and avant-garde film-makers to be the poison in cinematography, and for the Russian constructivist film-

maker and theoretician Dziga Vertov, even contra-productive and contrary to the purpose of a true 'film art' form and, of course, alien to the aesthetics of film-making. Vertov strives in his film documentaries to achieve the utmost purism in style, perceptual realism and absolute 'truth' in cinema, stripped of any narrative or psychological elements. The problem in silent film is, of course, the absence of words, which have been substituted and translated by images, montage and music. Film, therefore, demands a unique kind of imagination, which differs from literature.

The syntagmatic logic of reading and understanding film language is different from any form of literature, since cinema is a visual language, forcing the film-makers to think and perceive reality in a fundamentally different way than a writer. Cinema, much like literature and architecture, provides, by its imaginary and reconstructive technology, a unique means of preserving or memorializing the historic past, by creating an image, or a memory or perhaps a historical/cultural identity in one's cultural heritage, even as it provides for the transformation of that past and for becoming fiction and collective memory. Through the illusionistic and technical ability of the cinematographic apparatus through the objective perspective of a camera's eye, its montage principles, its trick possibilities and so forth, a synthetic environment is created on screen for the viewer. The virtual space, the plasticity and realistic impression of the objects created by film images change not only the perception and view of one's environment, but sharpen the audience's ability to perceive only things that can be seen on screen. Thus, cinema forces the film-makers to express their themes and ideas visually and not verbally.

Coming from a non-literary disposition, 'reading' or experiencing architecture in one's own (built) environment is equally physical, tactile, psychological and so forth and calls attention to its codes, symbols and meanings. For example, cities – their shape, forms and characteristics – can be read like an open book or 'by their walk', as Robert Musil wrote in his two-part novel *Der Mann ohne Eigenschaften* (Musil [1930]/2002). The recent collapse of greater economic, political and intellectual systems has led, besides many disorientations among societies, to a fundamental structural, cognitive and linguistic change in the contemporary perception of the metropolis in particular, and its sense of urbanity, or of a social urban micro-climate in general. No longer can the norm of the so-called *megacity* be seen as a unified, coherent whole, but rather in its fragmented and dislocated parts ('non places'). What seems to have gone to waste and fallen into decay through the rapid change in global culture, brings again something new and fresh, for better or worse. The image and history of a modern city have transformed from its positive, perhaps often naive notion as a generator of diversity and the various facets of human culture into a diabolic *Moloch*, destroying much of the quality of life of its inhabitants. Today's popular, though vaguely formulated, misconception of the city is evident. One of the paradigms, which Jane Jacobs claimed in her famous study *The Death and Life of Great American Cities* (Jacobs 1961), was the notion of diversity in a grand city. In her pioneering analysis, the urban sociologist and urban planning advisor, Jacobs mentions that the 'Classified telephone directories tell us the greatest single fact about cities: the immense numbers of parts that make up a city,

and the immense diversity of those parts', thus concluding that 'diversity is natural to big cities' (Jacobs 1961: 143). Jacobs's affirmative statement of an 'organized complexity of a modern metropolis' (Jacobs 1961: 143) seems to have disintegrated or disappeared without establishing a new form of identity of urbanism and 'being' (*Seinsform*) of postmodern, globalized urban life.

For Jacobs, reading a city was to decipher its chaotic or 'orgiastic assemblage' by analogy, sorting out the principles and elements of city planning and bringing some kind of general order into them as city planners try to regulate the size and growth of cities. Apart from the change in parameters and definitions, one no longer speaks of a big and dense city, but of urbanity in general. The loss of values, prestige, order and authority forwarded a rather vague vocabulary but nevertheless a comprehensive expression of what city life is all about. A new category of urban design and a sub-discipline of urbanism had emerged already with Modernity and Functionalism in the 1920s, for which a completely new terminology was invented and created by the leading figures of the avant-garde movement: *citta futurista*, *cité industrielle*, and, of course, the infamous *ville radieuse* by Le Corbusier. Since then, many other aesthetic and functional concepts and slogans of urbanism have appeared in regular intervals, such as *moving cities*, *collage city*, *megalopolis*, *suburbia*, *global village*, *ville panique*, or even *necropolis*, all of which have been received and exploited by the media.

Benjamin, Döblin, Ruttmann and Berlin

The magic of Berlin is connected with its still ongoing urban re-development, which means re-designing and re-inventing itself, especially with the process of urbanization and a constant new identity. The images of Berlin in German cinema emphasize the urban environment as a hustling, busy, self-destroying, decadent and oversaturated metropole. The history and complexity of the former *Reichshauptstadt*, the rapid pace of its chaotic growth and the resulting social changes, and last but not least, the change in architectural features have been and still are an important inspiration for local and foreign film-makers. Ever since the era of silent cinema, German film-makers – Heinrich Zille, Friedrich-Wilhelm Murnau, Fritz Lang, Joe May, Robert Siodmak and Gerhard Lamprecht – have been fascinated by this melting pot, showing Berlin in various of their movies as an public arena (*Schauplatz*) of Modernity with rapid change, growing markets and industrial power. But, at the same time, Berlin is ravaged by problems such as poverty, (mis-)integration, high crime rate, corruption, loneliness and social anonymity, so typical of many post-war cities. Some famous silent feature films and social dramas of the era, like *Die Hintertreppe/Backstairs* (Leopold Jessner, 1921), *Die Strasse/The Street* (Karl Grune, 1923), *Der Letzte Mann/The Last Laugh* (F.W. Murnau,1924), *Asphalt* (Joe May, 1929), *Menschen am Sonntag/People on Sunday* (Robert Siodmak, 1930), *M* (Fritz Lang, 1931) and *Emil und die Detektive/Emil and the Detectives* (Gerhard Lamprecht, 1931) were set in Berlin's genius loci, which described and characterized the city rather well in their plots. These examples also reflect the atmosphere

and social political climate, peculiar to this era of history, with its intellectual trends and odd, extreme contrasts within society. So we find kitsch alongside genuine art films, escapism and stark realism, human conditions and problems, and Marxist interpretation of class struggle together with a falsification of history.

A unique film portrait and epic narrative of Berlin is the semi-documentary feature film *Berlin Alexanderplatz* (Piel Jutzi, 1931) following an interesting novel of the same name by Alfred Döblin. The German director Piel (Philip) Jutzi had worked extensively as a documentary film-maker, editor and cutter for the leftist organization *Internationale Arbeiterhilfe* and their own successfully operated film distribution firm called *Weltfilm*. Jutzi later collaborated with the communist production company *Prometheus* and was even in charge of the editing of the German version of *Bronenossez Potjomkin/Battleship Potemkin* (Sergei Eisenstein, 1926). Together with the Russian cameraman Anatoli Golownia, he worked on the interesting Soviet–German co-production *The Living Corpse* (Fjodor Ozep, 1929) before becoming a director in his own right for the newly created film company *Prometheus*. Jutzi rose quickly to international fame with the social melodrama *Mutter Krausens Fahrt ins Glück/Mother Krausen's Journey Into Happiness* (1929), an absolute highlight in German proletarian Kino before the Nazis came to power. In the same year Jutzi directed, wrote and produced the semi-documentary *Hunger in Waldenburg* with amateur actors, presenting a realistic image of the working class in the Weimar Republic. However, the awkward narrative and agitprop style of *Hunger in Waldenburg* suggests Jutzi's relative inexperience with feature film and its severe pressures with a very tight production budget and a short time limit. Nonetheless, Piel Jutzi's social films are a very good example of the immense influence of the *Neue Sachlichkeit*, combined with so-called *white socialism* and agitprop messages, which had already started in the silent era in Germany. A number of contemporary films, produced by leftist activist groups and party organizations of SPD and KPD, focused on contemporary social problems as well. In particular, Ruttmann's aesthetic influenced all social film documentaries and newsreels of this period, not because of the inordinate use of Berlin's typical locations and street scenes, but because all these films display the same concern for photographic detail and truth, very similar to the methods of *cinéma vérité*. Jutzi's camera objectivity scrutinizes the life of humble people, and shoots the trivial incidents of the street from reality. In Jutzi's masterpiece, *Berlin Alexanderplatz*, a narrative of the intersection of biography and urban space, the famous public square is the symbol of city life, commerce and social activities, like a theatre for the masses. The very life of the main characters of the movie is settled on this central place of Berlin. Alexanderplatz, this urban gathering point is the locus of a paradigmatic and dynamic city space, extending beyond the boundaries of Berlin and beyond Germany, commemorating the national situation and even the real tragedy of Berlin's history since Adolf Hitler, taking us into the human disasters and modern metaphysics of twentieth-century history.

The narration of *Hunger in Waldenburg* (Piel Jutzi, 1929), though less complex and innovative than the following masterpiece *Berlin Alexanderplatz*, functions similarly as the other leftist agitprop films of the period. The film was shot on location in Silesia, in the

Waldenburg coal region. It is a drama that reports on the life and struggle of the working class. Its primary intention was to construct a realistic narrative with natural settings and amateur players to establish authenticity. Due to the severe economic crises in Germany, the leftist film firm *Prometheus* folded, and Jutzi was again out of a job until he signed up with producer Arnold Pressburger and the advocate Dr William (Wilhelm) Szekely for his next film project with the commercial film company *Allianz Tonfilm* to direct Döblin's truly avant-gardistic *Großstadtroman* into a feature film with several great *Ufa* stars like Heinrich George, Bernhard Minetti, Maria Bard, Gerhard Bienert, Reinhold Schünzel in leading and supporting roles. The Jewish-German writer and medical doctor Alfred Döblin was a professional neurologist, who had his practice near the busy Alexanderplatz in Berlin during the *roaring twenties*, where he experienced at first hand the dynamic and hectic atmosphere in Berlin's heydays. To reproduce this new and exciting kind of urbanism with its energy, traffic and diversity in a bursting, modern metropolis, the writer Döblin attempted to reproduce in his novel a feature he called *Strom des Lebens,* meaning a *stream of life* or *teems of times* (a quote from *Finnegan's Wake* by James Joyce) by miraculously describing in great detail the nervous and multi-simultaneity of contemporary urban life and various social behaviourisms of ordinary people. Strangely enough, the book is even more filmic than the movie.

Despite some flaws with regard to the minimalism and downplay of the political potential of the film in comparison with the social critical aspects in the experimental book, and also some unfortunate conflicts with censorship, petit-bourgeois values and standards, the film follows more or less the storyline along the sad and tragic destiny of its main character, the good-hearted mason, day labourer and ex-convict Franz Biberkopf (performed beautifully by the legendary Heinrich George). However, the film adds a bitter, opportunistic aspect and even an unexpected optimistic end, by its reactionary message: If one's heart is in the right place, like Biberkopf's remarkable survival talents or tactics against all odds, one will not go under in the 'big city'. The film scenario does not exactly follow Döblin's intention of a collage by presenting a chaotic image of the growing, careless and anonymous metropolis composed in diverse angles or even splitters of reality. Only in some of the sequences of the movie, does one feel the chaos and velocity of Berlin. In several episodes the film achieves a greater picture puzzle of the city by use of montage and even including some outstanding unstaged documentary sequences by Erich Giese's camerawork. Despite the moral and commercial compromises by the producer Arnold Pressburger, director Piel Jutzi decribes, captures and shows quite sharply and accurately the exposed subculture milieu he is describing. Jutzi has an alert awareness for this type of working-class sub-culture and even a more magic eye for detail – in which he places his larger-than-life characters and their criminal lives, making the movie a good social study, in retrospect, of Berlin's underdogs. But again, like most of the social stories of that period, it lacks the revolutionary power and a deeper commitment to class struggle. Perhaps, Döblin's new style and juxtaposed method of writing and storytelling – along with James Joyce's *Ulysses* (1922) or John Dos Passos's *The Manhattan Transfer* (1925) – was more contemporary in taste and relevant in

content than most of the movie itself. The exceptions are the sudden documentary passages, which are abruptly interwoven with the story, allowing one's own free visual associations and subjective perception of urban space. In these few documentary passages of a free-flowing, street-walking camera, we get a sense of the space/time framework on our stroll through the cityscape of Berlin. In particular, one sequence of the movie, as Biberkopf takes a trolley ride after his release from prison after a three-year sentence for a small armed robbery, he perceives the city indifferently due to his own personally experienced reality and perspective after having been jailed.

Now considered a true classic of German cinema in the Weimar Republic, *Berlin Alexanderplatz* also reveals the basic flaw in all these socially intended films in pre-revolutionary, Red Berlin about an impoverished proletarian in the famous working-class neighbourhood of Wedding. Not only is the actual social-realist milieu extremely romanticized (therefore distorted), the film directors and their art directors of Jutzi's and Döblin's generation, tried their very best to imitate and reinforce the city's clichés and myths. The few convincing documentary passages – of course, besides paying homage to the previous or parallel efforts by Walter Ruttmann, Robert Siodmak, László Moholy-Nagy, Slatan Dudow, Werner Hochbaum, Ella Bergman-Michel and Ernö Metzner – are mixed with melodramatic and corny effects, spoiling the mood and tone of natural and authentic observation. Thus, the unbalanced artistic quality or lack of sincerity leaves a bad aftertaste, perhaps due to some uneven traces or unpleasant remains of the sappy, romantic milieu of Heinrich Zitte's archetypical Berlin movies and/or street film genre from the silent film era. The once immensely popular so-called *Sitten-, Dirnen-* and *Strassenfilme* during the evolution from silent to sound cinema in Germany presented a powerful image of everyday life that, in retrospective, however, discouraged the social interaction necessary for a flourishing democratic and progressive society. In opposition to the complexity of the novel, the film adaptation is greatly simplified and the story runs thin like a rubbish *colportage* settled in Berlin's criminal underworld of the 1920s with characters of the so-called *Lumpenproletariat* (sub-proletarian). At the same time, Jutzi, guided by the Döblin script, constructed a cohesive narrative, integrating documentary footage with staged scenes in theatrical, semi-natural and anti-gloss studio sets by Viennese set designer Julius von Borsody in the Babelsberg studio, combined with real outdoor scenes on streets and squares of the great city.

Lost in translation – Zazie's crazy adventures in Paris

The surrealist writer Raymond Queneau (1903–1976) rose to popular fame in France after the huge success of his charming novel *Zazie dans le métro/Zazie in the subway* (1959), in which he tells humorously of the marvellous and fantastic adventures of his little heroine Zazie, who comes to Paris from her provincial hometown for the first time in her life to see her relatives and wants to see all the major sites of the metropole, which she has imagined

in her mind since her childhood. The film can also be read as a filmic *rendezvous* with the lovely and gay Paris. Within the maze of the big and exciting *cité*, she runs into some strange adventures with some wonderful characters of the *banlieue*. Zazie's dearest wish is to ride in the *métro*; however, the subway is on strike and the streets are stuffed with traffic. In this traffic chaos, Paris turns into a frolicsome adventure, full of action and fun.

After the book's and film's huge popularity in France, a small Parisian *métro* station in Bobigny-Pantin was commemorated to Raymond Queneau. Queneau's novel was filmed by French director Louis Malle the following year, when the French *New Wave* was in full bloom, and the huge success of both the book and the feature film boosted the poet Queneau to a sort of celebrity – a fame seldom experienced by writers sharing his level of erudition and complexity. In the novel, Queneau explored at length one of his favourite games and hobbies: the irresistible force and strength of the spoken *argot* (Parisian slang), corrupting and vulgarizing the classic French language. The ironic story is full of puns, wordplay, phonetic spelling and multiple strata of dialectic. Its intensely colloquial and anarchistic nature allowed it to become very popular, which was no small feat for a rather absurd and experimental book with such high literary qualities. Queneau was strongly impressed when he first read James Joyce's *Ulysses* in a French translation. Later, Queneau recognized that written French was a harder bone than he had initially believed, but his experiments with what he called *néo-Français* remain fascinating, and added much flavour to his body of literature. Zazie's slang words and her favourite curse *merde!* (shit) in every second sentence of her dialogue reveal a folk tradition in French literature, from Rabelais, François Villon to Alfred Jarry.

It is also useless to explain the plot of *Zazie dans le métro*, since it is all about language and idioms. For the Surrealist poet, Queneau, language was not simply a communicative and conversational instrument for expressing his ideas and thoughts. He argued that the real subject matter and concern of his literary output is language itself. In his novels, obscure and little-known outside of France, Queneau focused on unpretentious ordinary people, human characters from the margins of society, social misfits, innocent losers and pure children, exchanging social intercourse with each other in such everyday and very ordinary urban locations such as metro stations, small cafés, petit public parks, classrooms and suburban cinemas. Many of Queneau's novels and poems are very difficult to translate, because they are experimental, based on colloquial French dialects, puns and expressions, which play humorously with words, meanings, spellings and funny bowdlerizations. His main child character, Zazie, in the book and film *Zazie dans le métro* alike, starts with the word *Doukipdonktan,* which is a phonetic transcription of *D'où est-ce qu'ils puent donc tant?* meaning *What part of them is it that stinks so much?* His lyrical experiments are just as absurd and witty as his novels: *Si tu t'imagines* (1952) contains most of Queneau's central poems. The work of Queneau has been noted by critics for its Joycean wordplays and neologisms, which are often organized in a serial or mathematical pattern and logic system. *Cent mille milliards de poèmes* (1961), which consists of a set of ten sonnets in fourteen separate strips, fused mathematics with poetry. It is possible to construct one hundred trillion poems from its

lines. Therefore, Queneau's individual lingo in his novels is almost their content. Obviously, the colourful and hilarious comedy style of the film *Zazie dans le métro* is dominant, but also misleading. Initially, the movie picture appears as a stylistic and thematic deviation from his earlier work, be it for one the darkness and pessimist fatality expressed in his debut *film-noir* feature *Ascenseur pour l' Echafaud/Lift To The Scaffold* (Louis Malle, 1957) or the futility of the bourgeois melodrama explored in his second feature film *Les Amants/The Lovers* (1958). In this sense, the film *Zazie dans le métro* appears as a landmark of Malle's own rebellion against the tyranny of genre and convention, defying his own terms of a *cinéaste* and *auteur*, just when some arrogant intellectuals and film critics of *Les Cahiers du Cinéma* were elevating it to its now canonical status in film theory and history (Yakir 1978).

Yet, potentially, the easiest misconception regarding Malle's ironic and spectacularly slapstick pun on *nouvelle vague* would be to understand it as little more than a light-hearted and screwball comedy. Both the book and the film cleverly de-constructed the usual exceptions and conventional narrative deliberately. What writer Queneau does in a literary and linguistic sense – the de-construction of literature by a travesty of literary genres and the virtuosic meltdown of artistic speech and *argot* – film director Malle manages and achieves successfully by de- and re-coding the filmic language in his medium. In *Zazie dans le métro*, Malle did accomplish the double task, first to maintain the flavour of Queneau's original language, and second to translate it into visual terms. He uses and breaks the conventions of the slapstick genre to expertly scrutinize the values and ideals of 1950s bohemian culture in a cinematic explosion of the contemporary Zeitgeist of the Left-bank existential lifestyle and modern consumerism, similar to the sharp and ironic way in which comedian/director Jacques Tati brilliantly displayed his fictional figure *Monsieur Hulot* in the film classic *Mon Uncle/My Uncle* (1958) and the satire *Playtime* (1967).

Both the novel and the film *Zazie dans le métro* focus on the arrival and chaotic visit of the brat Zazie (Catherine Demongeot), a charming but audacious *enfant terrible* from the country with a bad tongue and a dogged determination to ride through the underground tunnels of the *métro* while visiting her bored uncle Gabriel (Phillipe Noiret) for an exciting weekend in Paris. But the *métro* is on strike, so her mother and relatives have to put up with her for the weekend, being her host and tour guide around Paris. Dumped at her uncle's bachelor apartment by her flittering mother (who prefers to spend her time with her boyfriend) the weekend provides Zazie the opportunity to explore the landmarks and tourist sights of the city and its offerings. It is interesting to note in this context, that the Franco-American photographer and underground film-maker William Klein was an artistic advisor to Louis Malle for selecting some of the locations in Paris. So Gabriel takes Zazie on a sightseeing tour through Paris by foot or by car. The turbulent odyssey is some way a tourist travelogue, visiting and depicting the famous landmarks of the *grande cité*. In one scene Zazie is riding in the open car around Place Saint-Sulpice, where Malle breaks all codes of classical *mise-en-scène*: for example, his imaginative use of simple and antique film tricks, including time laps, camera stops and slow motion colour and his very special use of sound.[2]

The tempo of the city in the film *Zazie dans le métro* is terrific, because everything is always in motion, each scene accelerates into the next, never to stop to contemplate or to rest until the very end, when the girl falls asleep just in the *metró* after a hectic weekend in Paris. However, Zazie's haphazard encounters with adult Parisians, her subjective perception and relationship with the city defy more traditional representations of both Paris and a nostalgic childhood innocence expressed in poetical films such as Albert Lamorisse's *Le Ballon Rouge/The Red Balloon* (1956). From the opening scene, uncle Gabriel is presented as a decadent French dandy, and to a certain extent even as an almost narcissistic noble snob, complaining about the sullied, putrid state of the Parisian plebeians waiting at the train station *Gare de Lyon* for the arrival of his relatives from the country. However, his manners and way of nasal speech distances him from his humble peasant and working-class background, which not only exposes from the start a personal distance between Gabriel and Zazie, but between the other members of his family as well. Queneau underlines the essential place of language as a means of dictating notions of belonging, heritage and class hierarchy. This was a fundamental concern of the book, and, remaining faithful to its *modus operandi*, the film takes its opening word directly from that of the novel. Gabriel, as a potential metaphor for this metamorphic adult world, is never what he appears to be, indifferent in his odd character of role play and eccentric behaviour. Sometimes Gabriel, a basic good-for-nothing, appears to be a romantic gentleman, sometimes a charmer, a joker and a low-gauge philosopher, living in his own old-fashioned world, in a less fashionable *quartier* of Paris, together with his clan members and past memories, legends, illusions and chimeras. This initial introduction of the setting becomes an ironic gesture that exposes for one, the delusions of Gabriel's own existence, and for the other, the fate of his many alter egos and escorts in this typical clique of Old Parisian men and women. Whilst criticizing sarcastically the institutionalized social and personal hierarchy itself, revealing the gaping contradiction between Parisian high culture and the historical status it is supposed to represent, the film makes fun of the bland and quotidian life of its inhabitants, whose attachment to this kind of past seems so untenable. Yet, it is Gabriel and all the twisted and bizarre characters of Paris, as well as Zazie herself, who also produce moments of real joy and light tragedy in the film. Multiple musical numbers, including an extended, intoxicating, jazzy exploration of the hullabaloo of late-night Paris (reminiscent of an earlier tribute to Miles Davis in Malle's wonderful *Ascenseur pour l'échafaud*), express the pulsating life of a brave and changing new world of Americanism. And, while on the one hand, the film's use of light and set design communicates a criticism of the late 1950s' obsession with consumer culture (which the characters destroy, be it accidentally and intentionally), these filmic elements also, if not paradoxically, memorialize a fascinating and exciting era of modernist architecture and design, which is as openly at odds with the values of an old Europe as the film's characters and young brat Zazie herself. Read in this way, the film has the potential to reflect Jean-Paul Sartre's own writings on the positive and dynamic motivations at the heart of existential crisis, as well as to celebrate freedom and sensuality beyond the conservative values of the bourgeois Parisian culture.

Now, some comments about the representation of the city: The film presents the city in a type of mini-travelogue format, skipping from the *Tour d'Eiffel* to *Notre Dame*, the *Moulin Rouge*, the *Marché aux Puces*, the famous boulevards, bridges (*Bir Hakeim*) and the banks of the Seine, but constantly arrests its audience mid-spectacle, demanding introspection – whether it be through the tragedy of a lovelorn ageing widow who believes herself to still be young, a policeman bordering on paedophile, or a housewife whose sadness towards her own marital entrapment has produced within her a sense of alienation that has almost made her an ethereal supernatural being. These shady, yet endearing, characters constantly demand critical reassessment of right and wrong. If we, like our heroine Zazie, are looking for absolute truth in this world, Malle seems to be presenting to us only a microcosmic rat race where the fundamentals of religion, the nation state and historical authenticity have all but disappeared. *Zazie dans le métro* also plays out as a matrix of contradiction, reflecting both the cultural revolution gripping France during the post-war era as well as the technical innovations of young French cinema on the rise, which would make director Louis Malle and his contemporaries renowned. It works, not despite its *mélange* of slapstick, tragedy, farce and satire, but because of it. If, as Robert Webster notes, the themes at the heart of Malle's work are 'jazz, suicide, obsessive love, [and] young people suddenly forced to confront an evil adult world', (Webster 1994: 915–16) then *Zazie dans le métro*, with its philosophical questions of being and mortality and its charming representation of life in all its complications and contradictions, works not as an anomaly, but rather, as the quintessence of Malle's œuvre.

Rather, Malle investigates an ambivalence regarding our social reverence towards such childhood purity, using Zazie to create a presence that Webster aptly describes as 'disturbing'. A self-professed lover of Lewis Carroll, Malle produces in *Zazie dans le métro* a fascination with the complexities and contradictions of youth, one reminiscent of Carroll's own figure Alice, which exposes the tensions between innocence and corruption, fact and fiction, and the nebulous grey areas that exist only in the adult world. The story of both book and film explores more existential concerns such as the relentless obsessions facing uncle Gabriel's own empty and meaningless existence, with the decaying status of a late bourgeois society and the futility and burden of everyday life. These concerns echo both the post-war philosophical mood of the late 1950s as well as the preoccupations of the *nouvelle vague*, with which Malle was shortly associated (Russell 1965: 73).

The teenager Zazie is actually described by Gabriel in an early scene as *la nouvelle vague* (the New Wave), in reference to her shocking vulgarity and challenge to the established order of the adult world. If Zazie, through her endless questions and boundless desire to see beyond the filth and scum of the city epitomizes youth, life, progress, or even the potentially ironic pretentiousness of the city's charm of old and new, dear uncle Gabriel works as an opposite reactionary force, content, passive and resentful. He becomes a fossilized product of the city's history, a historical matrix that, according to and like Gabriel himself, seems to have lost its essential meaning. When Zazie demands that he tell her the truth, his laconic answer seems to summarize the film's very essence: 'The truth! As if you knew what truth

was. As if anybody knew. The Panthéon, the Invalides, the Hôtel de Ville, Gendarmerie, the Madeleine, all a lot of hooey!' These objects and characters of the movie refer to the cliché of the *ancién regime* or of Old Paris, dressed up in its historical colour but ultimately meaningless to its contemporary inhabitants as it crumbles and decays from within. The film combines its themes of fact and fiction, present and past, old and new to tell an unwritten history. It is not the glorious shadow of the French Revolution, but one of pastiche, of fragments, of margins, of inequality, of colonialism, of collaboration and perhaps, even, of failed resistance and of *memento mori*. It is in this moment that the film becomes closely aligned thematically with Malle's previous works, as well as those to follow.[3]

Conclusion

Even if the mood and style of my chosen two films completely differ from each other, the illusion of authenticity played an equally important role in both, achieving some sort of sentiment for the old, glorious and lost great city. Each of my chosen film, in its very own fashion, portrayed a slice of life, and above all, they successfully convinced their audiences to perceive their filmic pictorials of Berlin and Paris as imaginary and chimerical, but never an authentic image of the city. In cinema, both the realistic and the visionary image of a city can naturally spark the mind in many different directions and set off one's imagination in various dreamlike journeys and fantasies. But in this necessarily selective and exclusive survey of just two paradigmatic 'big city tales' I have limited myself to the realistic and dramatic effect of existing, often very common and somewhat banal cityscapes of Berlin and Paris, rather than the sheerly fantastic, or, let us say, the chimerical screen representation of studio architecture or trick animation. The movie camera always did seek strong visual metaphors, and what can be better than the man-made environment of a super city with its magnetism of vibrant and chaotic city life to depict an urban jungle of heroes, villains, horrors and pleasures. As it is, both film-makers, Piel Jutzi and Louis Malle, with their unique visions of contemporary city life created some quite interesting and novel-looking features in the imagination of the spectator, partly from their life-like plot of urban life, and partly from their real existing locations in Berlin or Paris. Both movies also have two features in common: first that they are, despite their originality and marginality, commercial products of a large and thriving film industry and second, that they are a mere metaphor for modern urbanistic culture. Even though the established film industry always preferred a standard or cliché kind of narrative film genre that entertained mass audiences, it also continued to permit a modicum of risks for experimentation and innovation in every period of history. However marginal these two feature films were for their time and age, they nevertheless contributed significantly to mainstream cinema, thereby earning the eternal status of classics or so-called cult films. In addition to their literary roots or connotations to a famous novel, imposing a text of a prominent author or of an unseen storyteller, both films liberated themselves from the original narrative structure by improvisation in dialogue, staging, montage and the use

of visual signals. In both cases, authentic reel footage of real urban traffic scenes (Place de l'Etoile), some prominent landmarks (Gare de Lyon, Tour Eiffel, Eglise St. Sulpice) and very typical Parisian locations (Marché aux Puces, Opéra, métro stations) were integrated perfectly with the fictional studio street and/or café scenes to increase the suggestion of authenticity. Pure movie magic and its illusionistic power of semi-documentary authenticity played an equally significant role in these two prime examples of a city narrative in cinema. Some of these visually striking sequences of Berlin and Paris cityscape presented a powerful mental image of everyday human life and society that encouraged the social interaction necessary for a flourishing metropole and, in fact, even for a democratic society.

If one is looking for a leitmotif in both films, I prefer the term tableau rather than panorama. Instead of the gigantic and complete picture of the big city, both films concentrate on the humble private view of its characters, thus breaking the image of Berlin and Paris into many personal and subjective experiences with lesser important parts and little fragments. No doubt, both films define various non-places or voids, or of hidden unseen spaces in between the present and the past. This kind of heterotopia – defined by Michel Foucault as the other (exotic and erotic) and hidden spaces, or unseen spaces or even better in our case of so-called non-spaces (Marc Augé) – lay hidden behind the layers and myths of history. The term heterotopia can mean in cinema a metaphor for Plato's cave, perhaps a place without a place and no empirical connections. This means that not only current but historical events are blurred into metaphorical scenes. Subjects, objects, monuments, buildings, landmarks, neighbourhoods, societies and cultures emerge indiscriminately. This kind of deliberate fragmentation reveals a kind of dérive (floating) through urban space, depicting sites and places, where future and past come together and even mingle. Thus the movies make cities transparent, where everyone, everyplace and everything can coexist at the same time and at the same level of consciousness.

Walter Benjamin already emphasized in his pivotal essay 'The Work of Art in the Age of Mechanical Reproduction' (1936), that the invention of cinema destroyed a world that consisted of a dungeon with its explosions of ten seconds:

By close-ups of the things around us, by focusing on hidden details of familiar objects, by exploring common place milieus under the ingenious guidance of the camera, the film, on the one hand, extends our comprehension of the necessities which rule our lives; on the other hand, it manages to assure us of an immense and unexpected field of action. Our taverns and our metropolitan streets, our offices and furnished rooms, our railroad stations and our factories appeared to have us locked up hopelessly. Then came the film and burst this prison-world asunder by the dynamite of the tenth of a second, so that now, in the midst of its far-flung ruins and debris, we calmly and adventurously go travelling. With the close-up, space expands; with slow motion, movement is extended. The enlargement of a snapshot does not simply render more precise what in any case was visible, though unclear: it reveals entirely new structural formations of the subject. So, too, slow motion not only presents familiar qualities of movement but reveals in

them entirely unknown ones which, far from looking like retarded rapid movements, give the effect of singularly gliding, floating, supernatural motions. […] Evidently a different nature opens itself to the camera than opens to the naked eye if only because an unconsciously penetrated space is substituted for a space consciously explored by man. (Benjamin 1936/1999: 236)

It is true that the mobility of the unchained movie camera explores rooms and even can explode architecture to some extent in space. Cinema becomes itself architecture when the camera unfreezes the static structure and transforms architectural forms, elements and spaces into motion.

No doubt cinema, television and the Internet have radically re-shaped our view of the present world. By means of advanced electronic and digital apparatus it is now possible simultaneously, omnipresently and in real time to engage with the most remote places in the world, which also makes it possible to experience the unseen and unknown features of any global metropolis with a camera eye. In this chapter I have provocatively asked myself these few questions: How does the cityscape of Paris and/or Berlin give clues of its past, present and future? Or can its urban structure, its landmarks, buildings and common environment give meaning to the visual and symbolic representation in any picture media? As I mentioned earlier, it is not necessarily the real scenery and objects themselves that make these fantastic cinema experiences so real and convincing, but rather their inherent meaning and the specificity of their sustained architectural metaphor. This cartographic mapping of hidden spaces and times by sensitive film-makers is much like the methodical and painstaking work of an archaeologist or anthropologist, focusing and seeking carefully for buried information or clues of ancient cultures within the geographies of his fieldwork. However, when objective architectural space is transformed into a subjective, virtually visual experience in cinema, it requires another perception: that of the sub-conscious and the soul. During German expressionism in silent cinema, studio sets and stage architecture played an important role in achieving a perfect illusion. Also, it revealed two tendencies, the paroxystic and the decorative, which suited perfectly the atmosphere of the controlled studio environment during its heyday of classic Hollywood film-making.

By analysing and comparing just two examples of film narratives in the city film genre, one can create the illusion of an imagery, floating and boundless space, a sort of hyper-realistic *mise-en-scène* or a sanctuary of lost memories and forgotten feelings for the metropolis. Both the classic films that I have chosen here would have been unthinkable without their notion and significance of urban space. Producing and viewing a movie is not only telling urban storytales, but also re-creating concrete history and re-producing the time (and the space) or sites in a city. Various styles and types of films impose their unique space and time in history, and therefore each film that I have chosen here has its own character and significance of the place it describes. By depicting two different cities at various times in the twentieth century in two very different narratives, our gaze at pre-war Berlin and post-war Paris can allow each city candidly and vigorously to speak for itself. The perception of their

authentic cityscape triggers the creation of fresh and unspent images of its past. This is the quality that constitutes the power and truth of film documents. This is exactly what German film-maker Wim Wenders meant in his remarkable speech to Japanese architects in Tokyo, entitled 'The Urban Landscape' (1991) 'I ask you to view your own work differently for just one moment, as an exercise in providing future children with a place of origin, cities and landscapes that will form the visual world and imaginative powers of these children' (Wenders 1992: 128).

References

Benjamin, W. ([1936]/1999), 'The work of art in the age of mechanical reproduction', in Hannah Arendt (ed.) *Illuminations*, London: Pimlico.
Block, R. (1927), 'Not Theater, Not Literature, Not Painting', *The Dial*, January.
Bullock, N. (1997), 'Imagining the Post War World', in François Penz and Maureen Thomas (eds), *Cinema & Architecture: Méliès, Mallet-Stevens, Multimedia*, London: BFI Publishing, pp. 52–61.
Dos Passos, J. ([1925]/1986), *The Manhattan Transfer*, Harmondsworth: Penguin Paperbacks.
Jacobs, J. (1961), *The Death and Life of American Cities*, New York City: Vintage Books.
Loos, A. ([1908]/1982), *Ornament und Verbrechen*, reprint: *Trotzdem* (1931), Wien: Georg Prachner Verlag, pp. 78–88.
McInerney, J. ([1925]/1986), *Introduction to John Dos Passos's novel* The Manhattan Transfer, Harmondsworth: Penguin Paperbacks, pp. 7–8.
Musil, R. ([1930]/2002), *Der Mann ohne Eigenschaften*, vol. 1, 16 ed., Berlin reprint: Reinbek/ Hamburg: Rowohlt Verlag, p. 7.
Richter, H. ([1929]/1968), *Filmfreunde von morgen*, reprint: Zürich: Hans Rohr Verlag, p. 35.
Russell, L. (1965), 'Louis Malle', *New Left Review*, 1:30.
Taylor, A. J. P. ([1965]/1990), *English History 1914–45*, Oxford: Clarendon Press.
Webster, R. M. (1994), *The French Review*, 67:5, pp. 915–16.
Wenders, W. (1992), *The Act of Seeing* – Lectures and Discussions Frankfurt/Main.
Yakir, D. (1978), 'Louis Malle: An Interview from "The Lovers" to "Pretty Baby"', *Film Quarterly*, 31:4 July issue, p. 2.

Notes

1. Cf. the enlightening newspaper articles in context with cinema reviews bare: Bernhard von Brentano, in: Berlin – Von Süddeutschland aus gesehen, in: Wo in Europa ist Berlin? Bilder aus den zwanziger Jahren, Frankfurt/Main 1987 (pp. 95, 97, 100); or the essays by Siegfried Kracauer, in: Straßen aus Berlin und anderswo, Frankfurt/Main 1964 (pp. 50, 51, 69, 70).
2. For example: famous French jazz guitarist and pop-star Sacha Distel has a cameo role. You get to hear his singing voice in the off as soon as you see his face on a poster on an advertisement pillar, but then he emerges magically from the billboard.
3. For example, Louis Malle would go on to make *Au revoir les enfants/Goodbye Children* (1987), which deals much more directly with the themes of French history and memory that are only subtly implied in *Zazie dans le métro*.

Chapter 2

I Am Here, or, The Art of Getting Lost: Patrick Keiller and the New City Symphony

Patrik Sjöberg

As has been pointed out by Mark Monmonier in his book *How to Lie With Maps* (1996), there is a long tradition of distortion and deliberate falsifications of city space in the very long tradition of cartography: simply put, where the terrain depicted does not correspond to our expectations of the site in the real world. Yet the lure and appeal of maps and cartography remains; as documents, as fiction, as objects and as imaginaries. This is nothing new and there is a healthy amount of research into the connection between film, cartography, modernity and the city. This particular discourse often blends together with the staggering amount of research done into the early modern period and the development of a modern visual culture; so much so that film scholar Professor Thomas Elsaesser pointed out that the recent New History trend has put such emphasis on the emerging street culture of early modernity, together with photography, Hale Tours, panoramas, transportation vehicles, cinema, department stores, arcades, etc, that their role might be overshadowing other ways of articulating discourse in certain fields, film being one (Elsaesser 2008). A similar sentiment was echoed by Andreas Huysen in his introduction to *Other Cities, Other Worlds: Urban Imaginaries in a Globalizing Age* (2008), where commenting on much recent research, he states:

> Much of this work seems to have been energized by a critical nostalgia for a kind of urban formation that really belonged to that earlier stage of heroic modernity, rather than to our own time: the Paris of Baudelaire and Manet, fin de siècle Vienna, the London of Bloomsbury, Weimar Berlin, and the New York of the Harlem Renaissance. (Huysen 2008: 8)

In this chapter I would like to re-evaluate some of the assumptions made about the contemporary city film as we know it through documentary media. The last five years or so have seen several important studies of the way in which the contemporary moving image culture depicts our postmodern cities. Cleverly drawing on, but also departing from earlier research on city films, which starts out at the very first actuality films, through the various films of the 1920s – with particular attention paid to the City Symphonies by Walter Ruttman, Dziga Vertov, Joris Ivens, Paul Strand and Alberto Cavalcanti; on to the city in film noir, cop films of the 1970s, from the San Francisco of *Vertigo* (1958) to Scorsese's New York, science fiction cities found in films like *Blade Runner* (1982) and *Matrix* (1999), to the Hong Kong in Hong Kong cinema, and the Hollywood in Hollywood cinema, etc. The re-evaluation and re-contextualization of the theory and history of the city film as they relate to new technologies, new stylistic modes of presentation and new touristic sensibilities of

space is well on the way – when it comes to *fiction film*. The same, however, cannot be said when it comes to my own field – the study of documentary media and, in this case, how it relates to the depiction of the city. Although there are tendencies within the documentary studies community now to counter this claim, my ongoing project stems partially from this dissatisfaction.

To put it short: I argue that discourse on contemporary documentary works on the city (and the site-specific), which is all but extensive, is all too comfortable in drawing on the theoretical discourse made on early cinema and the city films of the 1920s, the canonized City Symphonies. The ambition of finding new ways of articulating how these contemporary city films work in relation to the social, cultural and technological conditions of our own time is hard to find. Perhaps, it is understandable. The substantial amount of work done on the connection between early modern theory, the city and early cinema consists of many seminal texts for our discipline as a whole, and perhaps this is part of the allure of treating the theories, however diverse, based on Walter Benjamin, Georg Simmel, Sigfried Kracauer and other thinkers of the time, as an all-purpose tool, ready to be used on any material.

Much of the theory surrounding this time, and the films of that time, is, as you all know, focused on experiencing the shocking newness of the modern city: the new means of communication, the new entertainment technologies, new behavioural patterns of the city inhabitants (flâneur), the fragmentation of experience and the montage-like structure of the psyche of the man in the modern city. But just as these conditions produced a city dweller specific for these particular circumstances in history, we should perhaps not assume that these, however interesting and rewarding considerations, are just as well suited to address contemporary works on the city. In this chapter I would like to offer a suggestive map, a cartography of sorts, offering a few coordinates to a few conceptual panoramic viewpoints that could aid us in articulating another way of investigating these contemporary works on the city, and the site-specific – modest baby steps towards an understanding of an Urban Media Geography, perhaps, what I, without any great enthusiasm, call The New City Symphony.

I will use the films of Patrick Keiller as one point of departure and inspiration for some of my excursions, as well as a number of new technologies and few literary works, perhaps particularly by W. G. Sebald, Thomas Pynchon, and Ian Sinclair.

From the art of getting lost, to, the lost art of getting lost

In his childhood chronicle of Berlin, Walter Benjamin talks about the pleasures of getting lost in a city, of losing one's baring, as a particular sensation of the modern. The art of getting lost, Benjamin suggests, was a historically conditioned phenomenon and relied on the several characteristics of the *flâneur*, traits that we are all familiar with. In a recent book that analyses the role of maps in modernist literature, Eric Bulson notes the way in which fiction, novels, uses real places in real cities for their diegetic constructions of space. The

mentioning of particular street corners, squares, and buildings is used to draw in the reader into a stronger sense of place and deepen the trust in the character and flow of events. Drawing on fiction and maps from Charles Dickens, to James Joyce, to W. G. Sebald and Thomas Pynchon, Bulson sees how the map, included in the novel or not, gave rise to the type of tourist maps that allowed visitors of a city to retrace, for example, the steps of Raskolnikov in St Petersburg. But just as these cartographic representations in fiction are grounded on observations found in the real, they produce, Bulson argues, a more-or-less deliberate disorientation – a false sense of proper proportion and accuracy. This disorientation, or lostness in the place of fiction, Bulson reads as a distinctly modern trait. But as convincing and detailed as Bulson's argument is, he is perhaps to quick in identifying a link between such works as *Ulysses* and *Gravity's Rainbow*, novels representing different cartographic impulses, I think: the first belonging to a distinctly earlier and modernist type of Benjaminian lostness, while for Pynchon there's something else entirely in play – perhaps the sublime sense, or vertigo, of not being able to get properly lost. The lost art of getting lost, replaced by the experience of site as a mediated experience, producing both a sense of reflexive distance and at the same time a heightened sense of presence.

I mention this because Bulson's discussion runs parallel to the project I am involved with here. Where I sense a distinct difference between Joyce and Pynchon in this regard, I sense a distinct difference between the classic city symphonies and contemporary works on city and place. Therefore, I will here try to sketch out a few points that can work as coordinates for considering this new sensibility towards site and city. I will use the notion of *psychogeography* as a transitional concept between the two. Such a transitional term serves as a mediator since what I am suggesting is not so much a complete rupture of traditions as it is a departure. Psychogeographical tendencies can be found in the early city symphonies as well as in contemporary work on the city, without properly belonging to either, hence its mediating function.

Psychogeography

According to the *Situationist International* (Guy Debord et al.), psychogeography is, to put it short, the study of the immediate experience of the environment – the city – and its implications for human emotion. *Dérive* is a technique through which these emotions are to be registered and experienced. The topography at hand, then, is less about the coordinates of a particular street corner or a park, as it is a conceptual map of the atmosphere, mood, sentiment, smell and feeling of a specific place, and how this may change over time, or depending on from which direction you entered the street, park, or square, or any number other contingencies. The underlying power relations affecting these *dérive* are also important and lend themselves to becoming a political analysis as well. The enemy for the Situationists is boredom, and the focus, then, lies on desire and excitement.

Neogeography

Neogeography means 'new geography', and is commonly applied to the usage of geographical techniques and tools used for personal and community activities, or for utilization by a non-expert group of users. It is also used as a summarizing term to describe a wide range of tendencies found in today's discourse on technology, mapping, locative media and re-imaginings of site (the city or the landscape). Application domains of neogeography are typically not formal or analytical and focus is often on grassroots applications of technologies. The important thing for my argument here is that there are technologies and their subsequent behaviour, as well as discourse, for addressing space and the city and the way in which we can navigate in it virtually, or be aided when we move about it in our daily lives.

Viewpoint One: Postmetropolis

I would here like to introduce a couple of terms coined by urban geographer Edward W. Soja, for the benefit of situating my argument. The first one is the notion of a postmetropolis. The concept wishes to come to terms with the process that produces the contemporary globalized city. This process originated in the modern city, and is a result of what Soja calls the fourth urban revolution. One of the characteristics of the postmetropolis is its formal complexity paired with certain instability. In it we can experience a convergence of simultaneous de-territorialization and re-territorialization, which means, parallel processes of disassembly of pre-existing urban realities and re-colonization of the city with new ones. The result is a considerable weakening of the sense and idea of place and the territorially defined social community that comes with that.

The second trait of the postmetropolis, is the difficulty in now separating the interior from the exterior, the suburb from the metropolitan area and from the country. The shift is as much social as it is architectural, economic and political. Patrick Keiller's films, *London* (1994) and *Robinson in Space* (1997), in my reading of them, almost beg to be considered along these lines. The text spoken by the narrator in combination with the carefully crafted static shots in the films seemingly deliberately elaborates on several of Soja's central concerns. The film makes theoretical detours, and comes back, gets lost in a detail only to return to a panoramic understanding of a site, involving the historical, mythical, and the fictional aspects of a place as they palimpsestuously intermingle.

Viewpoint Two: Thirdspace

The second term, related to the first, is thirdspace. In it, Soja offers a conceptual and, at the same time, actual space, as a potential for a decentered exchange of ideas and values within the social and the political. It all relies on an upgrading of the importance of space in our understanding of our world, ourselves, change and history. Soja writes:

The spatial dimension of our lives has never been of greater practical and political relevance than it is today. Whether we are attempting to deal with the increasing intervention of electronic media in our daily routines; seeking ways to act politically to deal with the growing problems of poverty, racism, sexual discrimination, and environmental degradation; or trying to understand the multiplying geopolitical conflicts around the globe, we are becoming increasingly aware that we are, and always have been, intrinsically spatial beings, active participants in the social constructions of our embracing spatialities. (Soja 1996)

Viewpoint Three: Real cities

The term *real cities* is coined by cultural geographer Steve Pile. By employing this term Pile aims to unearth the present but not immediately visible strata of the contemporary city by departing from a re-articulation of the term phantasmagoria. Specific buildings, neighbourhoods and city planning of major metropolitan areas are visualized and analysed, not according to a conventional cartographic logic and progression, but one akin to tropes that he calls the Vampire, the Ghost, Dreams and Magic. Through these four tropes Pile argues that the imaginary, the fantastic and the emotional must become part of the real politics of the city.

One of the objects of Pile's analysis were films by Patrick Keiller. Pile understood the written works by Ian Sinclair and Patrick Keiller's films as conceptual twins, though not identical. Pile traced three similarities in approach:

1. The fragments and bits of the city can be assembled and put together in any number of ways.
2. They both demonstrate how recent history and memory can unexpectedly flash up and thereby disturb and unsettle traditional time–space relationships
3. They both emphasize the importance of the visceral bodily experience of city life.

They were both seen by Pile as psychogeographers:

If Sinclair's and Keiller's psychogeographies are a series of pilgrimages, they are less about reaching a destination (the arrival at a place already known) than about amnesias, frustrations and diversions of the city. As the journeys are embarked and undertaken, they trace out specific geographies and histories of the city. Sinclair and Keiller emphasize particular events and focus on particular surfaces of the city. Even so, in their work, it is possible to discern a way of thinking *from* fragments *to* a broader understanding of London and city life. More interestingly, perhaps, each fragment suggests an alternative present – an alternative to the cities histories and geographies. (Pile 2005: 11–12)

Viewpoint Four: Lisa Parks

Professor Lisa Parks has for years been looking into the problematics of satellites and technologies for earth monitoring in a series of texts and books. She concludes several things:

- The invisibility of the technology and the difficulties with which we can imagine the technology that provides us with Godlike images of landscapes and cities.
- Parks also discusses the way these images are used, how they are implemented in a series of institutions.
- The tendency towards privatization of satellite imagery.

Parks' best work, in my opinion, is her writing on Google Earth, and how this accessible and inviting technology permits the user to browse images, get detailed information about places and cities. She convincingly argues that satellite technologies of earth monitoring in general, but those of Google Earth in particular, influence and, perhaps at times, condition how we relate to specific sites as they are represented and we interact with space in our daily lives. As Google Earth is made available and synchronized with other software found in our mobile phones, the abstraction of view from space becomes more relative, in a sense, and made more everyday as it helps you to find that particular restaurant in an unfamiliar city. This too contributes to another and more mediated sensibility towards the experience of place in general, and the city in particular.

Viewpoint Five: Michael Bull

Another way to re-articulate the way in which we experience the city within the contemporary media climate can be found in Michael Bull's studies of portable personal stereos and how these influence our behaviour in the city. Bull's emphasis is on how we move about and experience the city when the audio-visual contract of the everyday is abandoned and replaced by other sounds, music and spoken words. Bull takes on many aspects of what it means to create a soundtrack for your life, and in his vast number of case studies and interviews, people often describe their walks to work, to an appointment or other, as *cinematic* or 'as if they're in a movie'. Portable stereos do much more than making the city a more film-like experience to move through, it regulates looks, decides and influences which ways we take, why we take the roads we take, how we adapt the music to the time of day, mood and season. As users we are walking through the city as if slightly removed yet with at times a very heightened sense of presence, seeing buildings in a new way, looking at people you meet differently, etc. , is now par for the course for most urban dwellers. Again, to simply update our discussion of, let us say, the *flâneur*, would here be to miss out on a lot of the sensibilities developed here and not give proper account of the sense of mediated environments we all live in.

Conclusion

Most of this chapter has been spent in trying to articulate and argue for the need to rethink the foundations for a new way to talk about contemporary documentary work on the city and the site-specific. Giuliano Bruno writes on the represented city in Alain Resnais' film *Hiroshima, Mon Amour* (1959):

When urban culture – a haptic geography – thrives on tangible interaction and the transitory space of intersubjectivity, it filmically extends its inner perimeter. In the city, as when travelling with film, one's self does not end where the body ends nor the city where the walls end. The borders are fluid, as permeable as epidemic surfaces. (Bruno 2008: 25)

Urban cultures, urban geographies, the mass tourism on a global scale, and the new sensibilities that new technology produces in today's urban dweller begs, I argue, for another set of dynamics in discourse to more properly address this than the one we are currently being offered.

References:

Bulson, E. (2006), *Novels, Maps, Modernity: The Spatial Imagination, 1850–2000*, London: Routledge.

Bruno, G. (2008), 'Motion and Emotion: Film and the Urban Fabric', in A. Webber and E. Wilson (eds), *Cities in Transition – The Moving Image and the Modern Metropolis*, London: Wallflower Press.

Bull, M. (2000), *Sounding Out the City: Personal Stereos and the Management of Everyday Life*, Oxford: Berg Publishers.

—— (2007), *Sound Moves: Ipod Culture and Urban Experience*, London: Routledge.

Elsaesser, T. (2008), 'City of Light, Garden of Delight', in A. Webber and E. Wilson (eds), *Cities in Transition – The Moving Image and the Modern Metropolis*, London: Wallflower Press.

Huysen, A. (ed.) (2008), *Introduction: World Cultures, World Cities*, Durham, NC: Duke University Press.

Monmonier, M. (1996), *How to Lie With Maps*, Chicago, IL: University of Chicago Press.

Parks, L. (2005), *Cultures in Orbit: Satellites and the Televisual*, Durham, NC: Duke University Press.

Pile, S. (2005), *Real Cities: Modernity, Space and the Phantasmagorias of City Life*, London: Sage Publications.

Soja, E. W. (1996), *Thirdspace: Journeys to Los Angeles and Other Real-and-Imagined Places*, Cambridge, Mass.; Oxford: Blackwell.

—— (2000), *Postmetropolis: Critical Studies of Cities and Regions*, Oxford: Blackwell.

Chapter 3

Get Out of the Car: A Commentary

Thom Andersen

G et Out of the Car is a response to my last movie, *Los Angeles Plays Itself*. I called *Los Angeles Plays Itself* a 'city symphony in reverse' in that it was composed of fragments from other films read against the grain to bring the background into the foreground. Visions of the city's geography and history implicit in these films were made manifest.

Although Los Angeles has appeared in more films than any other city, I believe that it has not been well served by these films. San Francisco, New York, London, Paris, Berlin, Tokyo have all left more indelible impressions. It happens that many film-makers working in Los Angeles do not appreciate the city, and very few of them understand much about it, but their failures in depicting it may have more profound causes.

In *Los Angeles Plays Itself*, I claimed that the city is not cinematogenic. 'It's just beyond the reach of an image'. Now I am not so sure. In any case, I became gradually obsessed with making a proper Los Angeles city symphony film. I was aware of a few notable antecedents: *L.A.X.* by Fabrice Ziolkowski, *Mur Murs* by Agnès Varda, *Water and Power* by Pat O'Neill, *Los* by James Benning. These are all ambitious, feature-length films. My film is shorter (34 minutes), and it concentrates on small fragments of the cityscape: billboards, advertising signs, wall paintings, building facades.

Originally it was even narrower. It began as simply a study of weather-worn billboards around Los Angeles. The title was *Outdoor Advertising*. I've loved these billboards with their abstract and semi-abstract patterns since I was a teen-ager, and I would sometimes take photographs of them, but I resisted the idea of putting them in a film because 'it had been done', notably in still photographs by Walker Evans and Aaron Siskind. An interest in decayed signs had become a commonplace in contemporary art.

But it happened that there was one quite beautiful ruined billboard quite near my house that went unrepaired for many months. I drove by it at least once a week, and its presence was becoming a reproach: 'You cowardly fool, I won't stay like this forever'. So on Sunday, 22 February 2009, with my friend Madison Brookshire, I filmed it with his 16mm Bolex. For some months, when somebody asked about the film I was working on, I could simply say it was a film designed to destroy my reputation as a film-maker.

There was another inspiration: seeing a programme of recent videotapes by Kenneth Anger. His new movies were just records of things that interested him, documents pure and simple. He felt secure enough that he did not have to set out each time to make a masterpiece of even 'an Anger film'. He had made the films that established his reputation, and he could say, 'I'm proud of them'. Now he could make anything he wanted and not worry about what anyone thought of them. Although Anger is older than I am and his obsessions – Mickey

Mouse memorabilia, boys playing football, a wall covered with tributes to Elliott Smith – more idiosyncratic, I still felt I could follow his example.

In any case, like everyone else, I try to make movies I would like to see, and then hope there are others who share my sensibilities. The greater their number, the better, but fewer is also okay. For me, movies are, first of all, 'tools for conviviality', to borrow a phrase from Ivan Illich, a means of sharing images and ideas to create a circle of friends, or virtual friends. The size of the circle is less important than the intensity of the bonds among them. For these aspirations, originality does not matter much.

From the beginning, there were two other motives for the project: the desire to work again in 16mm film and the desire to explore the city. Why 16mm? I had made two compilation movies in video, and the quality of the image makes me cringe when I watch them. Three short 16mm films I made in the mid-1960s had recently been restored by Mark Toscano at the Motion Picture Academy Film Archive. For years I had been hearing complaints about declining standards in laboratory work and projection that brought into question the viability of 16mm film as a medium for the production of moving images, but the new prints of these films were superior to the ones I had made in the 1960s and the projections I attended were flawless. It was a happy experience, which reawakened my interest in the possibilities of the film image.

For years also, I had witnessed the conversion to digital image making by many film-makers I admired: Jon Jost, Ernie Gehr, Jonas Mekas, Ken Jacobs, Vincent Grenier, Leslie Thornton, Su Friedrich, Fred Worden, Lewis Klahr and, most recently, James Benning. The switch allowed them to compensate for the collapse of institutional support for film-making in the United States, and they became much more prolific than ever, but there was a decline not only in the image quality of their work, but also in its rigour, which nobody was crass enough to acknowledge. It would be like complaining because their earlier films were not shot on 35mm. I also found myself annoyed by the messianic proclamations that often accompanied these conversions. The stronger the conversion, the weaker the work, it seems.

How is it possible that working in a slightly different medium could produce such a giddy sense of liberation? Since they had mastered 16mm film-making, they did not need instant replay to judge the images they had created. Of course, digital image making is cheaper. We like to make things as cheaply as possible, but sometimes this desire is worth resisting. Films are not properly valued, but if we can go on making them, perhaps they will be. I guess I could afford to work in 16mm because I work slowly. I enjoy making films because it is a process of research and discovery (and I hate finishing them because something that's alive turns into something dead).

The outlook as I write this in the summer of 2010 is very different than it was at the beginning of 2009 when I began shooting the film. The slow motion digital revolution is finally upon us, and God saw that it was good. High definition digital imaging can now achieve higher resolution than 16mm or 35mm film formats, and the necessary projectors will be in place soon. Is there no longer any difference between the film image and the digital image? Still there

are grains and there are pixels, and I prefer grains. A film image is warm (thanks to the play of the grains), and a digital image is cold no matter how fine the resolution.

My desire to explore the city was occasioned by the response to *Los Angeles Plays Itself*. When it began screening around the world, I suddenly found myself regarded as an authority on Los Angeles. This kind of treatment had the effect of underlining my ignorance. Like most people who live here, I follow the same few paths all the time so I know a few neighbourhoods, a few streets. Since I drive most of the time and then mostly on the freeways, the areas I pass through daily or weekly is just driveover country.

In *Los Angles Plays Itself*, I claimed that only those who walk and ride the bus know Los Angeles. But they too follow the same paths every day. Now I would say that only politicians and policemen know the city, because it is their job. I still cannot claim to know the city, but I know it a little better than I did before starting out on this work.

As I explored the city, of course I found other things that fascinated me as much as the billboards, and I began to film them as well. Gradually the scope of the film broadened. This expansion suited me since it allowed me to claim that now I was imitating everybody, but most of all myself. The film could become a 'city symphony', a term I like because it sounds old fashioned, even 'old school', as somebody we met on the street during filming said of the camera we used, a 16mm spring motor Bolex.

I only put in things I like (with one exception, which I will come back to later), beautiful or funny things that most people would overlook, things that I would probably overlook if I had not been searching for them. It happened that many of these things were also outdoor advertisements, from custom-made neon signs to whimsical sculptures to mural-like paintings that cover the walls of restaurants, grocery stores and auto repair shops.

Some are a bit enigmatic. What is a papier-mâché horse doing on the roof of a motel? Why is a giant hot dog sculpture with white bricks as pickle relish sitting on top of a Thai Town Express restaurant? And the grotesque sculpture of a monkey dressed up as a baker outside Nicho's Pizza on Florence Avenue? 'You got to do something to compete with Domino's and Pizza Hut', the owner explained. But I think he just likes animal figures. On top of his insurance offices next door, he has a giant helium elephant, which we were tempted to film.

But what about an elaborate neon sign outlining a round face in half-profile with a yellow clothespin attached to the nose and three blue teardrops below the right eye? It's the logo of Twohey's, a restaurant founded in 1943 along Route 66. Twohey's featured dish is the Stinko Burger, which is nothing more than a hamburger with sliced pickles and onions. Proprietor Jack Twohey overheard a woman exclaim, 'Oh, stinko', when one was served to a customer sitting next to her, and he decided to take advantage of her remark.

The *muñeco* or muffler man might appear equally enigmatic, but it is part of a long tradition. At first I thought *muñecos* were Mexican imports, but I learned from *Muffler Men* by Timothy Corrigan Correl and Patrick Arthur Polk that they are indigenous throughout the United States, from Washington to Florida. At first, they were strictly utilitarian, replacing the flagmen on the street who tried to lure customers into the muffler shop. When a worker had some spare time, he would weld together a used muffler for the torso, some

Figure 1: Hot dog sculpture: Northwest corner of Hollywood Boulevard and Western Avenue, Los Angeles, California.

pipe for the limbs and a catalytic converter for the head to form a fanciful human figure. Now they have become an established form of folk art, but they are more often stolen for scrap metal than for their artistic value. The *muñeco* we show is fairly ordinary, nothing special, but the workers at Universo 3000 were so pleased by our curiosity about their work that I had to include it in the film.

Murals, on the other hand, did come from Mexico, and they are central to Chicano culture. Some Anglos seem to think they are the sum of Chicano culture. Maybe that's why I had been suspicious of them. Agnès Varda's *Mur Murs* converted me. However, there are only a few shots of public murals in *Get Out of the Car*. I preferred to film the more humble paintings commissioned by small shop owners to adorn the exterior walls of their businesses. The artists are not painting for the ages. They know the businesses that hired them can go under at any time. With the stakes not quite so high, they can be freer.

They know that humour sells – just like sex. And piety, a cynic might add. But I am inclined to believe that the religious sentiment expressed in Catholic iconography on store walls is genuine. Paintings of the Virgin of Guadalupe are especially common throughout the Mexican quarters of Los Angeles, as they are throughout the southwest US, perhaps more common than in Mexico. Since the Virgin of Guadalupe is the most resonant and polysemic symbol of the

Figure 2: Monkey sculpture: Sculpture outside Nicho's Pizza, Florence Avenue and Fishburn Avenue, Bell, California.

Mexican nation, her image also expresses the longing for *Mexico lindo* that many immigrants feel – particularly the *indocumentados* who cannot return even for a visit.

The iconography of the Virgin paintings is strict, but there are variations. I had to cut one beautiful painting on the side of a moving van because the Virgin looked too much like Veronica in the Archie comics. The most obvious variations among the ten paintings of the Virgin that appear in *Get Out of the Car* are in their condition. Some are pristine, some are covered with graffiti, and one is cracked and peeling (it has since been whitewashed over). I hope this film will lead defenders of graffiti to rethink their position. I supported graffiti myself in its initial phases when it defaced public space that had been sold to private interests, such as the advertisements in subway cars. I thought it was a direct and effective protest against the degradation of public space. But there is no justification for defacing property belonging to individuals, particularly when the graffiti disrespects and disfigures a work of art, even commercial art.

Camilo Vergara, who has created a photographic survey of crucifixion paintings, believes that storeowners commission them to discourage graffiti. 'If someone is going to put some tag on there', he claimed, 'the mural might lead them to think, Maybe something bad will happen to me if I deface a crucifixion' (Vergara 2009: A29). Unfortunately, it does not always

Figure 3: Crucifixion painting: Detail of mural by Manuel Gomez Cruz (2001), César Chavez Avenue and Indiana Street, Boyle Heights, Los Angeles, California.

work. We rephotographed one painting he had photographed earlier to show the progress of the graffiti. The other paintings of Jesus and the crucifixion were chosen to present a diversity of iconography and style. Some are crudely painted; others show a high level of skill. I like them all, and sometimes the less skilled artists compensate for their technical deficiencies by the originality and complexity of their ideas.

Manuel Gomez Cruz, for example, cannot paint much better than I can, and he has no sense of perspective or modelling. But he was willing to attempt a bold variation on the seminal Los Angeles mural, *América Tropical* by David Siqueiros, painted in 1932 and almost immediately painted over (its restoration has been promised since 1995). Cruz transformed the central figure of *América Tropical*, a crucified Indian with a bald eagle perched above him, into an abject prisoner on the lower right of his mural. He doubled the figure with a cast-iron relief replica projected out from the surface of the wall and wrote underneath it, '1.2.3. WILL GET YOU LIFE'. But he reversed the theme of victimization in the Siqueiros mural by filling most of the wall with the Battle of the Alamo seen from the Mexican side. The Alamo itself is very tiny, almost unrecognizable, with a few defenders hanging from its roof, and it is dwarfed by exultant Mexican soldiers reveling in their victory.

Figure 4: Carneceria mural: Mural (artist unknown), Michoacán Meat Market, Compton Avenue and 52nd Street, Los Angeles, California.

This mural is on the side wall of a *lavenderia* at the corner of Cesar Chavez Avenue and Indiana Street in East Los Angeles. It can be glimpsed in *Get Out of the Car* behind a *cemitas* truck. I also included a detail from another Cruz mural a few blocks west: the crucifixion scene in a charming mural depicting the life of Christ from his birth to his ascension.

In the end, I included many examples of Latino art, both painting and sculpture, and so the film became a kind of gloss on Mike Davis's book *Magical Urbanism: Latinos Reinvent the U.S. City*, although Davis devotes himself to the continued discrimination against Latinos in the US and their modest political victories, not to their cultural innovations. To grasp these innovations, it is more useful to read 'Into the Future: Tourism, Language and Art' by Peter Wollen, a world-wide survey of hybrid syncretic cultures, which reconsiders the work of the great Mexican muralists (Siqueiros, Rivera and Orozco) as a major challenge to the norms of western modernism. He concludes with these words:

Modernism is being succeeded not by a totalizing Western postmodernism, but by a hybrid new aesthetic in which the new corporate forms of communication and display will be constantly confronted by new vernacular forms of invention and expression. Creativity

always come from beneath, it always finds an unexpected and indirect path forward, and it always makes use of what it can scavenge by night. (Wollen 1993: 209–210)

Nowhere is this more true than in Los Angeles, which has always had an official culture and underground culture, where the projects for urban planning and architecture that come from above are incoherent at best, and nowhere is this more evident than in downtown Los Angeles. Ever since the destruction of the residential rooming houses on Bunker Hill in the 1960s, there have been two downtowns: an Acropolis of art and commerce on the top of Bunker Hill that has never quite jelled; below it and to the east, the decaying 'historic core' appropriated by Latinos as their major shopping district with Broadway as its center, its historic movie palaces dating from the 1920s turned into swap meets and churches (to the Anglo preservationist, turning a movie theater into a church is an abomination, but turning a church into a performing arts center is a triumph of 'adaptive reuse'). The storied old hotels such as the Alexandria where the founders of United Artists (Chaplin, Griffith, Fairbanks and Pickford) once met to gossip and talk business had been taken over by the denizens of Skid Row, people with just enough money to get off the streets.

The leaders of the city looked at these dynamic transformations of spaces they had abandoned with horror. They tried to recruit 'urban pioneers' (an apt phrase) to push out the Latinos and the homeless by turning unused old office buildings into luxury lofts and providing the services these pioneers require: Starbucks, French bistros, pet supply stores (at first I thought the dogs were to protect the *arrivistes* from the homeless people with whom they still share the streets, but that was unfair: many of their dogs are toy breeds).

There is now a third downtown: a shiny new $2.9 billion entertainment complex on its southern edge in a neighbourhood now called South Park. It was built by the Anschutz Entertainment Group (AEG), owned by billionaire Philip Anschutz, a conservative Republican and anti-gay activist invariably characterized as 'reclusive', and run by Tim Leiweke, whose liberal politics made him a more effective advocate with the Los Angeles city government. It began with the Staples Center, a $400 million sports arena opened in 1999. Then came L.A. Live, which includes a 7000-seat concert hall (Nokia Theatre), a more intimate 2300-seat concert venue (Club Nokia), a television studio for cable sports network ESPN, a multiplex movie theater (Regal Cinema Stadium 14), a Grammy Museum, a bowling alley (Lucky Strike Lanes & Lounge), a nightclub (Conga Room), a score of restaurants and bars, and a 54-story skyscraper (the only one built in downtown Los Angeles since 1991) with two hotels and 224 condominia.

To create this mega-development, AEG received unprecedented aid from the city and state governments. To build Staples Center, it got $58.5 million from the city and $12.6 million from the Los Angeles Community Redevelopment Agency (as well as $100 million from Staples for 'naming rights'). For the hotel-residential complex, which cost $900 million to build, AEG got only $5 million from the CRA but $246 million from the city in tax rebates. Although the primary announced goal of the CRA is the creation of affordable housing, it was once again complicit (as in the redevelopment of Bunker Hill) in a scheme

that eliminated affordable housing, but this time there was little protest, perhaps because the buildings themselves were not as picturesque as the Victorian mansions of Bunker Hill.

Leiweke even managed to sneak a special bill through the state legislature (the vote came after midnight on the final day of the 2007 session) so that $30 million in state funds could be diverted from affordable housing projects to beautify the public streets and sidewalks around L.A. Live and Staples Center. Although L.A. Live is 'private space' under the control of AEG, the Los Angeles Police Department maintains a special 'state of the art' substation there, usually manned by twelve to eighteen officers who wear special gold pins with the L.A. Live logo. When rioting broke out after the Los Angeles Lakers won the NBA championship in June 2010, the police rallied to defend L.A. Live and let the unruly fans vandalize small businesses just to the north.

I do not find L.A. Live inviting, and everything except the Starbucks and the movie theatre is too pricey for me. The architecture is competent if not inspired, but as *Los Angeles Times* architecture critic Christopher Hawthorne wrote, it is 'not really architecture at all but an extensive series of armatures on which the developer and its tenants can hang logos, video screens and a sophisticated range of lighting effects' (Hawthorne 2008: E1). In other words, the buildings are just backdrops to giant animated advertisements posted on LED screens. Even the hotel has been plastered on two sides with twenty-story high 'super-graphics' advertising Coca-Cola and Bud Lite. The central open square is remarkably charmless, even aside from the assault of constant advertising from giant screens on three of its sides. Nobody I have seen sitting there looked happy. They created a wasteland and they call it entertainment.

AEG's project is sterile and oppressive, of course, but most of all it is irrelevant. The hotels may draw new business to the nearby convention centre, which can use it. Staples Center replaced sports arenas without luxury suites located in poor, black neighbourhoods, so a new arena in a closely-policed zone where the slightest detail is arranged to reflect the social hierarchies of the city might be regarded by some as a significant gain. Los Angeles does need another bowling alley, but I would prefer one that is less expensive than $6.95 per person per game. On the other hand, downtown had a perfectly adequate (although perhaps not for gala premieres) three-screen movie theatre driven out of business by the Regal Cinema, and it still has some beautiful vintage concert venues. But is the city a better place if people drive downtown to see a movie? Does it matter whether his fans go to see Justin Beiber at the Nokia Theatre downtown or in Hollywood? Is this revitalizing downtown? Just a few blocks west of L.A. Live but across the great divide of the Harbor Freeway, there is a real city, a vibrant neighbourhood called Pico-Union, where immigrants from Central America first settled in Los Angeles. The people who fill the streets there have no need of L.A. Live, and it has no need of them.

No Los Angeles politician would say 'the most beautiful buildings must be built in the poorest neighborhoods', as Sergio Fajardo, the mayor of Medellín, once declared. But our politicians have decreed that the ugliest buildings will be built in the richest neighbourhoods.

I never had any interest in filming around L.A. Live, but I did intend to include the ugliest building in Los Angeles until I realized that the form of the film would make my criticism

seem callow. Even in this essay, I cannot begin to suggest the sheer hideousness of the Orsini apartment buildings created by developer Geoffrey H. Palmer on the northern end of downtown abutting the Hollywood Freeway, nor can I explain how Palmer and his lawyer Benjamin Reznik bullied the city government into approving his projects despite his refusal to build units for lower income tenants as mandated by city law, and despite his illegal demolition of an historic Queen Anne Style cottage that stood in the way of expanding the Orsini. It was the last nineteenth-century residential building in downtown Los Angeles. Although city officials at first demanded that Palmer be jailed for six months and forbidden to build on the site for five years, the city ultimately settled for a $200,000 'contribution toward civic improvements' from Palmer.

As its name suggests, the Orsini appropriates the Italianate style that has had a lasting appeal for residential construction in southern California because 'it represented the best of two worlds – classical order and control, and the picturesque' (Gebhard and Winter 1985: 469). Once historicist styles worked to make beautiful buildings in southern California, but today's versions are only impoverished replicas. Like many contemporary buildings, Palmer's Orsini looks like an architect's model built full scale. There is no detailing. It seems caught between two worlds, afraid to look too classical and afraid to look too picturesque. The unresolved tension is almost comedic, but this possibility has been repressed to produce a blandness that offers no sense of repose. Slipshod classicism without conviction and standardized, cheaply-fabricated decorative motifs make for the worst of two worlds. If the Orsini and Palmer's other projects in the same style (the Visconti, the Piero, the Medici) were tucked away in some remote corner of the city, I would not be so irate about them, but they are all situated in prominent sites around downtown, next to freeways and major boulevards so there is no escape from them when coming into the central city from the north or the west.

On the other hand, some of the most beautiful buildings in Los Angeles are in the poorest neighbourhoods. Not surprisingly, there were once many more that have been destroyed, and many of those that remain have been scandalously neglected. One appears in *Get Out of the Car*: the Bethlehem Baptist Church by Rudolph M. Schindler, our most inventive modern architect. Schindler belonged to the underground culture of Los Angeles, working almost exclusively on residential commissions from middle-class Bohemian clients with small budgets, gaining no public recognition until long after his death in 1953. He is still better known outside Los Angeles than he is here. The first few times I visited the church, Kevin Polk, who hangs out there almost every day, would ask me, 'Are you from Australia?'

The Bethlehem Baptist Church, located at the corner of Compton Avenue and East 49th Street in 'South Central' Los Angeles, is Schindler's only non-commercial public building. The congregation commissioned him to build their church because a carpenter who worked for him was a member. Schindler designed the church in 1944, but it was not completed until 1952 because the congregation was strapped for money. Schindler created a strikingly elegant house of worship with the simplest means: overlapping horizontal bands of stucco-covered wood siding with recesses, a small cruciform tower at one corner, and a band of

windows (now covered over) to soften the severity of the design. In essence, José Rafael Moneo's Cathedral of Our Lady of the Angels (2002) with its horizontal bands of faux-adobe concrete is nothing more than Schindler's modest church blown up to gargantuan proportions.

In 1975, the congregation moved to a new building at Normandie Avenue and 74th Street, and the church became the Prayer Tower for All Nations Evangelistic Center, a Pentecostal church with O. M. Miller as pastor. As blacks moved out of the neighbourhood and Latinos moved in, the congregation dwindled to a handful, and services were moved from Schindler's chapel to a small classroom on the west end of the property. Last year Rev. Miller became too ill to continue the services, and the church fell into disuse. Her son stops by once a week to water the grass and clean off the graffiti. The church has become a target for taggers, as Kevin Polk laments in the film. Aside from the graffiti, it is in serious disrepair; because of water damage, its roof could collapse at any time.

Even the most iconic of these buildings, Sabato Rodia's *Nuestro Pueblo*, commonly known as the Watts Towers, also suffers from serious neglect. It is the city's greatest civic monument and its greatest civic embarrassment, 'a beautiful metaphor for diverse Los Angeles' and also 'a symbol of [...] government's inability to do anything right', as Robin Rauzi has put it (Rauzi 2009: A23). Rodia was also an underground artist, a scavenger working by night, although his work was noticed in the *Los Angeles Times* as early as 1937. I discovered the towers in 1952 – two years before Rodia gave them away to a neighbour and moved to northern California – when I read 'The Artist Nobody Knows' by Selden Rodman in *New World Writing*, the earliest essay to treat Rodia as a major artist. When I was a teen-ager, they became for me a fabulous playground – as they appear in Andy Warhol's 1963 film *Tarzan and Jane Regained [...] Sort of* in which Taylor Mead and Naomi Levine dance amidst the towers with their skimpy garments falling off their bodies. There was no fence around them, no guards to keep people away. The Towers were, as I claimed in *Los Angeles Plays Itself*, 'the first world's most accessible, most user-friendly civic monument'.

I did not realize then that the city had proposed tearing them down in 1957 and that their survival was a fluke. It was actually three young film artists who saved the Towers. First there was William Hale, who made a short documentary about Rodia and his work in 1953. Two other film workers in their early 1920s, editor William Cartwright and actor Nicholas King, saw Hale's film, and it inspired an interest in Rodia's work that turned into a passion. Visiting the Towers, they found them apparently abandoned. With a few friends, they formed the Committee to Save Simon Rodia's Towers in Watts and raised $3000 to buy Rodia's property from its current owner. As Richard Cándida Smith notes in *The Modern Moves West*, 'The committee included no major arts patrons or representatives from major art institutions, nor were the city's cultural leaders supportive of the effort to turn the towers into a cultural heritage monument'. (Smith 2009: 156)

When the Committee discovered by chance that the city was planning to demolish the Towers as a safety hazard, they launched a campaign to prevent the demolition. They had the wisdom or the luck to enlist in their cause the gifted aerospace engineer Bud Goldstone

who realized that Rodia had built his towers better than anyone knew. Goldstone proposed a daring gamble to the Committee: a public 'torture test' to determine whether the Towers could withstand a force of 4.5 metric tons (equal to the force of an 80 mph wind) pulling against them. When the city accepted his challenge, Goldstone worried that he might become forever remembered as 'the man who pulled down the towers'. But on 10 October 1959, before television cameras and a crowd of one thousand people, the towers withstood the test, and the city had to abandon its efforts to tear them down.

Sixteen years later, when the Committee ran out of money to maintain them, the city agreed to take over and look after the Watts Towers, but its Board of Public Works contracted out restoration work to an unqualified architect who botched the work so badly that the Committee had to sue the city to stop it. An agreement was reached under which *Nuestro Pueblo* became a California Historic Park and responsibility for restoration was transferred to the city's Cultural Affairs Department. Its stewardship has been haphazard and miserly. Its restoration work has sometimes been as destructive as the earlier work sponsored by the Board of Public Works, and it has never invested enough to maintain the towers properly. However, it did manage to construct a particularly insensitive fence around them, hiding the beautiful wall Rodia constructed on the south side of the towers and making it impossible to see his composition as a whole. In the past, the pace of the restoration work has been so slow that the towers seemed closed to the public more often than they were open, but closures in the near future seem unlikely since the city has essentially given up on maintaining the towers, laying off all three of its conservation workers. It needs $5 million to restore them (more than it has spent in the past 30 years), but it has no plan to find the money other than asking the Los Angeles County Museum of Art for assistance.

A number of local commentators have claimed that this neglect can be attributed to the location of *Nuestro Pueblo* in a poor neighbourhood that most white Angelenos are afraid to visit, but I am inclined to believe it is just another example of the failure by local arts institutions and their administrators to understand or appreciate the real culture of Los Angeles. There are a number of architectural masterworks in southern California that could and should be public museums – Schindler's How House (1925), Frank Lloyd Wright's Millard House (1923) and Ennis House (1924), Richard Neutra's Kaufmann House (1946) in Palm Springs, all currently or recently on the market but unable to attract any buyers – but no local arts institution has moved to purchase any of them. With its restoration of Schindler's Kings Road House (1922), its purchase of his Mackey Apartments (1939) and Fitzpatrick House (1936), and its transformation of all of them into vital arts centres, the Museum für angewandte Kunst (MAK) in Vienna has done more to protect the architectural legacy of Los Angeles than all our local art institutions combined. Yet the Los Angeles Opera can spend $32 million to mount a production of Wagner's Ring Cycle (propped up by a $14 million loan from the county government, advanced in the misguided belief that this represents some kind of cultural rite of passage for the city) and the Getty Museum can find $44.9 million to buy a Turner painting.

The Watts Towers do not appear in *Get Out of the Car*, but a whole sequence was shot within a few blocks of the Towers. The sequence memorializes a more obscure civic

monument, the Barrelhouse, a rhythm and blues club established in 1948 by Bardu Ali and Johnny Otis at Wilmington and Santa Ana, one block east of the Watts Towers. No trace of it remains, and no plaque marks its location. So I hung a sign on a fence for the filming, like the sign on the other side of the street that advertises funerals for only $2695.

I dedicated *Los Angeles Plays Itself* to Johnny Otis and Art Laboe; I called them 'guardians of our history' because they kept alive the musical history of Los Angeles on their radio programmes. But that is only the sketchiest summary of their achievements. Through his long-running radio show (beginning in 1956 and still going stronger than ever), Laboe nurtured an appreciation for 1950s rhythm and blues among local Chicanos that helped spawn a distinctive style of hybrid rock in East Los Angeles and later a Chicano hip hop rooted in the 'oldies' Laboe championed. A Greek American who calls himself 'black by persuasion' and a person of unique integrity in the music business, Johnny Otis has been a drummer, a pianist, a vibraphonist, a singer, a bandleader, an arranger, a composer, a talent scout, a record producer, a newspaper columnist, a political activist, a pastor and a TV host, as well as guardian of our history on his radio programmes, which ran from 1953 to 1991. In *Get Out of the Car*, I wanted to elaborate a bit on my dedication to Otis and Laboe.

I found a way when I abandoned my original idea for the soundtrack. In the early stages of work on the film, I planned to use simple background ambient sound, a kind of 'street

Figure 5: Funerals advertisement: Site of the Barrelhouse, Wilmington Avenue and Santa Ana Boulevard, Watts, Los Angeles, California.

tone' for each shot that would do no more than differentiate one space from another. It came into my mind that I can still remember hearing certain songs in certain places even fifty years later: 'Runaround Sue' in a San Francisco bus station, 'Willie and the Hand Jive' in a beachfront hamburger stand in Santa Monica, 'Every Little Bit Hurts' on a street in Oakland, 'Just One Look' sung in Spanish on the car radio as I was driving alone through Arizona (never heard it before, never heard it since, but just one listen was all it took). I wanted to evoke these memories. These random juxtapositions of sounds and places are one of the great joys of modern life and of city life in particular. The cinema is the only art that can recreate these experiences and their emotional resonance.

So I built the film around juxtapositions of songs and places. The eighteen shots in the Barrelhouse sequence are accompanied by a live recording of tenor saxophonist Big Jay McNeely playing 'Deacon's Hop', introduced by disc jockey Hunter Hancock. It was not recorded at the Barrelhouse, but it could have been: Hancock often emceed there, and McNeely often played there. In fact, it was recorded on 6 October 1951, at the Olympic Auditorium in Los Angeles, during a midnight concert Hancock promoted and emceed. It was the birth of rock'n'roll, although nobody noticed it at the time and nobody has noted it since. For the first time, thousands of white 'hepcats' jammed a large auditorium to see black rhythm and blues artists and adopted the music as their own. Because American cultural history is written from an eastern perspective, Alan Freed is credited with building a 'crossover' white audience for rhythm and blues, turning it into rock'n'roll, sometime in 1954 or 1955. But it happened here first.

Before the 1960s, the United States was a nation of regional cultures. The 'national culture' was simply the regional culture of the northeast, the centre of publishing and the music business. Many Los Angeles singers and musicians recorded for local record companies that could not secure national distribution for their work, and consequently they never received the fame and fortune they merited. For me, discovering their music was an important part of discovering Los Angeles. I thought I knew it, but I did not. I listened to Johnny Otis and Hunter Hancock on the radio, and I loved Big Jay McNeely's 1959 recording of 'There Is Something On Your Mind' (it was his biggest hit, but an inferior cover version by Bobby Marchan was a bigger hit). I even put it in a movie.

But I did not realize that McNeely had created a sound more radical than bebop. He was the most inventive of the honking saxophonists whose playing was characterized by 'freak high notes, the relentless honking of a single note for an entire chorus, and the use of low notes with deliberately vulgar tonal effects', in the words of conservative jazz critic Leonard Feather (quoted in Shaw 1978: 170). It emerged in the late 1940s as an inchoate protest against the US failure to honour the promises of freedom made to its black population during World War II. It was a cry of despair and defiance, and Big Jay McNeely took it farther than anyone. Amiri Baraka called it 'Black Dada':

The repeated rhythmic figure, a screamed riff, pushed in its insistence past music. It was hatred and frustration, secrecy and despair. [...] There was no compromise, no dreary sophistication, only the elegance of something that is too ugly to be described [...] McNeely,

Figure 6: Black and white photograph: Photograph of El Monte Legion Stadium (with Greyhound bus station in foreground), El Monte, California.

the first Dada coon of the age, jumped and stomped and yowled and finally sensed the only other space that form allowed. He fell first on his knees, never releasing the horn, and walked that way across the stage. [...] And then he fell backwards, flat on his back, with both feet stuck up high in the air, and he kicked and thrashed and the horn spat enraged sociologies. [...] Jay had set a social form for the poor, just as Bird and Dizzy had proposed it for the middle class. (Baraka 2000: 184–185)

Hunter Hancock was also the first disc jockey to play 'Louie Louie', the original version recorded in 1957 by Richard Berry, who wrote the song a year earlier, making it a regional hit. I had always admired Berry's 'Louie Louie' (for me, it's still the best version), but I did not know the range of his work. He never had a hit outside Los Angeles, but he made some of the best records of the 1950s. One of them, a talking blues he recorded in 1954, suggested the title of my film, and the saxophone solo by Maxwell Davis is the music over the opening credits. Davis is another unsung master of Los Angeles rhythm and blues, a tenor saxophonist of great versatility (he has been under-rated because he did not have a distinctive sound – he could play like Big Jay McNeely or like Lester Young), and a gifted arranger-producer not only for Richard Berry but also for many of the best singers of the 1950s. He also discovered Leiber and Stoller. They showed up one day in 1950 at Aladdin Records without an appointment. Davis, who was then musical director for Aladdin, gave them a chance anyway. They played him two songs, and he immediately gave them a

songwriting contract. There is also quite a bit of Jerry Leiber and Mike Stoller in *Get Out of the Car*, mostly from the catalogue of their own small Los Angeles record company, Spark Records, which lasted only two years, 1954 and 1955.

Of course, this history is only back-story in *Get Out of the Car*, but I hope the film will at least inspire curiosity about the music.

Rock'n'roll was betrayed by men like Dick Clark who pandered to a racism that was more imagined than real by pushing out black artists. As a result, the careers of Berry, Hancock and McNeely ended prematurely. The saxophone became too black for rock'n'roll when it entered its racist phase, and it was replaced by guitars. Big Jay lost his audience and he settled back in Watts, where he had grown up, and found a job as a postman. Hancock could not accept the Top 40 format that took over radio in the 1960s, stifling the disc jockey's creativity, and he quit in disgust in 1968. Berry quit making records in 1962 and eked out a living by playing at after-hours clubs around Los Angeles. He sold the rights to 'Louie Louie' in 1957 in order to buy a wedding ring, but he was able to reclaim them in 1985. He made more money in the next year than he had in the previous 30.

Johnny Otis and Art Laboe were able to survive, although Otis was unhappy with most of the records he made in the late 1950s for Capitol Records and he quit making music for most of the 1960s to concentrate on working in the struggle for black civil rights. When he returned to performing in 1970, he tried to counter the emerging 'Rock'n'Roll Revival' formula by showcasing still forgotten musicians he considered the true originators of rock'n'roll, such as Esther Phillips, Pee Wee Crayton, Charles Brown, Big Joe Turner and T-Bone Walker. Art Laboe was sustained by the loyalty of his Chicano listeners to 1950s rhythm and blues.

I pay tribute to Laboe in a sequence filmed on the site of El Monte Legion Stadium, another cultural landmark that has vanished without a trace. Both Laboe and Johnny Otis (with business partner Hal Zeiger) promoted shows there, but the Legion Stadium is now particularly associated with Art Laboe because in 1963 his Original Sound Records released 'Memories of El Monte', written by Frank Zappa and Ray Collins for Cleveland Duncan of the Penguins, and for a while Laboe made it almost his theme song. Of course, it provides the music for this sequence of the film. In the 1950s, Otis and Laboe had moved their shows to El Monte, thirteen miles east of downtown Los Angeles, because racial harassment by the Los Angeles Police Department under Chief William H. Parker made it increasingly difficult to hold racially integrated dances in the city of Los Angeles.

When I went to the El Monte Historical Museum to research the shows put on by Otis and Laboe, the curator could barely acknowledge they ever happened. She could not tell me anything about them, and there were no records of them in her archives. However, she did recall vividly Cliffie Stone's *Hometown Jamboree*, a country music show telecast live from El Monte Legion Stadium on KCOP-TV beginning in 1949, which meant nothing to me, although it launched the careers of Tennessee Ernie Ford, Billy Strange, Merle Travis, Speedy West and many others.

I realized our tastes and interests are partial, mine as well as hers. However, we probably share a disdain for contemporary pop music. A sign of ageing, I guess. Rock music died

for me on 22 December 1985, the day of D. Boon's fatal van accident. But I do like recent *norteño* music, particularly Los Tigres del Norte. So all the more recent music in the film is by Mexican and Mexican American artists, mostly singing in Spanish, with an emphasis on Los Tigres. Anglos know Los Tigres del Norte – if they know them at all – as the popularizers of the *narcocorrido*, the ballad of the drug traffickers, but to Latino immigrants, they are the voice of the people. They are the most important music group in the United States today, their impact greater than Dylan and Springsteen combined.

Their song 'Ni aquí ni allí' plays over the end credits. It is the plaintive lament of a Mexican immigrant lost between two worlds, a protest song in a gentle and sometimes humourous vein. I will quote only the chorus, in the original Spanish and in English translation:

> *En dondequiera es lo mismo*
> *Yo no entiendo y no entenderé*
> *Que mis sueños ni aquí ni allá*
> *Nunca los realizaré.*
> *Ni aquí ni allá, ni allá ni acá*
> *Nunca los realizaré.*

> Wherever you go it is the same
> I don't understand, and I never will
> That my dreams, neither here nor there,
> Will never be realized.
> Neither here nor there, neither there nor here,
> Will never be realized.

The film is in English and Spanish, without subtitles. I wanted to put bilingual viewers in a privileged position (they are the only ones who can fully understand the film) and remind monolingual viewers of their cultural disadvantage. This perverse obscurity has a polemical purpose. Los Angles has become a bilingual city, but English-only speakers stubbornly refuse to learn Spanish, cutting themselves off from a good part of the local culture and compromising their ability to understand the politics of the city. The cure is obvious: real bilingual education in the schools of California to insure that all English-speaking students learn Spanish and that all Spanish-speaking students learn English. Only the crudest nativist sentiment would oppose this simple initiative yet animosity toward Latinos is so pervasive in California that no 'mainstream' politician or educator has even broached the idea. However, this 'dual language immersion' programme has been adopted in the schools of Chula Vista, a San Diego suburb near the Mexican border, and of course it works. Native English speakers learn Spanish, and native Spanish speakers learn English more quickly and thoroughly than they do in English-only schools.

The form of the film does not allow advocacy, but I can suggest something of what is lost to a monolingual person in Los Angeles.

Urban Cinematics

If California could become bilingual, perhaps there would be greater understanding between Anglos and Latinos and tragedies like the destruction of South Central Farm could be averted. In *Get Out of the Car*, the site of South Central Farm is another of the unmarked historic landmarks depicted. It is the one sequence of overt social criticism I left in the film, and the razor wire that surrounds it (also appearing in the three shots that follow) is the one thing I do not like that appears. I tried to include the essential information about South Central Farm in the memorial sign I made: 'Site of SOUTH CENTRAL FARM, 1994–2006, one of the largest urban community gardens in the United States, bulldozed on 5 July 2006 by owner Ralph Horowitz whose repurchase of the property from the City of Los Angeles in 2003 is still mysterious and legally questionable'. The battle over South Central Farm pitted the Spanish-speaking farmers against the English-speaking Horowitz and local councilwoman Jan Perry, and the moral rights of the farmers against the legal rights of Horowitz. I still believe that cultural misunderstanding played an important role in the unfolding of the tragedy, making compromise impossible when it should have been feasible.

Although Horowitz promised to develop the site as a distribution centre for clothing manufacturer Forever 21, it is still an immense 14-acre vacant lot.

South Central Farm should still be there, but I did not mean to suggest that the Barrelhouse and El Monte Legion Stadium should be. The German film-maker Klaus Wyborny once said, buildings disappear when our feelings desert them. Our feelings have not deserted El Monte Legion Stadium and the Barrelhouse, but we do not need the buildings to sustain those feelings and the memories they made. A building of intrinsic beauty should be preserved for as long as possible, and a useful building should not give way to a useless building, but it is not necessary to preserve a simple utilitarian building just because it is a repository of historic memories. That would be a misguided nostalgia.

Get Out of the Car could be characterized as a nostalgic film. It is a celebration of artisanal culture and termite art (in Manny Farber's sense, but more precisely in the sense Dave Marsh gives the phrase in his book *Louie Louie*). But I would claim it is not a useless and reactionary feeling of nostalgia, but rather a militant nostalgia. Change the past, it needs it. Remember the words of Walter Benjamin I quote in the film: even the dead will not be safe. Restore what can be restored, like the Watts Towers. Rebuild what must be rebuilt. Re-abolish capital punishment. Remember the injustices done to Chinese, Japanese, blacks, gays, Mexicans, Chicanos and make it right. Put Richard Berry, Maxwell Davis, Hunter Hancock, Art Laboe and Big Jay McNeely in the Rock'n'Roll Hall of Fame. Bring back South Central Farm. Only when these struggles are fought and won can we begin to create the future.

It is also a sad film, some people say. I presume they understand Spanish. Then it is a just film, because the world we live in is sad, but, as Jonathan Tel has written, 'Great cities are tough; their ugliness is inseparable from their sexiness' (Tel 2010: 21.) Los Angeles is certainly tough and certainly ugly when seen in medium shot or long shot. But Roman Polanski once suggested it has another kind of beauty: 'Los Angeles is the most beautiful city in the world – provided it's seen by night and from a distance'. *Get Out of the Car* proposes a third view: that Los Angeles is most beautiful when seen in a close-up and that its sexiness is not to be found where most tourists look.

References

Baraka, A. (2000), 'The Screamers', in A. Baraka (ed.), *The Fiction of LeRoi Jones*, Chicago: Lawrence Hill Books, pp. 184–185.

Gebhard, D. and Winter, R. (1985), *Architecture in Los Angeles: A Complete Guide*, Salt Lake City: Peregrine Smith Books, p. 469.

Hawthorne, C. (2008), 'It has no place', *Los Angeles Times*, 3 December 2008, p. E1.

Rauzi, R. (2009), 'Traveler in her own backyard', *Los Angeles Times*, 25 August 2009, p. A23.

Shaw, A. (1978), *Honkers and Shouters: The Golden Years of Rhythm and Blues*, New York: Collier Books, p. 170.

Smith, R. C. (2009), *The Modern Moves West: California Artists and Democratic Culture in the Twentieth Century*, Philadelphia: University of Pennsylvania Press, p. 156.

Tel, J. (2010), 'Untitled manifesto', in N. Peter and K. Meyer (eds), *Urban Future Manifestos*, Ostfildern: Hatje Cantz Verlag, p. 21.

Vergara, C. (2009), 'Street "passion"', *Los Angeles Times*, 10 April 2009, p. A29.

Wollen, P. (1993), 'Into the Future: Tourism, Language and Art', in P. Wollen (ed.), *Raiding the Icebox: Reflections on Twentieth-Century Culture*, Bloomington: Indiana University Press, pp. 209–210.

Part II

Cinematic Urban Archaeology

Chapter 4

Aids to Objectivity? Photography, Film and the New 'Science' of Urbanism

Nicholas Bullock

In the Introduction to *La Vie de Cité*, Marcel Poëte (1924: V–VI) talks of his desire to establish a 'science' of urbanism that would bring new objectivity to the study of the city and, in doing so, would put it on a par with the increasingly scientific approach to the new social sciences. Urbanism might then, he hoped, stand alongside the study of geography pioneered by Paul Vidal de la Blache and the Ecole Française de Géographie or the rewriting of the study of history by Lucien Febvre and Marc Bloch and the group centred on the *Annales d'histoire économique et sociale*. Poëte's quest for objectivity and respect for the nature of the sources for the study of the city was just as natural to his position as librarian at the Bibliothèque historique de Paris (Callabi 1988). This post gave him an unparalleled knowledge of the documentation along the centuries on every aspect of the growth of the city, from the charters essential to its early economic independence to the chance records of the daily lives of even the meanest of citizens. As librarian, Poëte saw his central task as marshalling the great mass of documentation of the city for the study of urbanism and his study, *La Vie de Cité*, was conceived as a great investigation over the 'longue durée' – in the manner of the *Annales* – of the life of the city. While recognizing the importance of the actions of the occasional 'larger-than-life' individuals, like Haussmann, the central focus of his study remains the collective actions of the city's population and the way that these are shaped by everything from the nature of the city's physical setting to the impact of religion or rise of capitalism.

Wrestling with the complexity of the interaction of these forces, Poëte had little time for the old Romantic accounts of the development of the city that privileged the actions of kings and generals. Instead, like Patrick Gueddes with whom he corresponded, Poëte sought to study the growth of the city like a biologist observing the development of some natural organism (Callabi 1988: Chapter VI). The documents contained in the Bibliothèque Historique were essential to his plans. They provided 'evidence' central to the project, as did the physical fabric of the city and the variety of maps, drawings, views and other representations of its past. The importance that Poëte placed on this visual evidence of the growth of the city is reflected in the fourth volume of *La Vie de Cité*, the 'Album', which provides a parallel visual narrative to the other volumes.

Poëte, urbanism and photography

Reviewing the history of the city reflected in images, Poëte hails the 1830s not only for the growth of that Romantic sensibility that brought a new engagement with realism and the

particular but for the advent, by the end of the decade, of the Daguerréotype. Poëte likens the impact of the Daguerréotype to that of printing, as initially providing a method of producing engravings more cheaply than by conventional means. But from these early faltering beginnings he welcomes the way in which photography by the 1840s has already transformed our ability to follow the history of the city with a new objectivity. Referring to some of the first photographs of the city, Arnoult's *Paris et ses environs reproduits par le daguerreotype*, of 1840, Poëte writes: 'The true state of Paris; this is just what this precious series of views provides: in place of an animated scene, we have a faithful record of our streets and buildings. It is for its documentary value, that photography truly excels'. (Poëte 1925: XVIII)

Poëte praises the ability of photography to keep pace with the transformation of the city brought about the headlong rush of industrialization:

> Thus these images, like those of so many things, are the exact record of life. This evolution carries on into the present in which, in its various forms, the art of photography reigns supreme. It offers that perfection of documentary precision but one which lacks that note of life typical of former methods of artistic production. (Poëte 1925: XXI)

In pursuit of this visual documentation of the development of Paris, the Bibliothéque Historique, founded in 1871, sought photographs of Paris from all sources, following in this respect in the footsteps of the Commission des Monuments historiques who had commissioned, in the form of the Mission Héliographique, a photographic record France's architectural heritage as early as 1851 (Nesbit 1992: 62–75). The process of securing a photographic record of Paris was given added urgency by the very scale of Haussmann's transformations of the city and the attendant destruction of so many major monuments.

The recognition in the mid 1890s of a renewed threat to the city from the building of the Métro and the consequent need to formalize the acquisition of the record of a vanishing Paris was marked with the establishment in 1897 of the Commission Municipale du Vieux Paris and the Commission. Both the Commission and its members, acting individually, bought up existing collections of negatives and prints from those who had been photographing the city since the early 1840s. Molly Nesbit credits them with pursuing photographs 'the way other amateurs chased butterflies' to such effect that one member of the commission, Georges Hartmann, amassed a personal collection of 100,000 photographs (Nesbit 1992: 65). Poëte, an active member of the Commission from 1907, reorganized the BHVP's Service des Travaux Historiques in 1906 and expanded its photographic collection that already included a major collection of the work of Charles Marville and Eugène Atget.

However, historians of photography, notably Molly Nesbit, Atget's most comprehensive biographer, have been concerned with showing that photographers like Atget worked in a way that, far from being 'neutral', was shaped by a prevailing aesthetic for different genres of representation. This, in turn, naturally raises questions about Poëte's 'objective' aspirations to use photographs.

Considering the case of Atget, Nesbit argues that he was providing photographs to a variety of different clients, to artists, architects, interior decorators and set designers as well as to the BHVP and the Commission du Vieux Paris and the demands of his clients did much to shape the approach that he adopted to different subjects. Thus, many of his architectural photographs frame the subject 'flat-on', rather as one might draw the elevation of a building or a particular feature. They suggest that Atget had less interest in capturing the three-dimensional qualities of, say, a doorway or a staircase than he brought to the photography of sculpture. In his well-documented encounter with the Surrealists, Atget may have been clear that he was producing 'documents' not art (Nesbit 1992: 28–41), but in this self-conscious choice of different modes of approach for different subjects, Atget's mode of working was at variance with Poëte's view of photography as the 'artless' recording of reality.

Nesbit argues that Atget's pictures of Vieux Paris clearly illustrate the point (Nesbit 1992: 62–75). The pictures acquired by Poëte for the BHVP were as varied as the Album for *Une Vie Cité* but those of Vieux Paris acquired by both the BHVP and the Commission represent

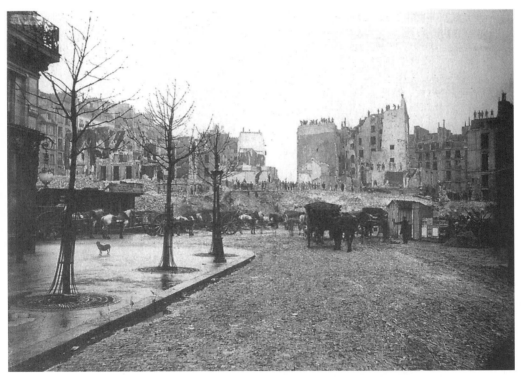

Figure 1: Recording the demolition of Vieux Paris: (1) the Place de l'Opéra in 1870 before the creation of the Avenue de l'Opéra; (2) Marville's photograph of the demolitions for the Avenue de l'Opéra, 1876.

a significant subset of Poëte's purchases. Far from being a neutral record of the city they demonstrate a clear set of aesthetic preferences. Thus, the choice of subject was already shaped by what was thought to exemplify the qualities of a Paris lost beyond recall and informed by Atget's reliance for the choice of subject and the choice of caption on early nineteenth century guide-books such as the Marquis de Rocheguide's *Guide pratique à travers le Vieux Paris* with their essentially nostalgically romantic view of Vieux Paris. The mode of composition, like the choice of subject was equally 'artful'. Not unlike Marville before him, Atget chose to compose his photographs, with their dark foregrounds and with light often appearing through a half-open door or at the end of narrow street, in a way that reflect the *pittoresque* values of contemporary illustrators.

Should we allow Nesbit's arguments about Atget's work to undermine Poëte's general enthusiasm for photography as 'objective' evidence of the nature of the city? Two arguments spring to mind. First, we should be careful not to exaggerate the *pittoresque* emphasis of Atget's work. A casual glance at the map of pre-Haussmann's Paris (or even a short stroll on a wet winter day in the area just to the south of Notre Dame) suggests that much of Vieux Paris probably did look what to our eyes would seem very like Atget's pictures with

Figure 2: Nisbet's comparison of painterly conventions with Atget's *pittoresque* compositions: (1) Jeanne Capitain's sketch of the Bièvre (2) Atget's photograph of industry along the Bièvre.

Figure 3: Atget's nostalgic recording of Vieux Paris.

narrow dark streets and a suggestion of light beyond. Second and more important, we must consider how Poëte used these pictures. True, he does not seem to have challenged their value as a record of vanishing Paris and the photographs of Vieux Paris may have figured prominently in the collection of the BHVP.[1] But if they did so this reflects a general concern, shared by members of the Commission generally, to record the old Paris that seemed to be in danger of disappearing so fast and even to retain, through their preservation, the picturesque qualities of village enclaves like Montmatre or Belleville from absorption and homogenization by the seemingly unstoppable development of Paris (Gotlieb 1996: 82–90). To contemporaries this kind of record had an immediate priority, but these photographs should not be given too much prominence in Poëte's overall documentation of Paris. As the huge range of photographs of Modern Paris in the BHVP's collection and Poëte's selection of photographs in the Album volume of *Vie de Cité* demonstrate, images of modern Paris were quite as important in recording the sweep of the life of the city: Cottamin and Duttert's Gallerie des Machines was as important a document of the development of Paris as the record of Vieux Paris. The work of the photographer is rarely absolutely 'objective' but at least the use that Poëte made of photographs of Paris does not seem to have called into question the 'scientific' way he was seeking to document of the city.

Urbanism and film

If we take seriously the arguments of historians of photography about the essentially selective nature of the way in which photographers record the world, how should we judge Poëte's interest in the use of film, a medium that is *a fortiori* even more selective in its ability to record the world around us? Poëte's interest in the possibilities of photography was matched from at least the early 1920s by his excitement at the potential of film to do what photography could do and much more. His growing awareness of the uses of film for the study of the city is evident from the discussions in the L'IUUP from its foundation in 1919 onwards. In an article, 'L'enseignement par le film' that appeared in the Institute's journal, *La Vie Urbaine,* Henri Sellier, Poëte's close collaborator at L'IUUP, wrote enthusiastically of the British use of film to spread the Garden City message and had in 1920 opened a cinema in Suresnes, the Garden City municipality of which he was mayor (Sellier 1919: 334). Other uses of film reported in *La Vie Urbaine* include the development of techniques of animation to bring to life the statistics and maps describing the growth of towns and cities, and the educational use of film in schools and colleges to bring the study of the city (and indeed geography generally) to life. Sellier, too, was quick to encourage the use film of film for educational and instructive purposes and as Minister of Health in Bloom's Front Populaire, Sellier enthusiastically promoted the use of film to make the case for greater awareness of health issues (Gauthier 2004: 79–85). Sellier was thus well placed to have alerted Poëte to the potential of film as a way of both recording the rhythms and the qualities of city life and of presenting the Insitute's understanding of the city to a wider public.

Sellier was but one of many who saw the potential of film to instruct or shape public policy. The 1920s and 1930s saw a great expansion in France of the number of films made for these purposes that might be broadly classified as 'documentary'. Charting this growth of documentary film, (Gauthier 2004: Chapters 3 and 4) identifies a number of different genres ranging from the recording of scientific or ethnographic investigation, to the films of the cinematic avant-garde. Perhaps the least cinematically self-conscious, or in Poëte's terms, those offering the most 'objective' rendering of a subject were the films financed by the Ministry of Education and exemplified by the films for projection nationally in schools, colleges, churches and Maisons du Peuple (Gauthier 2004: 57) on regional geography made by Jean Brérault, which criss-crossed the country recording the social and economic characteristics of France's different regions with an affectionate but essentially neutral lens (Gauthier 2004: 82). Comparable were those considerable number of short commercial films – Juan (2004) identifies more than 40 films made by Pathé and Gaumont in the late 1920s – that showcased the principal monuments and the other attractions of Paris (and other cities) in the manner of a series of animated picture postcards.

Cinematically more self-conscious are those, such as the films of Marcel Carné, that Gauthier qualifies as 'poetic realist'. Among the foremost films of Paris of the 1930s in this latter category Gauthier singles out Lacombe's *La Zone* (1928), Sauvage's *Études sur Paris* (1928) and Carné's *Nogent, Eldorado du dimanche* (1930), which might have been screened

as short films as part of a double programme in commercial cinemas or non-profit settings such as public halls and town halls of the municipalities of the left in the Paris region. But these Gauthier differentiates from those Modernist (if not avant-garde) films of the city, often identified as 'City Symphonies' such as Cavalcanti's *Rien que les heures* (1926) or Vigo's *À Propos de Nice* (1930), cinematic cousins of foreign films such as Vertov's *Man with a Movie Camera* (1929) or Ruttmann's *Berlin, Symphony of a Great City* (1927), which he characterizes not only for their cinematic ambition and their correspondingly more limited to the audiences of Paris 'art' cinemas such as the *Studio des Ursulines or Le Vieux Colombier* (Gauthier 2004: 58).

If only through Sellier and other members of L'IUUP or the pages of *La Vie Urbaine*, ever alert to developments abroad, Poëte would inevitably have been aware of the use of film, both in France and further afield, to document the nature of the city. But despite the number of films of different types, which sought to represent the city in one form or another, the first clear record we have of Poëte's own direct engagement with film dates from around 1934 when, in collaboration with Atlantic Films, he prepared the scenario and directed the shooting of two short films in the Atlantic Films' 'En 5 Minutes' series titled *Paris ne s'est pas fait en un jour*. Though neither is now to be found in any public collection[2], Poëte has left a sufficiently detailed scenario to give a clear indication of both the spoken text and the series of images (tied in one case to the running length of the film) to enable us to interpret his intentions (Papiers Poëte, Vol 148, Folio 409: pp. 410–416).

One is an animated history of the city, a highly compressed cinematic summary of Poëte's three-volume *Paris, Vie de Cité*, made with maps and visual material derived from prints and paintings with only occasional use of still or moving photographic images. The second also makes use of the techniques of animation to bring to life a sequence of maps showing the growth of the city but in this film there is greater use of 'des vues cinématographiques' to illustrate the 'most beautiful perspectives of the city' in the manner of a moving picture postcard of the type described by Juan (2004: 292–300). Neither film appears to be particularly innovative. The former, though buttressed by the authority of Poëte's historical expertize and command of the sources on the history of Paris, is little more than the kind of educational films already being made by Brérault. The latter was little different from the type of films on Paris already increasingly available from companies like Pathé or Gaumont. But Poëte's interest in film was growing.

Poëte's 'Paris Au Fil des Heures'

Shortly after this first engagement with film, Poëte was offered the opportunity by the Cinémathéque de la Ville de Paris to make another and more ambitious film to represent the Ville de Paris at the International Exposition in Brussels in 1935 (Papiers Poëte, Vol 148: pp. 392–403). The project had originated as early as the summer of 1932 in a proposal by M. Léon Riotor, a councillor in both the City and the Departmental Council of the Seine,

ATLANTIC - FILM

Suite N° I

PARIS, AU PROFIL des HEURES

Partie Muette

L'Eveil de Paris

Vue de rue, à l'aube, avec les poubelles, les devantures closes, un bistro ouvert, une voiture de laitier ou bien l'auto-balayeuse ou arroseuse au travail; de rares passants.

Au matin, les Halles

Un coin d'intense animation aux Halles et dominé, si possible, par Saint-Eustache - soit un vif contraste par rapport à la vue précédente.

La marée montante des travailleurs habitant la Banlieue .

L'afflux des arrivants des trains de Banlieue, à la Gare Saint-Lazare entre 8 et 9 heures du matin. Cette vue se lie, par fondu enchaîné, à une carte de la région parisienne, dans le rayon adopté pour le film: "Pour Mieux Comprendre Paris"

La marée au travail.

Et c'est Paris au travail .

Deux vues se succèdent: l'une du travail à domicile ou chez un petit patron, au Marais par exemple, pour l'article de Paris, l'autre du travail dans une grande usine.

avec vieilles
Renault

"Brasier d'âmes ! ... Le climat spirituel est tropical" (G.Duhamel)

(Ajouter en surimpression, dans les cas nécessaires, l'indication du lieu)

Rendre sensation du Brasier d'âmes et du climat spirituel tropical par accent spécial des vues: bouquinistes des Quais, cour de la Sorbonne animée par des Etudiants et que domine le Dôme de l'Eglise ou bien sortie des cours de la Faculté de Droit, soit du côté du Panthéon, soit du côté de la rue Saint-Jacques. Dans tous les cas, faire succéder à vue extérieure une vue d'intérieur, telle que celle de la grande salle de travail de la Bibliothèque Sainte-Geneviève ou de la Bibliothèque de la Sorbonne, pleine d'étudiants, en y joignant les Laboratoires du Collège de France (qui sont les derniers construits) ou de la Sorbonne ou encore de l'Ecole de Médecine ou de celle de Pharmacie, à l'heure du travail de Laboratoire. Faire succéder à ces vues de pleine animation laborieuse -par contraste et pour établir un rythme de la pensée, que

Figure 4: Poëte's scenario for the partie muette of 'Paris au Fil des Heures'

for funding to make a film intended to 'faire connaître et aimer Paris'. Though funding was yet to be agreed upon, work on the project began in earnest in December 1934 when Poëte was engaged to produce a scenario, already provisionally titled *Paris, au fil des heures*. By the following February Atlantic Films were involved along with one of their contacts, Pierre Lafond, who seems to have had access to considerable film footage on Paris and was perhaps connected in some way to Lafond, the well-known publishing house. By mid February the idea of using 'found footage', the kind of film that was being used by educational films of regional geography made by Jean Brérault, as a way of substantially reducing the costs of the film had been adopted.[3] So too had the central, structural idea for the film, almost certainly proposed by Poëte:

> In truth, Paris is the only city in the world in which one can find so closely connected a centre of such diverse artistic production – fashion, couture, jewellery, motor-cars, art – and a centre of luxury consumption which knows perfectly how to exploit the results of this production.
>
> Production Paris plays a 'walk-on' part in the life of Paris the centre of consumption and accepts the results with good humour.
>
> It is these two underlying parallel currents that can provide the driving conception for this film. It is the conjunction of these attributes of the city which have given rise to the 'Esprit Parisien' which wins the hearts of those who visit our capital'. (Papiers Poëte, Vol 148: p. 402)

Starting with this schema, Poëte (and his unknown Atlantic Films collaborators)[4] prepared a two-part scenario. The first part, the 'partie parlé' was intended to represent Paris as a world capital at the Brussels Exposition. In this aim, it strikes a glorious and patriotic note, emphasizing the terms in which every stage of the development of the French nation is gloriously reflected in the form and the architecture of the city. With images that range from the early middle ages (la Conciergerie and Notre Dame) to the late nineteenth century (the Eiffel Tower), and from the prosperous bustle of the centre to the elegant leisure of the Bois de Boulogne, the film presented 'postcard' Paris at its best, with a spoken commentary that matched the ambition of the film.

This first section, the 'partie parlé', may have been well made and able to draw on the authority of Poëte as historian of Paris, but, if not blandly conventional, it was hardly innovative by the standards of the mid 1930s. The second section, 'la partie muette', was, however, more cinematically ambitious. Planned for screening in Brussels with a musical score or perhaps a piano accompaniment – we cannot be certain – it would, in its silent form, have been well suited to projection in that wide variety of venues, from schools and churches to town halls and political clubs that seem to have been equipped with projection facilities during the course of the 1920s; indeed, Gauthier (2004: 57) records that by 1939 there were more than 4,000 16-mm silent projectors in schools alone. This second part is not only more ambitious but may also be seen as being closer to Poëte's 'scientific' aspirations to

use film as a basis for exploring the workings of the city, the 'flux' of its comings and goings, the connections between the different areas and thus the basis for the two parallel 'Parises' of production and consumption. The film demanded a dramatic simplification of Poëte's view of the dense interconnectedness of city life, that quality of 'tout tient à tout' that had defeated his ability to write the last, nineteenth-century volume of *La Vie de Cité*. But he seems to have seized on film's ability to represent in visual terms the life of the city as an 'organism' too complex for conventional, literary means of description.

The form of the film, registered in the title *Paris, au fil des heures*[5] (but also as *Paris, au profil des heures*), is framed by the rhythm of the city from dawn to dusk. While for the countryside and rural areas seasonal variation might be of prime importance, the daily cycle is a natural and immediately valuable unit of analysis for those like Poëte seeking to capture a sense of the 'flux' or the rhythms of the city, and through these a sense of its innermost workings. This was a theme with which Poëte had been working for some time using literary sources from the eighteenth to the early twentieth century. In a selection of papers titled 'Differentiation des quartiers, les heures du jour et de la nuit', Poëte seeks to establish an identity for different areas of Paris in terms of the patterns of activities at different times of the day, contrasting the bustle of workshops of the Marais during the working day with the evening displays of the 'beau monde' of the grands boulevards , the rush of morning traffic around the Madeleine with the pastoral release of an afternoon in the Bois de Boulogne (Papiers Poëte, Vol 148: pp. 460–62).

Poëte's 'Objective' Use of Film?

This dawn-to-dusk structure, emphasized in the films title, suggests parallels with the City Symphonies of the avant-garde. The start of Poëte's scenario sketches a series of images that seem to match exactly those of Ruttmann's Berlin: the early morning quiet contrasted with the calm efficiency of the street-cleaning machines, the flood of commuters arriving by train, the bustle of motor traffic. Moreover, these similarities are heightened by the 'realism' of the documentary format with its avoidance of actors. The camera angles, the almost abstract build-up of the rhythms of the city and other indications of the polemically Modernist ambitions of the avant-garde cinema to be found in the City Symphonies may be lacking in Poëte's scenario, but the possibility of shared inspiration is sufficiently plausible to frame the question: 'did Poëte consciously adopt the City Symphony' form for their film?

To which the answer must probably be negative. It is not unreasonable to assume that Poëte, working in l'IUUP with its wide-ranging international interests and its early interest in film, would have been aware of the work of Vertov or Ruttmann. But the most obvious parallels to the City Symphony, the dawn-to-dusk structure of the film, the absence of actors, the 'objective' documentary style of filming, are explicable in other terms. Poëte's 'scientific' interests would have put him at odds with anything other than a documentary approach and

the possibilities of reducing costs by using 'found footage' shot by others would have been a great advantage to a project that was launched with a minimal budget.[6]

More important, however, than the question of direct influence (which must necessarily remain conjectural in the absence of directs documentary evidence) is the larger question of the shared parentage and the common intentions of Poëte (and his team) and the City Symphonists. Both, linked in their desire to address the nature of the city, the locus of Modernity, face the same problem: how to capture the nature of the city 'objectively', or in Poëte's terms 'scientifically', without actors, recourse to the old-style romantic imagery or the trite clichés of the picture-postcard film.

By comparison with the 'old-style' historicism of the *partie parlé*, the *partie muette* is like the City Symphonies intended as a celebration of the Modern City with all its complementary complexity: the bustle of motor traffic and commuter trains and the peace of the parks; the city as the market for production and consumption of all kinds; the new means of production and the elegance of consumption. There may be differences of cinematic language (and at least Poëte's proposed film was free of Ruttmann's lapses of taste – the hammily staged fight or the mawkishly sentimental suicide) but their aims are essentially the same: to capture the essence of the modern city.

To do so required Poëte to go beyond the use of mere documentary reporting. Like the emerging social sciences of economics or geography he asked that Urbanism should both observe and, in some sense, 'explain' the nature of the city. By the mid 1930s, increasingly fascinated by Henri Bergson's ideas, Poëte seems to have welcomed film as a way of capturing the 'flux' of the city in a way that is hinted at by the curious diagrams of Gaston Bardet (1948), his son-in-law, but which other, more conventional, literary or visual modes of representation could not achieve.[7] Unable, or unwilling to develop the kind of analytical models already being developed in the other social sciences, Poëte might plausibly claim to be using film as a way of capturing 'objectively' the very workings of the Modern City.

References

Bardet, G. (1948), *Le Nouvel Urbanisme*, Paris: Vincent Fréal.

Callabi, D. (1998), *Marcel Poëte et le Paris des années vingt aux origines de 'l'histoire des villes'*, Paris, L'Harmattan.

Gauthier, G. (2004), *Un siècle de documentaire français, des tourneurs de manivelle aux voltigeurs du multimedia*, Paris: Armand Colin.

Gotlieb, C. (1996), 'Montmatre: un faubourg pétrifié', in J. Lucan (ed.), *Paris des Faubourgs, formation, transformation*, Paris: Pavilon de l'Arsenal, pp. 82–90.

Juan, M. (2004), 'Le cinema documentaire dans la rue Parisienne', in J.-L. Robert and M. Tsikounas (eds), *Imaginaires de Paris, Sociétés et Répresentations*, CREDHESS, No.17, March 2004, pp. 291–314.

Nesbit, M. (1992), *Atget's Seven Albums*, New Haven and London: Yale University Press.

Papiers Poëte, These are held at the Bibliothéque Historique de la Ville de Paris (BHVP): the items relating to Poëte's film project are in MS, vol. 148, Folios 392–403, 409 and 410–416; Poëte's interest in the rhythms of the city are in MS Vol 151, Folios 460–462.

Poëte, M. (1924), *Une Vie de Cité, Paris de sa naissance à nos jours*, vol. 1, Paris: La Jeunesse.

—— (1925), *Une Vie de Cité, Paris de sa naissance à nos jours*, Paris: Album.

Sellier, H. (1919), 'L'enseignement par le film', *La Vie Urbaine*, No. 3, September 1919, p. 334.

Notes

1. The BHVP seems to have quibbled with Atget over the quality of the pictures but not with the aesthetic judgement that he, like any photographer, was continually making (Nesbit 1992: 68-71).
2. Callabi (1998: 96-97) reports that the two films are still held in the vaults of Atlantic Films. However, this no longer (2009) appears to exist as an independent company.
3. There is no direct reference in *La Vie Urbaine* to Brérault's films but the parallels between the educational aims of the films and the Institute and its members like Sellier and the similarities between sequences in Brérault's films and the flow of images described by Poëte lead us to the conclusion that Brérault's films and their footage were the raw material to which Atlantic Films and Poëte hoped to turn for 'Paris au fil des heures'.
4. We know nothing from Poëte's papers of those with whom he was collaborating at Atlantic Films, nor apart from tone of the language used for different proposals and comments is it possible to attribute authorship with any certainty.
5. Disconcertingly the title seems to vary, from the start of the project onwards and with no obvious logic, between 'Paris, au profil des heures' and the simpler 'Paris, au fil des heures'; we have used the latter throughout.
6. Work on the film was abandoned when the Ville de Paris refused further funding, see the letter dated 16 April 1935 (Papiers Poëte: 398).
7. Bardet's diagrams figure prominently in his books such as *Le Nouvel Urbanisme*, Paris: Vincent Fréal, 1948.

Chapter 5

Which Role for the Cinema in a Working-class City: The Case of Saint-Etienne

Roger Odin

T his article is part of a broader research work undertaken within the European network Ville et Cinéma [Cities and Cinema], created in 2007 by the cinema section of the Maison des Sciences de l'Homme (led by Irène Bessière) and by IRCAV (Institut de Recherches sur le Cinéma et l'Audiovisuel de l'Université) from the Sorbonne Nouvelle Paris III (Laurent Creton and myself). The objective of this network is to consider the relationship between cinema and the city at least in terms of representation (the image of the city and how does cinema represent cities?), even if one does not refrain to address such issues, if only in terms of *interactions*: what does cinema do to the city? What does the city make of cinema?

It is in this perspective that the case study is presented here: I would like to try to understand what role the cinema played in the history of a city like Saint-Étienne or, more precisely, what role Saint-Étienne actually played in the cinema at three key moments in its history. What type of cinema has been used and why this type rather than another? What were the processes involved? And for what purpose?

In order to answer these questions, I use here my 'sémio-pragmatique' approach (Odin 1983, 1989, 1995, 2000, 2008). A sémio-pragmatique approach is a theory that attempts to model the contextual determinations governing communication. The key concept here is that of 'communication space', meaning a space defined as an array of determinations, which regulates the conditions for the production of meanings, of affects and relationships between the actors in this space. I consider the city as a 'communication space', and I will try to highlight the constraints at work in this space regarding the relationship between the city and cinema.

Saint-Étienne is a city of 180,000 inhabitants located in the Massif Central at about 60 km from Lyon, on the border of the Auvergne and the Forez. Coal mining and heavy industry (including steel) have shaped the urban landscape: coal tips (in Saint-Étienne, they call them 'crassiers') that stand like dark pyramids in different locations in the city, large factories and impressive red brick chimneys are the signs of the industrial past. Saint-Étienne is famous for its national arms industry (out of which came the famous Lebel rifle used in the French army from 1887 until World War II), for its manufacturers of shotguns and luxury weapons beautifully engraved, for its ribbons – and especially for those woven with figurative or even narrative patterns (scenes of Joan of Arc, the entrance of President Herriot in Saint-Étienne, etc.) – for Manufrance and its worldwide mail order catalogue (and now a collector's item), for its magazine (*Le chasseur français*), for its famous 'Hirondelle' bicycle, and finally for Casino, a leading supermarket, whose stores have spread throughout France and beyond (Merlet 1990).

Figure 1: Symbolic image of Saint-Étienne.

SAINT - ETIENNE

Cinema arrived early in Saint-Étienne (the first screening took place on 25 April 1896), shortly after the first screening of the Lumière brothers at the Grand Café in Paris (28 December 1895). It is as if Saint-Étienne, which has always been a city where popular shows have been very successful, was waiting for cinema: an entertainment fit for a working-class city. A sign of the special relationship between cinema and the city is the opening in 1910 of permanent cinemas: the Alhambra, the Etoile Théâtre. But my purpose here is not to relate the history of the cinema in Saint-Étienne, which has been done before (Zarch 2008), but to highlight three logics in the relationship between the city and cinema.

A logic of propaganda

To understand the first logic we need to look at the history of the inhabitants of Saint-Étienne. Nearly half the population comes from rural stock, farming families, usually very conservative and very Catholic, particularly those from the neighbouring Haute-Loire. Haute-Loire, one of the poorest regions of France, is a region where the Church has always been extremely influential to the point of opposing for a long time the Republic and of demonstrating violently against the secularization laws. In 1904, the decision of the Republic to record the Church's properties sparked riots among the people of the region (there were several deaths). In part, therefore, Saint-Étienne is a right wing Catholic city.

On the other hand, Saint-Étienne is a city of workers, miners and labourers, with many immigrants (Italians, Polish, later North Africans) with a very old and very strong tradition of organizing social protest. Saint-Étienne, the 'black town' (due to coal mining), is also known as the 'red city' because of the strikes and mass demonstrations that have taken place, and because of an extremely active presence of unions and activists (communists, anarchists, socialists, anarcho-syndicalists). Aristide Briand, Secretary of the General Committee of the Socialist Party, elected in 1902, a city councillor, and editor of the newspaper *La Lanterne* (a newspaper explicitly republican and anti-clerical – 'Journal Républicain Anticlerical' was its front page subtitle) is one of the great figures of this movement. Therefore, Saint-Étienne can also be described as a left wing anti-clerical city.

As it stands, Saint-Étienne is party to the conflict between the two great ideologies that have divided France since 1789. But what interests me here is that Saint-Étienne was a privileged place for the use of film as propaganda on both sides.

On the left were the 'Offices du cinéma éducateur' [offices of the cinema as educator], an offshoot of the powerful 'Ligue de l'enseignement' [teaching council] (Borde and Perrin 1992), which were the backbone of the operation. Nationally, the Offices have played a major role in popular education; they see the cinema as a 'great way of suggesting'. The title of their magazine is a whole programme in itself: 'Le cinéma éducateur' [Cinema as educator].

One of the first regional offices was created in Saint-Étienne in 1922 (after Strasbourg and Lyon). Eugène Reboul, its first director, is the author of several books on cinema as an educational medium, in particular *Le cinéma scolaire et éducateur, Manuel Pratique à l'usage des membres de l'enseignement et des œuvres post-scolaires* [Educational cinema for schools, a practical handbook for teachers and after-school workers] by Eugène Reboul, public school teacher in Saint-Étienne, and head of the school's film service in the Loire (1925) and 'Le cinéma parlant' [the talkies] (1935). It is also in Saint-Étienne and under the responsibility of Reboul that one of the first educational cinémathèques in France was created: one could refer to it as an 'educational filmathèque'. To this day, the Saint-Étienne cinémathèque has a remarkable collection of educational films.

The left wing City Council did a lot to develop the Office by specifically encouraging the cinema in schools. Municipal schools were all equipped with cinema projectors (Phoebus projectors, made in Marseille). In the classroom, but also in local associations, educational films are regularly screened: prophylactic movies guarding against alcohol, against the dangers of spitting, movies about science – such as Jean Benoit Levy's films (Vignaux 2007) or the famous *Pasteur* by Jean Epstein (1922) – films about history and geography, about animals, etc. In the associations, they even began to teach young people to make 9.5mm films, the format introduced by Pathé for amateurs. The goal was not to produce young film-makers but to give them an understanding of screen language: in other words, film education as part of a citizen's education. Projections also took place among the working class, including the *Bourse du travail* [Labour Exchange], headquarters of the trade unions. Finally, in 1929, the municipality gave the Office the task of producing a *ciné journal* [newsreel] about Saint-Étienne (the visit to the flying club by the Airline Minister, 14 July parades, the firemen's display, the death of Mayor

Figure 2: Eugène Reboul.

Antoine Durafour, etc.), newsreels that have persisted in various format, and with only temporary lapses, almost until the present day.

On the Catholic side, the Church having long insisted on the dangers of cinema and after having had great difficulties in shaking off a wholly negative attitude (Cinema is a disease! Anathema to the movies!), it begins to change in the mid-1920s. A well-developed network of cinemas emerges, based on patronage and devotees. Moreover, the Church encourages the production of films that would convey its ideas. The film soon becomes a genuine missionary tool mobilized in the Catholic quest to regain social ground. For example, Pierre L'Ermite, in *La Croix*, urged his colleagues to develop 'a combined propaganda of a good press and a good cinema'. In September 1927 the *Comité catholique du cinématographe* [Catholic Committee of Cinematography] (CCC) is established, chaired by François Hebrard, a law professor at the Institute, whose secretary general is Canon Reymond, who will also be the director of the *Dossiers du cinéma – Organe catholique d'information cinématographique et de critique de films*. [Cinema's dossier – Catholic information board for cinema and film critics]. CCC's purpose is to use film to fight against the Republican state, the left and lay associations. Schools are a privileged place for this struggle. The film educator offices are directly targeted:

'Their origin betrays their aggressive tendencies. […] we should not be mistaken: we are witnessing a new effort by the state to penetrate in the schools, in all the schools. The de facto monopoly of the educational film will achieve a monopoly of education. How to enforce our rights against this new form of state interference in the schools?' Catholic schools are then invited to seize the power of cinema. (Brohée[1] 2004)

The films screened in the Catholic schools of Saint-Étienne are obviously films on the Bible, religion – films whose stories are all moral lessons, but also educational films of the same type as those found in secular schools. The originality is that in Catholic schools, film education was integrated in the curriculum itself, while in secular schools it was an extracurricular activity. Similarly, learning the rudiments of film-making was fully integrated into the curriculum.

But there is more: in the 1950s in Saint-Étienne, L'Institut du Langage Total [The Institute of Total Language] was created, a Catholic organization dedicated to communication and the media that would intervene directly in schools. In this respect the Catholic schools are more open than their secular counterparts; as the name of the organization suggests, it is not only cinema but all the media that are now considered: radio, print, poster, audio recording, photography, cinema (later television will also be integrated). Langage Total was a very important organization, represented at UNESCO and editing a monthly magazine *Le langage total*. Father Antoine Vallet, responsible for the initial and continuous education of teachers at the Institut de Saint-Étienne, publishes various training materials (eg, *Du ciné club au Langage Total* by Vallet 1968) [From the Cinema Club to Total Language]).

In both areas, cinema is not regarded as entertainment or even as a spectacle, but is instead taken extremely seriously as a means of educating children and as a means of adult education. Pascal Laborderie, who has worked on the use of film (in particular the case of Saint-Étienne), speaks of 'film-parable' (Laborderie 2009) to denote the way movies were mobilized. Even films that were screened in the parish halls or in the secular clubs were chosen for their educational value. It should also be stressed that in this context, any movie can be an educational film. The audience was not invited to be entertained or engaged in a fictionalized play mode (reacting according to the narrative), but rather to implement 'a moralizing view point': to see a movie to draw lessons for one's personal life. Whether secular or religious morality, the process is the same.

In summary, we can say that Saint-Étienne was an experimental place for educational and propaganda cinema both on the secular and Catholic side. Within this context, it is not the city itself that is at stake between the two rival factions: the issue is national and ideological. The next logic concerns the city of Saint-Étienne more directly.

The logic of branding

In 1980, Saint-Étienne experiences a devastating economic crisis: the mines close down, Manufrance and many subcontractors are also closing down, the weapons and cycles industries are too in crisis. The social consequences are disastrous: thousands of people are unemployed. The Grand rue, which crosses the city from north to south, sees huge demonstrations almost on a daily basis. The crisis is generalized: Saint-Étienne is a city in distress. Even the football club, the famous 'Verts', start to experience defeat.

It is within this context that the Communist Party, which was heading the municipal council and was extremely active in the defence of employment, decided to create a large film festival. In fact, it was not exactly a festival, but rather more like a huge rally around cinema, a meeting that took place over a whole month: *Les Rencontres Cinématographiques de Saint-Étienne*. The event was aptly named: for over a month for five years, hundreds of actors, directors and film professionals were invited to Saint-Étienne to dialogue with the public. The public went in droves not only to the Maison de la Culture and to the town hall 'Le France', but also to local cinemas, which were partners in the operation (L'Eden, L'Alhambra), to schools and to secular associations.

Faced with a crisis, the idea was to allow the people of Saint-Étienne to forget their problems for a while, regain their confidence by participating in a successful operation, and regain momentum, but also to restore the image of the city through widespread coverage in newspapers and the media.

Note that the type of cinema summoned here is very different from the cinema previously mentioned in the context of the first logic. Film as educational media gives way to the cinema of fiction, film as myth and as the 7th Art. Directors and actors wander around the

city to the delight of its residents, who are only too happy to see in the flesh Françoise Arnoul, Marcello Mastroiani and Ettore Scola, among others.

But also it is where the relationship to the economic environment becomes more relevant as 'Les Rencontres' insist on cinema as a *métier* [craft]. Saint-Étienne is the place where professionals, 'movie people' (directors, actors, writers, technicians), meet, and discuss their problems. There are roundtables, conferences and symposia, one after another: 'Where is the French cinema going?', 'Cinema and Television', 'Film conservation and the role of the cinémathèques', 'Cinema, audiovisual and schools', 'Cinema and realism' (Lyant and Odin 1983). It was in the course of these meetings that 'La Fédération Internationale des Réalisateurs' [the International Federation of Film Directors] was created, whose purpose was to uphold the profession. The idea was to show that the crisis in Saint-Étienne was the result of a much more general problem and that the cinema and Saint-Étienne had a common enemy: international capitalism.

Figure 3: Poster for *Les Rencontres Cinématographiques de Saint-Étienne.*

Louis Daquin, the meeting chair, stated, 'Yes, the closure of film studios can be compared to shutting down industrial plants. We do not want to see our craft disappear'. The mayor of Saint-Étienne, Joseph Sanguedolce, is even clearer:

> Cinema is a job, a difficult craft, which effaces itself behind the final results: the movie we love him and admire. This craft is now seriously threatened, sometimes on the verge of asphyxiation, and this by the weight of the same causes familiar to all the other workers, especially in Saint-Étienne, where they know they have to fight hard not to disappear [...].

The press followed suit with the following slogans: 'Film-makers and workers – same rights', 'Cinema – Manufrance same fight'.

Even if the problem goes beyond it, the issue here is the city of Saint-Étienne and the economic crisis it is experiencing. Without claiming to solve the crisis, bringing in the cinema festival had the aim of at least eliciting its causes, mitigating the psychological effects

on the population and perhaps, while bringing back a national, even international, visibility to the city (this is the logic of the branding), tempting buyers to come forward to rescue failed companies (Bernard Tapi made a bid for Manufrance, but the rescue did not occur).

A memory-driven logic

The result of these five years of Festival was certainly positive for Saint-Étienne in terms of social life, but was not matched by improved economic performances, despite the efforts of the Communist municipality. In the 1986 election, the right returned to power in the municipality and Les Rencontres Cinématographiques were dropped. In an attempt to reinvigorate the economy of the city, the new municipality undertook to transform Saint-Étienne by focusing on design. The new slogan became 'Saint-Étienne, Ville Design [City of Design]'.

This mutation corresponded to a certain logic, Saint-Étienne having a long tradition of craftsmanship and luxury goods (woven ribbons, engraved firearms), and it also sought to capitalize on the good reputation of the Ecoles des Beaux Arts. The creation of a museum of contemporary art was part of this initiative. We should note, however, that this was a radical break from the working-class tradition and industrial past of the city; the design is nowadays linked to the computer industry and mobilizes a different social class than the manufacturing industries once located in Saint-Étienne, let alone the mines. Symbolically, the Cité du Design is housed in the former Manufacture d'Armes [Manufrance]. As noted by a local newspaper, 'A tabula rasa approach has been adopted for this ambitious new project'. In fact, what occurs here is a radical identity change.

To minimize the trauma that might cause this change in the population, the cinema was once again called upon. In truth, this process had already begun under the previous municipality who were perfectly aware that Saint Etienne should radically change its economic policy and even identity.

The municipality assigned the Cinémathèque the task of creating in its archive a special section dedicated to local film productions on the city and its region. A new director was appointed. The Cinémathèque then launched an appeal to amateur film-makers, inviting them to deposit their films shot on this theme in which the city would appear in the background (e.g. home movies). In exchange for depositing their films, the Cinémathèque offered to give their author or their owner a VHS copy (nowadays a DVD). The response was very positive. Three main reasons are given by those who made a deposit: to save a family heirloom (films are fragile and are better preserved at the Cinémathèque than in the home); to have the ability to see them again (often the original projector would no longer work); and finally, to participate in the creation of a local memory. The fund already included more than 5000 amateur films by 1990. In order to add to it, the Cinémathèque itself began to produce films and to encourage amateur film-makers to organize film competitions on the theme of the city. The schools were also invited to participate in these operations.

Note that the type of cinema called upon here differs from the approach in the other two logics: this is a cinema of amateurs. The approach is to involve the population in building an archive of their city, urging them to film the city in order to reflect on its identity.

In 1993, the Cinémathèque was reorganized and moved into the purposely built Bibliothèque Médiathèque in a popular neighbourhood of the city. The aim of bringing together these facilities at this location was to increase access by the public. A selection of films (about 300) was transferred to video and made available to the public at the library on television monitors linked to a VCR. The library equipped itself with a highly sophisticated device providing automatic cassette selection (a device that was used in Paris at the Forum des Images), but very quickly the cost of the operation and especially the cost of maintenance proved too much. Fortunately, the problem was solved with the advent of the computer and DVD.

The film selection includes clips about the mine, the demonstrations, the strikes, the history of the city, the decentralization of theatre activities (Jean Dasté), major figures of the resistance (Marguerite Gonon), the football club, Manufrance, Casino, crafts, everyday life (the tramway, the firemen), etc.

In addition to this provision on video screens, the Cinémathèque holds regular screenings of these films on a big screen. At each screening, the film-maker or, when it is an old movie, one of his or her descendants is invited to speak with the public. The debates preceding or following the projection have nothing to do with the discussion in a Ciné-club: it is not so much about cinema per se as about the city and its evolution. The exchanges are in the mode of 'I remember': people note the changes in their neighbourhood and make comparisons with the present.

The projections themselves are hardly silent; everyone is talking aloud when they spots changes in familiar spaces – no wonder, as this is basically an enlarged family film session (there is much talk at the screenings of family films). Moreover, these films have a special status – shot by people like us, they are immediately credited with a value of *authenticity*. Unlike documentaries, which can be questioned in terms of veracity, they are unquestionable: they are regarded as accurate. They also have a special *aura* (after Benjamin) because they are originals that could disappear at any moment (amateur films were shot in such a way that it was difficult to make copies). They

Figure 4: Cover of the video catalogue.

also carry an incredible emotional force, not only because of their content, but because of the grain of the film that imbues the image with a specific quality (in contrast with the excessively sharp and smooth images we are used to seeing). But the key point is that more often than not the amateur films are badly edited, forcing the viewer to participate actively in order to bridge the gaps (which is why it is very wrong to criticize family films for being badly made: the less smooth they are, the better they work; see Odin (1995). Those screenings amount to an exceptional sharing experience, a remarkable community experience.

The result is that the Cinémathèque is transformed from a projection and archive room into a 'lieu de mémoire' [site of memory] (Nora 1984). People do not come to see a 'film' (they do not behave like 'spectators' but as 'citizens' of Saint-Étienne), but to experience images that generate memories about the past and to exchange views with others. They do not come to gather information, but to relive past moments together and at the same time talk about the life of the city; the cognitive dimension gives way to the emotional dimension, the scientific archival space is transformed into a sacred space.

I am not certain that the city councillors at the beginning of the project had this clearly in mind, or that it been done knowingly, but one thing is sure – the creation of this 'lieu de mémoire' was very timely in mitigating the identity issues posed by a city in transformation (it was the right structure at the right time).

To summarize, I have highlighted three logics (logic of propaganda, branding logic, memory-driven logic) that mobilize three forms of cinema (film education, film as art, amateur films) in pursuit of three objectives: an ideological objective, an economic objective and an identity objective, three ways of putting cinema at the service of the city. There are probably others in other cities, but my aim here was essentially to illustrate an approach. From a methodological point of view, I have shown in particular that one should have an open mind about cinema and not reduce it to an art cinema or a cinema of fiction, but also not to concentrate solely on the film itself: just as important is where it is distributed, the context (economical, ideological, social) in which it was made and seen. This analysis also shows that if one really wants to treat the subject properly, one should not only mobilize cinema scholars, but also historians, economists, sociologists, etc. In other words, it highlights that this type of research cannot be achieved by a lone scholar. Studying the relationship between the city and cinema requires a multidisciplinary team.

References

Borde, R. and Perrin C. (1992), *Les Offices du Cinéma Educateur et la Survivance du Muet,* Paris: P.U.L.
Brohée, A. (2004), 'Dossiers du cinéma', in D. Vezyroglou (ed.), 'Les catholiques, le cinéma et la conquête des masses: le tournant de la fin des années 1920', *Revue d'Histoire Moderne et Contemporaine,* 4:51–54, pp. 115–134.
Laborderie, P. (2009), 'Le film-parabole dans les Offices du cinéma éducateur en France dans l'entre deux guerres. Histoire d'un cinéma de propagande et étude d'un genre cinématographique', Ph.D. thesis, Université de Paris III-Sorbonne Nouvelle.

Lyant, J.-C. and Odin, R. (eds) (1983), *Cinémas et réalités*, Centre interdisciplinaire d'études et de recherches sur l'expression contemporaine, Travaux XLI: Saint- Étienne: Université de Saint-Etienne.

Merlet, J. (1990), *Histoire de Saint- Étienne,* Privat.

Nora, P. (1984), 'Entre mémoire et histoire. La problématique des lieux', in P. Nora (ed.), *Les lieux de mémoire,* Paris: Gallimard, pp. 17–18.

Odin, R. (1983), 'Pour une sémio-pragmatique du cinéma', *Iris,* 1:1, pp. 67–82. English translation: 'For a Semio-Pragmatics of Film', in W. Buckland (ed.), *The Film Spectator, From Sign to Mind,* Amsterdam: Amsterdam University Press, 1995, pp. 213–227.

—— (1989), 'A Semio-Pragmatic Approach to the Documentary Film', in W. De Greef and W. Hesling (eds), *Image Reality Spectator, Essays on Documentary Film and Television,* Leuven, Acco, pp. 90–100. Reedited in *Film Spectator From Sign to Mind,* in W. Buckland (ed.), Amsterdam University Press, 1995, pp. 236–249.

—— (1995), 'Le film de famille dans l'institution familiale', in R. Odin (ed.), *Le film de famille, usage privé, usage public,* Paris: Méridiens-Klincksieck, pp. 27–42

—— (2000), 'For a Semio-Pragmatics of Film', in R. Stam and T. Miller (eds), *Film & Theory. An Anthology,* Malden and Oxford: Blackwell, pp. 54–67.

—— (2008), 'Reflections on the Home Family Movie as Document. A Semio-Pragmatic Approach', in P. Zimmerman and K. Ishizuka (eds), *Mining the Home Movie. Excavations into Historical and Cultural Memories,* Berkeley: University of California Press, pp. 255–271.

Vallet, A. (1968), *Du ciné-club au langage total, pédagogie et culture pour notre temps,* Paris: Ligel.

Vignaux, V. (2007), *Jean Benoit-Lévy ou le corps comme utopie, une histoire du cinéma éducateur dans l'entre-deux-guerres en France,* Paris, AFRHC.

Zarch, F. (2008), *Dictionnaire Historique du Cinéma à Saint-Etienne,* Saint- Étienne: Université de Saint- Étienne.

Note

1. Our analysis of the relationship between the Church and the cinema owes a lot to this article.

Chapter 6

A Film of Two Cities: *Sean Connery's Edinburgh*

Murray Grigor

I have to thank Helmut Weihsmann, who dropped my name to François Penz as a possible participant in the Cambridge Urban Cinematics conference. I came to know of his compendious knowledge of architecture and cinema when he invited me to screen a number of my films on architecture for one of his legendary whistle-stop tours of architecture-film centres across Austria. It was a most agreeable adventure, one that would be impossible to embark on here in the United Kingdom, where there is effectively no provision for screening films promoting architecture. But meantime this Cambridge conference, under the aegis of Centre for Research in the Arts, Social Sciences and Humanities (CRASSH), seemed to offer a good start in the right direction, despite the worrying implications of its acronym. In the conference's ambitiously motivated synopsis, I was heartened to read that cityscapes in *Urban Cinematics* could not only represent the city as such, but that they could also reinvent the city, 'enabling its imagination and creation, to bring out the hidden, silent and invisible features of the city to public consciousness'.

Although most of my films on architecture pivot on individual architects, I have made a number of Granada television programmes on cities. These have included Asa Briggs on Liverpool, A. J. P. Taylor on Preston and such north-west of England watering places as Southport, Morecambe and Blackpool. One of the episodes in the eight-part *PBS series* I made with Robert A. M Stern was on cities. It made the controversial claim that on the basis of its urban planning, the reconstructed colonial Williamsburg in Virginia was America's most important city of the twentieth century.

In the end, out of all my films, *Sean Connery's Edinburgh* was invited to the conference, despite being made to promote tourism and to encourage incomers to consider Edinburgh as a city worthy of inward investment. Although Penz could see that there was some evident sponsorship, he liked the idea of a famous narrator returning to his hometown, retelling his early days and weaving an idiosyncratic take on history around the city's landmarks. It reminded him of James Mason's *The London Nobody Knows*. But despite featuring one of Edinburgh's most famous sons, would a film with such a brief bear scrutiny in an international symposium? I imagined that some of the great classics of the genre would be on the agenda for discussion. How, for a start, could a popular, but in essence promotional, film stand up against Dziga Vertov's burstingly inventive *Man with a Movie Camera* of 1929, with its cascading montage delivering his delirious take on the city of Odessa, as fast moving as Denis Arkadevich Kaufman's adopted name, inspired by a spinning top? Or Alberto Cavalcanti's *Rien que les heures*, which is much more a portrait of Bohemian life in the Paris of 1927 than the director's self-effacing claim that it is 'no more than a series

of impressions on time passing'. Closer to home, Cav's film must surely have given John Eldridge enough courage to include Edinburgh's low life when creating his innovative 1948 drama documentary *Waverley Steps*.

A day in the life of the city is one of the great film stand-bys. And what better device could there be to open such a film than by following the steps of a milk rounds-man, as the city reveals itself street by street at dawn. If that city is Edinburgh, with its castle neatly dividing the picturesque Old Town, with its huddle of high-rise ancient homes, from the handsome squares and wide streets of the classical New Town, then you are off to a good start. But then, what if the milk deliveries are made from the back of a horse-drawn cart, clattering over the cobbles, stopping for arresting views, as an energetic young lad rushes the milk bottles across streets, up steps and onto the doorsteps of city landmarks? Isn't it now becoming quite cinematic? Then what if the boy, in this early-morning milk round, would grow up to become an internationally known screen actor? What if he became one of the 'Seven Beauties' as Steven Spielberg calls them, so essential for any successful Hollywood movie? One who can capture the 'lightning in the bottle', as Spielberg so memorably said of Sean Connery when he was awarded the American Film Institute's Lifetime Achievement Award, quoting from another of Edinburgh's famous sons, Robert Louis Stevenson.

Moving from street to street at the pace of a horse-drawn milk cart across Stevenson's precipitous city gave the young Sean plenty of time to appreciate the divided selves of Edinburgh. His daily journey would take him from the elegant buildings of Dr Jekyll's classical New Town to Mr Hyde's Gothic piles of the Old Town, at the dawn of his career in movies.

The idea for *Sean Connery's Edinburgh* came from journalist Andrew Fyall, who had recently been appointed the director of public relations for Edinburgh and had just returned from New York, where he had once covered the filming of *Sammy Davis's New York* for the *Daily Express*. When we met up, Connery asked me why I would want to make such a film. I said that what intrigued me most was that the author Ian Fleming had first expelled his lusty 16-year-old fiction James Bond from the garden of Eton, because of his dalliance with a college maid and had then sent the young Bond for a Scottish education to Edinburgh's Fettes College, a school where Connery, 007's future screen persona, had never delivered milk. Then I watched that famous eyebrow lift, 'But I *did* deliver milk to Fettes'. 'That's even better', I said. 'Then go and write it' said Sean. We would make a point of that in our film, comparing the education of the 007 commander with St Cuthbert's Dairy milk-cart driver 271, who left school at thirteen. As a footnote to his Fettes experience, Connery always gets a laugh claiming that he went to the same school as Tony Blair – then adding that it was only to deliver milk.

'Let's find out things that even the locals don't know', was Connery's advice to me. 'Go for something fresh, original and visual, but above all make it quirky', he winked. So instead of a predictable plod through the history of Edinburgh's eighteenth-century New Town, Sean would relate how its pioneering first inhabitants included an Irish dwarf and the hard drinking Polish Count Barolowski, known locally as Count Barrel of Whisky.

During a recent 'Edinburgh Festival', the industrial magnate David Murray, one of Connery's closest friends, re-ran our Edinburgh film in his Charlotte Square headquarters. Strangely, one of the first sequences we filmed in 1981 was a re-enactment of the schoolboy Sean dropping off milk next door to Murray's office at the recreated Georgian House of the National Trust for Scotland. We were lucky that the St Cuthbert's Dairy, which had employed the young Sean for 21 shillings a week in 1944, were still delivering milk bottles by horse and cart well into the 1980s. Now how strange it was to be in David Murray's elegant offices and to see that little milk cart parked on the street below on his desktop screen, as simultaneously we looked down through his windows at Charlotte Square Gardens with its tented pavilions hosting the 'Edinburgh Book Festival', one of the largest of its kind in the world.

Clattering along in a horse-drawn cart over the cobbles from street to street through Edinburgh's New Town was the pace at which people moved when the city was laid out in the eighteenth-century. They would have had ample time to appreciate the elegant buildings that were then rising throughout the New Town – 'new', that is, up to a point, for like most

Figure 1: Robert Adam's palace front on the north side of Charlotte Square. Photo Phoebe Grigor

things called new in Edinburgh, the New Town is nearly two and a half centuries old. It was in 1767 that its first streets and squares were laid out north of the castle, over open fields, by the 27-year-old James Craig.

The great eighteenth-century architect Robert Adam's original plan for Charlotte Square was a masterfully created urban space with classical architecture of the highest order. On the day we filmed, the 'palace fronts' of Adam's facades were raked in sharp light and shade, marvellously capturing what Adam called 'architectural movement', the very essence of his style.

Connery's memories of his early-morning forays with his horse Tich provided our camera with fresh perspectives on the city, many of which could shift dramatically as we turned from one street into another. My favourite was the entry into Melville Street from Queensferry Road in Edinburgh's West End, where those long classical terraces climax in the soaring Gothic spires of St Mary's Episcopal Cathedral. We are back again to those two architectural styles that constantly face each other along and across Edinburgh streets.

The brooding silhouette of Fettes College, posing against the Forth like a chateau of the Loire, would end our introductory sequence. Edging into fiction, we had a young aspiring actor play our schoolboy Sean delivering crate after milk crate into the pointed Gothic cloisters at the school's entrance. Then above, a gargoyle with grotesque jaws agape, begins to wobble menacingly. This was not so much a well-engineered special effect as the result of our long, over extended fireman's

Figure 2: St. Mary's Episcopal Victorian Gothic Cathedral closes Melville Street's classical facades. Photo Phoebe Grigor

Figure 3: Fettes College witnesses the surprise arrival of a helicopter to fly Sean Connery over Edinburgh.

ladder being unable to hold our camera still on a windy day. Serendipitously, it provided some motivation for our horse to rear up and startle the boy to take flight, whilst the music edged as near to the James Bond theme as it could without infringing copyright. The boy looks over his shoulder in terror and suddenly it becomes big Sean's face.

Then a helicopter spins around the Victorian neo-Gothic turrets to land behind him. 'James Bond may have continued his education here', says Connery, 'but that was not my problem. I left school at thirteen', he explains, climbing into the helicopter before taking off to explore the city from the air.

Connery demands a professional script, laid out along the lines of a Hollywood screenplay. He then goes to work on trimming the lines, condensing sentences in a creative process that he calls filleting the script. Having worked with such masters as Alfred Hitchcock he knows how well the camera can photograph thought. So when we see that the builders of William Playfair's Parthenon of 1822 only managed to erect fewer than a quarter of the required 50 columns of the Greek temple as a monument to the Napoleonic Wars, 'Edinburgh's own Parthenon', is all that is said, as we see the twelve columns through Connery's eyes. After all, having created a skyline film-set illusion of an affordable acropolis why build columns that would be unseen from the streets below? Isn't it a thrifty enough solution to sustain Edinburgh's claim as *The Athens of the North*?

Connery is one of the great storytellers, as anyone knows who has heard him yarn around a dinner table, when one topic can effortlessly leap to another. This gave us the idea not to be narrowly chronological from sequence to sequence. Just as buildings of different eras can jostle each other along the streets of any city, which is especially the case in the Old Town of Edinburgh's Royal Mile, we would aim for similar leaps in our film. The narrow closes (or alleys) wending down both sides of the Royal Mile, like the spines of a fishbone, may be picturesque today, but they once allowed Edinburgh's criminal classes free rein to roam. We set up a scene of a horse-drawn cart emerging from the darkness of one such close to evoke the times of the body snatchers Burke and Hare, that notorious pair who delivered their still warm murdered victims to the dissecting tables of the anatomist John Knox. Edinburgh may have ushered in the Enlightenment in the arts and sciences to become justly famous for its medical teaching, but the downside was what the historian Bill Zacks so memorably calls the Endarkenment.

Over William Hare's skeleton in the Medical School of Edinburgh University, in film noir lighting, Connery appears, wearing a deerstalker hat, to explain that it was here that the young Conan Doyle studied to be a doctor. The future world-famous author always acknowledged that the diagnostic skills taught to him by his Edinburgh University mentor Dr Bell inspired the astute observations of his detective, Sherlock Holmes.

Detective work of a different nature was required when Charles II invited the Dutch artist Jacobus de Wet to glorify his descent from an impossibly long line of over 100 Scottish monarchs, stretching back into the mists of mythic time. As he walked down the long picture gallery in the Palace of Holyroodhouse, which now displays over 80 of these portraits, Connery describes how the artist faced the understandable dilemma of not knowing what most of Charles' ancestors looked like. As one portrait dissolves into another, we hear that

Figure 4: The Calton Hill monument to the Napoleonic Wars, sometimes sneeringly referred to as 'Edinburgh's Disgrace', represents for Connery an affordable skyline feature for the 'Athens of the North'.

Figure 5: Conan Doyle studied medicine at Edinburgh University, which still displays the skeleton of William Hare, the supplier of murdered victims to the anatomy department.

Figure 6: Under a quarter of Scotland's monarchs displayed in the long gallery in the Palace of Holyroodhouse.

the inventive artist just painted the face he knew best – his own. Then in quaint deference to His Majesty's descent from a long line of Scot monarchs, the artist made sure that each portrait sported the prominent House of Stuart nose. As the kings and the one queen, Mary Queen of Scots, merge into each other in royal flashes, a handful of unlikely hats appear to be recycled over the monarchs' heads. The thrifty artist clearly saved on props, which few visitors had ever realized before.

Edinburgh was keen to present itself as a city of innovation, and so to give flight to this, quite literally, we celebrated the feat of the eighteenth-century aeronaut James Tytler. This local worthy, who also co-authored the first Encyclopedia Britannica, flew his hot air balloon in 1784, making Edinburgh the first city in Britain to be seen from the air. British Telecom

obliged us with its Buzby balloon, which came in the shape of a gargantuan kitsch cartoon bird. We tried to follow the aeronaut's celebrated aerial arc over Edinburgh, but ended up unexpectedly in a cabbage patch next to the Dalkeith Police Station. 'You're going to have to take that back to where you came from', ordered an officer of the law, who had seen us glide down from the sky. The pilot did his best to explain the fundamentals of wind-born travel to an increasingly perplexed police constable, as anyone might have been seeing Tytler land at the end of the eighteenth century.

Two Edinburgh worthies once held a wager on who could drive a golf ball over the crown of St Giles Cathedral in the heart of the Old Town. The re-enactment of such a scene was a natural addition to our film, and we had Neil Connery, Sean's young brother help us do the honours. The first ball soared up before bouncing back to hit the statue of the reformer John Knox, who would hardly have approved of such a game, even if he had not taken a hit on the head. We had the second ball roll down a drain before re-appearing, bouncing down Mary King's Close, one of the subterranean alleys under the City chambers. Here long forgotten shops and homes were sealed off in the early eighteenth century. Despite their cramped conditions, Connery remarked that the rooms were far more spacious than his old family home in Fountainbridge.

In 1981 the tenement where the Connerys lived still survived at 176 Fountainbridge, although their small flat had recently been demolished to make way for a brewery extension. Fortunately, an identical home still existed next door, which allowed us to film the 'high hing', that Connery remembered so well as a boy. On warm Saturday afternoons, the men used to 'hing oot' from their windows, resting their arms on pillows and sporting their best tweed 'bunnets' to watch the world go by. As Connery leaned out over the street to describe all this, our small backlight went out. We had run out of power, but Connery still remembered where the electricity metre was, and by popping in a coin the light sparked up and our filming continued.

Sport is a major passion for Connery, with soccer at the top of the list. In the Middle Ages in Scotland a crude form of football was played, which often got out of control. By the end of the fifteenth century Parliament decreed that 'no part of the realm should be used for soccer, golf, or other such unprofitable sports, but for the common good and the defence of the realm, bows should be offered for archery and targets made up as previously ordained'. The idea that soccer and golf are 'unprofitable sports' would stagger many of the sports-obsessed members of the Scottish Parliament today. But 500 years ago, defending the realm against England, the *auld inemie*, was a serious concern. Today the 'Sovereign's Body Guard in Scotland' is provided by the Royal Company of Archers, whose annual tournament on Bruntsfield Links provided a bizarre film sequence. When Mark Littlewood, the cinematographer, asked for a safe vantage point, one of the archers wryly suggested that he would be in less danger the closer he got to the target. And so it turned out to be. Not one of the arrows struck the target that day, never mind hitting a bull's eye. Our camera was then able to tilt up from this worrying demonstration of national defence to discover school kids enjoying a game of knockabout soccer, which we had carefully planted there. As goals were scored past jackets thrown down as goalposts, what

Figure 7: 'Hinging high' out of a window at 176 Fountainbridge in 1981 with the director in need of a haircut.

memories that brought back for Connery, for the boys were nearly all from his old Bruntsfield primary school beyond the Links.

Seeing *Sean Connery's Edinburgh* again in Cambridge was quite a humbling experience. Because it was made nearly 30 years ago it has now come to chronicle much in the city that has now been lost forever. The St Cuthbert's Dairy stable block, where the young Sean loaded up the early-morning milk crates, has given way to an insurance company office with little architectural distinction. Few buildings of the last three decades complement the grain and scale of the city. Despite there being a number of world-class architects based in Edinburgh, bland over-scale blocks, designed by large practices, have done much to erode the city's essential Edinburghness.

As the patron of the 'Edinburgh International Film Festival', Connery has returned to the city each year since the early 1990s, and laments the mediocre quality of the new architecture in his old hometown. When he visits his old friend David Murray in Charlotte Square he finds that this great monument of the Scottish Enlightenment now has its streets callously blocked off halfway round, denying its very circulatory function as a square. Ironically, in traffic-congested London, Robert Adam's Fitzroy Square now has three of its sides dedicated to pedestrians. Did we catch the eye of that Adam sphinx high up on the rooftops of Murray's office scowling down in disbelief?

So many of the elegant streets and crescents of the New Town have now had their granite setts, or cobbles, smothered over in black asphalt. John Loudon Tar-McAdam has won over Robert Adam. Since Edinburgh shares its World Heritage status with Copenhagen, its planners should look to this exemplary Danish capital to see how a World Heritage site is preserved. Those who now administer and plan developments in what they still claim to be the Athens of the North might stop and ponder the oath taken by the Athenians of ancient Greece: 'I will leave my city not less, but greater and better than I found it'. Apart from two recent public buildings, the New Museum of Scotland and the Parliament, and some innovative housing down the Royal Mile, there has been little built since the war that leaves Edinburgh a greater or better city.

As in many cities, the great dilemma in Edinburgh is how to adapt well-loved old buildings to new uses. Connery has often pondered why the Scottish brewers, who paid for the MacEwan Hall and the Usher Hall, insisted that we should take our entertainments dry. Today most of us love a tipple before a concert. The innovative architect Richard Murphy, who designed the British High Commission in Sri Lanka, finds few commissions in Edinburgh where his office is based, came up with a most imaginative scheme. His solution was to accommodate rooftop bars atop the Usher Hall, which has a generous set back around its central dome. Escalators would take concertgoers up to the rooftop where they could savour Edinburgh's eternal skyline as a backdrop to an interval drink. Based on the decision of one member of Historic Scotland, his scheme was vetoed in favour of a bulging protuberance on the side of this great rotunda, at probably three times the cost. Murphy's Oloroso restaurant

Figure 8: Richard Murphy's elegant, but unrealized, solution to the Usher Hall's lack of bar facilities.

Figure 9: Sir Sean Connery inspects an early model of Richard Murphy's proposed festival cinema complex.

high up on George Street, with its stunning view of Edinburgh Castle, just hints at what concertgoers might have had. His practice may have won the most awards in Scotland and Murphy may be his name, but like the Irish stout, he's not bitter. Perhaps he should be.

There are few on the city council who realize that Edinburgh, through its International Film Festival, has an international reputation in the wider world of cinema. Clearly, a dedicated contemporary cinema complex would go a long way towards showing local commitment to making Edinburgh a true film centre all the year round. After years of indecision, Murphy was persuaded to devise a scheme, thanks to the generosity of one of his key patrons. His theatrical solution was to complement the Usher Hall across Lothian Road by placing a circular cinema complex on Edinburgh's unloved and deserted 'Ceaucescu Plaza', the grim, bleak, inappropriately named Festival Square. His beautiful model became a talking point of the 2004 Venice Biennale. If Murphy's iconic design were built I believe it would become an immediate beacon to moviegoers worldwide. Apart from the Festival, it could mount exciting film events in Edinburgh throughout the year. Connery lent his name to the project to help with its initiation. 'It is', he said, 'a great honour for someone born on the other side of the tracks in nearby Fountainbridge to be associated with such an important Edinburgh project'. How wonderful it would be if it could yet be built in his own lifetime.

Chapter 7

Film as Re-imaging the Modern Space

Mark Lewis

T hank you very much for inviting me. I am going to show a few of my films today that 'speak' very generally to the relationship between images per se and images that, more specifically, move. I am very interested in trying to imagine what it must have felt like to see an image move for the very first time. The Frères Lumière must have understood something of this original and extraordinary cinematic special effect because they would often start their programmes of films with the projection of a still image that after some time would suddenly start to move. We can now imagine that this transformation of the image from stillness to movement is what startled and awed the early audiences of the cinema, and not any illusion that what was on the screen might actually enter into the real world of the audience. Reports that trains arriving at stations had audiences ducking in their seats or scrambling for exits were undoubtedly manufactured by theatre owners trying to attract bigger audiences for their attractions.

I am also interested in trying to think what it must have felt like to imagine yourself as the subject of a film for the very first time. There is a beautiful little film made in 1903 called *At the Foot of the Flatiron Building* that shows people rushing past the camera on a cold windy day. Everyone is holding their hats close to their heads, and in the case of the women, their dresses close to their legs (the foot of the Flatiron building was a notoriously windy place and some men apparently would wait there to witness a woman's dress fly up over her head). Many people who walk by the camera notice it, some smile, others look a little perplexed. But there is one extraordinary moment when an African American man noticed that he is momentarily the subject of a film and has a kind of reverie of discovery and (I like to think) a vision of a future where he imagines a moving image of himself existing in the world without him and even after he is dead (And, of course, he is right: he has been dead a long time and the film still exists). Because of this distraction he forgets about the wind and he loses his hat. It seems to me that what we see him experience – My God I will be a film – is something you can only really experience properly once. After that your judgements in this respect become increasingly sophisticated and you start to assume a kind of 'life as a film' narcissism – you compare, you prepare and you assume the pose.

I think that these two phenomenological experiences I have just described underline the importance of thinking film's relationship to the long history of picture-making. This is because both are experiences of interruption or transformation of something already understood. Viewers and subjects already understand that still pictures of the world or still pictures themselves already exist. Indeed they have seen such pictures many times before. What surprises them is that these pictures are now moving. I want therefore to identify

these two phenomenal experiences as the consequences of pictorial special effects, in order to underline their provenance in the subject's knowledge and experience of what pictures normally can or cannot do. For me, picture-making is also what art is, more or less. Of course we have the experience of the last 100 or more years when the historical avant-garde subjected the picture to a violent and probably necessary iconoclasm. But this assault on picture-making did not, in my opinion, weaken the picture in any way. On the contrary, by learning from the avant-garde, from all of the latter's innovations and inventions, picture-making today could be said to be stronger and more contemporary than ever. I think of my own work as continuing in this long tradition of picture-making, even if it is true, we need to recognize that once a picture moves there is no longer a composition and therefore strictly speaking there is no longer a picture. It could be argued that in this respect film is an iconoclastic machine with regard to pictures: each of its pictorial compositions destroys the one before it and simultaneously anticipates its own replacement by the one that will necessarily follow. Perhaps film is only ever the promise of a composition, and this promise only understood or realized through decomposition. I believe that this is one of film's radical contributions to the idea of the picture. To paraphrase Stendhal, film is *une promesse d'une bonne composition.*

If the attention to film's origins in the history of pictures is one of the formal principals of my work, I would like to show and discuss a few films that could be said to combine this attention with aspects that are specifically the subjects of this conference. I should add that if I am interested in architecture more generally it is because I like to make films in the world and specifically in the modern world of the city. So, to some degree, architecture is something that I cannot avoid taking as my subject. It may be that my particular attention or attraction to what we might want to call classic modernist architectural forms is because, as Walter Benjamin has described, film and modern architecture sometimes seem to hold a mirror up to each other: the assumed mobility of the subject in architectural space often feels like a simulation of the virtual mobility assumed by the subject in a filmic space.

Gladwell's Picture Window (2005)

This first film I am going to show is called *Gladwell's Picture Window* (2005), and I shot it in The City, London's financial district. It is a film that depicts a very ordinary, common experience of modern city life: what happens, for instance, when the image of the city is reflected back to it via its numerous shiny surfaces. Here the reflective surface is a nineteenth-century curved shop window and when I made this film I tried to imagine myself as a camera: if I was a camera walking by that window, what would I look at? What would I do when confronted with such a montage of reflection and display? In fact with many, if not most, of my films, I try to imagine the film camera as having a basic consciousness, in order to understand what it might see and what it might do. Or, to try and imagine its equivocations and indecisiveness (look at this, but not this, but then again, maybe this), or its reverie and excitement when

Figure 1: *Gladwell's Picture Window*, Mark Lewis, 2005. Super 16mm transferred to 2K, 2'59". Film still courtesy and copyright the artist.

seeing something that reminds it of itself. With *Gladwell's Picture Window* I was trying to understand the architectural, phenomenological and pictorial experience of the camera as it looked into a curved window that reflected back to it dislocated and distorted aspects of the city. And what it 'found' was a kind of machine for making compositions, compositions that, through the camera's mobility, are continually transformed, that appear and disappear with the flux of everyday life. I made the film because one day I walked past that window and saw some of those reflections and then found myself moving my head backwards and forwards for some considerable time as I experienced the magic of the different transformations and juxtapositions.

Rush Hour, Morning and Evening, Cheapside (2005)

Here is another film that I made in the same year and in more or less the same city location as *Gladwell's Picture Window*. This film literally shows the experience of seeing pedestrian rush hours (morning and evening on the same day) upside-down, and trying to understand the shadows as having a 'life' all of their own.

Figure 2: *Still from Rush Hour, Morning and Evening, Cheapside*, Mark Lewis, 2005. Super 35mm transferred to 2K, 4'34". Film still courtesy and copyright the artist.

[Question: Is it true that you do not use sound?]

[Answer:] There's no sound in this film. From time to time I do use sound, but only when I think that a film needs sound added. But most of the time I do not think my films need added sound. I am interested in the visual experience of looking at something, and sound can sometimes vitiate that experience, even undermine the possibility of thinking when you are standing in front of a picture or a film. Film, when it was first invented, began without sound. In fact the experience of watching a moving image of something that you recognized (a train entering a station) without sound was one of the extraordinary and uncanny experiences of watching early film. This 'making strange' was one of the original special effects of film. So film begins in 1895 as a series of optical reproductions of the act of looking, but it's also true that very quickly sound was added to film (and even in the beginning there were the so-called 'lecturers' who gave live commentaries on what was being projected): music and eventually dialogue. But I think it's important to remember that

sound is *added*, that this is a decision, that there is nothing natural about attaching sound to film. So for me, every film starts out *au naturel*, without any sound added. It is necessary to make a very precise decision about the addition of things like sound. Moreover, and perhaps even more importantly, like pictures, films can depict sound by other means. Images are always full of sound; it's just that you don't always have to literally hear that sound.

Nathan Phillips Square, A Winter's Night, Skating (2009)

This next film is called *Nathan Phillips Square, A Winter's Night, Skating*; I made it last year and it was one of the films in my exhibition at the Venice Biennale. The background 'plate' of the film was shot at Toronto City Hall Skating Rink, part of the architectural public space of the building complex designed by the Finnish architect Viljo Revell that opened I think in 1963. Growing up in Toronto, as a child I skated all the time in that location, when it was still 'new', when the place's modernity was exceptional. It stood out as a kind of bold beacon for the future, surrounded as it was by a collection of lazy faux classical civic and corporate buildings. Whenever I am in Toronto in the winter now I still skate there, and one of the things I really enjoy about that is that when you skate at night you experience the city in a very special romantic kind of way. As you glide across the ice you can have the impression that you might be a movie camera mounted on a dolly with the city appearing and disappearing through the arches above, a montage of composition and decomposition. I feel this optical intensity when I am there, so my film *Nathan Phillips Square, A Winter's Night, Skating* is an attempt to replicate that intensity. My film is also constructed through montage of background and foreground. The background of the film is shot on film on location in Toronto. The camera was mounted on skates and its movement across the ice was choreographed along with around 60 or so skating extras. Then this film was back projected onto a screen in a studio in Los Angeles and in front of this we built a plastic ice rink on a turntable. The two lovers skating in the foreground are more or less skating against the rotation of the turntable and interacting as much as possible with the moving-image background shot in Toronto. And this montage effect, the placing of film within a film, helps to accentuate, I believe, the original montage effect of skating at the location with the arches in the foreground and the city in the background. This way of working is called 'Rear Projection', and it was bought into general use by Hollywood cinema during the late 1920s. The introduction of sync sound recording with its very crude microphones necessitated that the world against which the actors spoke be silent. So by filming things and then projecting them in the studio, it was possible to achieve a silent world. This was the expediency by which sound recording was made possible, but by accident an important visual transformation was achieved; for once film was 'inside' of film, film became truly modern: it could quote itself, it could use itself as its own material or subject matter, and also produced a form of montage that was already highly developed in other pictorial arts.

Figures 3 and 4: *Nathan Phillips Square, A Winters Night, Skating*, Mark Lewis, 2009. 35mm and 4K transferred to 2K and 35mm, 4′. Film stills courtesy and copyright the artist.

Children's Games, Heygate Estate (2002)

This film was shot in the Heygate estate by the Elephant and Castle in South East London. This estate is apparently one of the largest public housing estates in Europe, and it obviously has its architectural origins in the ideas of Le Corbusier. For instance, the whole idea of public living on the estate was predicated on the separation of pedestrian and vehicular traffic, so that people could walk completely unimpeded along elevated structures from one end of the estate to the other. In this 'city in the air' there were shops and playgrounds and meeting places, etc. The original plans conceived of this network of elevations stretching from the South Bank to Peckham – people would be able to walk five or more kilometres without ever having to stop for a car or a traffic light. So we could say that this housing estate was a project steeped in the modernist idea of 'the future'. For a variety of reasons the project began to fail almost immediately after the first tenants move in. Notably, there was not enough funding available to ensure the safety and maintenance of all the walkways, and the latter quickly became dangerous and dirty. Within 10 or 15 years, the elevated walkways

Figure 5: *Children's Games, Heygate Estate, Heygate Estate*, Mark Lewis, 2002. 7′27″, super 35mm transferred to 2K. Film still courtesy and copyright the artist.

and public areas were more or less abandoned by the residents, who preferred instead to arrive and depart by car and to shop in the large shopping centres that grew up off the estate. One of the architect's failures, if you like, was not anticipating the extent to which the poor and the working class would become so attached to their cars to the point where it actually undermined their own quality of life there.

When I moved into the area in 2001, I used to cycle along the elevated walkways, and I had this impression that now that they were abandoned, the walkways could be re-imagined as ready-mades for cinematic dolly shots. So I chose one particular route, about a kilometre long that traverses several main roads, and I staged a film that used the walkways as the tracking device for the camera. By shooting it in this way I also wanted to try and re-imagine the utopian idea of the place, so, rather naively perhaps, I staged about 60 or 70 children playing games around the estate – a reminder perhaps of what might have been there if things had worked out differently. Formally, the shot begins at one end of the walkway and ends at the point when the camera descends to the street and can no longer proceed.

North Circular (2000)

This film is called *North Circular* and I made it in 2000. If the films I have shown up until this point could be said to simulate in some way the experience of architecture, to be surrogate forms of what it feels like to inhabit architectural spaces, *North Circular* is an example of a film that strictly speaking takes an architectural form as the subject for depiction and observation. The building was a modest modernist building that used to stand on the North Circular Road next to Brent Cross Shopping Centre. It was torn down about six or seven years ago, but when I discovered the building it had already stood empty for some years. I used to cycle and drive by the building, and I often saw young people playing there. So I decided to stage a scene that seemed to naturally represent what you might expect to find there if you passed by – a few boys playing inside of the derelict building. As you can see, the film ends with the camera zooming in on the spinning top and abandoning the young men who have moved onto something else off camera. I like to think of this film as depicting a love affair between two mechanical objects that introduce some kind of impossible magic into the world: the spinning top that defies gravity and the camera that manages to pictures seem as if they are moving.

Figure 6: *North Circular*, Mark Lewis, 2000. 35mm cinemascope transferred to High Definition, 4'. Film still courtesy and copyright.

TD Centre, 54th Floor (2009)

This film was shot was from the 54th floor of Mies van der Rohe's, TD tower in Toronto. The TD tower is one of the two or three really great modern buildings in Toronto – another one being Viljo Revell's New City Hall, featured in *Nathan Phillips Square, A Winter's Night Skating*. What fascinated me here was the optical effect that you experience as you walk along one of the glass walls on 54th floor. The building gifts you this experience of being able to look down, to celebrate with the building its vertiginous modernity. In addition, as you walk along the edge of the glass wall, you can experience the building and the city outside as existing with two different temporal dimensions: the mullions in the foreground, though moving very slowly, seem to move faster than everything below at ground level. In fact, the ground seems impossible not to move at all. This is a very simple effect of vision, and we experience it many many times each day. What this building achieves is the production of a frame within which to observe and try to understand this obvious but perhaps seldom noticed optical effect.

Figure 7: *TD Centre, 54th Floor*, Mark Lewis, 2009. 35mm and 4K transferred to 2K, 6'18". Film still courtesy and copyright the artist.

Hendon F.C. (2009)

Hendon F.C. was shot just a few months ago in northwest London. After 100 years of continuous play, Hendon Football Club is now bankrupt. Temporarily at least the grounds are still there, and for the first time in more than 100 years the grass has not been cut. When I first discovered this location (again on my bicycle), the grounds had been squatted by a number of Romany families. So I decided to make a film of what the place had become, and I asked some of the current inhabitants to be in the film. I am interested in this area of London, the northwest, because in many ways it is shockingly banal. I cannot say that I love the area, and I certainly would never live there. But it does reveal a lot about London and we rarely see it depicted. It is not so poor as to look abject enough to become the subject of concerned photographs and documentaries. But it is certainly poorer than many areas and is now home to immigrants from all over the world. But its overall characteristic is this visual banality; it projects a kind of unremarkable series of vistas that are scarcely noticed, let alone pictured. Most of what is now northwest London – Wembley, Hendon, Neasden, Willseden – were originally planned 1930s suburbs. And right in the middle of all of this last summer was a football meadow.

Figure 8: *Hendon F.C.*, Mark Lewis, 2009. 4K transferred to 2K, 4'. Film still courtesy and copyright the artist.

[Question: What did you use for tracking in *Hendon F.C.?*]

[Answer:] A large crane. In this film the camera moves from the maximum to minimum elevations and at the same time through a full 360-degree turn. This is more or less what the crane can do: it can go up, and it can go down; and it can turn all the way round.

[Question: Did you use the same piece of equipment for *North Circular?*]

[Answer:] No, that was a more basic crane mounted on a truck. The truck drives towards the building from the car park and as it does so the crane rises up until it reaches its maximum elevation.

Isosceles (2007)

This film is called *Isosceles*, and it was shot right next to Smithfield Market in London. In what seems now to be the theme of my talk, this is a location that I cycle through regularly, and I often cycle around the triangular building that is the subject of the film: an old disused public toilet. Architecturally speaking, this is a very interesting part of London. Because of the River Fleet, now long since removed, London here is on two levels. From below, the upper level is perceived as a series of bridges, whereas from above you rarely notice this effect at all. At the same time the area contains a unique composition of different industrial

architectural forms from the eighteenth century through to the late 1950s, all montaged together, unplanned and without any obvious sense of order. Increasingly, this sense of London as a city built through the montage of different waves of industrialization and importantly modernization (i.e. the introduction of 'the modern') is disappearing. Perhaps necessarily so, as homogenization and preservation work to bring clarity and order to the city landscape – who knows? But there is still something quite unique here: a memory of a very recent past when many of the different architectural and geographical elements of London as it became a modern city were still visible. Smithfield Market, for instance, is probably the last remaining, and certainly the most visible, traditional industrial working site left in the centre of London. And right in the middle of all of this is a monument to public urination, almost a palace by today's standards. The urinal here underlines the publicness of the place – rich or poor you stand next to each other as equals in the palace of pee.

[Question: You don't use cuts at all?]

[Answer:] If I do, you probably cannot see them. They are invisible. Most of my films are single shots, but I sometime use several shots but combine them in such a way so that they appear to be a single uninterrupted shot.

Figure 9: *Isosceles*, Mark Lewis, 2007. Super 35mm transferred to 2K, 3′20″. Film still courtesy and copyright the artist.

Figures 10 and 11: *Spadina: Reverse Dolly, Zoom, Nude*, Mark Lewis, 2006. 35mm transferred to High Definition, 2′53″. Film still courtesy and copyright the artist.

[Question: Do you sometimes use slow motion?]

[Answer:] No. I never use slow motion. I really dislike slow motion. I like to slow things down, but I never do so artificially via some special effect. I do not really understand why anyone would want to use slow motion; it seems like a tautology or a contradiction.

Spadina: Reverse Dolly, Zoom, Nude (2006)

I am going to finish with one last film, and although things do seem very slow in this film I promise that it is not in slow motion. The film is called *Spadina: Reverse Dolly, Zoom, and Nude*. The title more or less tells you what is going to happen – the camera will reverse dolly, then it will zoom and then we will see someone naked. I have made a number of films where the titles literally describe the films in similar ways. I think I do this to try not only to get the 'suspense' of what is going to happen out of the way, but also to underline the extent to which the formal moves of the camera are as much the content of the film as what is depicted there. So in this film a 'zoom' and a 'nude' are equally its subjects or content. Now 'the nude' is a historically important subject of art and we might agree that making nudes today, is difficult, certainly more complicated than before, but as I am interested in thinking through all the pictorial genres, I am de facto interested in the nude. As you can see the nude here is very small and very brief.

Part III

Geographies of the Urban Cinematic Landscape

Chapter 8

Mobility and Global Complexity in the Work of Van der Keuken

Hing Tsang

Introduction

The aim of this chapter is to introduce one of Europe's premier documentary film-makers, Van der Keuken (1938–2001), to a wider audience, with a special emphasis on his description of contemporary urban space at the very end of the twentieth century. It is also an attempt to show that, while there has been an emphasis on mobility within the social sciences, most prominently in the recent work of John Urry, there have also been developments in documentary film practice that are broadly complementary. There are parallels between longstanding inquiry already conducted within documentary, exemplified by the later films of the Dutch film-maker Van der Keuken, which largely correspond with Urry's espousal of a new mobility paradigm – where social life is characterized by the 'movement of people, ideas, objects and information' (Urry 2007: 18), and that the activities and patterns that shape human interaction are always 'augmented by various material worlds, of clothing, objects buildings and so on' (Urry 2007: 45).

This hints at a strong intentionalist stance, which Urry, to his credit, develops through his emphasis on interaction between an embodied human agent and an environment that is characterized by materiality, affect and imagination. Similarly, Van der Keuken's work, which avoids the didacticism of attempts by both journalism and academicism to explain away the world from without, places great emphasis on the physical world, as manifested through objects that dominate the film frame, the use of handheld mobile camerawork, as well as giving much space to the human body in movement – his body and the bodies of others interacting with one another through perpetual movement.

Attention is also given to the presence of the film-maker's body, both in individual autobiographical films such as *On Animal Motion* (1994) and through self-reference in films that engage with the other in seemingly more conventional documentary fashion in films such as *Face Value* (1991) and *Amsterdam Global Village* (1996). In the latter two cases, the presence of, respectively, the film-maker's naked torso and his own personal voice is placed within a much more general context than what we would normally associate with the social documentary. *Face Value* contains a self-portrait where Van der Keuken refers in overtly cosmological terms to both his self and its effacement through its encounter with the other, which is described as the desire for the 'unattainable'. In a lyrical sequence in the latter film, which depicts the movement of solitary walkers and swimmers on the banks and waters of Amsterdam during the early-morning hours, Van der Keuken also uses a voice-over where he speaks about his wife picking him up from the airport. The combination of voice-over

and elemental images, which depict the sensual interface between human skin and the natural environment, suggests a wider context for human existence that is primitive to and yet contiguous with human history and culture. By doing so, the sequence hints at a context for self-reference, which is much more embodied and vital than cerebral forms of literary or artistic self-reference, and is rooted in timescale that exceed the purely contingent. This also entails that Van der Keuken's overall poetic approach to film, which he compares to 'the approach of the painter with the love of music' (Van der Keuken 1998: 39),[1] is not so much an espousal of the myth of the 'great artist', but is instead part of an overall world-view that sees self-reference as part of what characterizes the act of living and interacting intelligently with an environment, which is possibly intrinsic to all living form. The biologist and semiotician Soren Brier expresses this well in the following:

> I have endorsed the non-reductionist view that knowledge always originates from feeling – that is, from a volitional signifying living system with an inner experiential world and with, as well, a body relating to and distinguishing itself from both a natural world and a cultural environment by means of social communication. (Brier 2007: 147)

I will argue that, while Van der Keuken was a visionary whose work anticipates current interest in human mobility, his films also strive to locate all human movement within a wider natural context, contextualizing human understanding within a wider view of semiosis and intentionality that characterizes all living form. This is already present, if not fully developed, in Urry's pioneering work, where he implicitly criticizes the binary division between nature and culture that has plagued the social sciences since its inception, speaking as well of both 'glacial time' and an awareness 'of the long-term relationship between humans, animals and the rest of nature' (Urry 2000: 58). These valuable observations have been further developed in other fields such as the information sciences and biosemiotics. The biologist Jesper Hoffmeyer has attempted to describe forms of continuity between man and other animates. He criticizes a more mentalist account of intentionality derived from the work of Brentano and Husserl, referring to the uncoupling of human mental behaviour from bodily actions:

> This uncoupling causes philosophers to wonder how it can be that mental states are always 'about' something. But this is because they never consider that mental 'aboutness' – human intentionality – grew out of a bodily 'aboutness' (i.e. the behaviour necessary for assuring reproduction and survival – what could be described as evolutionary intentionality, the anticipatory power inherent in all living systems. (Hoffmeyer 1996: 47 – original emphasis)

In short, I shall also demonstrate that Van der Keuken not only highlights the importance of human mobility within a modern mostly urban context, but his work also places man in a wider context that is thoroughly cosmopolitan in the full sense of the word, taking account

of the evolutionary context of human agency, as evidenced by his longstanding interest in nature and the co-presence of other animates alongside human beings, irrespective of the geographical setting of his films.

Mobility within the documentary tradition

Nevertheless, it should be noted that documentary, long before Van der Keuken's emergence as a world-class film-maker, was already directly engaged with describing mobility and inscribing the film-maker within different modes of both physical and social mobility, even if this has been barely developed within documentary theory. Yet even a cursory consideration of the practices of early documentary brings to our immediate attention the fact that these early films were both studies of human movement and often films shot on the move. This was the case in Flaherty's classic work *Nanook of the North* (1922), which was a portrayal of the Inuit's hunting expedition. The same can be said for Vertov's *Man with a Movie Camera* (1929) and Vigo's *A Propos de Nice* (1934), which defined the human body as being in perpetual movement. The camera obsessively films such things as sports and dance, in a way where the corporeality of the profilmic subject is reflected in the movement of the camera, which does not film at a distance but participates in the action. Vertov, as early as 1923, had defined film in terms of mobility in both micro and macro terms. He referred to both movement itself and the possible ways it would involve the audience, forcing 'the eyes of the audience to see the consecutive details' (Christie and Taylor 1988: 92) of actions inherent to sport and dancing, while he also broadened his vision to speak of the cinema 'interval', whereby a single filmic space would 'involve twelve walls filmed by me [sic] in different parts of the world' (Christie and Taylor 1988: 92). Vertov has not only defined the human body through movement, but, just as importantly, has also suggested a new way of considering urban space that is not limited to traditional cartography where image and object are directly mirrored. He has strongly hinted that both imagination and human movement are central to any portrayal of the modern city.

But documentary theory itself has been somewhat slow to respond to Vertov's challenge, and the same criticisms made by Urry towards the overly static nature of social theory's main paradigms might also apply to much of documentary theory. Arguably, because of theory's priviledging of epistemology over ontology, mobility, whether corporal or more general in nature, has not featured highly within canonical texts from documentary studies. Nichols' emphasis on discourse and different modes of discourse, whereby a distinction is made between 'a world', which is the subject of fiction, and 'the world', which is accounted for by documentary film, is essentially static in nature (Nichols 1991: 113), re-emphasizing the gap between subject and object, and reproducing traditional mechanistic accounts of a neutral observer and a lifeless natural world, which have been much criticized in both theoretical biology and the social sciences (Brier 2007; Prigogine 1984; Urry 2007). Similarly, Winston's obsession with scientific inscription (2008: 135–140), because of its point of departure in

what he perceives as being prototypical (Newtonian) science, does not allow for a developed discussion of these motifs, nor does it allow for a first-person account of embodied experience, which is continually emphasized in MacDougall's work (1998, 2006) and has been reconfirmed by Van der Keuken himself. The Dutch film-maker not only speaks of the relationship between his own work and expressive art forms, but also emphasizes the role of partial knowledge and the physicality of cinema:

> I do not envisage reality as something which can be fixed through film but rather as an energy field. The filmed image results form a collision between the field of the real and energy which I bring to my exploration. It is active and aggressive. (Van der Keuken 1998: 14)

Fortunately, these gaps have been partially filled by Elsaesser's recent work on Van der Keuken. The German film critic speaks of the importance of the body within Van der Keuken's work, and hints at a unity of the senses that runs against a Cartesian mind or body split. According to Elsaesser, Van der Keuken's films are defined in the following way:

> His is the task to teach the eye new skills, and in particular, to develop the eye into an ear, and extend the ear to become a 'hand'. It would mean seeing the world around the tactile register and learning to experience the body less as a container, and more as a surface. It would be a surface not bounded by frame and view, and instead a permeable and vulnerable membrane, combining the properties of screen and filter, veil and curtain, as well as the softness of flesh with the hardness of lacquer. (Elsaesser 2005: 209).

Elsaesser's highly corporeal account of Van der Keuken's cinema is also confirmed in Van der Keuken's own descriptions of his own practice. He criticized a Cartesian 'age-old rejection of the body' (Toubiana 1997: 52),[2] while also attacking the totalization of knowledge that, he believed, characterized ethnography at its most extreme: 'I often say that I work against ethnography. It's always the moment when the model is ruptured, when representativity does not function, that things become interesting' (Toubiana 1997: 45) This account of both emergent cognition and personality allows for constructivism, yet its temporal dimension also insists on the existence of a world that is not subsumed by the models that we construct and impose upon reality. Not surprisingly, Van der Keuken was keen to consolidate the immediacy and spontaneity of American direct cinema and the more reflexive and constructed forms of French cinema vérité, without ever adopting a doctrinaire line. He was also a polymath, who began as a photographer and maintained a strong interest in other visual plastic and auditory arts, defining his own montage as akin to the sculpture of Henry Moore where there is a tension between parts and whole that does not reach a final equilibrium, as well as comparing his shooting and editing with the improvisation of jazz. Elsewhere, Van der Keuken criticizes the neutral aesthetics of television practice, and speaks of a debate between those (including himself) who want to free themselves from single narratives in search of what he describes as polyphony (Van der Keuken 1998: 32). He also describes himself as an improviser, and the difference between improvising

and not improvising as a much more important distinction than that between fiction and documentary. Accordingly, 'improvisation is a real category' (Van der Keuken 1998: 33), which also suggests that spontaneity and chance are genuine forces in our emergence as both subjects and objects within a shared perceived world (Prigogine 1984: 8–9; Hoffmeyer 2008: 62–68). This provides further credence for Elsaesser's observations regarding the participatory kinaesthetics of Van der Keuken's work, and is also in keeping with Urry's more general view of human society, which is predicated on theories of emergence and complexity (Urry 2007: 26–31). Urry mentions 'the mutual intersection of objects and things' with human agents, while suggesting that future sociological research will involve much needed investigation into the 'sensuous constitution of humans and objects' (Urry 2007: 9), and thus hints that Van der Keuken's work, while highly complex in its description of different geographies, does not lose track of the qualitative and experiential uniqueness of the individual human agent.

But while Elsaesser's work is invaluable in bringing critical attention towards one of Europe's foremost film-makers, his work does not explore human mobility on a more macroscale, partially because of his desire to locate Van der Keuken's work within a specifically Dutch visual tradition, valid though many of his observations remain. By contrast, it should be noted that the theme of movement (both human and non-human, animate and non-animate) is a long-term concern in Van der Keuken's films, making his work a valuable contribution as to how we might describe contemporary urban spaces in ways that are different from static cartography. His films produced in the 1970s and 1980s had increasingly forefronted a series of simultaneous journeys between different countries, as shown in the 'Triptych North South', which contrasted the affluence of Europe and North America with the movement of people from the countryside into the larger cities in films such as *The New Ice Age* (1974) and *The Way South* (1981), while the *Palestinians* (1975) was a sympathetic portrayal of displaced people. A slightly later film called *I love dollars* (1986) dealt with the flow of international capital in a way that foreshadows Castells later work on the networked society (2009), but it also examined individual lives on a microscale by engaging with Latino emigrants in New York as well as describing the lives of both rich and poor Hong Kong Chinese (who were of course recent emigrants from mainland China). He also made more obviously lyrical films that were celebrations of travel as leisure, as shown in *A Filmmaker's Holiday* (1974), while his very last film, which was a summation of his entire career, was unsurprisingly entitled the *Long Vacation* (2000). His work, therefore, describes mobility in terms of the entailment and curtailing of population movements mentioned by Urry (2007: 8), while also defining travel as involving a myriad of forms ranging from enforced migration to the leisured movements and habitats of the travelling tourist/film-maker and any possible permutation of these.

Amsterdam global village

Nowhere is this more elaborately articulated than in Van der Keuken's magnum opus *Amsterdam Global Village* from 1996, which is a four-hour film, shot and researched over some three years. It locates Amsterdam within a global context, by moving to and fro from the city to different locations around the world, while the city itself is characterized by the physical movement of people and objects along its roads, canals and air spaces. It is filmed with a constantly mobile camera that is either handheld or mounted on cars, boats, airplanes or even upon the motorcycle of one of the main characters, Khalid, a second-generation Moroccan emigrant who is used by Van der Keuken as a link between the diverse strands of the film. In regard to this, Urry recommends that mobile methods be adopted in order to describe mobile objects, '"walking with", or travelling with people as a form of sustained engagement with their worldview' (Urry 2007: 40). This has been a long-term strategy of many of Van der Keuken's films, and, as implied earlier, was part of a documentary tradition, extending from the pioneering innovation of Vertov and Vigo through to Jean Rouch's ethnographical work. In *Amsterdam Global Village* walking is augmented by many other forms of human movement such as dance, physical sports, swimming and copulation, many of which are directly imitated by the movement of the camera. In one striking sequence, Van der Keuken goes as far as to imitate the movements of Acid House music, which was the motorcyclist's favourite music. While we hear this music on the soundtrack, the camera whip pans over different objects within the apartment. The same simulation of other people's corporeality is also repeated in a later sequence, where rapid camera movement both describes and imitates the movement of a conductor during an orchestral rehearsal.

The title of the film, which refers directly to McLuhan's canonical work, also highlights Van der Keuken's interest in the theme of mobility, for he had read *Understanding Media* (1964) immediately after its publication, and had expressed a fascination with its provocative assertions. Nevertheless, Van der Keuken's reaction was not uncritical, referring to 'the oppression of electricity' in more broadly social and economic terms, when he also asserts that 'media cannot be disassociated from the economic interests they serve; not a global village, but a global market' (Van der Keuken 1998: 71). This is brought home for us in the film itself through Van der Keuken's juxtaposition of airplanes leaving a runaway and discarded consumable goods being crushed and burnt in a massive waste disposal unit. Elsewhere, and following on from Van der Keuken's objections, McLuhan's emphasis on 'allatonceness' whereby 'we are already entering a global theatre in which the entire world is a Happening where space and time are overcome by television, jets and computers' (McLuhan 1969) has now been problematicized. It is almost as if McLuhan has frozen time, and has taken a still shot of perpetual movement rather than a moving film, or even better, a set of autonomous movies that are running simultaneously and feature a multitude of individual and indivisible human narratives. The latter, as we shall argue, is what Van der Keuken attempts, and is closer to an account of time and space, which, though it embraces

simultaneity, also respects the individual timescale of personal lives that occur across diverse spaces but cannot be subsumed by a 'view from nowhere'.

Nor has McLuhan's enthusiastic account engaged with social class and economic difference, which may often manifest itself through enforced movement between countries, and involve individuals who have attempted to escape from ecological, social and political turmoil (Urry 2007: 8–9). By contrast, this is a central theme in many of Van der Keuken's films, where his camera engages with the lives and feeling of first- and second-generation emigrants both in the Netherlands and in any of the many countries he has travelled to and across. Van der Keuken travels in order to discover others on the move. This, then, is a view of mobility from within – individual mobility occurring amongst varied and diverse forms of mobility.

Home away from Home

This of course redefines how we might define home and place, as is rightly expressed by Elsaesser, where he draws a part–whole relationship between the interrelationship and the senses and Van der Keuken's global vision. The former is described as a 'parable for the whole, breaking both the rule of the centre versus the periphery as well as the global local divide' (Elsaesser 2005: 210). The German film scholar's description is also compatible with Urry's more general observations about place and its relationship with emergent personality, whereby 'places are not fixed and unchanging but depend upon what gets bodily performed within them by hosts and especially by guests' (Urry 2007: 269). This is confirmed by Van der Keuken's initial blueprints for the film, where he drew diagrams that defined Amsterdam through circular movement within the city itself, and movement inwards and outwards from the city, all of which are defined through movement across water, earth and air (Van der Keuken 1998: 183–185). By doing so, Van der Keuken presents us with a highly decentred view of both person and space, as these are now defined more as forms of intersection and flux than as self-contained units. Amsterdam, as portrayed by Van der Keuken, is now shown in very different terms from the earlier city films shot in places such as Nice or Berlin during the 1920s and 1930s, where movement was defined in terms of activity occurring within a more or less fixed location. Indeed, Van der Keuken remarked that after making films in India and Hong Kong, he had returned to a new city where the act of walking around any street corner in Amsterdam would now bring him to a different culture. 'For if I am not cosmopolitan here, wherever will I be?' (Van der Keuken 1998: 194)

Therefore, Amsterdam's canals and narrow roads can be seen as a microcosm of larger trends of travel and immigration. Urry's observation that 'places are like ships that move around and do not remain fixed within one location' (Urry 2007: 42) is borne out throughout the film where we are constantly on the move, following individuals from cars or across water and returning to their homelands on other continents through the air. While some of this might seem simply descriptive of Amsterdam's geography and architecture, Van der

145

Keuken also spoke about the fact that he was interested in the fact that, at any moment in time, there were also multiple stories involving movement that constantly intersected (Van der Keuken 1998: 32). This defines human narrative in spatial as much as temporal terms, since individual narratives are defined as much by the other narratives against which they are juxtaposed, and each narrative involves a sense of time that is predicated by the individual actors' sense of both their own world and where they sense they are located within their individual narratives.

Indeed, it might even be argued that Van der Keuken's account of multiple overlapping journeys has much in common with recent work concerning complexity and emergence. This work, as Urry is at pains to point out, emphasizes nonlinear development, where chaos and chance play a role in causation in a way that is no longer directly teleological in the traditional deterministic sense. It is also marked by a part–whole relationship whereby the whole cannot be reduced to its parts in a Newtonian mechanical fashion: 'Order and chaos are in a kind of balance where the components are neither fully locked into place but yet do not fully dissolve into anarchy' (Urry 2007: 29).

There are then some definite parallels between this and the structure of *Amsterdam Global Village*, which involves all types of journeys to and from Amsterdam as well as multiple journeys across the city; these journeys intersect with one another, even mirroring one another at times, but direct linear causality is constantly broken up by the presence of simultaneous narratives. As viewers, we venture far outside the Netherlands, accompanying different protagonists on their journeys towards home in Bolivia, Chechnya and Sarajevo, but these journeys are broken up by a set of journeys at 'home' within the city of Amsterdam where we are introduced to Chinese, African, Thai and Jewish communities, including visits to the habitats of the old, the young, the disabled and the mobile. While there is not the space to provide an exhaustive study of the film, sequence by sequence, it can be noted that the two main journeys abroad are not presented in linear form, but are intercalated between other sequences. For instance, after we have been introduced to Roberto, the Bolivian musician, and his Dutch-born wife, it is not until after further sequences, which depict the daily lives of black emigrants, local Dutch people playing dominoes and Borz Ali the Chechnyan businessman, that we venture into Roberto's new home in Amsterdam before returning to his birthplace in rural Bolivia.

Similarly, the Chechnyan's journey home only occurs after we have visited the habitats of different communities living within Amsterdam itself. This presents a view of time and space, which is distinct from a Cartesian/ Newtonian account of time that is reversible and quantifiable (Prigogine 1984: 307–310). Instead, both time and space stand in relation to a particular actor and his social and cultural values rather than existing without. The same can be argued for how we might experience the film, since the lack of obvious didactic direction on the part of the film-maker forces the viewer to make connections between areas of experience that are disparate in temporal, geographical and cultural terms, and our capacity to make these connections is not solely predicated upon our knowledge of the history of documentary film form, relevant though this is, but also upon our personal

Figure 1: Roberto in Bolivia.

somatic and historical experience, which, though subject to external social and discursive norms, is not subsumed by these.

These two examples also show us how Van der Keuken personalizes experience of time and space without resorting to postmodern scepticism, for *Amsterdam Global Village*, as much as any of his previous work, insists on the existence of a shared collective world, which, though only accessible through personal embodied experience, does not constitute either a denial of a shared world across different spaces or a traditional view from nowhere (Brier 2007: 116, 394; Prigogine 1984: 298–301). In both of these portraits, Van der Keuken introduces us to their personal habitats, which are already contextualized within the global flow of Amsterdam. These are the spaces from which he cuts directly to the protagonists' arrival in Bolivia and Chechnya, respectively, and we are immediately reminded of different experiences of time as shown by the presence of Ayamara ritual and tradition, which is as different from imposed colonial Spanish values as it is from more general neo-liberal cultural values; while the Chechnyan sequences, shot during the prolonged civil war with Moscow, remind us of a different historical and geographical world that lies in strong contrast to the wealth and political stability of Amsterdam. Van der Keuken has linked the individual to the collective, personalizing his protagonists' experience of a longstanding collective history that exceeds the limits of the narrative of their individual lives and that of this particular film shot at the end of the twentieth century.

In the second of these journeys, Van der Keuken also reminds us of the irreversibility of time, which features as a major feature in recent work about complexity and emergence, and also defines Peirce's semiotic account of both individual personality and operative chance within the universe (Hoffmeyer 2008: 62–65; Houser and Kloesel 1992: 215–224). Both these bodies of work, which have recently interacted with one another, postulate a non-mechanistic view of a universe in which the human agent (alongside other animates) is a participant rather than an isolated observer. As pointed out by Prigogine with great

enthusiasm, there are strong parallels between his discussion of 'intrinsic irreversibility and entropy', followed by the emergence of new order within a sea of disorder with Peirce's earlier work on chance, which is operative in the universe and acts to 'move things in the long run from a state of homogeneity to a state of heterogeneity' (Houser and Kloesel 1992: 221). Peirce also relates chance to what he describes as a developmental teleology that applies to human personality as well, reminding us 'were the ends of a person already explicitly, there would be no room for development, for growth, for life; and consequently there would be no personality' (Houser and Kloesel 1992: 331).

Irrespective of how much we wish to take from Peirce's account of personality and its isomorphic relationship with chance in the universe, it can be noted that Van der Keuken gives ample room to the agency of the dialogical human agent who interacts with these devices and remains engaged with a shared collective world, and who is constantly renegotiating his position with the wider social order, as well as the various selves of both the past and what Colapietro has described as the 'critical self' (Colapietro 1989: 93–95) – a sense of personality that is ever emergent, and never fully completed, and continues to emerge after the individual filmic encounter has come to an end. Colapietro's account of the semiotic self is akin to the many comparisons made by Van der Keuken himself between his own work and the improvisation of jazz, where the qualitative immediacy of both the soloist's solo and his personality is still predicated and germane to the work and aims of the collective.

In other words, while Van der Keuken does describe a material world characterized by mobility, using the visceral and kinaesthetic advances of the moving image, this always occurs in the context of human meaning, which involves internal dialogue as much as external intersubjective dialogue with real existent others (Archer 2003: 93–129; Petrilli and Ponzio 2005: 55–58). The self remains expressive and communicative even within, and perhaps because of, the larger collective context. The latter is often either associated with civil war, as shown through Borz Ali's journey to Chechnya, or defined through unresolved issues of occupier and colonized, as explored through Roberto's return to his native community in Bolivia. Yet within the film itself, we are given access to the 'loci of affect' (Urry 2007: 253) through their manifestation in physical objects and appearances, be this close-ups of individual faces, or the material objects that are of both practical and affective value for the individual agent. The sequences of Borz Ali shot in Amsterdam employ close-ups of the mobile phone used by the businessman as he travels in his car around Amsterdam, while at home the camera also films images taken from video recordings of CNN news reports. As well as cutting to close-ups of the remote control, the video image is actually paused in order to reveal the face of Ali's brother who was a soldier fighting against the Russians. This alternation of close-up shots of hands and the mobile phones and remote controls in the room remind us that Van der Keuken is not only describing new forms of mobile topography that do indeed refer us to a shared political geography, but is still concerned with showing how this is experienced from a first-person perspective.

Figure 2: Borz Ali in car.

Nevertheless, Van der Keuken also provides a major surprise when the sequence shot in Chechnya is revealed to be a flashback. The camera cuts from close-ups of the brother to Borz Ali holding a remote at home, where he laments both the death of his brother and the pain and hardship that this will cause his mother. Therefore, while time might seem to be reversible and mechanically controllable because of the existence of rewind and the remote control, in terms of lived experience, the presence of new technologies actually serves to reinforce the finality of time – finality both through the irreversibility of time and through an awareness on the part of the communicative agent of his possible aims and ideals. As we watch this later sequence, we are made aware that what seems to be a forward movement towards a future is actually a form of flash back. This strongly implies that any recollection of the past is not a neutral account of events set in the past, but is related to future self-

Figure 3: Chechnyan child.

Figure 4: Borz Ali mourning.

awareness and self-conduct for the implicated individual. This is emphasized in filmic terms by a shot of Borz Ali's face, which expresses grief at the loss of his own brother, while he also speculates on the voice track about his mother's future predicament and how he will have to console her in the face of this loss.

In both journeys, we learn about the protagonists' personal family relationships and their emotional lives as much as we do about the wider social groups with which they identify. Much screen time is dedicated to the Ayamara communal rituals that symbolize and reenact cultural transmission, but also focuses upon the relationship between Roberto and his elderly mother. Therefore, the motif of travel is linked to the affective and emotional pull of both the places and traditions out of which the individual has been borne forth. Van der Keuken thus forefronts the importance of biological blood relationships, which manifests itself both through affect and grief, and whose pull is strengthened rather than weakened in the context of material mobility and technological communication.

Van der Keuken's ecological vision

This, I would argue, places the work in strong contrast to the disembodied emphasis on non-place and anonymity of Marc Augé (1995: 75–116) in his work on speed and travel, or even to Castell's work (2009: xlii) on 'timeless time', which features some kind of escape from the biological clock. It can be argued that Van der Keuken presents us with a more nuanced account, for his interest in contemporaneity is augmented by an interest in time, as it is experienced by the individual agent, as much as it is by a wider contextualization of subjectivity within a wider evolutionary context, which refuses a binary division between nature and culture that is easily resurrected in our attempts to map both hyper-modernity and contemporary mobility. This is an argument that Van der Keuken sustained over several

decades, and his earlier work in *Flatlands* (1978) and *Face Value* (1991) needs to be briefly mentioned, as a way of contextualizing his final clarifications in *Amsterdam Global Village* and reminding us that his films work against a facile 'demarcation line between town and country that is mainly to blame for the pathetic attitude to nature of many people today, that wavers between arrogance and romanticism' (Hoffmeyer 1996: 143).

These very concerns were evident in his groundbreaking work in *Flatlands*, which addressed ecological issues long before these became fashionable. In this film, Van der Keuken described relationships between species and plants, even venturing to explore fish and crustacean life on the bed of the ocean floor. Human interaction is contextualized by other forms of intentionality within other animate forms, so that human culture is always continuous and contiguous with other forms, even if there are differences between the lifeworlds or *umwelts* of animals and that of the specifically human animal. This was what was implied by the great French critic Serge Daney, who spoke of how Van der Keuken's search for forms of connectivity between micro- and macro-scales of life was linked to his political and moral commitments (Daney 1978: 70) and anticipates the work of philosopher John Deely in a more overtly biosemiotic context. Because these ideas are quite complex, yet are expressed extremely lucidly, I will quote extensively from his work:

> Every species can be said to have a species-specific apprehension and consequent means of communication. This is in no sense unique to the human species; every species lives in a species-specific objective world, however much that world may be varied by actual experiences. But, on this planet, all the diversity of species-specific communicative modalities among animals extant outside the gene pool of homo sapiens reduce to subspecies, or varieties, of perceptual semiosis, which both reveals and constructs objects according to sensory appearances strictly in terms of the self-interests of the organisms involved. The human animal, by contrast, goes beyond the relation of objects quite apart from biological interest which we find in them, insofar as they exhibit an independence of relations to us. (Deely 2002: 75)

What is admirable in Deely's formulation is that it postulates a form of self-awareness that is unique to human beings, but still accounts for the richness of the natural world and other forms of semiosis that occur within nature and form the basis of human agency. Deely's account of the interrelationship between human and other forms of semiosis in nature is far from a disenchanted view, for it allows a sense of wonderment and humility towards other species irrespective of their ecological niche within the lifeworld, which, in turn, is expressed through human artefacts such as painting, music, literature and, more recently, the documentary film.

Similarly, *Face Value*, which was shot just a few years before *Amsterdam Global Village* and is in many ways a companion piece to the latter film, deals ostensibly with the new face of a multicultural Europe. Likewise, it also cuts between diverse locations so that we often do not know where we are. At the same time, Van der Keuken reminds us of a wider evolutionary

context out of which human communication has emerged. One sequence describes a conversation between deaf mutes. What is highlighted is the role of gesture and imitative corporeal expression, which is an inheritance we share with other animates, as shown in Darwin's classic work on the relationship between animal and human gesture (1871). The conversation itself is a direct example of human empathy towards other animates, where two children speak about how they enjoy seeing snakes in the grass and the sensation of water on human skin when swimming. Later sequences link human subjects and their capacity for representation with a much wider evolutionary context in which various forms of semiosis occur. Bodies are seen sunbathing by the sea, at the same time as adults embrace and children build models in the sand of human bodies. Footage from this beach sequence is later projected upon a couple who embrace and kiss one another, so that although we might see this later sequence as emblematic of film's artificiality and endless self-reference, Van der Keuken has also reminded us of the importance of instinct and sentiment even in later much more mediated stages of human development. According to Van der Keuken's vision, human representation, because it is capable of creating and constantly renewing the relationships between things, objects and their representation, is distinct from animal perception and contingency. But at the same time, Van der Keuken has celebrated our rootedness in a wider lifeworld and the continued existence of feelings and instincts that are primitive to the advent of language and culture yet are essential to our communal and social existence as a species.

These examples from Van der Keuken's earlier work provide an understanding of sequences in *Amsterdam Global Village* that are formally distinct from what we associate with either direct cinema or cinema vérité, and which might otherwise be seen as formal experimentation, of the type associated with reconstruction, on the one hand (Winston 2001: 24–25), and the avant-garde camera work of figures such as Stan Brackhage, on the other. Towards the end of the film there is a series of sequences that encapsulate what has been implied in his earlier work. This begins conventionally enough; we are shown

Figure 5: Canal at dawn.

Figure 6: Canal at dusk.

impressionistic shots of water bathed by morning light, where a lone swimmer is surrounded by mist, followed by shots of the canals, which are filmed during sunset. The latter part of the sequence is underscored by the use of music from Ravel's Daphnis et Chloe, which is then revealed to be part of a live orchestral rehearsal. Van der Keuken films this using frenetic movements between the conductor and musicians that initially appear totally arbitrary. Immediately following this, in a bizarre scene that has been totally set up for the camera, Van der Keuken enters the interiors of houses where we now see naked couples, both hetero- and homosexual, embracing and copulating. This is finally concluded by a sequence where he films birds landing and flying away from the water, in such a way that the camera literally swoops and dives, and whose sheer physicality has been anticipated by the whip pans used in the orchestral sequence.

Figure 7: Young couple.

In a set of extremely bold formal moves Van der Keuken has made connections between eroticism, as represented in art and as experienced by the human self in the face of the other, and the felt sense of movement experienced by the birds. Van der Keuken's reference to the pre-existing and coexistent presence of motor-sensory habits within other animates serves as a further reminder that human intentionality is rooted in and contiguous with other forms of intentionality in the animal world.

Nevertheless, I also argue that Van der Keuken's account of continuity between culture and nature should not be conflated with more extreme forms of biological determinism associated with sociobiology and gene replication. It is here that the work of art scholar Ellen Dissanayake is useful. Dissanayake's work, which sees art as rooted deep within human evolutionary history rather than as a recent western phenomenon of parochial origin in the last two centuries, makes clear associations between animal play and what she describes as the making of something 'special' that defines art and ritual. But she also is keen to emphasize a form of 'bracketing' that is part of a human capacity to differentiate 'between an order, realm, mood, or state of being that is mundane, ordinary, or "natural", and one that is unusual, extra-ordinary, or "super-natural"'(1995: 49). Her ideas about making things 'special' as well as our capacity to take life seriously through the medium of art can be extended to a more general human capacity to rise above the contingencies of biological survival without neglecting our sense of awe at our shared animal heritage, which is indeed compatible with Deely's own conclusions in his recent work, where, most unfashionably, he speaks of truth and our capacity to distinguish it from falsehood. He tells us the following:

> Reality within our own experience does not become what it is without our own involvement in giving a shape and structure relative not only to our own bodies and heritage in biology, but relative also to our understanding of the hard core realities uncovered in their evolutionary structures and possibilities in the physical universe surrounding us near and far, and relative to our ideas of the good that is possible for human beings to reach. (Deely 2007: 202)

This is what is suggested by the film itself when the sequence of birds flying upon water is immediately followed by shots of the motorcyclist travelling through the roads of Amsterdam.

The cyclist expresses the following, which is also intended to be of general human application: 'Can I criticize life? What do I think of life? It's what you make of it and others around you. Take it as it is. One time it's hard, the next it's easier. A cliché really. Who doesn't think that'. It can also be noted that the last shot of the film, which might otherwise be seen as an example of semiotics in a purely formal sense, consists of a zoom out from the cyclist that reveals a traffic sign with two arrows pointing in opposite directions. This suggests an openness to experience, but also a set of responsibilities and ideals that develop over time, whereby we must make choices in order to define who we are and what we stand for. This can

Figure 8: Motorcyclist.

also be seen as indicative of Van der Keuken's overall vision, which insists on our growing moral commitments to the people we know and the places from which we have been borne forth. This is an account of individual human commitment that is emotive, temporal and embodied, yet situated within the wider context of global mobility.

References

Archer, Margaret (2003), *Structure, Agency and the Internal Conversation*, Cambridge: Cambridge University Press.

Augé, Marc (1995), *Non Places: Introduction to an Anthropology of Supermodernity*, London: Verso.

Brier, Soren (2007), *Cybersemiotics: Why Information is Not Enough*, Toronto: Toronto University Press.

Castells, Manuel (2009), *The Rise of the Networked Society*, Oxford: Wiley-Blackwell.

Christie, Ian and Taylor, Richard (eds) (1988), *The Film Factory: Russian and Soviet Cinema in Documents*, London: Routledge.

Colapietro, Vincent M. (1989), *Peirce's Approach to the Self: A Semiotic Perspective on Human Subjectivity*, Albany: SUNY Press.

Daney, Serge (1978), 'La Radiation Cruelle de ce qui est', *Cahiers du Cinéma*, pp. 290–291, pp. 68–72.

Darwin, Charles ([1871] 2005), *The Expression of the Emotions in Man and Animals*, Stilwell, KS: Digireads.com Publishing.

Deely, John (2002), *What Distinguishes Human Understanding?*, Indiana: St.Augustine's Press.

—— (2007), *Intentionality and Semiotics*, Chicago: University of Scanlon Press.

Dissanayake, Ellen (1995), *Homo Aestheticus: Where Art comes from and Why*, Seattle: University of Washington Press.

Elsaesser, Thomas (2005), *European Cinema*, Amsterdam: Amsterdam University Press.

Hoffmeyer, Jesper (1996), *Signs of Meaning in the Universe*, Bloomington: Indiana University Press.

—— (2008), *Biosemiotics: An Examination into the Signs of Life and the Life of Signs*, Chicago: University of Scanlon Press.

Houser, Nathan and Kloesel, Christian J.W. (eds) (1992), *The Essential Peirce Volume 1*, Bloomington: Indiana University Press.

McLuhan, Marshall (1969), 'The Interview', <http://www.mcluhanmedia.com/m_mcl_inter_pb_01.html>. Accessed 17 November 2009.

—— (2001), *Understanding Media*, London: Routledge.

MacDougall, David (1998), *Transcultural Cinema*, Oxford: Princeton University Press.

—— (2006), *Corporeal Cinema: Film, Ethnography and the Senses*, Oxford: Princeton University Press.

Nichols, Bill (1991), *Representing Reality: Issues and Concepts in Documentary*, Bloomington: Indiana Press.

Petrilli , Susan and Ponzio, Augusto (eds) (2005), *Semiotics Unbounded: Interpretive Routes Through the Open Network of Signs,* Toronto: University of Toronto Press

Prigogine, Ilya (1984), *Order out of Chaos*, London: William Heinemann Ltd.

Toubiana,Serge (1997), 'Le Monde au fil de l'eau. Entretien avec Johann Van der Keuken,' *Cahiers du Cinéma*, no. 517, pp. 44–55.

Urry, John (2000), *Sociology Beyond Societies: Mobilities for the Twenty-first Century*, London: Routledge.

—— (2007), *Mobilities*, Cambridge: Polity.

Van der Keuken, Johann (1998), *Aventures d'un regard*, Paris: *Cahiers du Cinéma*.

Winston, Brian (2001), 'Lies, Damn Lies and Documentaries', London: BFI.

—— (2008), *Claiming the Real*, London: BFI.

Notes

1. This and other quotations from Van der Keuken's own book are my own translation from the French.
2. This is extracted from an interview between Van der Keuken and Serge Toubiana, which I have translated into English from the original French. Other quotations from the same text are also my own translation.

Chapter 9

From Maps of 'Progress' to Crime Maps (and back again?): The Plasticity of the Aerial Shot in Mexican Urban Film

Celia Dunne

Narrative cinema tends to situate the spectator at the heart of the action, alongside characters as they move through space at ground level. This perspective lends itself to the spectator's assimilation of the cinematic world on similar terms to his or her everyday existence, leading in turn to an intensified sense of involvement in the film's events. By contrast, aerial shooting offers an alternative, rarely seen vision of space, one that, in some ways, clearly resembles cartographic representation (in terms of its apparent orderliness and objectivity). Certainly, as Michel de Certeau points out in his account of the view from the summit of the World Trade Center in New York, a top-down perspective provides the beholder with a greater feeling of mastery over the landscape; 'the bewitching world by which one was "possessed"' is transformed 'into a text that lies before one's eyes' and 'allows one to read it, to be a solar Eye, looking down like a god' (1988: 92).

The directors of the two Mexican urban films I will analyse here play on this heightened sense of mastery, interspersing short sequences of aerial footage with the main narrative action (shot on the ground) in order to promote particular conceptions of Mexico City. In *El hombre de papel/The Paper Man* (1963), Ismael Rodríguez seeks to nuance the official determination of the capital's post-Revolutionary modernization as a runaway success. Meanwhile, Fermín Gómez, in his first feature, *Don de Dios/Gift from God* (2005), recurs to aerial shots in order to reinforce the dominant perception of one of Mexico City's working-class neighbourhoods as the site of recalcitrant criminality. I will suggest, however, that notwithstanding Gómez's intentions, these shots, like those in *El hombre de papel*, operate as a kind of counter-cartography, by highlighting the inequalities Saskia Sassen affirms are inherent in the fabric of so-called global cities (2001). Ultimately, this chapter interrogates the plasticity of the aerial shot – its efficacy in communicating these directors' conflicting agendas – and puts forward a case for its capacity, albeit not by design, to convey concurrently messages that are strikingly dissimilar.

El hombre de papel depicts the efforts of mute scrap-paper scavenger Adán to mitigate his social alienation by adopting or engendering a child. The protagonist's goal seems to become more attainable halfway through the film when he realizes that a wallet he has recovered from a bin contains a ten thousand-peso note.[1] Yet, any illusions that this spending power might allow Adán to form a family are soon extinguished. Indeed, the discovery only serves to increase his isolation, as both dishonest strangers and his covetous friends try to con him out of the cash.

Made in 1963 and set in Mexico City, the film is inextricably bound up with the results of nearly two decades of intense import-substitution industrialization during the presidencies

of Manuel Ávila Camacho, Miguel Alemán Valdés and Adolfo Ruiz Cortines. Each of these leaders governed under the aegis of the PRI (the Institutional Revolutionary Party), which, as its name suggests, positioned itself as the inheritor of Mexico's socialist Revolution. In theory, all three Presidents were committed to achieving the twin goals of national development and social justice, yet the 'progress' they propagated between 1940 and 1958 was, in fact, of an undeniably free-market bent.[2]

Aerial shots are relatively uncommon in Golden Age[3] Mexican cinema, but where they do appear they usually work to promote this 'progress', most often alongside crane shots in establishing sequences representing modernist landmarks.[4] State film funding through the Cinematographic Bank, which was founded in 1942 (García Riera 1998: 123; Noble 2005: 16), ensured that filmic output at this juncture largely reflected the epoch's rhetoric of optimism, despite the growing numbers of urban poor. The poverty of Mexico's masses was recognized on-screen, but it was almost always construed as a virtue in melodramas designed to provide working-class audiences with emotional relief.[5]

In many ways, Rodríguez's 1947 box office hit *Nosotros los pobres/ We the Poor* exemplifies this formulaic, sentimentalized genre. Its final scenes, for instance, portray the punishments meted out to the characters that have pursued dishonest financial gain, and the wedding and baby granted as a reward to the protagonists who have borne patiently their meagre lot in life. However, this earlier film also anticipates Rodríguez's refusal, in *El hombre de papel*, to subscribe wholeheartedly to the myth of an ideal modernity. The lumpenproletarians housed in *Nosotros los pobre*'s downtown tenement fail even to identify, let alone access, the fundaments of the cultural capital required for social mobility. The film begins, for example, with a pair of scruffy children discovering an equally tatty-looking book in a roadside bin. Having consumed the book's pictorial narrative, which coincides with the plot of the film, the children toss it back onto the rubbish heap, a complicitous shake of their heads signalling either their disgust at the condescension of the final message of learning through suffering, or their disengagement with the notion of leaning altogether.

Similarly, for *El hombre de papel*'s illiterate protagonist, newspapers have a purely material value; they are exchangeable, in sufficient quantities, for a modest income. Hence, in the film's first ground-level scene, Adán disregards the sheets of printed information that might teach him about his surroundings, becoming captivated, instead, by a broken mechanical toy. As he delights in the limbless doll that cries when inverted (an apparent surrogate for the child he does not possess), Adán neglects his dog long enough for it to be run over and killed by the traffic coursing behind him. The scene can be read as self-reflexive. Adán, like the urban hoards turned cinema-going public, is distracted from the tools that would equip him for a critical engagement with modernity by an apparently marvellous, though actually relatively straightforward, technology, which promises to fulfil his utmost desire but finally renders him worse off.

Having thus implied his disdain for cinema's collusion to guarantee the poor's compliance with the state's programme of capital-intensive investment, Rodríguez sets about articulating this policy's contradictory outcomes. Within this contestatory vision of urban expansion,

on-the-ground shots serve to illuminate the realities of disenfranchisement, whilst aerial shots point to its causes. The first aerial sequence, for example, starts with a sweeping shot of Adán's *ciudad perdida*, one of thousands of squatter communities that sprang up at the fringes of Mexico City proper as rural migrants arrived to search for work in a capital with a severe shortage of affordable housing. The camera takes in what at first appears to be wasteland, its dusty, uneven surface seemingly populated only by sparse vegetation. Gradually, however, in a shot that lasts thirteen seconds, the movement of flocks of birds towards the horizon draws our attention to the presence of clusters of squalid, self-built dwellings at the top of the frame. The camera cuts away from the *ciudad perdida* to another aerial shot of similar length. This time the landscape captured is densely packed with buildings. Nonetheless, a sense of order and legibility prevails here, created by the architecture's even geometry and the visibility of a grid system (the remnants of the colonial *traza*). It is immediately obvious to the initiated viewer that the camera has relocated to the very heart of Mexico City. Indeed, the shot culminates with the camera hovering over the Zócalo, [6] the capital's central square and, like the grid system, still idealized as a symbol of its civility, in spite of its associations historically with conquest and latterly with contestation (political demonstrations and protest camps).

Such visually jarring shifts, within a single sequence, between Mexico City's periphery and its centre are re-enacted throughout *El hombre de papel*. Later, for instance, Adán's *ciudad perdida* is replaced suddenly as an object of the viewer's gaze by the Le Corbusier-inspired Nonoalco Tlatelolco housing project (inaugurated between 1958 and 1962), the recognizability and geometric regularity of the latter contrasting starkly with the anonymity and asymmetry of the shack Adán occupies. This constant to-ing and fro-ing knits together two spaces that are geographically separate and, as a consequence, frequently conceptually segregated. The viewer is afforded optical access to the two spaces in rapid succession, a somatically impossible experience that reveals a causal nexus that has hitherto been obscured or, perhaps more accurately, obfuscated. In this way, Rodríguez impels us to trace Adán's inability to thrive in the spaces of modernity back to his rootedness in a *ciudad perdida* and to the allegedly rural 'backwardness' that persists there (figured by the protagonist's double exclusion from language via illiteracy and aphasia). Aerial shots, then, become the vehicle for Rodríguez's provision of a more complete picture of Mexico's industrialization and, on the basis of this new presentation of facts, his challenge to the exclusionary social order.

Utterly at odds with iconic cinematographer Gabriel Figueroa's aesthetically pleasing, art-referential[7] aerial shots in *El hombre de papel* is the crude aerial footage that punctuates the narrative in *Don de Dios*. Gómez's chief concern in this moralistic film is to draw our attention to the operation of organized crime in Tepito, a resolutely proletarian neighbourhood at the centre of Mexico City, just blocks away from the Zócalo. Although from the outset it is clear that the protagonists Jorge and José Luis are involved in serious criminal activity, the latter, at least, is portrayed as an essentially decent young man. Indeed, the tragedy of the film's denouement derives from his powerlessness to escape the delinquency ubiquitous in the neighbourhood in order to provide an honest living for his family. Embodying this

lawlessness is Reyes, the local gangland boss. It is Reyes's decision to abandon Jorge to his fate when he is arrested during an armed robbery and sentenced to a lengthy jail term that sets in motion the film's principal events. Embittered and eager for revenge, Jorge teams up with a secondary corrupting force, the crooked leader of a mainstream political party, in a battle to win from Reyes control over the drugs trade in Tepito. José Luis sides with Reyes after Jorge's goons murder his father and pregnant wife, and tit-for-tat killings ensue until eventually the former partners in crime execute each other on a flat roof overlooking the neighbourhood that, it is suggested, both nurtured and strangled them.

Mexican cinema's powerful role in the 1940s to 1960s, reflecting back to its inhabitants and hence legitimizing a particular account of the cityscape, doubtless belongs, at the start of the twenty-first century, to television. Gómez's decision to include aerial sequences taken from televised news reports in *Don de Dios* seems to have been motivated, to an extent, by financial constraints: the film was produced on a low budget for a primarily domestic audience.[8] The use of the putatively documentary footage is also calculated to lend authority to the frequently simplistic versions of events represented in the film's fictional elements, by gesturing to their place within a wider social context, although this is not explored at all. In addition, however, the wholesale extraction of footage from news bulletins aligns *Don de Dios* with the tabloidized media's semanticization of the real neighbourhood that is the locus of the film's action.[9] This connection is reinforced by Televisa's ownership of the film's distributor, Videocine, since Televisa (Latin America's second largest media conglomerate) is arguably Mexico's most prolific broadcaster of tabloidized news: both as part of routine bulletins and within specialized formats such as *Fuera de la ley/Outside the Law* and *Duro y directo/Tough and Direct*.[10] Certainly, Televisa's own film production company, Televicine, has a track record for making 'aggressive urban films in registers that range from the salvageable to the pathetic and ridiculous' (Aviña 2004: 120 [my translation]).

It is important to note that Tepito, which, along with its immediate environs makes up Mexico City's 'Colonia Morelos', does, in fact, have one of the capital's highest crime rates. Nonetheless, its average of 3.6 crimes per day in the first six months of 2009, for instance – an official statistic that earned it tenth place in the list of most criminal neighbourhoods – is considerably lower than the 16.5 crimes recorded for the nearby 'Colonia Centro' or the 5.7 for the mainly middle-class 'Colonia Roma' (La Dirección General de Política y Estadística Criminal 2009). Furthermore, television news coverage of this crime is highly suspect. Crucially, attention to facts has been replaced with sensationalist presentational devices. No distinction is made between petty and organized crimes (the official statistics cover everything from bicycle theft and vandalism to murder and rape), and an engagement with the underlying causes of crime is lacking. Instead, what David Altheide terms the entertainment emphasis has become the habitual format of these reports; overwhelmingly, they are 'visual, brief, action-oriented, and dramatic' (1997: 652). This format lends itself to communicating complex events within Altheide's 'problem frame' (1997: 653), which is facile in its reliance on putatively universal 'moral truths and understanding' and on discourses of fear that, in part, it has helped to produce (1997: 654–655).

In the nearly two minutes that elapse from the end of *Don de Dios*'s titles to the protagonists' first appearance, news footage (mostly aerial shots) is combined with staged action filmed on-the-ground to generate a fast-moving montage that illustrates the narrator's spoken prologue. The staged scenes display some of the crimes perpetrated on Tepito's streets: drug dealing, piracy and kidnapping. One of the short clips, depicting the kidnap of Jorge's sister, will be repeated later on as part of the main narrative. The other two are merely a means of communicating events that are purportedly real (and what is more, pervasive) and yet cannot be readily filmed. Similarly, the news footage presents us with images of the official response to Tepito's criminality, rather than images of the wrongdoing itself. Four of the six aerial takes, each of which lasts between two and ten seconds, show large quantities of heavily armed police advancing on the neighbourhood, on foot, on horseback and alongside an armoured vehicle. The other two aerial shots in the sequence indicate the reasons for this ellipsis. Like the opening sequence of *El hombre de papel*, these shots offer us a bird's-eye view of a portion of Mexico City's centre. The same structural density is perceptible in footage from both films, but in *Don de Dios*, it is undomesticated by urban planning. Moreover, the paradigmatic signs of polity that the Zócalo and the grid system might be considered to constitute are pointedly absent here. Instead, permanent and temporary constructions fill every available space, including public thoroughfares. Indeed, in the second of the two shots, the camera zooms away from a small patch of tarmac to reveal it is the only part of the street that is visible from above. The shots stress Tepito's impenetrability, suggesting the difficulty of transiting the neighbourhood at ground level and proving the impossibility of surveilling it from the air.

Gómez thus furnishes viewers with a perspective that produces division, positioning them on the side of the authorities by dint of their disconnection from an on-the-ground experience of the neighbourhood. This breach is widened via the footage's explanatory lacunae, that is, its failure to provide any visual clues as to why Tepito's inhabitants might commit the crimes detailed in the prologue and main narrative, for example, markers of social and/or economic marginality. In their original, mediatic context, the aerial shots inserted into *Don de Dios* manipulate this sense of the otherness of Tepito's residents to induce fear in the law-abiding majority and to justify a particular crime-fighting strategy, which might otherwise be questioned or even rejected, on the basis of its dubious respect for human rights.[11] Gómez seeks to import a similar atmosphere of nebulous threat into his film, in order to vindicate his portrayal of Tepito's all-encompassing criminality. Likewise, he disavows the non-criminal ways of life that exist in Tepito, neglecting to acknowledge the diversity of lawful occupations practiced by Tepito's inhabitants that are amply evidenced elsewhere, for instance, in the portraits taken by photographer Francisco Mata as part of the series *Tepito, ¡bravo el barrio!* (2006).[12]

Whereas Rodríguez imbues his criticism of modernity with ambiguity, via the aestheticism of shots of modernist landmarks and the introduction of a potential girlfriend for Adán in *El hombre de papel*'s final moments, Gómez's representation of Tepito as a deviant locale is, then, entirely unnuanced. An unexpected by-product of *Don de Dios*'s removal from sight of those who are able to operate successfully within the formal economy is the heightened visibility of those who are not. This emphasizes the systemic inequalities brought forth in the course

of Mexico City's ongoing reconfiguration into a global city, defined by Christof Parnreiter as a 'nodal place where the flows of capital, information, commodities, and migrants intersect and from which they are directed' (2002: 146). For Parnreiter, there can be no doubt that Mexico City has become the key 'pivot between the Mexican and the global economy' (2002: 147) thanks to the intensification in the implantation of neo-liberal economics in Mexico after the catastrophic debt crisis in 1982. Recovery, from this and later financial emergencies, has 'happened at the expense of most of the city's inhabitants' (2002: 164), who, faced with rising income and labour market inequity (2002: 152–153), have turned increasingly to informality.

Regardless of Gómez's aim, with *Don de Dios*, to concretize the predominant impression of Tepito as criminal, the film's aerial shots can, in fact, be understood to contribute to a more accurate rendering of the neighbourhood as a victim of the uneven course of 'progress' in Mexico City. As is true with *El hombre de papel*, the 'progress' mapped is not the idealized sort Mexican politicians might wish to promote, for example, the scientific and technological development the capital's current mayor, Marcelo Ebrard, recently expounded as the solution to the capital's growing environmental problems (Notimex 2009). Rather, it is a more equivocal 'progress', often entailing the deterioration in many citizens' circumstances, as those of some improve.

Rodríguez's reliance on the aerial shot, in *El hombre de papel*, to overcome the problem of Mexico City's scale validates Michel de Certeau's designation of this perspective as epiphanic, as one that affords viewers an enlarged field of vision and, as such, greater power over the space around them. For Rodríguez, this mode of filming functions as both an economy of means for the narration of place and an ideological instrument; by signalling the peripheral *ciudad perdida*'s connection with the rest of the capital, it provides the former with a cartographic identity and, thus, a political presence. Ideology is at play in Gómez's *Don de Dios*, too. Here, however, the aerial shot is not geared towards the empowerment of the spectator (his or her liberation from optical restraints), but rather is designed to reinforce the verticality of power by offering a glimpse of policing visuality. The divergent intentions behind each director's use of aerial shooting is reflected in the form this takes in each film: the abstractive beam-effect shots in *Don de Dios* contrast with *El hombre de papel*'s inclusive panoramas, working to alienate the viewer from the landscape pictured and thus promote fear. The artlessness of the aerial footage in *Don de Dios* is calculated to add authenticity to the version of Tepito presented; it purports to be unmediated, unlike Figueroa's shots in *El hombre de papel*, which bear the hallmarks of careful composition. Yet for the critical viewer at least, this crudeness is clearly an affectation – a rhetoric the producers of tabloidized news consider appropriate for the subject matter. Similarly, *Don de Dios*'s relentless focus on Tepito's criminality is open to be interpreted according to a different logic to that intended by Gómez; it is a focus that can also bring to the fore the existence of social and economic inequalities in the fabric of Mexico City. The plasticity of the aerial shot in Mexican urban film, then, derives from its capacity to both augment and limit knowledge about a particular locale, but this knowledge is not always convincing or, indeed, controllable; the characteristics that ensure the aerial shot's pliability also guarantee its slipperiness.

References

Aguilar Camín, Héctor and Meyer, Lorenzo (1993), *In the Shadow of the Mexican Revolution: Contemporary Mexican History, 1910–1989* (trans. Luis Alberto Fierro), Austin, TX: University of Texas Press.

Altheide, David L. (1997), 'The News Media, the Problem Frame, and the Production of Fear', *The Sociological Quarterly*, 38:4 (Autumn), pp. 647–668.

Aviña, Rafael (2004), *Una mirada insólita: Temas y géneros del cine mexicano*, Mexico City: CONACULTA/Oceano.

De Certeau, Michel (1988), *The Practice of Everyday Life, Volume 1* (trans. Steven Rendall), Berkeley, CA: University of California Press.

Doremus, Anne T. (2001), *Culture, Politics, and National Identity in Mexican Literature and Film, 1929–1952*, New York, NY: Peter Lang.

García Riera, Emilio (1998), *Breve historia del cine mexicano: Primer siglo (1897–1997)*, Mexico City: Ediciones MAPA.

Gómez Lara, Fermín (2005), *Don de Dios*, Mexico City: VideoCine.

Hallin, Daniel C. (2000), 'La nota roja: Popular Journalism and the Transition to Democracy in Mexico', in C. Sparks and J. Tulloch (eds), *Tabloid Tales: Global Debates Over Media Standards*, Oxford and Landham, MD: Rowman and Littlefield.

Isbister, John (1971), 'Urban Employment and Wages in a Developing Economy: The Case of Mexico', *Economic Development and Cultural Change*, 20:1 (October), pp. 24–46.

La Dirección General de Política y Estadística Criminal, La Procuraduría General de Justicia del DF (2009), 'Informe estadístico delictiva en el Distrito Federal en el mes de enero – junio de 2009', http://www.pgjdf.gob.mx/temas/1-3-1/fuentes/09.pdf. Accessed 14 September 2009.

Mata, Francisco (2008), *Tepito, ¡bravo el barrio!*, Mexico City: Trilce and Océano.

Monsiváis, Carlos (1995), 'Mythologies', in Paulo Antonio Paranaguá (ed.), *Mexican Cinema*, Lonon and Mexico City: BFI/IMCINE, pp. 117–127.

—— (2006), 'Triple salto mortal de los acróbatas de la memoria: La red de protección es el olvido', in Francis detto Alÿs and Carlos Monsiváis (eds), *El Centro Histórico de la Ciudad de México*, Madrid: Turner, pp. 105–106.

Noble, Andrea (2005), *Mexican National Cinema*, London and New York, NY: Routledge.

Notimex (2003), 'Terminan de grabar su don', *El Siglo de Torreón*, 10 August, http://www.elsiglodetorreon. com.mx/noticia/44023.terminan-de-grabar-su-don.html. Accessed 4 September 2009.

—— (2009), 'Apoyo a la ciencia se acelerará: Ebrard', *El Universal*, 5 October, http://www.eluniversal. com.mx/ciudad/97877.html. Accessed 2 November 2009.

Paranaguá, Paulo Antonio (1995), 'Ten Reasons to Love or Hate Mexican Cinema', in Paulo Antonio Paranaguá (ed.), *Mexican Cinema*, Lonon and Mexico City: BFI/IMCINE, pp. 1–13.

Parnreiter, Christof (2002), 'Mexico: The Making of a Global City', in Saskia Sassen (ed.), *Global Networks, Linked Cities*, New York, NY and London: Routledge, pp. 145–182.

Pineda, Georgina (2008), 'Ortega toleró abusos en las expropiaciones, insiste CDHDF', *Milenio*, 16 November, http://impreso.milenio.com/node/7143557. Accessed 4 September 2009.

Ponce, Ramón (2005), 'Vivir y morir en Tepito', *El Gráfico*, 25 October, http://www.eluniversal.com. mx/grafico/41243_4.html. Accessed 4 September 2009.

Ramírez Berg, Charles (1992), *Cinema of Solitude: A Critical Study of Mexican Film, 1967–1983*, Austin, TX: University of Texas Press.

Rodríguez, Ismael (1947), *Nosotros los pobres*, Mexico City: Rodríguez Hermanos.

—— (1954), *Maldita ciudad*, Mexico City: Rodríguez Hermanos.

—— (1963), *El hombre de papel*, Mexico City: Rodríguez Hermanos.

Rosales Ayala, S. Héctor (1991), *Tepito ¿barrio vivo?*, Cuernavaca: UNAM/Centro Regional de Investigaciones Multidisciplinarias.

Sassen, Saskia (2001), *The Global City: New York, London, Tokyo*, Princeton, NJ and Oxford: Princeton University Press.

Segre, Erica (2001), 'Reframing the City: Images of Displacement in Mexican Urban Films of the 1940s and 1950s', *Journal of Latin American Cultural Studies*, 10:2, pp. 205–222.

Notes

1. A considerable sum; in 1960 the minimum weekly wage in Mexico City was 91 pesos, rising to 151 pesos in 1964 (Isbister 1971: 38).
2. For an excellent overview of the Mexican Revolution and the economic and political course plotted by post-Revolutionary governments up to the end of the 1980s, see Aguilar Camín and Meyer (1993).
3. The chronology of Mexico's cinematic Golden Age is disputed. Charles Ramírez Berg affirms its occurrence between 1946 and 1961 (1992: 5). Paulo Antonio Paranaguá describes the period from 1937 to 1946 as an 'industrial apogee with fixed codes and genres' and the years 1947 to 1964 as an 'industrial decadence and the regressive repetition of old formulae' (1995: 13). Andrea Noble cites the assertions of both Carl J. Mora and Carlos Monsiváis that the Golden Age coincided with Miguel Alemán's presidential term (1946–1952), whilst Emilio García Riera observes sceptically that, 'if the epoch existed at all, it was during the years of the Second World War' [my translation] (1998: 120).
4. See, for example, Rodríguez's earlier film, *Maldita ciudad* (1954).
5. Various critics, including Carlos Monsiváis (1995: 124), Erica Segre (2001: 210) and Anne T. Doremus (2001: 4), have noted the cathartic role of these melodramas.
6. Officially, Mexico City's main square has been called la Plaza de la Constitución since 1813; its nickname derives from the pedestal (*zócalo*) that was constructed at its centre in 1843 (but stood empty until its removal in the early 1920s) (Monsiváis 2006: 105).
7. Erica Segre observes echoes of the work of acclaimed photographers such as Nacho López and Manuel Álvarez Bravo in *El hombe de papel*'s cinematography (2001: 206, 219).
8. The film's minimal budget was a prominent aspect of press coverage, including interviews with the director, both at the time of *Don de Dios*'s production (2003) and when it was released (2005). See, for example, Notimex (2003) and Ponce (2005).
9. Since the early 1970s, media coverage of Tepito has been characterized by 'astonishment at the poverty, the "subhuman" conditions, the violence, the cruelty, the neglect' allegedly in evidence in the neighbourhood (Rosales Ayala 1991: 110 [my translation]).
10. See Hallin (2000) for a detailed description of the development of this media phenomenon (including the role played by Televisa's main competitor, TV Azteca).
11. See, for example, Pineda (2008).
12. That Mata intends his project to be read as a corrective to negative conceptions of Tepito is clear from the wordplay of its title, which puns on the multiple meanings of *bravo* (able to be understood as a congratulatory interjection as well as an adjective signifying both savage and courageous).

Chapter 10

Night on Earth, Urban Wayfinding and Everyday Life

Andrew Otway

S ince the beginnings of film in the nineteenth century there has been a strong link between film and cities. Mark Shiel says: 'the cinema has long had a striking and distinctive ability to capture and express the special complexity, diversity and social dynamism of the city through *mise-en-scène*, location filming, lighting, cinematography and editing [...]' and he goes on to mention '[...] the curious and telling correlation between the mobility and visual and aural sensations of the city and the mobility and visual and aural sensations of the cinema' (Shiel and Fitzmaurice 2001: 1). There is also a link between film and driving: Iain Borden points out that in driving '[...] the landscape appears in cinematic terms – notably those of framing, sequencing, editing [...] changing pace, unexplained events and sights and so on, all of which is induced by the speeding, kinematic nature of driving' (Borden 2010: 108–109). This chapter looks at the film *Night on Earth* (USA 1991), a film about driving taxis in cities, and shows how it illustrates three things:

1. The opposition between the notions of modern, scientific map-reading and 'wayfinding'.
2. How 'wayfinding' relates to narrative and to the way in which film uses narrative.
3. The connection between two previously neglected notions: that of 'wayfinding' itself and that of everyday life, or 'la vie quotidienne'.

Before I discuss *Night on Earth* and its director Jim Jarmusch, I will briefly give some background on these three points and explain my terms.

1. Modern map-reading and 'wayfinding'

The history of navigation has been adversely influenced by a reductionist scientific world-view that prioritizes the abstract and the visual in the distancing techniques of modern scientific map-making and map-using. To oppose this, Ingold examines in *The Perception of the Environment* (Ingold 2000) an alternative notion of the map in terms of a kind of navigation he calls 'wayfinding', which is both more complex and experientially richer than the familiar methods of post-Enlightenment scientific navigation. Physically finding one's way, which involves finding one's present position and then moving from one place to another, is not performed in reality by moving between abstract spatial points. Ingold argues that the cognitive maps (see Hubbard 2006: 30–31) that we believe we carry around

with us and that we think we can access at any time do not actually exist. He believes that this is because places do not have locations as such but they have histories. One starts by positioning oneself in relation to one's latest movements in an actual and continuously forming narrative of all the journeys one has made as well as those known to have been made by others. He explains:

> Bound together by the itineraries of their inhabitants, places exist not in space but as nodes in a matrix of movement. I shall call this matrix a 'region'. It is the knowledge of the region, and with it the ability to situate one's current position within the historical context of journeys previously made – journeys to, from and around places – that distinguishes the countryman from the stranger. (Ingold 2000: 219)

He goes on to say that what he refers to as 'ordinary wayfinding' 'more closely resembles storytelling than map-using' (Ingold 2000: 219). Wayfinding is a kind of knowledge. He also distinguishes mapping from map-making:

> For the designs to which mapping gives rise – including what have been variously categorized as 'native maps' and 'sketch maps' – are not so much representations of space as condensed histories. Thus, to put my thesis in a nutshell, knowing is like mapping, not because knowledge is like a map, but because the products of mapping (graphic inscriptions), as those of knowing (stories), are fundamentally un-maplike. (Ingold 2000: 220)

Wayfinding then does not work by moving or navigating between pre-existing points as on a conventional map. Wayfinders *feel* their way *through* a constantly changing world, moving within it as it continuously moves and comes into being around us. Different senses are included in the process of wayfinding, including the aural and the haptic as well as the visual.

Different forms of mobility or transportation, such as walking, car, train and aeroplane can be associated with either one or the other of these opposing poles of wayfinding and navigation, or with a position in between them. Air and rail travel, for example, follow regimented time and seem to both cocoon and distance the traveller from the outside world. Car travel and especially walking are more suited to wayfinding and to a greater physical connection with the environment. Drivers familiar with cityscapes, despite the limiting choices of directions dictated by the extent of road systems, do navigate as 'wayfinders' with a ground-level perspective, as opposed to aircraft pilots who navigate with a 'map-reader's' bird's-eye view. Pedestrians are in direct physical contact with their immediate environment but car drivers too are in contact with their environment through the extended prosthetics of the steering wheel, accelerator and brake pedals, etc. They do not have a bird's-eye view of their surroundings. Drivers also, in a way, produce their own narrative reading of the world as presented to them through the frame of the windscreen. In Borden's words:

Through this frame, landscapes become fragmented by driving, rendered into a series of discrete objects, vistas, markings and so on, but also then reconnected and resynthesized as a sequence – a specific narration, if you like, constructed by the particular driver. (Borden 2010: 108)

Taxi drivers are car drivers who earn their living as wayfinders and their experience of wayfinding increases throughout their working life. Even before they begin their employment, to get an all-London Green Badge trainee, London taxi drivers have to learn 320 routes and all the landmarks and places of interest along these routes – basically every street within a six-mile radius of King's Cross. The experienced taxi driver has the 'knowledge' mentioned by Ingold above that separates the stranger from the countryman (or the city man, in this case). Borden describes the wayfinding of a taxi driver thus:

[…] the London cab driver's experience is far from being just about abstract maps and locations; urban driving is about a whole range of related spatial tactics, such as taking short-cuts, merging, doubling back […] and so on […] All of this enables the driver not just to get around the city but to produce themselves as a metropolitan resident […] (Borden 2010: 105)

2. Wayfinding, narrative and narrative in film

Films about car journeys, and especially those set in cities, with their increased experiential complexity, often relate to wayfinding. There have been many films that include taxis and/or taxi driving: *Taxi Driver* (USA 1976); *Escape from New York* (USA 1981) and *Taxi* (France 1998). Some of these could be included in a sub-genre of the 'road' movie. Films about maps, or in which maps play an important part in the plot, include, for example, *The 39 Steps* (Great Britain 1935) and treasure-map films like *Treasure Island* (USA 1950) and *The Goonies* (USA 1985). All these use a map as narrative engine and recall pre-scientific narrative maps that aid wayfinding in a visual narrative form.

Scientific map-making and map-reading ignore the narrative element present in pre-Enlightenment maps, which wayfinding retains. Early maps, such as the medieval Hereford *Mappa Mundi* of circa 1300, often drew on the experience of many different people over long periods of time.[1] In visual form these maps *narrate*. In the last century the situationists were interested in making maps in the wayfinding spirit. They were also interested in cinema. Simon Sadler tells us:

Situationist maps […] declared an intimacy with the city alien to the average street map. The narration to the opening sequence of the film *The Naked City* (USA 1948), an aerial view of lower Manhattan tracking northwards, must have summed up the mood, the penetrating realism and the sense of humanity that Debord and Jorn sought in maps:

'As you can see, we're flying over an island, a city, a particular city, and this is the story of a number of its people, and the story, also, of the city itself […] The city is as it is, hot summer pavements, children at play, the buildings in their naked stone, the people without makeup'. (Sadler 1998: 82)

This describes urban everyday life in New York only a year after Lefebvre's first volume of *Critique of Everyday Life* (1947) was published in France.

Films, as well as spoken stories and novels, contain narrative. We talk of 'reading' a film. The literature and films of the aesthetic of everyday life make a point about genuinely trying to get closer to everyday lived experience. The more credible and realistic narration of this type of film is closer to the narrative aspect of wayfinding.

3. Wayfinding and everyday life

Certain non-mainstream modern films from the 1960s to the early 1990s can be perceived as part of a predominantly urban philosophy and aesthetic of everyday life, a trans-media phenomenon vital especially to French cultural life from at least the middle of the last century, if we take the first volume of Henri Lefebvre's *Critique of Everyday Life* (Lefebvre [1947] 1991) as part of its origin, or possibly even earlier in some of the work of the French surrealists and Walter Benjamin. This philosophy and aesthetic attempts to atone for a perceived neglect of the everyday within culture by rescuing it from oblivion and highlighting its importance. The everyday concerns the things, events, personal and communal relationships, mobilities and immediate environments that constitute the minutiae of everyone's lives and experience. Lefebvre gives us an example of how the importance of everyday life experience is epitomized in film by referring to Charlie Chaplin:

He comes as a stranger into the familiar world, he wends his way through it, not without wreaking joyful damage. Suddenly he disorientates us, but only to show us what we are when faced with objects; and these objects become suddenly alien, the familiar is no longer familiar […] But via this deviation through disorientation and strangeness, Chaplin reconciles us on a higher level with ourselves, with things and with the humanized world of things. (Lefebvre 1991: 11)

The complex of ideas on everyday life written about, for example, by Henri Lefebvre, Michel de Certeau and Georges Perec has evolved to include such writers in this century as François Maspero, Marc Augé and Jacques Réda and an increasing number of non-French writers such as (to give examples of writers in English) David Inglis (Inglis 2005), John Roberts (Roberts 2006) and Elizabeth Shove (Shove et al. 2007).[2]

We can find a link between this broad notion of everyday life and the notion of wayfinding in de Certeau's *The Practice of Everyday Life* (de Certeau 1984: 91–130). In the section

entitled 'Voyeurs or walkers' he discusses his feeling looking down from the 110th floor of the World Trade Center. He feels like a voyeur, a god, a solar eye, separated from the seething mass of bodies below. This is the pilot's aerial viewpoint, mentioned above, and the walkers 'in mobile and endless labyrinths far below' (de Certeau 1984: 92) are a community of wayfinders with a ground-level view, immersed in the everyday practice of 'walking the city'. These two perspectives represent for him, as for Ingold, polar opposites.[3] De Certeau also sees the ground-level intermingling movements of the city's inhabitants as a kind of unreadable text: 'The networks of these moving, intersecting writings compose a manifold story that has neither author nor spectator, shaped out of fragments of trajectories and alterations of space [...]' (de Certeau 1984: 93).

Before he became a film-maker, Jarmusch, director of the quirky *Night on Earth* was a poet studying at Columbia University. He was shaped by the New York school of poets (which included John Ashbery), who were strongly influenced by the French poetic tradition. During his final student year he spent ten months in Paris (returning in 1976), spending much of that time in the *Cinématèque Française* watching films by Bresson, Dreyer and others. In vogue around that time was *2 ou 3 Choses que Je Sais d'Elle* (France 1967), about which its *auteur*, Goddard, said in a 1967 interview: 'During the course of the film – in its discourse, its discontinuous course, that is – I want to include everything, sport, politics, even groceries [...] Everything can be put into a film. Everything should be put into a film' (Narboni and Milne 1972: 239); everyday life, in other words.

Night on Earth

Night on Earth has much more in common with the type of European films associated with this notion of 'la vie quotidienne' than with the mainstream cinema of Hollywood-dominated North America. It comprises five vignettes, each concerning a taxi journey in five different cities: Los Angeles, New York, Paris, Rome and Helsinki. Like many of his other films, such as *Stranger than Paradise* (USA 1984), *Down by Law* (USA 1986) and *The Limits of Control* (USA 2009), it deals with displaced people trying to find their way to some destination. Each vignette of *Night on Earth* begins at the same real time and ends with a connection traced to the next city on the same world map used in the film's opening sequence.

The film's visual content is juxtaposed to the more haptic and aural content, which includes a mood-enhancing soundtrack by Tom Waits. Shots of mostly empty night-time cities are contrasted with shots of a more complex, human interaction (or inaction) inside the confines of the film's five taxi cabs. The film shows in its five taxi journeys an inherent link or connection between two notions: that of urban wayfinding and that of everyday life. Both the wayfinding rôle of driving a taxi and the very act of taking a taxi ride, which can also involve wayfinding, are both practices of everyday life. The film's five separate narratives are varied, unconventional and apparently directionless. Jarmusch believed that fiction should have no plot, as there is no plot in life. (The term 'plot' is after all a term used in

navigation, and concerns the connecting of points on a map or chart in a scientific manner). I have chosen to focus on only the first three parts of the film because they are more relevant to my arguments than the final two.

Los Angeles

As the title credits begin, we approach the earth in the film's long opening shot. The earth becomes an old-fashioned looking globe marked with the names of countries and cities, and then clouds appear. Then five clocks appear with the names of five different cities, telling the simultaneous time in five different time zones. The first vignette begins in a very shabby-looking Los Angeles, a city that gives up half its surface area to road traffic. An eccentric but earthy Tom Waits' sound track plays. Corky, the taxi driver (Winona Ryder), is taking two wild-looking rockers to the airport. A chance aeroplane sails very low overhead. (Or is it chance?) Meanwhile, at the airport the businesswoman Victoria (Gena Rowlands) strides from her plane towards the terminal and talks into her cell phone. In *Mobilities* Urry says: '[…] air flight affords a god's eye view, a view of the earth from above […] In Ingold's terms, air travel generates "map-readers" rather than "wayfinders" […] While way-finders move around *within* [original emphasis] a world, map-readers move across a surface as imagined from above' (Urry 2007: 153). Victoria represents this attitude of distance and disconnection from life. Corky is more connected to the nitty-gritty of everyday life. On a public telephone at the airport she mentions fixing her own taxi's engine herself. The two meet and Victoria's expensive-looking luggage is dumped into the boot of Corky's scruffy taxi. On the way to their destination in Beverley Hills they chat and make a warm connection despite the interruption from Victoria's cell phone. There are occasional shots of the darkening city streets outside the taxi, but most of the shots are of the (subdued) action inside the taxi. These shots look inwards, using the taxi's windscreen as a frame, reversing the usual view of the driver. The narrative is unconventional and lacks the usual Hollywood-style plot and action. Mood is more important here.

The journey, like the narrative, seems directionless. This is probably aided by the very nature of Los Angeles. Barry Miles, biographer of Charles Bukowski, wrote in 2005:

> There is not one building that you could show in a backdrop that people would instantly recognise as a Los Angeles setting, as you could with New York, London or Paris. The city is not that well known, it is formless, lacking in definition […] In Los Angeles there is no sense of place, the street landscape is so similar from one block to the next that the residents have to devise recognition tricks in order to cope with the long commutes, and an unfamiliar destination can often result in getting lost in the seemingly endless sprawl. (Miles 2005: 8)

Victoria mentions names of streets to Corky. The one element of the plot in the whole vignette concerns Victoria, who is in fact a movie talent scout, trying to persuade Corky

to star in her film. But predictably this plan falls flat: everyday life is not a fairy story with a spectacularly happy ending. However, Corky has the narrative of her own life planned out. She will become a mechanic, marry and have a family. She now shows the strength of a person grounded in reality, and seems a very different and more rounded character. We have witnessed a fairly typical slice of the narrative of her life. She is a wayfinder in her work and in life in general; in the light of this Victoria's life now seems to us to be disconnected from basic everyday reality and to be lived at one remove via her cell phone.

New York

The second vignette begins with a black man, Yoyo (Giancarlo Esposito), trying to get a cab home from Manhattan to Brooklyn. He eventually gets a ride with the former clown Helmut, played by Armin Mueller-Stahl, a newly arrived East German who obviously does not know much English. He does not know the city either or how to drive his automatic-drive taxi. Yoyo soon takes over the driving and begins to initiate the completely naïve Helmut into the rôle of wayfinder and the street-wise ways of his city. As in the previous journey, the two start to talk and to get to know each other. They swap names, backgrounds and jokes. The streets are almost deserted, and again most of the camera shots take place within the cocoon of the cab. Shots taken from outside the taxi have a jazz backing as in the first section. By chance they come across Yoyo's sister-in-law, Angela (Rosie Perez), whom Yoyo physically forces into the taxi as she swears and screams at him. They carry on fighting inside the moving taxi as introductions are made. 'Nice family [...]' says Helmut, but he and Angela begin to get acquainted. Eventually, the two leave Helmut after Yoyo tries to give him directions back to Manhattan, advising ironically, 'Learn English, Helmet!' As Helmut drives off he seems lost in the chaotic traffic at first, but then he catches on to the automatic transmission and starts to look more confident as he peers out through the windscreen wearing his clown's red nose. He marvels in fascination at the bright lights and noise of his new home, and immerses himself in his new rôle of wayfinder as he symbolically takes off his red nose, the mark of his past life. He whispers 'New York, New York [...]'. The New Yorker Paul Auster, who is perhaps the best known North American poet and novelist of everyday life, has commented on this part of the film:

> Unlike most American directors, he has little interest in dialogue per se (hence the so-called European flavour of his work), choosing instead to recount shaggy-dog stories filled with loopy asides, unpredictable digressions, and an intense focus on what is happening at a particular moment [...] Nothing happens, or so little in the way things traditionally happen in stories that we can almost say there is no story. (Auster 2007: 2)

All these are characteristics of an aesthetic of the everyday.

Paris

The setting of the Paris vignette shares with the preceding two uniform scenery and a kind of pervasive night-time monotony and dulling shabbiness. A (nameless) taxi driver from the Ivory Coast picks up a pair of other African men but dumps them in an urban wilderness when they annoy him too much with their insults and teasing. We notice that he, too, like Helmut, is a bad driver. After this contingent false start to the episode, the taxi driver next picks up a beautiful blind woman with a white stick (Béatrice Dalle). In the journal *USA Today* a news article entitled 'When in Paris, shrug as Parisians do', which gives advice to the foreign tourist on returning Parisians' rudeness, quotes a Parisian bank employee: 'The retailers, café and bar waitresses and taxi drivers are the most arrogant and pretentious people' (Sanchez 2007: 13a). But in this vignette the roles seem to be reversed, as they were in the previous one. The passengers, male and female, are all rude to the hapless taxi driver from the start. His new client gives him very detailed directions of the route she wants to take. I believe that she does so because she appreciates the sounds and the feel of this particular route. She is a connoisseur of the haptic sense; she carefully puts on her lipstick by touch in the back seat.

The taxi driver takes a detour through a tunnel under the Seine, thinking that his passenger, being blind, will not notice. The sound of the tunnel alerts the woman to the detour and she complains furiously. The differences between optic perception on the one hand and aural and haptic perception on the other are stressed here. The woman is a wayfinder who uses all the sense input available to her to navigate through the city she knows so intimately. The situation of the driver of a car also applies to passengers to a great extent: '[…] the kinaesthetics of driving involves a substantial reorientation of the experience of time and space, where […] senses, intellect, landscape, meaning, artistic creativity and the human body are all potentially reconfigured' (Borden 2010: 109). The taxi driver at one point asks her what it is like making love when you cannot see, and she answers disdainfully that through her other senses she feels things in lovemaking that he, because he is so hampered by his reliance on sight, could never feel. As she leaves the cab at her destination, the taxi driver gazes after her and we realize these two people belong to two different worlds and that *she* is the more effective wayfinder. Still with his attention on her, the taxi driver pulls away from the roadside and carelessly collides with another car. A loud argument follows, and the woman smiles, walking away.

To conclude: in an interview with Peter Keogh for *Sight and Sound* in 1991 Jarmusch said:

If you think about taking a taxi, it's something insignificant in your daily life; in a film when someone takes a taxi, you see them get in, then there's a cut, then you see them get out. So in a way the content of this film is made up of things that would usually be taken out. (Keogh 1991: 9)

In the concept of wayfinding Ingold has given us a tool to help us rethink the way we both relate to, and move around in, our environment. In the philosophy and aesthetic of everyday life we have tools to help us rethink the way in which we relate to our daily practices, of which wayfinding is one of the most important. Wayfinding – on foot or in a taxi – and the importance of everyday life and its aesthetic are what have been neglected or left out of the 'official' narratives of both cinema and navigation. Through the unlikely heroes and heroines of *Night on Earth* Jarmusch tries to atone for this.

References

Auster, P. (2007), 'Night on Earth: New York – Jim Jarmusch, Poet', <http//:www.criterion.com/current/posts/571-night-on-earth-new-yorkjim-jarmusch-poet>. Accessed 15 July 2010.

Borden, I. (2010), 'Driving', in M. Beaumont and G. Dart (eds), *Restless Cities*, London and New York: Verso, pp. 99–121.

Carpenter, J. (1981), *Escape from New York*, USA: AVCO Embassy Pictures.

De Certeau, M. (1984), *The Practice of Everyday Life* (trans. S. Rendall), Berkeley: University of California Press.

Donner, R. (1985), *The Goonies*, USA: Warner Bros.

Goddard, J. L. (1967), *2 ou 3 choses que je sais d'elle (Two or three things I know about her)*, France: Argos Films.

Haskin, B. (1950), *Treasure Island*, USA: RKO Radio Pictures.

Hitchcock, A. (1935), *The 39 Steps*, Great Britain: Gaumont British.

Hubbard, P. (2006), *City*, London and New York: Routledge.

Ingold, T. (2000), *The Perception of the Environment: Essays on Livelihood, Dwelling and Skill*, London and New York: Routledge.

Inglis, D. (2005), *Culture and Everyday Life*, London and New York: Routledge.

Jarmusch, J. (1991), *Night on Earth*, USA: Locus Solus Inc.

Keogh, P. (1991), '"Home and Away": interview with Jim Jarmusch', *Sight and Sound* 2:4, pp. 8–9.

Lefebvre, H. ([1947] 1991), *Critique of Everyday Life, vol. 1: Introduction* (trans. J. Moore), London and New York: Verso.

Miles, B. (2005), *Charles Bukowski*, London: Virgin Books.

Narboni, J. and Milne, T. (eds) (1972), *Godard on Godard*, London: Secker and Warburg.

Pirès, G. (1998), *Taxi*, France: ARP Sélection.

Roberts, J. (2006), *Philosophizing the Everyday*, London and Ann Arbor: Pluto Press.

Sadler, S. (1998), *The Situationist City*, Cambridge MA: MIT Press.

Sanchez, C. (2007), 'When in Paris, shrug as Parisians do', *USA Today*, 8 January, p. 13a.

Scorsese, M. (1976), *Taxi Driver*, USA: Columbia Pictures.

Sheringham, M. (2006), *Everyday Life: Theories and Practices from Surrealism to the Present*, Oxford: Oxford University Press.

Shiel, M. and Fitzmaurice, T. (eds) (2001), *Cinema and the City: Film and Urban Societies in a Global Context*, Oxford: Blackwell.

Shove, E. et al. (2007), *The Design of Everyday Life*, Oxford: Berg.

Urry, J. (2007), *Mobilities*, Cambridge: Polity Press.

Notes

1. This *Mappa Mundi* is kept in Hereford Cathedral.
2. For an excellent account of everyday life in surrealism, Benjamin, Lefebvre, de Certeau, Perec, Maspero, Augé, Réda and others see Michael Sheringham's important book (Sheringham 2006).
3. De Certeau, however, excludes car drivers from his group of 'ordinary practitioners' (walkers only) who live 'down below' (de Certeau 1984: 93).

Part IV

The Cinematic in the Urban

Chapter 11

Sleepwalking from New York to Miami

Alison Butler

In the winter of 2007, every evening for a month, Doug Aitken's moving image work *Sleepwalkers* was projected onto the exterior walls of the Museum of Modern Art in New York. The project was a collaboration between Aitken, the Museum and Creative Time, a New York-based organization that commissions public art projects. A new, site-specific version of the installation has been commissioned by the Miami Art Museum for the opening of its new facility, designed by Swiss architects Herzog and de Meuron, in 2013. This chapter examines *Sleepwalkers* as a manifestation of the rich tradition of 'urban cinematics' and as an example of the emerging form of public screen art.

Public art is about popularizing art, commemorating events in public life, encouraging expressions of community, recognizing particular communities, provoking and challenging audiences, intervening in public and corporate discourse, revealing the hidden histories of places and uplifting neglected sites. The notion of public art may be inherently contradictory, especially in the US, where the art world can be characterized as intellectually and economically exclusive. Public art can work against this, with populist, activist and oppositional strategies, but it is also often understood in market terms, as civic publicity, tourist attraction and as an incentive to urban renewal. By its nature, public art is uniquely placed to address important issues in the construction of public space, such as the encroaching privatization of space and the consequent decrease in public association. However, it is also an intensely contested field, as Miwon Kwon has pointed out, relying on the notion of the public sphere, which is 'always necessarily an ideal, an idealized construction (fantasy), insofar as it imagines a possibility and potential of overcoming social differences to debate issues of common concern' (Kwon 2005: 30).

Historically, public art has been identified with the construction of monumental and permanent pieces in public space ('big art'), and also with the debates about artistic taste that these have often provoked. Since the 1960s, however, notions such as 'site-specificity' and 'community' have increasingly come to be perceived by artists and curators in this arena as constraints on their activities rather than their core values, and the idea that permanence is a necessary attribute of public art has been challenged by performance pieces and time-based works. Through timed interventions, such as performances, parades, installations and projections, public art contributes to public life as a process rather than public space as a fixed location. This shift in emphasis is consistent with the current mediatization of urban public space. Scott McQuire describes the modern city as a media city: 'a media-architecture complex in which the *mediatised production of urban space* has become a constitutive frame for a new mode of social experience' located in what he calls 'relational space': 'space which

has been stripped of inherent qualities, such as stable dimensions and appearances (and of course stable social meanings), but is increasingly experienced as shifting, variable and contingent' (McQuire 2006). Relational space is an interesting concept, evoking new immaterial forms of connection and interaction, although – as McQuire stresses – these operate in conjunction with, rather than displacing, the material environment and the local contingencies and prerogatives that shape it.

Creative Time has undertaken a number of public art projects using film, video or projected light. Its best-known – and perhaps most telling – work of this type is the memorial *Tribute in Light* (2002), consisting of two beams of light illuminating the night sky above the site formerly occupied by the twin towers on every anniversary of 9/11 since 2002. Reaching beyond the earth's atmosphere, it is arguably, earth's tallest manmade 'structure'. With a lack of critical self-consciousness that would be startling in relation to almost any other moment in recent history, Anne Pasternak, the director of Creative Time, claims that: 'The simple idea of two beams of light, symbolizing knowledge, fortitude, and enlightenment, projected into the heavens was in itself pure power' (Pasternak 2007: 112). *Tribute in Light* shows how the immateriality of the medium makes projected public art particularly, perhaps even definitively, ideological.

The screening of *Sleepwalkers* in New York did not commemorate or celebrate an event, but it does seem in some ways to have been a response to debates about the space in which it was shown. In 2004, the Museum of Modern Art re-opened after an ambitious renovation designed by Japanese architect Yoshio Taniguchi, described in the *Architectural Record* as 'a monumentally scaled, serene series of cubiform volumes and slabs [that] seems to have evolved naturally out of the institution's own architectural unconscious' (Stephens 2005: 95). A poster campaign proclaiming that 'Manhattan is Modern Again!' underscored the intention to retrofit the museum for new times. Although it was widely acclaimed, a more sharply critical minority focused discussion around the institutional contradictions implicitly addressed – and sometimes pointed up – by the renovation, most notably those between public space and private patronage, modernism and the contemporary. Benjamin Buchloh suggests that the building spatializes the institution's internal and external conflicts: 'the museum's architecture and the museum's pedagogical mission now confront extreme contradictions: to be liberal-democratic on the façade and plutocratic in the center' (Buchloh 2005: 142). In a trenchant critique, he argues that MoMA's claim to function as an institution in the bourgeois public sphere is compromised by its engagement with late-capitalist corporate spectacle culture and that this irreconcilable contradiction bears on the experience of the museum's visitors, caught between 'modernism's traditional claim to constitute a self-critical subject determining itself within the spaces of the public sphere, and the actually governing conditions of an oligarchic spectacle-and-entertainment culture within which the viewer's subjectivity has to position itself' (Buchloh 2005: 206).

Criticism of the renovation focused particularly on the question of whether and how the museum connects with the surrounding city. One of the problems with museum architecture is that exhibition spaces require windowless walls, and when the building is situated in a

busy city street, this can have alienating effects on the passers-by. To improve the integration of the museum into the city, a new public lobby connecting West 53rd and 54th Streets was created and the exterior along West 53rd Street was treated with clear, fritted and grey glass. The museum was opened to expansive vistas of the city and the sculpture garden and, through the addition of a large central atrium, internal views from one part of the museum to another were created. Despite these efforts, in 2007 the museum's exterior featured in the Project for Public Space's 'Hall of Shame', where it was described as 'monotonous and impenetrable' with a façade that at no point permits 'any transparency between the sidewalk and the interior'. The sheer black granite wall along 54th Street attracted particular criticism. The authors quote William H. Whyte on the way that blank walls: 'proclaim the power of the institution, the inconsequence of the individual, whom they are clearly meant to put down, if not intimidate' (Project for Public Spaces 2007).

The notion of transparency features prominently in the rhetoric surrounding the renovation. Taniguchi has been widely quoted as saying that if the museum gave him enough money he could make the architecture disappear. Admirers have acclaimed his 'art of transparency' and his mastery of 'light construction'. Transparency has the potential to bridge the gap between the modernist and the contemporary, being arguably as true to the precepts of modernist design as it is appropriate to the virtuality of the digital world. Hal

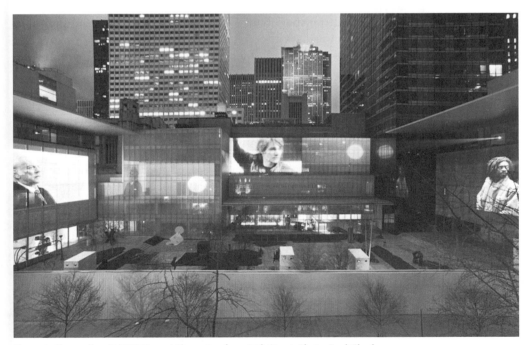

Figure 1: *Sleepwalkers* © 2007 Doug Aitken, view from 54th Street. Photo: Fred Charles

Foster attributes this view to Terry Riley, MoMA's Chief Curator of Architecture at the time, but contends that there is a significant slippage here, between the structural clarity and material integrity of modernist transparency and the phenomenal tricks and light effects of the contemporary (Foster 2005).

A similar slippage takes place in the galleries, where the walls of the classic white cube are recessed at the base, making them appear to float without substance. Robert Campbell comments:

> It looks not like a wall, but like a white projection screen. The paintings on it, as a result, begin to feel like projected images. You are in the placeless, timeless world of the slide lecture. Because the wall doesn't feel real, neither does the artwork. You begin to feel unreal yourself. Architecture has failed to create a place that either the paintings or you can inhabit with a sense of presence. (Campbell 2005: 67)

This 'disembodied media experience' (Campbell 2005: 68) is only one of the ways that the renovated museum appears to register the influence of the culture and economy of consumerism and spectacle: the controversial $20 entrance fee introduced on the museum's re-opening locates the experience in the world of shopping and entertainment, and the shop, restaurant and cafés encourage visitors to make a day of their outing. The large atrium follows the new paradigm of the 'continuous interior', which recent museum architecture shares with shopping malls and transport hubs (Pimlott 2007: 230–239) and corporate sponsorship of free admission on Fridays after 4pm sets the terms on which the museum can be considered as a public space. Instead of a democratic public space, the renovated MoMA offers 'the image or the (private, corporate) dream of an idealized public space where everyone knows how to act' (Message 2006: 69).

The projection of images onto the museum's façade is an extension of the renovation strategy, blurring the boundaries of the building as if in response to criticisms of its apparent impenetrability by showing how, through media technology, any part of the building can become *windowed*. In interviews and press releases, Aitken talks about wanting to fold the museum inside out. He also talks about the work merging with architecture and city space, 'to say that maybe a building can be something other than a solid structure. Maybe it can also be transformative and aesthetically and emotionally fluid. Maybe a high-rise can be a waterfall of moving images and ideas' (Aitken 2007: 156). By using images shot in all five boroughs of New York, the work makes midtown Manhattan a synecdoche for the city, folding the wider city as well as the building's immediate surroundings into the museum.

The imagery of *Sleepwalkers* plays on the aspects of the museum building that have attracted most criticism: its scale, its opacity and its relationship with its environment. Projectors were installed at a number of sites around the museum to show the work from 5 to 10pm in the evening. The images appeared ghostly at twilight, taking on more solid form and brilliant colour as darkness fell. A number of the projectors screened images onto glass rather than opaque surfaces, and this had some interesting effects, including allowing for the

interaction of the images with activity inside the building and the reflection of images from one surface onto another. Some of the effects of the projection resulted from differences in scale between the images and the building, overlaying intimate gestures on upscale architecture, generating a *Land of the Giants* effect as huge limbs and faces appeared on five-storey walls. This produced some playful transformations, such as turning a bathroom shower into a waterfall on the museum façade. Rain and snow sparkling in the projector beam mingled with the image of water pouring in the shower, extending the imagery into the surrounding space. As it is a silent work, the ambient sounds could take on the functions of a soundtrack, occasionally in serendipitous synchronization, as when a screen full of clocks coincided with local church bells ringing.

Sleepwalkers has, what Aitken calls a 'broken screen narrative' distributed across a number of screens (Aitken 2005). It comprises five separate but parallel stories, all thirteen minutes in length, each with one nocturnal character: a businessman (Donald Sutherland), a postal worker (Chan Marshall, a.k.a. Cat Power), an office worker (Tilda Swinton), an electrician (Seu Jorge) and a bicycle messenger (Ryan Donowho). Each character wakes in the evening, gets ready to go out, travels through the city to their place of work, then undergoes a transition from the everyday to an abstracted, dreamlike state in which each gives an ecstatic performance, the businessman dancing on the hood of a taxi, the bicycle messenger drumming on a bucket, the postal worker playing a violin in a concert hall and the electrician making a lasso from an electrical cable and circling it above his head. The five films re-combine across the screens throughout the course of each evening, offering new juxtapositions of the characters in a continual cycle. Because each storyline has the same duration and structure, these re-combinations produce deliberate synchronicities. The characters' occupations stress energy and communications, implying a kind of symbiosis between themselves and the city. The curators describe the work as 'a blueprint for the metropolis as a living, breathing organism fuelled by the desires, energies and ambitions of its inhabitants' (Biensenbach and Eleey 2007).

With its parallels and synchronicities, its quickening rhythms, its temporal structure based on a night in the life the characters, and its themes of electricity, commerce and communications, *Sleepwalkers* joins the tradition of the City Symphony film. But it also combines this with another poetic film genre: the trance film, a mainstay of American experimental cinema since Maya Deren and Alexander Hammid's *Meshes of the Afternoon* (USA, 1943) with roots in the European avant-garde, going back to *Das Cabinet des Dr. Caligari/The Cabinet of Dr Caligari* (Germany, 1920).[1] The trance film is based on the two qualities that have traditionally seemed to distinguish cinema from other arts: movement and a similarity to dream. The motif of the somnambulist is a reflexive figure, responding to the darkness necessary for projection, the hypnagogic reverie of the spectator and the uncanny effects of lifelike human figures without autonomous consciousness. It also implies a subconscious relationship between the city and its inhabitants, perhaps a dream life in the sense that interested Walter Benjamin and Charles Baudelaire. Traversing the city in a waking dream, Aitken's solitary somnambulists reprise one of the key experiences of modernity,

that of the *flanèur* whose trance-like absorption Siegfried Kracauer compared to cinema spectatorship (Gleber 1998: 158). Watching *Sleepwalkers* in mobile reverie, spectators are invited to become somnambulists themselves, circling the museum in a mediatized trance.

MoMA's press materials described the work as 'site-specific cinema, expanded into the urban landscape and keyed to the pedestrian experience' (Biensenbach and Eleey 2007). To take account of the spectators' mobility, Aitken uses only certain aspects of narrativity, those concerned with movement and change, and avoids hermeneutic problems. The narrative structure is simple and archetypal, without enigmas or complex plotting. Spectators were issued with viewing instructions stating that: 'There is no seating in the Sculpture Garden and portable seating is not allowed'. The temperature in New York in the middle of winter was also an incentive for visitors to keep moving.

Walking around the museum, the viewers became editors of the work, sampling and recombining fragments. Describing the spectator's experience of new media and especially immersive media works, Mark Hansen talks about framing as a function, not just of the image but of the embodied spectator:

[T]he body undergoes a certain empowerment, since it deploys its own constitutive singularity (affection and memory) not to filter a universe of preconstituted images, but actually to enframe something (digital information) that is originally formless. Moreover, this 'originary' act of enframing must be seen as the source of all technical frames (even if these appear to be primary), to the extent that these are designed to make information perceivable by the body, that is, to transform it into the form of the image. (Hansen 2004: 8)

Framing, in Hansen's sense, is crucial to the experience of *Sleepwalkers*, not only because the mobile spectator effectively samples and re-edits the work, but also because of the way in which the work is interposed between the spectator and the museum building. *Sleepwalkers* is, in effect, a *media skin* on the building – enveloping but insubstantial and impermanent, transient, without commitment and therefore unthreatening to the modernist purity of this particular institution. The spectator is also enveloped in a skin, as when, listening to an MP3 player or talking on a mobile phone, people inhabit imaginary bubbles of privacy in public space (and in fact, the museum provided a dial-up mobile phone tour, to enhance this aspect of the installation). The experience is qualitatively different from the collective experience of the traditional, seated cinema spectator – it is an experience in shared public space, but individualized by the specific bodily framing of each spectator. This may be part of what Aitken means when he talks about bringing intimate actions and personal moments out into the exterior and exploring the individual's relationship with the environment. The characters are connected to the city but isolated within it, and like them, the spectators are connected through an experience in shared space, but also isolated by the emphasis it places on individualized sensory responses. Combining imagery that evokes cinematic vernacular modernism with a new media aesthetic at the level of reception, *Sleepwalkers* brokers a

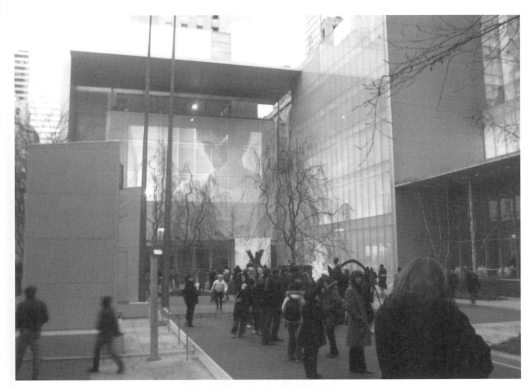

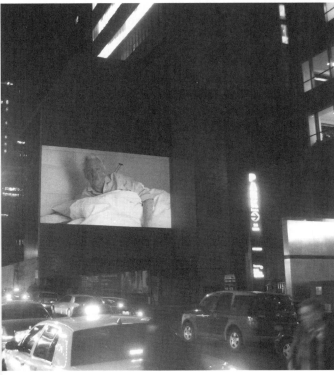

Figures 2 and 3: *Sleepwalkers*, installation view. Photo: Brent Burket.

temporary reconciliation of modernist and contemporary culture and public and private space.

Visitors to the installation inevitably compared it with the LED signs and billboards four blocks away in Times Square, and Aitken invited the comparison by filming one of his characters behind the electric signage of One Times Square, the famous building that became a billboard (Vanderbilt 2007: 45–6). However, there are important differences between *Sleepwalkers* and the signs of Times Square: the signs emit light whereas the images in the installation are formed from projected light; the installation has a longer duration and more complex rhythms than the signs, and it does not address its viewers in the imperative tone of advertising. *Sleepwalkers* does not belong with the 'mannerist architecture of communication' lauded by Robert Venturi, and exemplified by 'the building as a digital sparkling source of information, not as an abstract glowing source of light' (Scott-Brown and Venturi 2004: 94). A work of medial transition rather than new media, *Sleepwalkers* evokes the cinematic city, not the media city, matching its sedate and elegant modernity with that of the museum. Not surprisingly, given its architectural context, *Sleepwalkers* looks back at the historical associations between film and the modern city, re-configuring them outside the cinematic institution.

However, despite its aesthetic alignment with film rather than billboards, *Sleepwalkers* has a significant relationship with publicity. In the press release from the Mayor's office that greeted the announcement of the project, Mayor Bloomberg commented:

> We've seen great art bring people out of hibernation, and so our Administration has always looked for bold initiatives in the winter months, when tourism is at its slowest, to attract visitors to our City. Doug Aitken's project is certain to be the kind of exciting artistic event that will do just that and it is this kind of imaginative marketing of our City that has helped bring our economy back.[2]

The same press release announced the results of a study on MoMA's economic impact, which estimated that between its reopening in 2004 and mid-2007 the museum would generate $50 million in tax revenue for the city. To the Mayor's office, *Sleepwalkers* was first and foremost a contribution to the economy of cultural tourism.

Sleepwalkers is Aitken's first work of public art, but it is also a collector's piece, made in an edition of six. Editioning is a peculiar practice in digital film-making: unlike striking celluloid prints, making perfect copies in digital video is cheap, quick and easy. Editioning is engineered scarcity, intended to drive up the value of each copy and the value of the artist's work in general. For Aitken, the public display of his work *is* a kind of advertising, in which the spectacle of the show functions as the guarantee of something that might otherwise seem not to be art. *Sleepwalkers* functions at arms' length from advertising as such, but it draws on the spectator's familiarity with an environment saturated in commercial messages to achieve its effects, and its production and circulation takes place within the art world, which negotiates the boundary between private wealth and public culture in very particular ways.

The relocation of *Sleepwalkers* from New York to Miami was transacted via the private sector: one of the six editions of the work was bought by the Arison Arts Foundation and donated to the Miami Art Museum. The museum commissioned Aitken to shoot additional footage for *Sleepwalkers (Miami)*, to be screened on the opening of the new museum building, currently scheduled for 2013. Commenting on plans for the work, Aitken has said that '*Sleepwalkers (Miami)* will expand the work's landscape and characters in a manner that reflects the diverse social fabric of Miami' through the addition of two local characters: a young Latin American woman who works as a lighthouse attendant and travels through different urban neighbourhoods, and a transient man who wanders all over Miami.[3] Transience and light are essential qualities of the work as it already exists, but will accrue additional meanings *in situ* in Miami.

Miami Art Museum's new building is to be located in Bicentennial Park, which will be re-designated Museum Park and be shared with the science museum. Architects Herzog and de Meuron have drawn on the traditions of tropical modernism in a design that blurs the distinction between the museum inside and the park outside, with the main gallery appearing to hover between transparent levels above and below. A perforated canopy above the museum will create a microclimate in which lush vegetation will be grown. The design was developed under Terry Riley, Chief Curator of Architecture at MoMA during its renovation and Director of Miami Art Museum from early 2006 until late 2009. A crucial difference between the two projects is that while the capital campaign for MoMA's renovation was led by its trustees, who donated over two-thirds of the money, funding in place for the Miami Art Museum's (considerably less costly) new building is in approximately inverse proportion, with County bond proceeds more than double the value of private donations (a situation that has generated a debate about the shortage of arts patronage in the city). The context for the development of Museum Park is a wider strategy to revitalize Miami that includes the Miami-Dade County Open Space System Master Plan, a plan to make the county's open spaces 'a seamless, sustainable system of great parks, public spaces, natural areas and cultural areas' and the adoption in October 2009 of 'Miami 21', a new zoning code promoting the location of schools, shops, parks and other amenities within walking distance of residences.

As a public art event, the screening of *Sleepwalkers (Miami)* will differ in crucial ways from the screening in New York. The Miami version will be less intrinsically site-specific than the New York version, as it will present a cinematic creative geography, combining the two locations in a metonym for cities in general as well as this city in particular. The installation's hybrid image of New York and Miami may well take on a symbolic function in relation to the city planners' New Urbanism, with its themes of 'great public spaces' and 'walkability'. As transparency and openness will be built into the new museum's structure, the softening of the building's outlines will probably be an unnecessary effect, and the recombinant structure of the work may well appear to reflect more on the museum's interior, with its modular galleries in a non-linear arrangement, than on the surrounding city. In its first installation, *Sleepwalkers* was interposed between the museum and its visitors and functioned to modulate

Figure 4: The new Miami Art Museum at Museum Park, Herzog & de Meuron, Park view © Herzog & de Meuron, visualization by Artefactorylab.

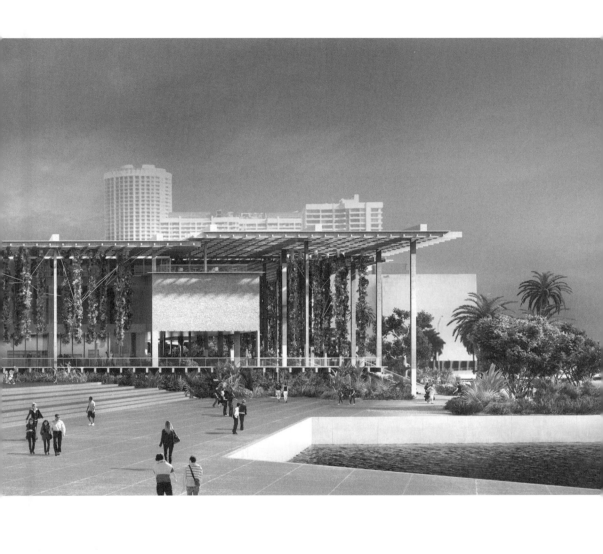

the encounter between the two, paradoxically answering criticisms of the museum exterior as a usable public space by promoting a privatized – or at any rate, personalized – experience of the site. In its second installation, it will function as part of a coordinated strategy to create new public space and to influence the shape of commercial development. In a reversal that clearly demonstrates the pliability of public screen art, *Sleepwalkers* will be transformed from a work that positions a place shaped by private patronage as public space into a work that establishes a place shaped by public policy as a model for patrons and entrepreneurs in the private sector.

Rather than the idealized public sphere described by Miwon Kwon, *Sleepwalkers* operates in a discursive space in which public and private realms, cultural and economic objectives and collective and individual experiences are folded together. With its hybrid aesthetics, Aitken's installation addresses a range of concerns that circulate around contemporary museums, including those arising from the inherent contradiction of a museum of modern art and those arising from the conflict between private patronage, corporate sponsorship and the public sphere. Critical discourse around the emerging phenomenon of public screen art tends to emphasize the interactive, relational and interventionist potential of media technologies in public space and the convergence of media and architecture. *Sleepwalkers* is interesting precisely for the ways in which it falls short of these ideals. By using projection rather than LEDs, it avoids the necessity for architectural intervention, achieving striking but transient effects without touching the buildings. Site-specific to a degree, it is also adaptable and capable of expressing comparative and generalized urban qualities and even ideologies. Its imagery of isolated individuals subject to constant recombination, but never in contact with each other, models the behaviour of spectators as they cruise the museum gazing into the middle distance. As an intervention in public space, *Sleepwalkers* follows the logic of MoMA's retrofit, preserving and upholding the image of the modern city in super-modern times. In an adaptation of the slogan that announced the re-opening of MoMA its relocation will proclaim that Miami is Modern Again.

References

Aitken, Doug (2005), *Broken Screen*, New York: Distributed Art Publishers.
—— (2007), *Sleepwalkers*, New York: Museum of Modern Art.
Biensenbach, Klaus and Eleey, Peter (2007), 'Overview', *Sleepwalkers* website: <http://www.MoMA. org/interactives/exhibitions/2007/aitken/flash.html>. Accessed 15 November 2009.
Buchloh, Benjamin H. D. (2005), 'Our Own Private Modernism', *Artforum*, February, pp. 140–143, 201, 206.
Campbell, Robert (2005), 'What's Wrong with MoMA? Disappearing Architecture and a Sense of the Unreal', *Architectural Record*, 193 (1), pp. 67–69.
Foster, Hal (2004), 'It's Modern, but is it contemporary?' *London Review of Books*, 26:24, 16 December, pp. 23–25.
Gleber, Anke (1998), *The Art of Taking a Walk*, Princeton, NJ: Princeton University Press.

Hansen, Mark (2004), *New Philosophy for New Media*, Cambridge, MA and London: MIT Press.

Kwon, Miwon (2005), 'Public Art as Publicity', in Simon Sheikh (ed.), *In the Place of the Public Sphere*, Berlin: b_books, pp. 22–31.

Message, Kylie (2006), *New Musuems and the Making of Culture*, Oxford and New York: Berg.

McQuire, Scott (2006), 'The politics of public space in the media city', *First Monday*, Special Issue #4: 'Urban Screens: Discovering the potential of outdoor screens for urban society' (2006), <http://firstmonday.org/htbin/cgiwrap/bin/ojs/index.php/fm/index>. Accessed 15 November 2009.

Pasternak, Anne (2007), *Creative Time: the Book*, Princeton, NJ: Princeton Architectural Press.

Pimlott, Mark (2007), *Without and Within: Essays on Territory and the Interior*, Rotterdam: Episode.

Project for Public Spaces, 'Hall of Shame: Museum of Modern Art exterior', <http://www.pps.org/great_public_spaces/one?public_place_id=936&type_id=2#>. Accessed 15 November 2009.

Scott-Brown, Denise and Venturi, Robert (2004), *Architecture as Signs and Systems: for a Mannerist Time*, Cambridge, MA: Harvard University Press.

Stephens, Suzanne (2005), 'New York's Museum of Modern Art Finally Becomes What it Wanted to be All Along', *Architectural Record*, 193 (1), pp. 95–108.

Vanderbilt, Tom (2007), 'City of Glass', *Artforum International*, January, pp. 45–46.

Notes

1. The avant-garde trope of trance has its mirror image counterpart in mainstream cinema in the figure of the zombie, a potent sign whose meanings range from colonial anxiety to contemporary alienation (most notably exemplified by the zombies in shopping malls in George A. Romero's *Dead* films).
2. Press Release, Office of the Mayor, 25 July 2006.
3. Press Release, Miami Art Museum, 26 October 2007.

Chapter 12

Film in our Midst: City as Cinematic Archive

Janet Harbord and Rachel Moore

T his chapter addresses cinema's place within the architecture of the urban experience. Here we look at two art installations, Patrick Keiller's 'The City of the Future' in 2008 within an art gallery context, and Idris Khan's 'Fragile', on a central London street in order to begin to think about our contemporary landscape in which moving image screens proliferate.

In these two examples, film has left the movie theatre and entered a more fluid social milieu: the art gallery and the street. Newly situated, these films have become a form of architecture: Keiller's screens construct an architecture in that they appear to form alleyways or walls one can walk around in a gallery, and for Khan, the screens are embedded in the fabric of the footpath's pavement. It seems no accident to us that both installations work with films that invoke the recent past. Like architecture they perform the work of history, bearing a past into the present context of mixed architectural temporalities.

That we perceive cinema and architecture in similar ways has been variously elaborated upon.[1] Cinema and architecture move us through time and space, yes, but their patterns of light and shadow, their cracks and crannies also catch us unawares and produce an unconscious tactile sort of apperception. What is key to the work of both Keiller and Khan is the way in which their architecture presents us with the material of history as an archive in which time accrues and abides. Where Debord saw in the spectacle an annihilation of historical knowledge, in particular the destruction of the recent past,[2] these films appear to be designed to do something quite the contrary. They insert a historical consciousness into the landscape as a mobile form, looped or open to manipulation. Our second concern is to consider the sort of attention these installations elicit. When film leaves the movie house to enter the urban experience directly as architecture, the situation of viewing is everything, demanding new forms of engagement. Situated in various contexts, films as architecture make for a different configuration of what has been called spectatorship. The screen is different, the position of the viewer is mobile, and the ambience of the viewing scene is charged by the flow of people moving through, towards and around. Within this new configuration, these installations invite us to re-occupy films from the recent past in a mobile present. Finally, we want to understand the nature of engagement with material history to which these installations attempt to draw our attention.

Patrick Keiller installed a set of seven screens at the BFI Southbank gallery (Nov 2007 – Feb 2008), which showed actualities from 1896 to 1909 arranged so as to give the feel of walking through streets or alleyways with the images projected to approximate life-size. Each screen also had an interactive console that allowed the visitor to choose a site on a

map and then view a film of that place locating him or herself within a range of 68 places in the UK. More than the arrangement of the films, or the interactivity of their access, the artfulness of this installation lay in its perplexing title, *The City of the Future*, that aligns a series of films made before the lifetime of just about any observer with our faded utopian vision.

Both new and old, the installation delivered turn-of-the-century actualities via digital projections, a gallery space mimicking the conditions of early cinema viewing through visitor-driven computers, and urban scenes whose sameness and difference to today was a source of continual amusement. While there were many uncanny resemblances to our everyday, the order in the chaos and the chaos in the order of traffic, for example, be the vehicles largely horse-drawn, even the sense that more has remained the same than has changed, this semblance, this game of sameness and difference that one can play in perusing these scenes sheds little light on the installations' almost antiquated title. It would almost be more fitting for a situation in which those on screen were watching those in the gallery.

The arrangement of the films formed an environment akin to architecture. As a form of architecture, the installation made one keenly aware of the temporal in the spatial. Ambling through these screens of London, one began to feel that the things around us hold time within them, time that can explode into our present just as readily as they might draw us to recede into a past. Buildings pre-date and outlive us; the degree to which this is or is not true only highlights the way in which they mark us in time, and so too ambling through a series of old films from still familiar places. Far from a reminder of mortality, however, I found myself waving back at these life-sized images and honestly wondering if people really die anymore. When looking at the face of a person, you would walk behind and expect to see the back of their head. But just as you did that, you were interrupted, for someone at the console had changed the screen. This was not such an easy stroll after all, for the seven screens each had interactive consoles and you would rarely see a film through to its end, even though the films were quite short. For the screens began with maps and from those maps you could select a place from which to view a film. The clarity with which the time and space were marked, designed to orient the viewer, did just as good a job of disruption, disorientation and alienation, as you were often faced with scenes you could not recognize at all, and did not know from where or when they had been chosen. From these fragments, you begin to construct fantastical stories about the people or the places; Keiller claims that there is a man talking on a mobile phone in one of them. The forms of attention are manifold, so absorbed at points as to actually feel the people as live and present only to be confused and momentarily disorientated, yet the angles of the screens with their everyday scenes promise the leisurely delights of a Sunday stroll. If, as Benjamin says, the utopian dimension of a social form or a technology is present at its birth and once more released at its obsolescence, these obsolete films seen through digital technology have yet to reveal that dimension.

The overall impression Keiller's films give belies all that talk about the crisis of modernity, shock and trauma. Where is the visual, aural noise? Casually arranged, in comfortable proportion to our human size, these films nourish unnatural intimacies. The intimacies go

beyond fabricating scenarios, waving at the people, to the technical touch created by the wonder at the fact of seeing such old things so easily and clearly, but also the inscription of technology that becomes palpable on the film's surface. They make us aware of the film strip as ageing celluloid, with its grainy texture and sometimes tinted frames, and in so doing viscerally foreground their technology. Films like the phantom train, tram and boat rides celebrate those then-burgeoning technologies, and with their attendant pleasures celebrate that technology on its own. The tactile quality these features carry serve to break through the hundred years of historic time to compound the old with the new, and in so doing easily trump what Ernst Bloch called the 'Scotland Yard badge' history customarily displays.[3] Instead of a linear progression of history, the abundance of the archive, the film archive in this case, hints at a formless, infinite past that technologies, from time to time, might partially reveal. Across the surface of these layers of time is the visceral present in the form scratches and cuts, stops and starts, which engages us in the now. The way we take in such installations as this, as architecture, allows, in fact invites, haphazard associations with the past, both bodily felt such that one gestures at the screen, and contemplative, such that we think about what it meant and means to work, play, move through a city; how infrastructures worked and continue to work on us. The urban experience, then as now, is a series of momentary intimacies and estrangements whose mobile and ephemeral nature is of course particularly apt for the medium of film. But setting them as an environment that we casually occupy, repeatedly, in fragments, grants these strips of time from the past their rightful place, not to haunt us but to ground us as urban subjects, just like the people in the movies.

Jonathan Crary's epilogue to the book, *Suspensions of Perception*, entitled '1907: Spellbound in Rome' uses Freud's letter home that describes an evening's stroll in the Piazza Colonna to pit the all-absorbing, history-erasing, time-suspending sort of attention Freud observed when viewing images projected on a makeshift screen within the Piazza with an immediate sense of loneliness against the social, convivial, history-accommodating mood with which the entire scene is described.[4] Unlike the traditional shock-ridden experience Simmel described, or the isolated distracted flaneur, Freud delivers us a scene of relaxed attention, open to everything he sees and hears, in all a convivial affair. This Crary goes on to align with Freud's technique for analysts to follow, which he called 'evenly suspended attention' in the face of all that one hears.

Written in 1907, Freud would have been watching films contemporary to those Keiller shows, and while Freud has only one screen to watch, many urban amusements catch his eyes and ears. While Crary goes on to describe various forms of engagement, the primary value of Freud's letter is simple. Unlike film theorists such as Benjamin, Kracauer and Epstein, who looked at similar situations and only saw the screen, Freud conveys the entire scene with its multiple sensory stimuli.

Crary uses Freud's letter to describe two forms of attention and two different modern subjects. Spellbound, watching the moving picture repeatedly, Freud finally feels lonely and turns to go. This typifies the isolated, homeless subject associated with bourgeois interiority,

the single subject whose alienation stands out against a crowd. The social arena within which this takes places, however, along with Freud's lengthy description of activities and physical façades, point to a social subject who, along with others, is immersed in viewing. This, for Crary, describes the continuous oscillation of contemporary subjectivity, which shifts between immersion in a collectivity and absorptive solitude.

One hundred years later, we find ourselves in much the same place. But film is old now, and what we are looking at is not a scene of new stimuli but ruins. Ruins mark the moment of their registration, evidence of time's wear, as remnants from a distant past, and as the site of loss. The presence of ruins corrodes the stability of the present. The archive – here in the form of films – in as much as it stores our ruins, awaits reawakening. Benjamin writes, 'Allegories are, in the realm of thoughts, what ruins are in the realm of things'.[5] The wear of progress corrodes the stability of the present and, in so doing reveals a detail, a flash of light, or a thought, from which we might get a purchase on the present, before it becomes the past. 'For radical natural-historical thought', writes Adorno, 'everything existing transforms itself into ruins and fragment, where signification is discovered, in which nature and history interweave'.[6] The task at hand then is to restore our ability to see things splintered and contingent rather than packaged and whole, thus awakening a spectator who is alert to the possibility of his or her social presence amidst the city's architecture. Where ruins do not exist they need to be created.

Heading through the streets from Victoria station towards Parliament Square, after five minutes of ambulatory activity, a piazza opens up on the right, a square at the back of which a catholic cathedral is situated. Walk across the square diagonally and the street is Howick Place, an unremarkable thoroughfare that runs behind a row of shops and arrives at the back of a department store, the Army and Navy. Walk along this street at twilight and the pavement breaks up ahead into a set of luminous squares. In place of paving stones is a collection of four plasma screens showing moving image sequences. The screens are set at right angles to one another so that it is impossible to view the subject matter of all the screens at once. The pedestrian has to walk around or over each screen to view each of the films individually. Having performed this task once, the pedestrian-turned-viewer finds an echo of something, a repetition, and is forced to re-examine each one only to discover that two of the screens are displaying the same work running at the same time. The pedestrian-turned-viewer has by now unwittingly performed a turn of elegant urban dance choreographed by the screens. In the twilight a barely discernable metal plaque on the wall above reads 'Fragile (2008) Idris Khan'.

There is something of an inside-out to Khan's film sequences displaying the sorting of mail. Set into the pavement outside of a former Royal Mail sorting office and adjacent to a still-functioning post office, the films celebrate a type of labour that no longer exists. As though tossed from the door of the building as it turned from a site of industrial labour into an art gallery, the films appear to have landed on the street. Here they are, continuing the rhythms of hand-sorting mail, weighing letters and parcels, bundling envelopes into sacks. They exhibit what appears to be a practiced ritual between hand, eye and paper as letters

fall from hands into bags, slide from fingers into marked boxes. Watch for a moment longer and the process hovers, reverses. Letters fly backwards across a room, leap from sacks into hands. Like a gust of wind, the film blows matter backwards.

Commissioned in 2008 by Howick Place Developers, to mark the re-development of the building as an art gallery, Fragile is a permanent public art installation. To make the films, Khan reconstructed a 1950s postal office from the materials of cardboard, paper and tape, in the space of his studio. There is nothing 'authentic' about the representation of postal work at Howick Place, for this is not a record of postal work as it existed but a re-enactment. Nor are we seeing the hands of a postal worker, but the hands of an artist. The films that Khan has made perform the past of a public service of sorting and sending, at a moment when it is not only the form of bodily labour that appears historical, but the practice of letter writing itself is almost rendered quaint. This is a eulogy to the passing era of hand-written correspondence, when the time of writing coupled with the time of delivery stretched communication across a number of days. It is also a play on the unilinear direction of a communication that is yet to arrive. Khan may be mindful of Derrida's warning that no matter how clearly we may write an address, a postcard may never reach its intended destination[7]. Khan may also be indulging us in an imaginary reversibility of events, a fantasy provided only by cinema's command of time that can run backwards as well as forwards.

The films evoke a type of history, a history of re-enactment rather than representation, a re-enacted history re-located to the street, where the prefix 're' reminds us of return and repetition. But the physical location of the screens, embedded into the angular matrix of paving slabs, brings an awareness of the world under-foot. The material surface of the street, patched together from paving stones, concrete slabs, soft tarmac, metal drain covers and ribbed air vents, is brought into view. Once our attention is turned towards the ground, the surface of the street references a world of disguised activity: the routing of electricity, gas, water, sewage and fibre-optic cables. The screens signal a subterranean layer of activity that recalls Stallybrass and White's insistence on reading the topography of the nineteenth-century city as a body, divided into zones of hygiene and filth, disclosure and disguise, consciousness and repression.[8] In the twenty-first century city, the surface skin of the street represses the material forms of industry that power the city and that enable the newer forms of instantaneous communication running on invisible power sources. Khan's films, set into the fabric of the pavement, depicting a lost manual labour, direct us metonymically towards another history, the buried archive of industrial and post-industrial labour that secures the functioning of the city. As we hover above the surface of the screens, the films below our feet have become part of the architectural material of London, of architecture as an enduring archive of substances and designs patched together over centuries.

But this is close-up. At a distance, and in the dusk of early evening, the installation is part of a street scene characterized by the noise of the traffic from Victoria Street, the lights of the piazza behind, the neon sign of a coffee shop ahead, the lit tableaux of department store windows to the left and the stream of passing pedestrians taking a short cut to and from Victoria Station. Film in this street of this city is part of a pluralist world of multiple

sensibilities and stimuli, and if one is spellbound, there is a question of what exactly is casting the spell. In the midst of Piazza Colonna, Freud stands 'spellbound' before the repeating loop of a cinema screen, the contents of which are not conveyed in his letter home. It is the spectre of the technology itself that Freud recalls, and its trance-inducing repetition that concerns Crary, who comments, '[r]epetition here is inseparable from the modern production of historical amnesia'. Freud's lack of attention to historical detail, that is, to the monuments of the Piazza, is a sign of 'the installation of a new temporality which subsists as a dehistoricized perpetual present'.[9]

Crary reads Freud's absorption in the repetitious image as a state that renounces historical time. Yet repetition as a form of return, a going back over events, is part of the therapeutic process that Freud had set up as the practice of psychoanalysis. To repeat is situated at one end of a spectrum of return, where going back risks the endless replay of a pathological performance of the same. But at the other end of the spectrum is the necessary repetition of return, where going back is a requirement for the breaking open of the past to a new interpretation, an act ultimately directed towards the future.[10] As Freud stands spellbound in the square, his experience of the film as it is repeated, is a different experience to watching the film for the first time (albeit moments earlier). In other words, repetition necessarily has a past.

Repetition, or rather reconstruction, also has a future. Freud retires to his hotel room to reconstruct the experience of the piazza in a letter to his family, a letter that will arrive days later. He turns from the external world to the enclosure of the room, as though the ambience of scale can only be seen and felt in another place, an inverted space. The enormity of the experience of the urban landscape demands a spatial disjunction, and the enclosed intimacy of interior space can be more keenly perceived in the flux of urban life. Here, in this act of reconstruction, Freud communes with the artists, Keiller and Khan. Keiller takes films of the outside, the urban landscape, and presents them inside a gallery. Khan takes the interior life of a post office and puts it out on the street. In so doing they perform the dance of risk and safety, intimacy and alienation, which is choreographed by the urban experience.

Idris Khan's screens offer the same casual address of the Piazza, making a play for the passers-by, commuters, visitors to the gallery, visitors to the post office, cyclists, café frequenters, shoppers at the nearby department store, attendees at the catholic cathedral. They play to and become part of the various temporal rhythms of the city, including the ritual attendance of the homeless community who congregate on Howick Place at 8.30pm every evening for the soup kitchen. The films play their loop of postal bureaucracy, evidencing the historical efforts to keep communication on course, to manage the chaos of multiple messages and urgent correspondences, taking the liberty of slowing down or speeding up the process. Khan says of this installation, 'By manipulating time we enter into a utopian world whereby complicated or easy tasks look beautiful and mesmerizing', and where letters flying out of bags and into hands has the quality of magic realism. In performing the past of this particular location, these films place history amidst a continually shifting landscape of diverse temporalities, and draw attention to the multiple times of the city embedded in the fabric of its architecture. The films, should we cast a look or stop to watch, return us to

the recent past, and they return us once again as the loop ends and the film begins again. It is only in going back and re-organizing the past that the future comes into view. In this sense, film in our midst in the city is part of a utopian aspiration of imagining a future by re-inventing and re-enlivening the past.

Idris Khan's title, 'Fragile', presents us with the problem and promise of the urban experience. The connections he means to evoke and encourage viewers to imagine or pursue are fleeting. The transitory way in which we occupy the city, the contingency and chance that characterize the danger and pleasure of urban life all speak to the fragile nature of our presence in it. When one enters a city, one enters a history, in the case of London, one of the early seats of European capitalism built, like the others, on a swamp. Structurally, as well as epistemologically, it was and is fragile; every moment could or can be otherwise. For all of the durability of stone, brick and mortar, screaming their fidelity, for all the blue plaques that tell you that great things were accomplished here then, a city experience never places one at ease. Ease comes with the chance, fragile moments when you recognize that you are there, here, now. This is made possible artificially in these installations that take a random form of address, and deliver history in a random fashion.

Cities give you a mixed message. They emerge, so we believe, from over-determined geographical, geological circumstances; they have rooted historical birthrights. At the same time, they are defined by their dynamism, their up-to-the moment change, their amorphousness; they are permanently in motion with their ups and downs monitored as carefully as the stock market index. Cities are always at risk of going under, sinking down into the swamp, just like the people who occupy them. Small wonder then, that an artist's intervention in the city seeks to galvanize that solid history in the form of a state institution, the post office, to connect the lurid undergrowth of permanence with the spontaneous and risk-riddled passer by.

Although architecture carries the promise of a stable presence of the past, and these iterations of the past via digital cinema too bring us some of history's comforts, they also cannot but remind us of their instability. When Keiller's installation was almost over, I re-visited it with a friend. The consoles were all broken. With no buttons or maps to interrupt the films, they ran continually on the seven screens, finally allowing that gentle stroll through screens as if they were side-streets in London, with time past repeatedly left to run on and on. Walking around the decrepit consoles with their missing buttons and broken wires, we agreed we liked it much better this way.

References

Adorno, Theodor (1984), 'The Idea of Natural-History' (trans. Bob Hullot-Kentor), *Telos 60*, Summer, p. 119, 121.
Benjamin, Walter (1977), *The Origin of German Tragic Drama* (trans. John Osborne), London: Verso, p. 178.

—— (1999), 'N On the Theory of Knowledge, Theory of Progress', *The Arcades Project*, Cambridge, Mass: The Belknap Press of Harvard University Press, p. 463.

—— (2002), *Selected Writings*, vol. 3, Cambridge, Massachusetts and London, England: The Belknap Press of Harvard University Press.

Bruno, Guiliana (2002), *Atlas of Emotion*, Benjamin, London & New York: Verso.

Colomina, Beatriz (1994), *Privacy and Publicity: Modern Architecture as Mass Media*, Cambridge, Massachusetts & London: MIT Press.

Conley, Tom (2007), *Cartographic Cinema*, Minneapolis & London: University of Minnesota Press.

Crary, Jonathan (1999), *Suspensions of Perception: Attention, Spectacle, and Modern Culture*, Cambridge, MA: MIT Press, pp. 369–370.

Debord, Guy (1988), *Commentaires sur la societe du spectacle*, Paris: Editions Gerard Lebovici, p. 29.

Derrida, Jacques (1993), *The Post Card: From Socrates to Freud and Beyond* (trans. Alan Bass), Chicago: University of Chicago Press.

Freud, Sigmund (1914),'Remembering, Repeating and Working Th rough', in *Beyond the Pleasure Principle and Other Writings* (trans. John Reddick), London: Penguin Books.

Stallybrass, Peter and White, Allon (1986), *The Politics and Poetics of Transgression*, New York: Cornell University Press.

Vidler, Anthony (2006), *Warped Space: Art, Architecture, and Anxiety in Modern Culture*, Cambridge, Massachusetts & London: MIT Press.

Notes

1. See Benjamin (2002), Bruno (2002), Colomina (1994), Conley (2007), Vidler (2006)
2. Debord (1988) as cited in Crary *October* 50, p. 106.
3. In "N On the Theory of Knowledge, Theory of Progress" (Benjamin 1999: 463). The full passage reads: A remark by Ernst Bloch apropos *The Arcades Project*: 'History displays its Scotland Yard badge." It was in the context of a conversation in which I was describing how this work – comparable, in method, to the process of splitting the atom—liberates the enormous energies of history that are bound up in the "once upon a time" of classical historiography. The history that showed things "as they really were" was the strongest narcotic of the century. [N3,4]'
4. See Crary (1999).
5. See Benjamin (1977).
6. See Adorno (1984: 119, 121).
7. See Derrida (1993).
8. See Stallybrass and White (1986).
9. See Crary (1999: 369).
10. For a concise rendering of this argument, see Freud (1914).

Chapter 13

Parkour Vision

Layla Curtis

When I first saw the parkour scenes in Luc Besson's film *District 13*,[1] Channel 4's documentary *Jump London*[2] and the BBC's short promotional film *Rush Hour*[3] they had a profound effect on how I subsequently experienced and ultimately navigated the urban environment. Seeing Dave Belle's[4] alternative journey home across the London skyline in the energetic, fast-paced short film *Rush Hour*, was a catalyst in setting my imagination free to understand the urban fabric, not as a series of controlled thoroughfares, channelling and directing flow or refusing access, but as a collection of surmountable obstacles offering seemingly unlimited combinations of routes through it. The film begins at the end of the working day, with David Belle climbing out of his office window and edging up onto the rooftop high above scenes of gridlocked commuter traffic and overcrowded pedestrian walkways on the streets below. With a backwards summersault onto the neighbouring building he begins his breathtaking journey home across the rooftops – running, vaulting and climbing over and around rooftop obstacles and executing astonishing leaps spanning huge gaps between one high building and another. His movements are fast, fluid, graceful and precise and at times he seems to move beyond the normal limitations of the human body to overcome the obstacles in his path. Finally, he completes his journey with one last carefully controlled slide down a roof onto a balcony, enters his top floor apartment through a window, spins into his armchair and switches on his TV.

David Belle's journey, liberating him from the rush hour taking place on the city floor, led me to discover the discipline of parkour and subsequently transformed the way in which I looked at space, prompting me to rethink architecture's manifold possibilities. Even as an observer of parkour rather than a practitioner, my imagination began to skip, leap and vault around the city – in my mind's eye I took shortcuts over railings, balanced on tiny ledges and used architectural idiosyncrasies to help me mentally scale walls and buildings. In my imagination I navigated London like a super hero. I had begun to experience what Sébastien Foucan[5] referred to in *Jump London* as 'the vision of parkour'. I put my newly acquired Parkour Vision into practice when I began training with Parkour Generations[6] in 2007 and experienced for myself what it felt like to be physically free of the usual constraints of navigating the city. I witnessed firsthand the grace and fluidity of the skilled traceurs[7] and was inspired to make an artwork which traced their alternative routes through the urban environment.

It was at this time that I was commissioned by Westminster City Council to create a temporary public artwork in the district of Mayfair and began to develop a project that used the central London location as a backdrop for a new video work exploring the navigation

of the city through Parkour. I made numerous site visits to Westminster in search of suitable filming locations and began the arduous task of negotiating access to buildings across the borough. I filmed in locations with and without official permission and worked with some of the most proficient practitioners on the scene today, including Stephane Vigroux,[8] Johann Vigroux,[9] Thomas Couetdic[10] and Steve Kazuma Rognoni,[11] to create the body of work *Traceurs: to trace, to draw, to go fast*.

The resulting series of films was exhibited at Chelsea Futurespace, London, and also included in the group exhibition *Actions: What You Can Do With the City*, at the Canadian Centre for Architecture, Montreal, Canada, which toured to the Graham Foundation for Advanced Studies in the Fine Arts, Chicago, Illinois, USA. A documentary[12] by Julie Angel following the artwork's creation was screened at the Institute of Contemporary Art, London, and later in Skate City as part of London Festival of Architecture's Screenings and Performances programme curated by the British Film Institute. A publication about the work, including an essay[13] by Richard Grayson, was published to coincide with the exhibition.

Traceurs: to trace, to draw, to go fast

Traceurs: to trace, to draw, to go fast is a collection of black and white films, created using a thermal imaging camera, which captures a series of moments in which traceurs come into physical contact with the urban fabric. The camera, which sees the world in terms of temperature rather than light, makes visible the glowing white heat residue transferred from hands, fingers and feet onto the surfaces, which the traceurs nimbly leap onto, run across and spring off.

The camera remains static – focused on greyish images of walls, trees and roofs – while traceurs quickly move in and out of shot, often executing moves in just a fraction of a second. The only traces left of their flourish of activity are their lingering heat prints. Each different move in a traceur's repertoire – Cat Leap, Turn Vault, Kong, Slide Monkey, Wall Run, Cat Balance – determines the type of mark left behind. The intensity of these marks, each drawn like a unique signature, is affected by the proficiency with which the traceur executes his move – an experienced practitioner is extraordinarily light on his feet and may touch a surface for only the briefest of moments, leaving behind only a delicate smudge of white, while larger impacts leave bolder marks. The weather also has an effect – long, scratchy marks with chalky qualities are left behind on wet surfaces that provide little friction.

Each resulting film is a kind of temporal drawing in black and white – its duration determined by the length of time it takes for all traces of activity to fade away and for the surface to return back to its ambient heat. Some materials hold the heat for longer than others (a tree, for example, holds the warm scuff of a handprint for longer than a brick wall) but gradually all marks cool to reveal once again the grainy blank façade of the city.

Traceurs: to trace, to draw, to go fast was commissioned by Westminster City Council. For more information about the artist and to view the work please visit: www.laylacurtis.com

Following six images (page 212 to 215): *Cat Leap & Traverse* (selected stills), video, 2008, from the series *Traceurs: to trace, to draw, to go fast.*

Following four images (page 216 to 218): *Turn Vault* (selected stills), video, 2008, from the series *Traceurs: to trace, to draw, to go fast.*

Notes

1. *District 13* (French: *Banlieue 13*) is a 2004 French action film directed by Pierre Morel and written and produced by Luc Besson. It has also been released as *District B13* and *Barrio 13* (Australia DVD release) featuring French traceurs David Belle, Stephane Vigroux and Steve Kazuma Rognoni.
2. *Jump London* is a documentary about parkour, first broadcast by Channel 4 in September 2003, directed by Mike Christie and produced by Optomen Television, featuring French traceurs Sébastien Foucan, Jerome Ben Aoues and Johann Vigroux. The sequel, *Jump Britain* was first aired in January 2005.
3. *Rush Hour* is a short film featuring David Belle made in 2002 for a BBC advertising campaign.
4. David Belle (born 29 April 1973) is a French traceur who along with Sébastien Foucan is considered one of the founders of parkour.
5. Sébastien Foucan (born 24 May 1974) is a French traceur who along with David Belle is considered one of the founders of parkour.
6. *Parkour Generations* are the largest global collective of first and second generation traceurs (source: http://en.wikipedia.org/wiki/Free_running).
7. A *traceur* (if male) or *traceuse* (if female) is a practitioner of Parkour. *Traceur* [tʁasœʁ] and *traceuse* [tʁasøz] are derived from the French verb *tracer*, which normally means 'to trace',[1] or 'to draw', but which is also a slang for 'to go fast'.[2] (1) Random House Unabridged Dictionary (v 1.1) (2006). 'tracer – Definition by dictionary. com". dictionary.com. http://dictionary.reference.com/browse/tracer. Accessed 28 August 2007. (2) "Portail lexical — Définition de tracer" (in French). http://www.cnrtl.fr/lexicographie/tracer? Accessed 28 August 2007. Source: http://en.wikipedia.org/wiki/Parkour
8. Stephane Vigroux, founding member of Parkour Generations, featured in Luc Besson's 2004 film *District 13* and learned parkour from David Belle. He is now considered one of the world authorities in parkour.
9. Johann Vigroux, younger brother of Stephane Vigroux, is a member of Parkour Generations and featured in the Channel 4 documentary *Jump London*.
10. Thomas Couetdic learned Parkour in Lisse, France, he appeared in the 2008 action movie *Babylon A.D.* and took part in the Madagascar leg of the parkour world tour with David Belle.
11. Steve 'Kazuma' Rognoni met David Belle in Lisses, France, in 1998 and began to practice Parkour. He featured in Luc Besson's 2004 film *District 13* and is a member of *Parkour Generations*.
12. Julie Angel's documentary film *The Making of Traceurs: to trace, to draw, to go fast*, 2008 can be viewed at: http://www.youtube.com/watch?v=tig5DSG5YcY, a short trailer for the film can be viewed at: http://www.youtube.com/watch?v=VPjO0OTe-zs
13. *Traceurs: to trace, to draw, to go fast*, published by Chelsea Futurespace, with essay by Richard Grayson is available to view online at: http://www.laylacurtis.com/info/view/66.

Part V

Cinematic Urban Design Practice

Chapter 14

Urban Anagram: A Bio-political Reflection on Cinema and City Life

Maria Hellström Reimer

1. Life Work: *Cinema*

There are many ways of understanding the bond between cinema and the city. The most common explanations refer to movement, time and technology. Both cinematography and urbanity are technologies for the capturing and managing of movement and change over time; they are technological expressions for an emergent culture of speed, flow and more or less fugitive timelines – inscriptions, stories, memories, simulacra.

Other explanations are more inclined towards the spatial. Like urbanity, film is an expression for a secular sensation of space; an intensified and empowering encounter with a landscape of multiple optic angles and aspects; a 'creative geography';[1] or a 'sensory and motoric field of reference'.[2]

Another slightly different way of understanding both urbanity and film is as expressions of a new and passionate interest in *life*. When Georg Simmel around 1900 describes an emergent urban 'life form', it is in surprisingly 'cinematic' terms, as 'a life of the spirit' or a life of the '*Geist*'. More precisely, Simmel referred to the intensification of nervous life caused by the metropolis, which through a continuous stream of stimuli recasts the character of the human being as an incessantly differentiating *Untershiedswesen*.[3] What Simmel described was a radicalized existence of propellant forces continuously fuelling change, a space traversed by rapidly moving gazes and interests and an existence stretching the limits for what life as *Erlebnis*, as lived experience, may hold.

While the modern metropolis certainly provide the breeding ground for differentiating imagination, the cinema, once invented, presented a further twisting of urban life. Repeatedly, film has been defined as having an immediate, penetrating presence, throwing back at us a life that is almost more alive than the original. '[T]he cinema', wrote Sigfried Kracauer, 'is conceivably animated by a desire to picture transient, material life, life at its most ephemeral'.[4] What made cinema so pertinent, was neither its artistic monumentality, nor its grandeur as *œuvre*, nor its auratic dignity. No, according to Kracauer, it was its very *triviality*, its ability to depict everything from the movements of street crowds to the whirl of leaves stirred by the wind, for it is first and foremost the momentary impressions of film that constitute 'its very meat'.[5]

Kracauer's ambition to redeem the *élan vital* of existence to a large extent concurs with the cinematic reflections of Walter Benjamin. In an often cited passage from the *Work of Art in the Age of Mechanical Reproduction*, Benjamin discusses the relation between film and life:

By close-ups of the things around us, by focusing on hidden details of familiar objects, by exploring common place milieus under the ingenious guidance of the camera, the film, on the one hand, extends our comprehension of the necessities that rule our lives; on the other hand, it manages to assure us of an immense and unexpected field of action. Our taverns and our metropolitan streets, our offices and furnished rooms, our railroad stations and our factories appeared to have us locked up hopelessly. Then came the film and burst this prison-world asunder by the dynamite of the tenth of a second, so that now, in the midst of its far-flung ruins and debris, we calmly and adventurously go travelling.[6]

What comes through in these and numerous other reflections is the *bio-political* aspect of cinematic urbanism, the complex inter-mediality between film and *city life*. In a situation where relationships of power and subjugation have taken on new infrastructural forms, film appears to be uniquely equipped, not only to 'record and reveal physical reality',[7] but also to interfere with or impinge on the same. Film has become a power in itself, as Thomas Elsaesser has expressed it acting as '"an invisible hand" in our affective lives and in our modes of being-in-the-world'.[8] Incorporated into our lives, the cinematic glow reaches far beyond the screen, governing us even when we are not at the movies, which suggests that, as Elsaesser puts it, 'there is no longer an outside to the inside: we are already "in" the cinema with whatever we can say "about" it!'[9] As Benjamin, Elsaesser points to what is certainly cinema's all-pervasive force; on the one hand it substitutes our thoughts by moving images;[10] and on the other hand it transgresses the representative limits of imagery, revealing to each and every one of us the potential of agency, of mobilization. Also in this respect, film seems to not only represent, but actively encroach upon life, releasing a whirlwind of unforeseeable and capricious possibilities, yet, at the same time, paradoxically proposing a new regime of maximized subordination, presenting an 'adventurous', although as Benjamin so carefully points out, safe and calm ride through life.

Life-bringing or not, the 'vivifying' effect of film brings 'life' into attention: material life, mental life, everyday life, potential life; in many recent films also life in an explicit, blunt form: bare, biological life; fragments of life, zombie-life, exaggerated life, life at its most precarious.[11] In Pedro Almodovar's *Hable con ella/Talk to Her* (2002), cinematic life unfolds on the border between life and death, as an aspect of a comatose existence, yet, with the suggestive materiality of the early silent movie and its penetrating, erotic force. Similarly, in films like *The Idiots* (1998), *Dogville* (2003), and now lately in *Anti-Christ* (2009), Lars von Trier explicitly addresses the borderline between life and non-life, often through a merciless exposure of a paradoxical and/or razor blade sharp *élan vital*. A totally different example is proposed by Michel Gondry, who in *Be Kind Rewind* (2008) investigated the revitalizing effects of cinema as collaborative, playful and empowering grassroots' activism, confronting the suffocating effects of a peri-urban environment deficient in oxygen.

What does this intensified exposure of life and its conditioning forces indicate? Is it simply the pragmatic manifestation of cinema's technological potentials? Or is it revealing a more radical change in contemporary culture and in the ways in which we relate to our

own being-in-the-world? Does film really have the potential to enhance, intensify, deliver or even replace life? And in case film really contributes to what sweepingly could be referred to as 'the production of life' – how is this production performed?

In order to find answers to these and related questions, it is important to approach film not only as a representation of life or as a form of bio-narrative, but more importantly, also as a form of bio-production, or *life work*. As a social and communicative technology, film is a form of composite, spatial production that may take place everywhere, 'throughout the entire social space', thus operating through the recognition of 'life' as 'work', as a form of relational, desire work.[12] The realization of a film constitutes in itself a situated, historical event including social and spatial interaction, material considerations, financial transactions, technological mediation and furthermore a creative playing off of these aspects against each other. There is in this sense no real borderline between cinematic work, life rehearsal and live urbanity, the one constituting the raw material for the other. And as they merge, it becomes increasingly difficult to imagine an outside to this mediated and mediating existence that we have now come to take for granted. In the wake of the filmic 'explosion' that Benjamin so vividly was depicting, we find ourselves to a great extent released from physical constraints, yet, at the same time immersed in an 'urban' live show of intersecting, but also conflicting, courses of action.

The question that in the radiant lights of cinematic 'life work' needs be addressed anew is then that of government and control. If film really constitutes a vital force with a significant and direct influence on urban life – what does this say about the governing of urbanity, about the distribution of experiences, about the powers administrating urban existence and, perhaps most importantly, the potentials to affect its continuous reproduction?

2. Life Politics: *Bio-Power*

Bio-politics, the politics of life, should not be seen as a distinct theory, but more as a comprehensive term for an emergent approach to similarly emergent structures of power and patterns of power play that concern the ways in which we lead our lives. It does in this sense express a shift in the way power has been understood: a shift from a definition of power as associated with *sovereignty* – power exercised through the control of a certain area from a certain point – to an understanding of power exercise as the regulation of the ubiquitous and relational forces imbuing everyday existence.

When the notion of bio-politics was introduced by Michel Foucault it was meant to describe how new and increasingly systematic, yet to a large extent *invisible*, institutional forms of power exercise emerged. As such, bio-politics may seem distant from conspicuous, exhibitionist cinematics. Yet, as a practice concerning the 'governing, administering and taking charge of humans as living beings'[13] – as an apparatus embracing the totality of contemporary, everyday life – its subject matter to a large extent coincides with that of cinema.

Bio-politics, Foucault claimed, is not a matter of recoding scattered or fragmented experiences into a unified discourse. Nor is it a question of amassing all the minor expressions of political will to 'superimpose on them a sort of theoretical crown that would unify them'.[14] Rather, the introduction of the notion of bio-politics is an attempt 'to specify or identify what is at stake' in a situation where different 'power-and-knowledge-effects' are played off against each other, not only through the actual governing of certain aspects of life, but through *governmentality*; through governance *as* life, as a managing of the adaptable and relational equilibrium, with dependencies and losses, through which the self is constructed and modified.[15]

The central issue in bio-politics is thus the shift in the understanding of power as a centralized accumulation of executive strength to an understanding of power as practiced also through complex processes of experiencing and knowing, processes dispersed and played out as to embrace also the construction of subjectivities. It might in this respect be of value to recall the workings of what can be described as the traditional view of power. Foucault reminds us of the fact that in classical theory of sovereignty, the right to reign over life and death is a major attribute, and that sovereign power is a power concerning the right either 'to take life or let live'.[16] Sovereign power is in this sense executive; it is power *in actu*, which in practice means that it is first and foremost related to death, to extinction or exclusion. 'The right of life and death', writes Foucault, 'is always exercised in an unbalanced way; the balance is always tipped in favour of death'.[17] It is when the sovereign sits on the potential to literally execute that he exercises his power.

What happens during the course of industrialization and urbanization is that this old right – 'to take life or let live'[18] – is not so much replaced with as accompanied by a new right – a right that could also be described in terms of *force* – yet, not an obliterating force but a penetrating, permeating force. As opposed to the absolute and executive force of sovereign power, this new force is relative and structural, concerning the continuous capability 'to "make" live and "let" die'.[19]

In his tracing of this new and 'modern' form of life-bringing power, Foucault also points to an operational shift, a shift concerning the technologies of power exercise. While sovereign power during the early phases of modernity developed increasingly efficient means to exercise power over individual bodies through institutionalized separation, disciplinary alignment, carceral surveillance, bodily drill or new forms of monitoring technologies, it is step by step being complemented with new and *non-disciplinary* technologies, applied not to the individual living body, but to the multiplicity of living human beings; to masses and populations. Power is now to an increasing extent exercised through overall spatial processes, like new forms of immaterial production and patterns of consumption, new schemes of housing, general education, or regulations of health, nativity or migration. It is a power that is not individualizing, but as Foucault says, 'if you like, massifying',[20] where the mass as the norm of the population constitutes the governing backdrop also for the construction of the self.

A power like the one described above, a power focusing on the 'making' *of* and facilitating *for* life, is not only spatial but furthermore forward-looking, projective. It is a

power accompanied by forecasting technologies, planning procedures, statistical prospects, regulatory and stimulating mechanisms, in different ways modifying probabilities. It is a power unfolding as an economy rather than a discipline, a power operating through distraction and commotion – against a background of life.

In this sense bio-politics unfold as much as an actualizing as a controlling of the possibilities for people, not only to submit to societal structures, but to absorb them as part of their own life. What emerges here is an affinity between 'the cinematic' and bio-political practice, expressed in the workings of the camera, which, according to Benjamin, 'intervenes with the resources of its lowerings and liftings, its interruptions and isolations, its extensions and accelerations, its enlargements and reductions,'[21] all of which are operations actualizing the (political) instability of a heterogeneous and flexible urbanity.

Accordingly, for most urban environments or financial hubs, the film industry today constitutes an indispensable force for the lowering and lifting, enlarging and reducing, accelerating and stimulating of their own inherent vitality. At the same time, film provides the most efficient sphere for subjectivation, for the consolidating of 'selves' through immersive identification. The creative and smart urban citizen is not only born under the influence of the star system and its enticing suspension of disbelief; he or she also emerges as a product of cinema as a 'social factory'[22] delivering collective subjectivities or *people* as an accessory of life. As Georges Didi-Huberman recently pointed out, film largely works 'according to the ambiguous status of "extras"'[23] – *figurants* in French and *Statisten* in German – engaged and loyal crowds, which above all constitute a new kind of life-enhancing resource. Expectant and apprehensive, these crowds also form the broad base of the new, urban and spectacular economy; a stream of 'workers' continuously leaving the social factory;[24] a tail of *veline*, dancing girls continuously filling out the voids of the urban show;[25] throngs of hopeful people waiting by the cinematic side-scenes for their thirty seconds of fame, yet with no real influence on the main story.

In this sense, cinema seems to be the ultimate bio-political apparatus, and according to George Duhamel also a highly dubious and manipulative one: 'a pastime for helots, a diversion for uneducated, wretched, worn-out creatures' who happily absorb what according to Duhamel is nothing but 'a spectacle which requires no concentration and presupposes no intelligence, which kindles no light in the heart and awakens no hope other than the ridiculous one of someday becoming a 'star' in Los Angeles.'[26]

Yet, this power *in potentia*, so efficient in manipulating and governing people, is not only controlling but also enabling. It is a spatially creative power that not only represents, but produces life as a function of its own capacity to act or intervene. Life is where relational power is exercised, where energy is consumed and matter modified, where bodies are played out and set in motion, where happenings take place and courses of action unfold.

Although all-pervasive and massifying, cinema does not only produce normative behaviours or hegemonic values. It also gives rise to a general, spatial awareness and attentiveness as to the spatio-temporal conditions of a both repetitious and specific becoming. Cinema emerges in the gap between spatial dependency and potential agency, between

227

projective scope and performative impact, between subjective agency and mass movement, between the imposing moment of the workers streaming out of the factory and the persistent traces each and every one of them will leave.[27] In relation to the urban landscape, cinema is perhaps therefore not simply the perfect bio-political chaperon guaranteeing a both safe and side-splitting journey for all. It also holds an unpredictability, an expansive *potentia* to bring into sight the routes of deviation not yet spotted or incorporated in the official urban set.

3. Life Tactics: *Savoir-vivre*

While the filmic equation of individual life and collective work may seem like the ultimate pictorial sealing of the urban landscape, it does at the same time actualize a ubiquitous multiplicity of intersecting gazes, movements and desires. It reminds us of the monumental promise of the metropolis, its pledge to human perfection, where cinema may have been conceived of as the ultimate painting of modern life. Yet, it was, as Harun Farocki has expressed '[w]hen it was no longer possible to believe in such perfection [that] cinema was invented'.[28]

As a combination of monitoring and production of subjectivities, cinema thus brings to urbanity a spatial and material self-reflexivity. Historically, this has also constituted a major cinematic theme, repeatedly explored on the screen through explicit self-referentiality and overt actualizations of the very technological and material apparatus of film-making. Most often, this self-referentiality revolves around cinema's life-bringing or animating powers. In Vertov's *Man with a Movie Camera* (1929), it is bluntly expressed as the living eye is reflected in the camera lens, thus bringing into focus not only the representative or revealing ability of the technology, but furthermore its ability to bring into attention the very life of the eye – its seeing activity. In another sequence, frozen portraits of ordinary people are brought to live by the camera, faces as images being disclosed and vitalized, showing off an amazing expressivity and historical presence. The same kind of igniting principle can be found throughout what after Ruttman has been called the *city symphony* tradition, an explicit self-reflexion over the instrumental potentials of cinema to deliver – through the lens – a life-giving, at the same time empowering, sparkle to urban space.

Although closely associated with differentiation and change, this self-referentiality has nevertheless been combined with strong claims to knowledge and truth. The *kino-eye*[29] of Vertov was in this respect also considered a truth-eye: not only an oxygenizing but also a penetrating instrument handled by a new kind of artist/scientist. Like the later 'film-maker-diver' of *cinéma vérité*, who '"plunges" into real-life situations'[30] uncovering 'a life that possesses aesthetic secrets within itself',[31] the cinematographer was a new kind of artistic super-hero, with the new technology and the Fine Art of capturing guiding his self-fulfilling mission. Although the ambition may have been the revolutionary undermining of the 'apparatus' of capitalist subjectivation,[32] the daring explorer of representational depths runs the risk of becoming no more than the blue-eyed defender of an *authenticity myth* that constitutes the foundation also for what can be described as a 'caring' bio-power.

At least this was the criticism raised by among others situationist Guy Debord, who in his *Critique de la Séparation* (1961) launched an explicit attack on *vérité* aesthetics. Completely rejecting the idea of cinema as a capturing tool he chose to develop a more negative self-referentiality, a fundamental loss of reference expressed as a sceptical '[w]e don't know what to say'.[33] Similarly, in *I am Curious Yellow/Blue*,[34] Vilgot Sjöman presented a 'droll, Brechtian-Pirandellian, mock-*vérité* exploration of the chasm between the political and the personal',[35] films where naïve curiosity was played off against all forms of patronizing directing. An even more ambiguous self-referentiality can be found in the films of Chris Marker and Michael Haneke, who both in different ways deliberately have actualized the uncanny and contradictory abyss that cinematic practice, as double-edged intrigue, has produced.

What these film-makers add to cinematic life-work is a more radical awareness of cinema as part of a bio-political power play, a play where different versions of life are played off against each other. In Marker's *Sans Soleil* (1982), this is laconically expressed, as the female narrator refers to a letter written by what appears to be the director: 'I've been round the world several times and now only banality still interests me. On this trip I've tracked it with the relentlessness of a bounty hunter'.[36] Yet, the cinematic trophy is no longer 'the authentic'. Rather, it is the banalities of life that provide what should rather be described in terms of an aberrant and tense, or sometimes also absent-minded, counter-force. A common trait of these counter-practices is also the lack of closing or revelatory circuits – the absence of specified meaning. Instead, they rely on a fundamental ontological insecurity that comes close to Debord's situationist destabilizing of any claims to conclusion. Yet, as Debord pointed out a propos of his *Critique*, '[t]he relation between images, commentaries and subtitles is neither complementary nor indifferent'.[37] Instead, it was meant as a de-mystification of cinema and a dissolution of its subject matter, which was the sphere of 'everyday encounters' as a more 'authentic' everyday life.[38]

Spatially reflecting upon *cinéma vérité* and *Situationist* cinematic practice, art and architecture theorist Tom McDonough also has focused on the distinct approaches to everyday life.[39] While *vérité* aesthetics constituted a topographic venture, an attempt to a comprehensive and close-fitted mapping of authentic life, *Situationist* practice unfolded as topological modification, as a tactical attempt to activate the conditioning forces of everyday spatial order *from within*.[40] Furthermore, where *verité* practice was an attempt to produce a document that could form a basis for revolution, *Situationist* film-making was in itself a subversive action, a semiotic re-coding of bourgeois *savoir-vivre* into a revolutionary art of living 'despite all'.[41] Explicitly bio-political, Situationist *savoir-vivre* directly contested the increasingly ubiquitous power of Hollywood, which according to Situationist Raoul Vaneigem operated indirectly on the body, like 'a crowd of little hypnoses'[42] conditioning everyday life. Spatially distributed and hypnotically life-modifying, the new power of mass-mediation puts up new demands also on any counter-movement, which, in order to infiltrate the all-pervasive grid, will have to develop a similarly invasive, life-enhancing tactics, fusing situated creativity and political being into one and the same resourceful life.

As an advanced spatio-temporal technology cinema is indeed part of an emergent bio-political apparatus of self-referentiality and hypnotic self-control. As such, it is a means of not only representing, but producing and reproducing life, especially urban life, including its inherent power structures. At the same time, however, cinema allows for the development of a bio-politically motivated *savoir-vivre* for a new urban situation, a cinematic street or life wisdom, which does not come through truthful representation, but through a structurally interfering *performance*.

4. Life Play: *Urban Anagram*

The last part of this bio-political reflection approaches the critical question of how cinematic *savoir-vivre* – as interfering performance – may be staged. If not representational, what is then the mode through which to confront a spatially evasive and mesmerizing bio-power, a power that furthermore is readily exercised through the cinema? How do we counteract power on a bio-political level without subscribing to the same ontological presumptions as those we would like to contest?

One answer is *play*. Rather than a return through optimized representation towards a true state or an innocent and 'real' life, cinema presents another kind of motion, performed on a socio-material level of 'cultural play'. According to Michel Foucault, it was George Bataille who 'introduced play to thought – a risky play – of the limit, of the extreme, of the summit, of the transgressive'.[43] The human being was, according to Bataille, engaged in a both creative and destructive play with its own insufficiency, an exploratory play that would often manifest itself through an intervening *laughter*, which 'characterizes the totality of emptied existences as ridicule'.[44] The sustaining logic is of course that of Dadaism and Surrealism, artistic approaches that like later Situationism deliberately act *from within* a prevailing order. If no representation, irrespective of how proper and careful, can ever match with what it represents, then we do not have other options than to start playing.

It is also possible to express this inclination towards play in positive terms. It is possible to claim that play – by Schiller described in terms of an essential *play drive*[45] – precedes power, and that in this sense play is just another authenticity claim. The important aspect, however, is the performative and thus relational dimension of play, the fact that play is a *playing off* of different forces against each other. And in this sense, there is no innocent play, no innocent laughter. There is always a resistance in play, always a polemical tension, always an *agon* or an unsettlement that concerns the fundamental conflict between *potestas* and *potentia*, 'between creative power and its exploitation'.[46]

Although not innocent, the play may start anywhere, in any in-between, as is the case in René Clair's *Entr'Acte* (1924),[47] anywhere where there is a spirit of unsettlement. A veritable play between life and death, the film was originally screened in between the two acts of the performance *Relâche* (*Release*) of the *Swedish Ballet* in Paris. Already in the opening scenes, a piece of death-bringing artillery is playfully animated, releasing a highly ambiguous fire,

a blast of metropolitan crowds, traffic jams, cascades of lights, diagonal movements, no less than a swarm of activities, which also takes residence in the human head. There is in the film a continuous power play, boxing punches interlaced with the pirouettes of a ballerina, a precarious rooftop chess game passing on to a hunter taking aim with his rifle pointing it alternately at us and at an elusive cinematic target. Soon, the hunter is himself transformed into a target, eventually leading to his fatal fall.

In *Entr'Acte*, death is not absolute, but accompanied by the liveliest of funeral escorts, commanded by a camel and followed by a train of running men and women, moving forward in an exaggerated, leaping manner, trotting forward, initially in slow motion, but as the hearse runs off on its own, the accompanying crowd gathers momentum, chasing death as it races through an increasingly fragmented and multi-layered urban landscape. Excitement rises as the frequency of clips is intensified and the combination of sequences becomes progressively more arbitrary. A rollercoaster trip is superimposed on top of industrial skylines, cut off by foliage sweeping by, by running legs, by bits of the road, all of which results in a visual frenzy, which eventually comes to a halt when the coffin falls off the carriage and ends up in a meadow. As the followers catch up, the lid opens and the killed rifleman jumps out, now equipped with a magic wand with the help of which he annihilates the band of people, including himself. The life mocking game then starts all over again as a person (the director?) breaks through the capital *FIN* in order to kick off an inanimate body in the street, only to disappear into cinematic space as the torn screen is magically patched and sealed.

Entr'Acte could be seen as a fantastic concoction of dream images with no or highly arbitrary meaning. At the same time, it clearly addresses the complex and competing forces of life, as Kracauer suggested, acknowledging physical reality 'in toying with it'.[48] And eventually, this 'toying' with reality, or with the construction of reality, through film, develops into something more than an exercise, something more than an experiment with all the moves and turns that the device of the camera and the cinematic medium allows for. It opens out onto a field of possibilities, a recombinatory multiplicity that we could call *anagrammatic*.

A word play bringing out the multiplicity that resides even in the most controlled of structures, the *anagram* is the 'transposing of the letters of a word or group of words to produce other words that possess meaning'.[49] Preferably, the reconfigured outcome should bear some logical relation to the original, which is why anagrams, as relational to their character, historically are thought to have heuristic effects, revealing the hidden possibilities that are woven into a certain order. Yet the most important function of the anagram is its actualization, through play, of the material working conditions of linguistic practice, and the vast potentials that linguistic activity always hold.

Accordingly, film makes it possible to approach the city in an anagrammatic way. Film deconstructs urbanity into pieces, cascading its potentials out, even teasing the life out of it, or charming out its multiplicities of meaning. This is the exciteable mode of operation in Clair's *Entr'Acte*.

A more contemporary, equally playful, at the same time more violent example would be Mike Figgis' *Time Code* (2000) – a film that also presents the multiplicity of forces and options at work within a given spatio-temporal setting. Figgis' film is furthermore a film about film-making; a self-referential yet anagrammatic play with film production; a micro-physical playing off of urban and social conditions against each other. This play is most explicitly exposed through the double split screen, which creates the possibility to project four images simultaneously. Each of these images was shot in a single, long continuous take, although synchronously, so that you follow the same course of action from four different perspectives. As some light earthquakes take place, this synchronicity becomes very conspicuous, causing all four images to quiver and the people to take shelter or concurrently react in different ways, even transgressing the framework in an uncontrolled move from one image field to another. As Helmut Draxler has pointed out, this makes explicit 'the dense interlocking of structure and content in the film',[50] an interlocking that could be described as both urban and bio-political. Yet even though the film presents a pan-optical logic, it also unfolds as an anagrammatic exploration of the new media economy, recombining its different gazes and 'toying with' its techniques of domination and control.

If Figgis' film presents a dystopian anagram, Michel Gondry's *Be Kind Rewind* (2008) provides a more cheerful anagrammatic course of action. Set in a mundane video-store somewhere in a drained post-industrial cityscape, the film tells the story of how the two shop assistants, after having accidently de-magnetized all the soon-to-be-superfluous VHS-tapes, decide to undertake the 'mission impossible' of re-enacting, or as they say 'sweding' the films – or in other words remaking them by themselves, with a low budget and a crew from the neighbourhood.[51] Re-staging the plot of movies like Ghost Busters or Rush Hour in their own local environment, they manage to re-configure and re-appropriate not only representational agency and narrative potentiality, but also the social infrastructure of what has become an inconsistent and eroded architectural landscape. Instead of critically dismissing the entire setting, Gondry's 'extras', grassroots of the media culture, throw themselves into the same, thus in an unprejudiced way 'toying with' what seems to be its implacable presuppositions. What comes out are new urban constellations, new spatial potentials, and also eventually a more distributed, collaborative and continuous locality production based upon a playful do-it-yourself performativity. With its humorous approach, furthermore explicitly disrespectful of copyrighted formats, Gondry's tactics has already generated what almost amounts to a 'sweding' movement, an anagrammatic activism of considerable magnitude.[52]

It is not difficult today to encounter film-makers who make use of similar anagrammatic tactics, turning the premises both of the film industry and the urban order inside out. Some, like Swedish director Roy Anderson in *Songs from the Second Floor* (2000) and *You, the Living* (2007), explicitly experiment with a recombinatory and self-referential practice with tragicomic undertones, in this way indirectly articulating a biting societal critique. Another similarly Swedish example is offered by Ruben Östlund, who in his recent, prize-awarded film *Involuntary* played off five everyday micro-situations against each other, all of which

within themselves constituted more or less cynical power plays, and which, taken together and in different ways intertwined, furthermore provided an adventurous travel into the bio-political workings of life as it is lived.

5. Conclusion: *Uncoil Cons*

In his despise of normative cinematic practice, Guy Debord dismissed what he saw as cinema's blandishing of bio-political effects: "'People who love life go to the cinema'. But this life and this cinema are equally paltry, which is why it hardly matters if one is substituted for the other'.[53] The form of cinema that Debord despised was, as he expressed, 'a deranged imitation of a deranged life', a media-industrial product capably designed, yet communicating nothing, serving only as a circular 'boredom with a reflection of that same boredom'.[54] His answer to the pressing situation, even though not exaggeratedly cheerful, could be described in terms of play: 'Like lost children', Debord declaims, 'we live our unfinished adventures'.[55]

In the previous, I have aimed to actualize what I see as the creative or even artistic potential of cinematic practice in relation to or as a part of a ubiquitous and bio-politically governed urbanity. In relation to a situation where urban space to an increasing extent is produced and reproduced in and through mass-media, and where the media is not only the clear-cut 'message', but rather a form of long-range, decompressing 'massage',[56] cinema may also provide room for resistance, space enough for the development of tropes and turns enabling us to slip out of even the most modifying and pacifying treatment.

Today, it is essential that art, including also cinematic art, not only contemplate but actively engage in probing all of its material means and sensory tactics in order to confront what can be described as the nihilism of power. The faith we can have in cinematic practice today in relation to urban space is in this respect neither related to its potential transgression of representational limits, nor to its ability to animate the most carceral of urban environments. We cannot rely solely upon cinema to burst our trivial commonplaces 'asunder' to offer us comfortable and virtual trips to an authentic Beyond. Instead, our faith is associated with the ability of cinematic practice to make present the bio-political apparatus and to release its inherent potentials, to uncoil its latent cons and tricks: all that 'tangle of unresolved relationships and fatal ambitions'[57] inherent to complex, urban life.

No matter how animated or real, what the cinema most clearly demonstrates is 'that life itself can never be authentic, that producing exemplary authenticity is instead one of the foundational myths of the modern understanding of art'.[58] Regardless of whether authentic life is looked for in subjectivity, or in self-referentiality, in the direct encounter with 'everyday life' or in the perfection of a certain formal approach, there will always be loopholes or leeway enough as to reconfigure and thus also 'revitalize' a given order.

The contribution that bio-politics can bring to the discussion on urban cinematics is therefore threefold. First of all bio-politics can contribute to the problematization of the notion of *life*, both in relation to urbanity and as regards the cinema, of life not as an inherent

quality to be represented, but as a performative dimension or a function of *the capacity to act*. Secondly, bio-politics actualizes the importance of self-referentiality. In a situation where power has become dispersed, interlaced and to a large extent incorporated through a an all-pervasive regime of mass-mediation, the potential counter-forces have to be sought for through a radical, 'cinematic' situating of the self and its practices *from within* a given order, thus developing a form of *savoir-vivre*, a qualified way of living 'despite all'. Thirdly, film presents a new field of recombinatory *play* – of 'toying with' but also confronting various forces; of anagrammatically exhausting possibilities; of playfully attacking urbanity 'at its extremities', where it conducts its grip: 'at its outer limits',[59] where its sense borders on nonsense. As an anagrammatic play, cinema may in paradoxical ways also transgress its own inherent order, involuntarily exposing what Benjamin described as the disregarded dimension of the 'slip of tongue'.[60] While before the cinema, such slithering would have passed more or less unnoticed, it may today reveal hidden mechanisms as well as release unexpected forces.

Perhaps it is fair to say that with the assistance of the filmic medium, urban space has managed to rub a heavy sleep out of its eyes in order to face itself, its conditions, its potentials and limitations. At the same time, newly awakened and thoroughly rested it has returned the favour through the incorporation of the cinematic, through the transformation of cinema into its own system of oxygenization. In this sense, the cinema has come to transgress its representative duties to interfere with the very life and survival of the city in a very concrete and manifest way.

What ultimately comes forward is thus not simply the animating flash of a cinematic effect. Instead, the ambiguous force of cinema may be an indication of a new societal order or a new urban *dispositif*, where *life* – both in its most precarious and its most mundane forms – constitute the new foundation for the exercise of power, for the exertion of influence *and* for the delivery of transformative or empowering affects.

References

Agamben, G. (1998), *Homo Sacer: Sovereign Power and Bare Life*, Stanford: Stanford University Press.

—— (2007), *Profanations*, New York: Zone Books.

Anagram (2009), 'In *Encyclopædia Britannica*'. Download date 7 December 2009, from Encyclopædia Britannica Online: http://search.eb.com/eb/article-9007328.

Bazzicalupo, L. (2006), 'The Ambivalence of Biopolitics', *diacritics*, 36:2, pp. 109–16.

Benjamin, W. (1936/1999), 'The work of art in the age of mechanical reproduction', in Hannah Arendt (ed.) *Illuminations*, London: Pimlico.

Baines, P. (2005), *Penguin by Design, A Cover Story 1935–2005*, London: Penguin Books.

Bataille, G. (1970), *Œuvres Complètes I: Premiers écrits 1922–1940*, Paris: Gallimard.

Baudry, J.-L. ([1985] 1992), 'The Ideological Effects of the Basic Cinematographic Apparatus', in G. Mast, M. Cohen and L. Baudry, (eds), *Film Theory and Criticism. Introductory Readings*, New York: Oxford University Press, pp. 302–312.

de Certeau, M. (1984), *The Practice of Everyday Life*, Berkeley: University of California Press.

Debord, G. (ed.) ([1964] 2005), 'Contre le cinéma' (Facsimile), *Oeuvre cinématographique complète*, Paris: Gaumond.

—— (1961), *Critique de la separation/Critique of separation*, Paris: Dansk-Fransk Experimental filmskompagni.

Didi-Huberman, G. (2009), 'People exposed, people as extras', *Radical Philosophy*, 156, July–August 2009, pp. 16–22.

Draxler, H. (2003), 'Ohne Dogma. Mike Figgis "Time Code" als Allegorie der Gesellschaftlichen Fabrik"'/"'Against Dogma. Mike Figgis "Time Code" as an Allegory of the Social Factory', in Marion von Osten (Hg.), *Norm der Abweichung*, Zürich, S. 139–157, available at *Avantgarde Film Biopolitics*, http://www.b-books.de/jve/. [download date 2009-12-02].

Duhamel, G. (1930), 'Déjà, je ne peux plus penser ce que je veux. Les images mouvantes se substituent à mes propres pensées', *Scènes de la vie future*, Paris: Mercure de France, p. 52.

Elsaesser, T. (2004), 'The New Film History as Media Archaeology', *Cinémas: revue d'études cinématographiques/Cinémas: Journal of Film Studies*, 14:2–3, pp. 75–117, <http://id.erudit.org/iderudit/026005ar>. Accessed 2 December 2009.

Farocki, H. (ed.) (2001), 'Workers Leaving the Factory', *NachDruck/Imprint, Texte/Writings*, Berlin: Verlag Vorwerk, New York: Lukas & Sternberg. Available at <http://archive.sensesofcinema.com/contents/02/21/farocki_workers.html>. Accessed 15 February 2010.

Feld, S. (2003), 'Editor's introduction', in Jean Rouch (ed.), *Cine-Ethnography*. Minneapolis, MN: University of Minnesota Press, pp. 1–25.

Foucault, M. (1993), 'About the Beginning of the Hermeneutics of the Self' (transcription of two lectures in Darthmouth on 17 and 24 November 1980, Mark Blasius (ed.)), *Political Theory*, 21:2, May, pp. 198–227.

Geene, S. (2006), 'I like your life (more than mine)', Manuscript for Avantgarde, film, biopolitics, – a project organized by Sabeth Buchmann, Helmut Draxler, Stephan Geene, Jan Van Eyck University, URL: <http://www.b-books.de/jve/eyck-i-like-your-life.html>. Accessed 5 December 2009 [download date 2009-12-02].

Giddins, G. (2002), 'Still Curious', *Criterion Collection*, URL: <http://www.criterion.com/asp/release.asp?id=180&eid=283§ion=essay>. Accessed 20 November 2009.

Guyer, P. (2007), '18th Century German Aesthetics', *The Stanford Encyclopedia of Philosophy* (Winter 2003 Edition), Edward N. Zalta (ed.), URL: <http://plato.stanford.edu/entries/aesthetics-18th-german/#SchResKanAesGraDigAesEdu>. Accessed 7 December 2009.

Hellström, M. (2006), 'Steal This Place: The Aestehtics of Tactical Formlessness and the Free Town of Christiania', Doctoral Thesis, Alnarp: SLU, Department of Landscape Planning.

Kracauer, S. (1960), *Theory of Film – The Redemption of Physical Reality*, London, New York: Oxford University Press.

Kuleshov, L. (1974), *Kuleshov on Film. Writings*, (Selected, trans. ed. Ronald Levac), Berkeley: University of California Press.

Lemke, T. (2002), 'Foucault, Governmentality and Critique', *Rethinking Marxism*, 14:3, pp. 49–64.

Luoma-Keturi, S. (2003), 'Mellan rummen – en studie i Gilles Deleuzes kritik av filmens representationsontologi'/'In Between Spaces – a study in the ontology of representation of Gilles Deleuze', Doctoral dissertation, Stockholm University, Department of Film Studies.

Marker, C. (1983). *Sans Soleil/Sunless*, Argos Films.

McDonough, T. (2007), 'Calling from the Inside: Filmic Topologies of the Everyday', in *Grey Room* 26, pp. 6–29.

Morin, E. ([1962] 2003), 'Chronicle of a Film', in Jean Rouch (ed.), *Cine-Ethnography*, Minneapolis, MN: University of Minnesota Press, pp. 229–265.

Penz, F. (2007), 'The Notion of Creative Geography Contrasted with the Concept of Topographical Coherence in Films – the Case of Rivette's *Pont du Nord* and Rohmer's *La Femme de l'Aviateur*', in Andrew Webber and Emma Wilson (eds), *The Moving Image and the Modern Metropolis*, London: Wallflower Press.

Simmel, G. ([1903] 1997), 'Metropolis and Modern Life', in M. Featherstone and D. Frisby (eds), *Simmel on Culture*, London: Sage.

Sjöman, V. ([1967] 1968), *I am Curious Yellow/Blue*, Sweden: Sandrews.

Toscano, A. (2003), 'Art Against Empire: On Alliez and Negri's "Peace and War"', *Theory Culture Soociety*, 20:2, pp. 103–108.

Travers, J. (2000), 'Entr'acte', *Filmsdefrance.com*. <http://filmsdefrance.com/FDF_Entre_acte_rev.html>. Accessed 3 December 2009.

Vaneigem, R. (1967), *Traité de savoir-vivre por les jeunes generations*, Paris: Gallimard.

Wennö, N. (2008), 'Drömmakare som vägrar ge upp'/'Dream maker who refuses to give in', *Dagens Nyheter*, 20 April .

Notes

1. See Lev Kuleshov (1974), pioneer of montage, for whom editing amounted to a 'creative geography'; and Penz, François (2007).
2. Luoma-Keturi (2003: 182).
3. Simmel ([1903] 1997: 185). See also Hellström (2006: 179).
4. Kracauer (1960: ix).
5. Kracauer (1960: ix).
6. Benjamin (1936: XIII).
7. Kracauer (1960: 28).
8. Elsaesser (2004: 76).
9. Elsaesser (2004: 76).
10. This reflection of Elsaesser also refers back to Benjamin, who famously quoted French author Duhamel, George (1930); See Benjamin (1936: XIV) and Elsaesser (2004: 113), footnote 3.
11. In *Homo Sacer: Sovereign Power and Bare Life* (1998) Giorgio Agamben developed and discussed how law has been used to identify and separate bare, naked life, *zoe*, from qualified life, *bios*, at the same time distinguishing political beings or citizens from mere bodies. See Agamben (1998). See also Bazzicalupo (2006).
12. Draxler (2003).
13. Bazzicalupo (2006: 109).
14. Foucault ([1997] 2003: 12).
15. See Lemke (2002: 52) and his discussion of Foucault's (1993).
16. Foucault ([1997] 2003: 241).
17. Foucault ([1997] 2003: 240).
18. Foucault ([1997] 2003: 241).
19. Foucault ([1997] 2003: 241).
20. Foucault ([1997] 2003: 243).
21. Benjamin (1936: XIII).

22. See Draxler (2006).
23. Didi-Huberman, 2009:18.
24. I am here referring to the video montage by Harun Farocki, *Arbeiter verlassen die Fabrik* (*Workers leaving the factory*, video, 37 minutes, b/w and colour, 1995; a montage transformed into an installation on several screens – *Workers Leaving the Factory in Eleven Decades*, 2006, exhibited at Raven Row, London, 19 Nov 2009 to 7 Feb 2010.
25. velina, Italian, literally tissue-paper. Yet in a media context the most appropriate translation is perhaps 'cheer-leader'. See Erik Gandini's documentary on Berlusconi's Italy, *Videocracy* (2009).
26. Duhamel quoted in Benjamin (1936: XV).
27. In his essay 'Workers Leaving the Factory', Harun Farocki discusses the impact of the Lumière Brothers' sequence as a rhetorical figure. See Farocki (2001).
28. Farocki (2001).
29. Feld, (2003: 13).
30. Morin ([1962] 2003: 230).
31. Morin ([1962] 2002: 231).
32. The founder of the so called 'apparatus theory', Jean Louis Baudry, referred to self-referentiality in Vertov in terms of 'revealing the mechanism' (Baudry J.-L 1992: 302–312). See also Draxler (2003).
33. Film soundtrack, Guy Debord (1961).
34. See Guy Debord (1961) and Vilgot Sjöman ([1967] 1968).
35. Giddins (2002).
36. Soundtrack, Marker (1982).
37. Debord ([1964] 2005).
38. Film soundtrack (1961).
39. McDonough (2007).
40. See McDonough (2007: 25). Michel de Certeau makes a similar distinction between operations and movements that are '*topological*, concerning the deformation of figures, rather than *topical*, defining places' (Certeau 1984: 129).
41. See Vaneigem (1967). See also Hellström (2006: 247–252).
42. Apparently influenced by Foucault's work on the clinic, Vaneigeim talks about '[…] une foule de petites hypnoses' (Vaneigem 1967: 15). See also Hellström (2006: 249).
43. See Foucault's 'Preface' (Bataille 1970: 5).
44. Bataille in 'Le labyrinthe' (Bataille 1970: 440). See also my previous discussion in Hellström (2006: 245).
45. Schiller's aesthetic theory posited that we are driven on the one hand by a 'form drive' and on the other by a 'sensuous drive', but that we also need to cultivate a new drive, the 'play drive', which would bring the two others in balance with each other, 'to preserve the life of sense against the encroachments of freedom; and second, to secure the personality against the forces of sensation' (Guyer 2007).
46. Toscano (2003: 105).
47. *Entr'Acte* was based upon a scenario by Francis Picabia, produced by Rolf de Maré, with choreography by Jean Börlin. The music score for both the ballet and the film was composed by Erik Satie.
48. Kracauer (1960: 183).
49. anagram (2009).
50. Draxler (2003).
51. The concept of 'sweding' does not necessarily have anything to do with Sweden but was randomly chosen as a notion 'that meant nothing but still sounded cool'. Gondry interviewed by Nicholas

Wennö in the major Swedish newspaper *Dagens Nyheter*, 20 April 2008. In the film, however, it has the connotation of 'quality and high price'.

52. There are today several thousands of 'sweded' movies to be found on YouTube.
53. Soundtrack, *In ignis girum*
54. Soundtrack, *In ignis girum*
55. Soundtrack, *In ignis girum*
56. The 'medium' is, as Marshall McLuhan pointed out, *not* equivalent with the message, which would reduce it to a pre-coded and exclusively representative system. This is also why McLuhan chose to change the title of his seminal book from 1967, a change that also has an (almost) anagrammatic background. As his son retells the story, '[…]the title was a mistake'. When the book came back from the typesetter, it had on the cover 'Massage' as it still does. The title should have read 'The Medium is the Message', but the typesetter had made an error. When Marshall McLuhan saw the typo he exclaimed, 'Leave it alone! It's great, and right on target!' Now there are four possible readings for the last word of the title, all of them accurate: 'Message' and 'Mess Age', 'Massage' and 'Mass Age'. See Eric McLuhan in Baines (2005: 144).
57. Draxler (2003).
58. Draxler (2003).
59. Foucault ([1997] 2003: 27).
60. Benjamin (1936: XIII).

Chapter 15

Reconsidering Cinematic Mapping: Halfway Between Collected Subjectivity and Projective Mapping

Marc Boumeester

Introduction

Connected to the research described in *Understanding the Socius through creative mapping techniques* (Graafland 2008), a long-term research and educational programme was set up by the Delft School of Design, faculty of Architecture at the Delft University of Technology in the Netherlands, to investigate whether and how videography could play an additional role in the exploration, registration and understanding of urban environments. The programme started with a design studio called 'Camera Eye' as described extensively in *The Body in Architecture* (Hauptmann 2006). This and subsequent projects clarified how to apply moving images in urban mapping, and show why it is helpful to start with the notion of *collected subjectivity* as a guideline in this quest. With this is meant the method of collecting video footage that was produced by a number of individuals or groups without much orchestration, but with a very specific artistic approach and a clear identification of the site-specific conditions, in order to create an 'objective' depiction of those urban settings. Particular interest was drawn towards the development of a methodology that would apply videography as part of a mapping process and that was in itself comprehensible enough to be transferred, solid enough to be operated in remote places, and thorough enough to lead to repeatable and comparable results.

Suppositions

Building on James Corner, Arie Graafland (2008) uses four primary mapping techniques as a starting point (*Dérive, Layering, Game-board and Rhizome*) and clarifies how these methods philosophically and theoretically interlink with specific site analysis and design in his book *The Socius of Architecture* (Graafland 2000). It was clear that a direct implementation of the moving image in or on top of these techniques would not automatically function properly. So the first challenge was to find a method of translation that would enable us to apply the moving image in the framework of an intellectual and cognitive setting, as well as to develop the procedures in order to link to the site-specifics, without necessarily taking over the functionalities of other media, such as cartography and photography.

For this purpose we needed two suppositions. One, theory should come first. Starting this trajectory without exploring the analogies in constructing film and architecture and the corresponding interchangeable notions of rhythm, structures, space and time would

have been completely wrong. Two, we made a very clear distinction in what could be called its happening 'In the screen' and its happening 'On the screen'. This notion refers to the fundamental distinction between the perception of moving image as being a fixed and static object, which can be studied but cannot be altered (on the screen) and working with moving image while being able to create and alter the images and sounds (in the screen). I will address this distinction below, as it is a vital element in my argument on how to reach a state of projective mapping.

When working with mapping techniques, the first issue that arises is the matter of objectivity. To what degree will the mapping process lead to an objective representation, and is the process intended to do so? How will the different types of media relate to each other in this process, and which media type performs best in this process? Noël Carroll regards Arnheim's *specificity thesis* as a proposal: 'As a recommendation, the specificity thesis appears to have two components. One component is the idea that there is something that each medium does best. The other is that each of the arts should do what differentiates it from the other arts. These two components can be called the excellence requirement and the differentiation requirement' (Carroll 1988: 57).

With this notion in mind, it was clear that using video – produced according to some of the basic rules of cinematography – as a mapping tool should not compete with the other techniques, especially when it comes to objectivity and completeness, and it should utilize its unique features such as the ability to manipulate time, the ability to show motion, the ability to change orders and the ability to switch between linearity and non-linearity. Eventually the path we took developed itself along the following line: objectivism, mapping, structuring, gridding, zoning, collecting, sensing and collected subjectivism. Some of these stages will be briefly addressed.

Gridding

The first strategy put into practice was that of *gridding*, meaning that firstly the group of researchers were distributed into smaller groups that were to *videomap* a given area in an unknown foreign city according to a specified set of instructions (a grid). Groups were connected to specific topics like infrastructure, boundaries, mobility, economy and housing, and would produce videomaps that were strictly limited to their particular theme. By combining the different maps, we would ideally get a collectively constructed and complete map of the area of interest. Note that *gridding* is connected to *layering*, but differs (among other aspects) because it is applied in a descriptive and outside-in way and not as a projective inside-out method. This is because we are not physically making an intervention – we only take in and leave no marks (outside-in) – as opposed to designing interventions that actually alter the specific setting (inside-out). This method had the advantage of being easy to use and clear in its instructions, but missed the very necessary depiction of context, relations and interdependencies. A railway line crossing a rural area obviously has a

substantial impact on its surrounding, but this effect would not be made visible by applying only this method. Meticulously summing up the parts might be precise and full of detail, but this will not necessarily lead to a better understanding of the whole. In addition to this, it proved hard to make a balanced presentation of the different approaches; combining them in one film raised the question of priority (due to the linear structure), and using multiple projections dispersed the attention of the viewer and required a meta-editor with a strong vision on what to present, which again took away much of the diversity.

Zoning

The next strategy was connected to the *game-board* theory and was referred to as *zoning*. By differentiating the usage of different urban areas and places, we distinguish their function on a different level. We will see the city map being built up out of corridors, hubs, transistors, collectors and transformers. If, for example, we would look at a railway station in relation to the quality of 'movement', its primary character would be that of a transformer (turning pedestrians into passengers, train passengers into bus passengers, etc.), which would connect several corridors (roads and tracks). A bus stop could be regarded as a collector and a warehouse, a transistor (keeping people in for a certain amount of time). To focus on these parts, their function, and the effects on their surroundings and on the urban conditions at large, we will be able to produce a (video)map that will be comparable to similar maps made of different cities or places, regardless of their geographic situation, cultural background or size. It also allows us to compress or skip less interesting areas in the way we would do if we wanted to map a subway system. In line with this method, an attempt was made to compare three cities (London, Paris, Amsterdam) by mapping their performance at three different times during the day, and see how all the hubs, corridors and transformers handled the morning, noon and evening rush hours. The level of abstraction was necessary to make the cities comparable. The question was not how many cars, buses, train and other forms of transport were using the networks, but how well the network handled the amount of traffic. It is like translating exact figures into percentages. The disadvantages were of course this level of abstraction, which was not always compatible with other types of maps and the loss of scale, which took away elementary information as in 'what are we talking about?' By looking at various functionalities (hubs, corridors, etc.) of the different elements (buildings, areas, etc.) on multiple levels (transport, economy, etc.) in relation to their position in the hierarchy of the urban setting, hidden structures may become clear. This contributes to the understanding of the complex force fields that determine this hierarchy, and thus comes within reach of the game-board theory.

Provisional conclusions

After having passed these stages some provisional conclusions should be made:

(1) Videography did not prove to be able to be a self-supporting, objective and complete mapping tool.
(2) Videography excelled in portraying the 'soft side' of mapping, beautifully described by Jonathan Raban in his book *The Soft City* as 'The city as we imagine it, the soft city of illusion, myth, aspiration, nightmare, is as real, maybe more real, than the city we can locate on maps in statistics, in monographs on urban sociology and demography and architecture' (Raban 1988: 10).
(3) Videography could not be made into a useful mapping tool without authorship.

Fragmentation

In order to complete the next transition, we should look at some specific qualities in what I refer to as the 'Agency of Moving-Image'. As we are not looking at the production of cinema in the classical way, where the premises would include the ability to shape and reshape the surroundings for the purpose of making the film, I would rather avoid the term constructing when looking at these intrinsic qualities. One could argue that the connecting meta-quality of moving images is the ability to fragment. For this purpose we could define fragmentation as *creating the whole by the collection of its fragments*, as opposed to defragmentation where we *create the whole by the assimilation of its fragments*, a classification open for discussion, but I would like to propose it because it is at least compatible with Rancière's scale of montage, where he puts dialectic montage on one end and symbolic montage on the other when he makes the following description:

> The dialectic way invests chaotic power in the creation of little machineries of the heterogeneous. By fragmenting continuums and distancing terms that call for each other, or, conversely, by assimilating heterogeneous elements and combining incompatible things, it creates clashes. And it makes the clashes thus developed small measuring tools, conducive to revealing a disruptive power of community, which itself establishes another term of measurement [...] The encounter therein of incompatible elements highlights the power of a different community imposing a different measure; it establishes the absolute reality of desires and dream [...] The symbolist way also relates heterogeneous elements and constructs little machines through a montage of unrelated elements. But it assembles them in accordance with the opposite logic. Between elements that are foreign to one another it works to establish a familiarity, an occasional analogy, attesting to a more fundamental relationship of co-belonging, a shared world where heterogeneous elements are caught up in the same essential fabric,

and are therefore always open to being assembled in accordance with the fraternity of a new metaphor. (Rancière 2009: 56–57)

We argue that 'The Agency of moving image' has three types of fragmentation that it uses most, but it should be noted that no single type could exist in a pure form. In all cases, one of the types will serve as the leading type, whereas the others will serve as functions of this leading type. There are some films I would like to use as examples, but I am very aware that we will not be able to recreate these elaborate stylistic pieces within the frame of our research. It does serve a purpose nevertheless, because it also tries to close (part of) the gap between theoretical analysis and practical fieldwork.

1. Fragmentation of time: Whether we approach it from Marker's perspective 'Nothing sorts memories from ordinary moments. They claim remembrance when they show their scars' (Marker 1963) or take the *Irréversible* (Noé 2002) motto 'Le temps détruit tout' (time destroys everything), it is clear that moving images provide an opportunity to arrange, rearrange, fragmentize, de-fragmentize, order, sequences, speed up and slow down time on an unchallenged level. We will look at some elements of this in the section on representation and production.

2. Fragmentation of memory: A usable definition of narrative cinema could be *the reconstruction of a fictitious memory*, but as I carefully try to avoid any connotation with heavily loaded architectural notions of (de)construction, we could rather speak of *the creation of a fictitious memory*. Note how I name this memory non-specific. A memory, not 'The memory'. The completion of the depiction takes place in the mind of the viewer. The subjective view of the director will have to transform into the subjective state of his public. If we look at a film like *L'Année dernière à Marienbad/Last Year in Marienbad* (Resnais 1961), all types of fragmentation are aligned to serve the main theme: creating a fictitious memory by fragmentation. According to Bruno, 'The film is an architectural exploration of a memory, perhaps held as a shared space between two people' (Bruno 2002: 39). Carroll states that it is not a film at all; it is a film about films, which calls for the title *meta-cinema*, mainly because it does not adapt to the system of erotetic narration (i.e. the narrative does not answer the why-question):

> That is, by frustrating our expectations in these matters, the plot arouses in the viewer the recognition that we are accustomed to having all of our pressing questions about the storyworld answered before the lights go up in the auditorium. By subverting these expectations, we are brought to an awareness of the way in which these expectations enable us to follow and organize the motion picture as it unfolds. (Carroll 2008: 142–143)

We could classify narration as a form of – scientific – explanation and follow Kourany in distinguishing three conceptions of explanation: an interferential explanation (i.e. the explanation would follow a logical argument), a causal conception (i.e. the explanation

would have a causal nature) and the already mentioned *erotetic* notion (i.e. the explanation answers a proposed why-question) (Kourany 1987). But if we would apply Rancière's notion of dialectic montage within the frame of our quest, we could easily reach the conclusion that we do not need erotetic narration or even any kind of narration at all to create an *absolute reality of desires and dreams*. We would be talking on a totally different platform in a totally different language where the traditional narrative has no effect.

3. Fragmentation of space: There are numerous films where we can see the function of architectural conditions represented very clearly. Its function as a medium, that is, because stripped from their third dimension these conditions can no longer provide a physical interaction with the audience of the medium. In no way can we recreate any of the practical aspects of any three-dimensional object, nor its aspects in terms of these functionalities. The only architectural conditional elements that can be represented in two-dimensional moving images are those that are connected to the way in which they are interacting with the *inhabitants of the moving image*, which in our case could be the actual users of the space we are recording, and in the case of a motion picture these would of course be the actors and extras. As soon as we have recorded an architectural or urban condition, it obviously loses all its spatial and dimensional functions, but even in the process of recording we are not so much interested in these functions. All qualities connected to its volume and spatial structure function merely as manoeuvring space for the camera or manoeuvring space for the inhabitants. We just have to remind ourselves how carefully Hitchcock recreated his housing block for *Rear Window* (Hitchcock 1954) in order to give the camera maximum manoeuvrability, as is described in great detail by Pallasmaa in his *The Architecture of Image* (Pallasmaa 2009). For all we care, it does not have to exist at all. Add to this the ability to create any *given suggestion of a spatial structure* in the editing phase and it is clear that there is no use in being true or precise in the depiction of such conditions, although their very nature – purely through their physical state – would demand this. In other words, we can only involve architectural conditions on an equal basis in our moving imagery, if we regard them solely as a medium. Note that this would bring us in conflict with the suppositions made in the *specificity thesis*. We then can start transferring some of the typologies of two-dimensional media onto architecture and start combining their values working on the same level.

We will take two films to exemplify this, which have a very strong mutual connection (even the name is the same), but differ in the way they utilize fragmentation of time and space in order to strengthen the storyline (although there might not be any traditional storyline present). Where Alan Clarke's *Elephant* (Clarke 1989) uses the spatial structure of urban Northern Ireland to silently comment on a very violent social drama, Gus Van Sant's *Elephant* (Van Sant 2003) uses the spatial architectural structure of the Columbine high school to create a psycho-sociological depiction of a specific group of young people. The inevitable spatial and temporal intertwining of the lives of these people creates situations that not only exemplify the almost banal normality of their lives (which could be seen as

one of the leading motives of the film), but also push the architectural structure forward as a major player in the organization of their physical and mental states. It functions as the labyrinth that connects, divides, protects, conceals, attacks and, ultimately, kills. The structure carries the pretence of uniting its inhabitants, but in fact isolates and estranges them. Clarke uses his (urban) structure in a different way. By using ordinary settings and keeping them deliberately empty and tranquil, he also amplifies the banal nature of this normality, but with a different purpose. His structures function as hunting grounds, where anonymous victims are being killed by anonymous hunters. The feeling of inescapability is greatly exaggerated. Where the structure has an independent character in Van Sant's film (almost like an entity), Clarke's structure gets its role by totally blending into normality. In contrast to the carefully applied fragmentation of time in Van Sant's *Elephant*, where every scrap of time frame is meticulously glued together at key scenes and other essential marks, Clarke's *Elephant* shows his scenes in a blunt serial order. He does not even use sequencing to accentuate relations or crosscutting to indicate the volume of the events, nor does he attempt to give any explanation of their order in a temporal or sequential way, he just shows series. Van Sant uses the repetition of exactly the same moment – seen from different perspectives – as an amplifier of 'his' normality. As the events have already taken place, Van Sant can utilize these time frames in a different way. His time is precisely defined and possesses an intrinsic inescapability, whereas Clarke's time has a random and open nature. Yet inescapable nevertheless.

But regardless of the different ways time is fragmented in both films, the relation between the spatial structures and their *inhabitants* is made very clear and plays a key role in the understanding of the narrative, although the notion of narration is ambiguous. These relations are shown by using the spatial structure as a social reference in the film. In other words, the structure is not the direct subject (and nor is the architecture for that matter), but rather its *function* for the inhabitants. Essential in both films is the precise usage of the partial interchangeableness of time and *the suggestion of* space in film. Space gets the suggestion of volume by giving it time and movement, very well exemplified by the opening shot in Jennifer Baichwal's *Manufactured Landscape* (Baichwal 2006). Space gets the suggestion of dimensions by showing different angles. By observing the architectural conditions indirectly through the mirror of their function in relation to the inhabitants of our picture, we can show much more of their character than by approaching them directly. So, two directives can be found in the above. One, serial depiction of elements is a very mono-directional but highly effective way to convey multitude; parallel depiction is more effective to focus on structure. Two, architectural conditions will reveal their nature much more effectively if 'peeked at' through their relationship to their inhabitants, but for this we have to address them purely on their merits as medium.

Collected subjectivity

The presumption that we initially made was that all attempts to produce any kind of videography should be orchestrated beforehand and during the actual site surveys. But after the first series (*gridding and zoning*) it had become clear that the use of video did not necessarily add much clarity to this process, as other media had proven to excel in certain aspects of the mapping techniques. Apart from the already mentioned disadvantages, the practical boundaries of what could be done on this scale and with this limited equipment became more and more clear. The second paradigm shift consisted of the evolving awareness that the notion of conducting these experiments in a centralized and preconceived way had not proven to lead to better results. As many of our students were automatically drawn towards the same highlights and hotspots when they entered new and remote cities, the thus formed *illegal* footage proved to be a valuable addition in order to construct small self-supporting moving city maps, in which the harshness of the underlying strategy was being softened by the personal and often human-focussed additional footage. We realized that the dominant aspiration to rule out any form of narration, except that which was being generated by the strategy itself, blocked the better understanding of the social interaction and its human context. By allowing the loading of the *industrial and hollow* shell that was being created by the strategy, with very subjective and emotionally generated soft topics like human interaction and behaviour, the impact of the complex relationship between the built environment and the human actor became much clearer. By strictly applying the predetermined rules, a container for emotional content is created.

The last strategy that I will address here is that of *collected subjectivity*, which is probably nearest to the *Drift technique (Dérive)*, coined by the 'Situationists International' in the mid-1950s. It appears that the best approach so far was that of the use of the notion of collected subjectivity, which I have briefly summarized above. Although one could dispute whether the terminology is the most suitable, I strongly cling to the expression *collecting* rather than *combining*, as combining automatically implies making compromises and losing intrinsic qualities. To exemplify this I will describe the process surrounding an expedition in which Singapore played the lead role.

Singapore

The Singapore workshop distinguished itself not only by the high quality of the results, but also by its unique group configuration. Unlike the Newark, Santiago, Istanbul and Mexico groups in which teams were formed on the basis of *metier* (urbanists to the right, architects to the left or something similar), the Singapore group was divided on the basis of their individual artistic approaches and worked according to a set of guidelines. The first guideline was the steadily growing level of complexity in the assignments, which followed the line Single fixed images>sequenced imaging>moving image>sequenced moving image>sequenced moving

Stills taken from the Singapore project.

image with sound>designed sequenced moving image with multi-layered sound design. The second guideline was found by exploring some medium-specific features that were connected to the level of complexity of the assignments. The understanding of the nature and effect of these features was exemplified by showing the work of Chris Marker (research and dynamic mapping), Patrick Keiller (dynamic mapping and projective videography), Stan Brakhage (medium analysis), Matthew Barney (projective), Karl Heinz Stockhausen (sound architecture), Lars von Trier (medium analysis), Alexander Sokurov (volume – time conversion) and Guy Debord (dynamic subjective mapping).

After having completed the first series of preparations, it was clear that the group could be divided along the lines each participant used in response to the assignment. This resulted in the formation of four groups: the conceptual, the poetic, the narrative and the constructive. The narrative group could express itself best if they used a form of visual narration; the constructive group literally constructed its films in the editing phase, to a point where the content of the footage became subservient to the editing process. The poetic group constructed intuitive, almost esoteric, visual poems that were inspired by the site visits themselves, this in sharp contrast to the approach of the conceptual group, which precisely worked out all shots and editing plan beforehand and made sure they shot what they had intended. Part of the preparation for filming on location was the division of subjects – connected to the respective approaches – which helped to prevent the generation of double images. The general directive for all groups was not to strive for objectivity, but to *collect* their subjective visions on the topic. The four short films put across a clear and critical yet constructive notion of the *problematique* (the complex interrelatedness of different problems) of the given sites. The dynamics of the generated images – edited in a very style-specific way – in combination with the constructed *soundscapes* portray a highly intuitive and valid mental image, which runs quite well alongside the maps, drawings and statistics. When viewed sequentially, the individual and multi-angled character of the films adds greatly to the overall understanding, and contributes greatly to the explanation and exemplification of the proposed interventions that have been generated in the studio. The Singapore workshop marked the end of the development of this particular methodology, and its success proves it is ready to be used on a different scale.

The next and provisional final phase in the development of our methodology can now be defined. Authorship, indirect depiction of architectural conditions, no pretence or need for objectivity or completeness, no urgency for narration, and collecting on the basis of the individual perception all carry the familiar feel of the methods used by the Situationists International. But it would be far too simple to state that the next phase in videography would be no more than a *technified* version of the *dérive*. As Graafland clearly states:

One of the most important precepts upon which Situationism was based was that social progress did not subsume the individual, but instead had to maximize his or her freedom and potential. This precept linked Situationism (as a practice), and in specific the 'drift', to ideology and politics, something that is often overlooked in contemporary adaptations or

interpretations of Situationism. The drift is not just another way of microscopic attention to city life; we cannot strip it from its political content. Using it as another way to 'explore' the city is against everything the Situationists stood for, namely the revolution of the working class and an overturning of power. (Graafland 2008: 12)

As these particular political aspirations are not the primary motives for developing our videographic methodology, we have to make another connection.

The above-mentioned explosive increase in the ability to collect and to distribute moving images that has taken place (following the tracks of non-moving images) has given us opportunities to easily experiment with other types of mapping. If we could – for the time being – accept the notion that images are true in themselves – with this is meant the pure physical/digital image, with no connotation of any kind attached – we could regard the huge online social networked image banks (such as Flickr, YouTube, etc.) as multi-angled meta-mapping devices. As these data collections are so extensive in size, they are likely to comply with all sorts of statistical standards for manipulation, which would make them the true socially liberated agencies of mapping. Apart from all *Folksonomic* issues, we could – in time – simply navigate through a compressed non-formalized pre-selection of any given environment, registered by the highly subjective 'Eyes of the people' by applying our personal system of meta-tagging. Although this is a highly speculative thought, at this point there is no indication that such a system of collected subjectivism would function less well than any orchestrated form of audio-visual mapping. By allowing the collective to be the curators of their own work, including the choice of the way the different fragments were connected (think of the serial/parallel distinctions as described above), this mapping project becomes a significant part of the design process. The depiction the soft-sided context of the intervention proposals in all its variety, by reflecting the architectural conditions through their relations to the inhabitants of the moving imagery and by allowing the audience to complete the internal structure of the presentation by refraining from using an overall narrative, is perceived as a highly valuable form of cinematic aided design through projective mapping.

Future research

It should be clear that the results of this research formed the starting point from which many new directions can be taken. New outlines for future research have been drawn in which the use of moving image in relation to the *problematique* of mapping still plays a central role. But unlike the previous research we are not only focussing on mapping existing environments, but also trying to depict future conditions. Not in a way a designer or a planner does, but as an archaeologist of conditions still to come. For this we should reenter the level of the notions of what is happening 'in the screen' and what is happening 'on the screen', because not only do

they define the different approaches towards the theme, they also coincide and thus form a connecting element in which production and representation appear simultaneous.

This means that whenever we look at *architectural conditions* in cinema, we tend to look at them in terms of objects instead of functional subjects. Objects that play an important part in the depiction of the narrative structure, in the visual narration if you wish, but objects never the less. Objects being used as setting, decorum. Although it is clear that this distinction is very ambiguous, both in terminology and in interpretation, it is imperative to raise this question first, as most of the theoretical and practical research has been done in the setting of 'what is happening on the screen'. A film could be regarded as a finished product, an object that can be analysed, criticized and interpreted, but not altered. When we start depicting the urban and architectural structures for the sake of depicting urban and architectural structures *with a special set of directives*, then we can start looking at what is happening 'in the screen'. We then have made the essential transition from non-alteration to alteration. Now that we have found the road to getting 'in the screen', can we make sure to connect to both past and future, shaping and depicting future conditions simultaneously? For this we have to get a little deeper into representation and memory.

On representation and production

The same media are being utilized both in the depiction of the creation and in the production itself. We could claim that specific media would be appearing in different avatars. Under certain conditions, they would behave as a medium of creation; under other conditions they would act as a medium of representation. But of particular interest is the moment when a medium reaches both states simultaneously. Eisenstein exemplified a similar state by looking at:

> The principle of the hieroglyph – denotation by depiction – split in two: along the line of its purpose (the principle of 'denotation'), into the principles of creating literary imagery; along the line of its method of realizing this purpose (the principle of 'depiction'), into the methods of expressiveness used by Sharaku. And, just as the two outspreading wings of a hyperbola meet, as we say, at infinity (though no one has visited so distant a region!), so the principle of hieroglyphics, infinitely splitting into two parts (in accordance with the function of symbols), unexpectedly unites again from this dual estrangement, in yet a fourth sphere – in the theatre. (Eisenstein 1957: 35)

A medium such as photography functions as a peephole, an encrypting encoder with its distinct yet limited qualities. Both production and representation pass through the same *corridor*. The act of taking a photograph (and the presentation of it) requires the presence of a very distinct set of mental assumption and rules in both the photographer and the audience. Notions of the fixation of movement and time, the dislocation of physicality,

the counter-natural possibilities to analyse the subject in a one-way fashion (without the possibility to act or interact), and the removal of the third and fourth dimensions and others are all part of the code that belongs to this particular medium. This encryption process needs to be understood in order to be able to know what a photograph is, both in the process of producing and in representation. I do not mean the process of breaking through the *studium* by the emergence of a *punctum*, in the way Barthes distinguishes this, as we have not yet entered the level of the content of the image. But it is most likely that there is a correlation between the two systems.

As the production of the new is more and more limited to an automated process – based on the same encrypted code – the mental distance between the creation of a concept and the actual production of 'the physical' is getting smaller and smaller and its practical boundaries are getting more opaque. Therefore, fixed notions of the possibilities and limitations in physical production will shift towards a state of mental *Plattenbau*, based on the models that have been conceived on the basis of the encrypted codes brought forward by media of representation. Physical distances are increasingly being replaced by reproductions, which in their turn are being collected and transformed into archetypes. The same sources that connect and explore architectural conditions also simplify and standardize them. In other words, we could only produce what our mental models allow us to conceive, but if these models are created by perceiving the representation of what exists, it is clear that the production could in the end become reduced to being only the representation of the representation.

If we were to regard moving image in its state as cinema (on the screen) we could – conditionally – argue that the creation and the representation are overlaid. Filmic conditions are being created that can only be represented by the medium itself. And how does this relate to physical space? Obviously, the inhabitants of the movie show us that their space is as real as our space, as it is defining their conditions as much as our conditions are being defined by our space. In this way one could state that the viewer and the inhabitant are only separated by time, as we are witnessing a depiction of their being shown from the logical perspective as seen in hindsight. When Bergson makes a distinction between the notion of pure recollection, which can only be virtual, and the notion of the recollection image, which needs to be connected to the present, it seems logical to stick to the latter to enable us (those of the present) to actually share in this conditional analogy space.

If representation itself would not be too ambiguous a notion to be unchallenged – Rancière notes that 'the failing of the stable relationship between the perceptible and the intelligible' might perfectly well be construed as the unlimited character of the powers of representation' (Rancière 2009: 130) – we could leave it at that. But if representations are based on mental models, inevitably the representation changes as we change these models. In this state we could argue that the continuous shaping and reshaping of the mental models involved in the perception of the creation of such circumstances affect the socio-economic paradigm shifts that underlie the changes in our urban settings. As we close the gap between the representation and the production of physical space, changing the representation also influences the production.

On time and memory

Deleuze's *sheet proposition* is a case that could provide the essential link between the now and the recollected now in an interactive way, by stating:

> We constitute a continuum with fragments of different ages; we make use of transformations which take place between two sheets to constitute a sheet of transformation. For instance, in a dream, there is no longer one recollection-image which embodies one particular point of a given sheet; there are a number of images which are embodied within each other, each referring to a different point of the sheet. Perhaps, when we read a book, watch a show, or look at a painting, and especially when we are ourselves the author, an analogous process can be triggered: we constitute a sheet of transformation which invents a kind of transverse continuity or communication between several sheets, and weaves a network of non-localizable relations between them. In this way we extract non-chronological time. (Deleuze 1989: 119)

And it is exactly this transformative notion that enables us to apply the notion of collected subjectivity to our future quest, as we are about to construct a form of 'projective mapping'.

Taking the conception that the representation of memory (recollection-image) is dependent on the mental models that exist in the perceiver's mind, then it would be defendable to state that the collection of mental models in any given group would form the social-cultural paradigms of that particular group. Following Halbwachs' notions of collective memory, we could now arrange all media avatars on a plane connecting reproduction, observation, analysis, criticism, instantiating, memorizing and production that – by the permeable nature of 'the peephole' – would become a *variable field array of media typologies*. By this array I indicate an abstract flexible organizing and storage system, in which every stored element itself defines the volume it needs. When focussing on the relation between photography and film in this context, we start with the premise that the absence of sequential motion in photography suggests a stronger state of objectivity, and therefore shapes the visual mental model of the producer more than other media, like film. On the other hand, the ability to reproduce motion in film influences the spatial mental model much more than photography does. But looking at contemporary and future conditions, we should also include the influence of modern media. Hoskins says:

> The transformations in time and space that have distanciated (and instantiated) human relations since the writing of Halbwachs have also fundamentally altered the constitution of collective memory. The connectedness of the electronic media – of the network society – has provided new global collectivities through the use of satellite and digital technology. The social supports of collective memory are often intensively and extensively mediated. Thus, 'cultural memory' is based on socially organised mnemonics, institutions, and media. Although the individual remains (or perhaps appears as) the real holder of memory, what is valuable or necessary to remember (and to forget) is directed

by a collective that today seems increasingly media-afflicted. Or one might even say that with the magnitude of the televisual archive and the internet, memory is less a function of remembering but more a question of knowing where to look. (Hoskins 2003)

Next phase

The next phase in our research will collect (not combine!) all mentioned notions to form its presumptive position and strive to engage moving images in the process of mapping future conditions from a *neutral* standpoint. By partaking in the construction of a medium (*in the screen*) that can represent and produce at the same time (*the peephole*), connecting ourselves to the past and the future past by applying the notion of sheets of transformation, using the paradigms formed by the underlying mental models, it should be possible to create a depiction of how future architectural conditions will be perceived. When we are able to calibrate and align the corridors of production, representation, perception and projection, this would create an open connection between communicators on all sides of the sheet of moving image, enabling the existence of intentionally installed and highly subjective *punctums*, as guidelines in the objective projection of the future. In order to clarify the distinguishing character of this type of mapping, Radman has suggested that the *projective* be replaced by the well-known 4EA approach – a suggestion I am happy to adopt as soon as a workable shorthand is found.

References

Baichwal, Jennifer (2006), *Manufactured Landscapes*, New York: Zeitgeist Films.
Barney, Matthew (2003), *The Order; Cremaster III*, New York: Palmpictures.
Barthes, Roland (1993), *Camera Lucida*, London: Vintage, pp. 26–27.
Brakhage, Stan (2003), *By Brakhage: An Anthology*, New York: The Criterion Collection.
Bruno, Giuliana (2002), *Atlas of Emotion: Journeys in Art, Architecture, and Film*, New York: Verso, p. 39.
Carroll, Noël (1988), *Philosophical Problems of Classical Film Theory*, Princeton: Princeton University Press, p. 57.
—— (2008), *The Philosophy of Motion Pictures*, Oxford: Blackwell Publishing Ltd, pp. 142–143.
Clarke, Alan (1989), *Elephant*, Belfast: BBC Northern Ireland.
Debord, Guy (1994), *The Society of the Spectacle*, New York: Zone Books.
Deleuze, Gilles (1989), *Cinema 2*, London: Continuum, p. 119.
Eisenstein, Sergei (1957), *Film Form*, New York: Meridian Books, p. 35.
Folksonomy: 'the user-created bottom-up categorical structure development with an emergent thesaurus would become a Folksonomy', in Thomas Vander Wal, *Folksonomy Coinage and Definition*, The vanderwal.net Blog posted 2 February 2007, <http://vanderwal.net/folksonomy. html>. Accessed 21 June 2010.
Graafland, Arie (2000), *The Socius of Architecture*, Rotterdam: 010 Publishers.

—— (2008), *Understanding the Socius through Creative Mapping Techniques*, Delft: Delft School of Design.

Halbwachs, Maurice (1992), *On Collective Memory*, Chicago: The University of Chicago Press.

Hauptmann, Deborah (ed.) (2006), *The Body in Architecture*, Rotterdam: 010 Publishers, pp. 223–233.

Hitchcock, Alfred (1954), *Rear Window*, Universal: Universal City CA.

Hoskins, Andrew (2003), *An Introduction to Media and Collective Memory*, Swansea: Department of Media and Communication Studies.

Keiller, Patrick (1994), *London*, London: British Film Institute.

Kourany, Janet A. (ed.) (1987), *Scientific Knowledge: Basic Issues in the Philosophy of Science*, Bolmont: Wadsworth.

Marker, Chris (1962), *La Jetée/The Jetty*, Neuilly-sur-Seine: Argos Films, text from voice-over.

—— (1983), *Sans Soleil/Sunless*, Neuilly-sur-Seine: Argos Films.

Noé, Gaspar (2002), *Irréversible*, Paris: Wild Bunch, film's motto.

Pallasmaa, Juhani (2001), *The Architecture of Image*, Helsinki: Rakennustieto Oy, pp. 145–174.

Raban, Jonathan (1988), *Soft City*, London: HarperCollins Publishers, p. 10.

Radman, Andrej (2010), Personal communication.

Rancière, Jacques (2009), *The Future of Image*, London and New York: Verso, p. 130.

Resnais, Alain (1961), *L'Année dernière à Marienbad/Last Year in Marienbad*, Neuilly-sur-Seine: Argos Films.

Sokurov, Alexander (2002), *Russian Arc*, St Petersburg: The State Hermitage Museum.

Stockhausen, Karlheinz (1996), *Helicopter String Quartet*, Amsterdam: Allegri Film.

Van Sant, Gus (2003), *Elephant*, Santa Monica: HBO Films.

Von Trier, Lars (2003), *The Five Obstructions*, Hvidovre: Zentropa.

Chapter 16

Mapping Urban Space: Moving Image as a Research Tool

Wowo Ding

They wanted to know, they wanted to learn, they wanted to understand the strange world around them – did they not deserve better nourishment? (Feyerabend 1975: 264)

Introduction

Urban planners and architects whose works concern our artificial world have to work with maps that represent of a city by reducing its scale. The map has the advantage of helping people to understand the city in the sense of form, shape, pattern or structure. Relying more and more on maps, we are used to creating space on a horizontal plane, and pay less attention to the qualities of real urban space.

The Image of the City (Lynch 1960) aroused great interest among architects and urban planners. In this book, Kevin Lynch explains the legibility of urban space, and reveals what elements in the built structure of a city are important to our perception of the city. The concept of **place legibility** indicates whether people can grasp the layout of a place with ease. To make sense of the layout of a city, people first and foremost create a mental map. Mental maps of a city are mental representations of what the city contains and its layout according to the individual. This shows the gap between the geometrical attributes of urban space and people's recognition of them. This theory challenges traditional views on urban space and brings human cognition into the discussion of urban space, which becomes meaningful only by combining humankind and the space. Although Lynch did not provide a comprehensive answer to a question that is highly significant to current city and spatial planning (Petrin 2008), his work has triggered a good many research studies, in particular research on the method of representing urban space. How to approximately map urban space became a topic for discussion after the cognition theory was integrated into the representation method of urban space.

Spiro Kostof put forward two methods of representing urban characteristics (Kostof 1991: 25): using the spatial characteristics of the city and using the characteristics of the city in space. Although both are used for representing urban characteristics, the former surveys urban form from the top and the latter looks from inside the city. These two cognition modes have totally different representation mediums, with the former expressed by the urban ground plan and the latter by perspectives. Although both are frequently used, these representation methods have different functions. The former serves as a platform for quantitative research and decision-making while the latter is only used as a complement

to the former. Lynch's research showed the limitations of using traditional ground plan in urban study and emphasized that one has to focus on the characteristics of the city in space simultaneously. Since the urban ground plan is the only medium for quantitative research, this requires a new medium for the characteristics of the city in space, which needs reflections upon the methodology for urban space as well as epistemology.

The cognitive science provides insights into the selectivity and constructiveness of perception that are essential to any analysis of the formation of the conceptions of space. Neurobiology shows us that we see with our brains and not with our eyes. Space is a construct of perception and evaluation, of physiology and psychology, of possibilities, experiences and knowledge. This 'perceptual space' overlays the 'physical space' and makes the latter's meaning and use visible to us, just as software brings hardware to life (Petrin 2008). We recognize space by images in both our brains and our eyes. Therefore, it is also very important for us to study images from inside urban space directly – the characteristics of the city in space – and to explore the ability and possibility of using the images or photographs.

William H. Whyte introduced a new understanding of urban space by using cinematography (1980). Whyte used film as a survey tool, which made it possible to record human actions in urban places. In Whyte's film, it can be noticed that the social space for human activities have different meanings according to the physical configuration of urban space focused on by architects and planners. For example, different temporal and spatial effects exist in the same space and the popularity of the same kind of space differs due to different locations in the city. Whyte's experiments have two meanings: First, the cinema could describe and picture urban space on a real-life scale by filming. Second, the real-time filming shows more advantages, including the possibility of investigating motion in urban space. This filming experiment not only shows the importance of using a new tool for re-constructing urban cognition, but also proves its possibility. We assume that the perception of urban forms, such as perceived distances, the sense of openness and the type of spatial form of the urban streets, will contribute to the creation of temporal experiences of both motion and movement within the urban physical environment. Cinematography with its capacity of recording can be used as a tool to study present phenomena and should not only be used for representation. Searching for a method of analysis-filming, we shall test this medium as a platform for mapping urban space.

1. Issues about presenting urban space

1.1 Map and human visual images

Since the time cities first appeared, they have been subject of human planning and building. Being an artificial form and spatial place simultaneously, the city should be read and recorded differently. Gradually, people represented a city with a map and got to know

its characteristics by reading the map, making the map the most efficiency medium for constructing knowledge of urban space.

> Lines and forms count among the essential visual components of the map. They define two different types of space: a space of position, 'in which are inscribed circuits, trajectories, distances, directions', and a space of figures, 'with their properties: configuration, contours, size, homologies, symmetries, notion of continuity/discontinuity, steadiness, regularity/irregularity, direction, good or bad form, reversibility'. (Jacob 2006: 306)

The advantages of the map lie in its representation of the location of objects on the surface of the Earth and of the relative relationship in a static three-dimensional space, which reflects the spatial characteristic of the city but not the city in space. On the other hand, the map is an important medium and working interface for architects and urban planners, based on which the future urban space is formed, which again gives no idea of the city in space. Therefore, many urban planners and architects raise questions about using maps as their working interface. To produce a map for a more effective working interface, many new map-drawing principles and methods have been put forward (Cosgrove 1999).

American landscape designer James Corner has repeatedly emphasized the considerable problem of using a map to represent the landscape from the aspect of landscape design. The advantage of the traditional map is that it can locate objects within the indicated area in a relatively accurate way. However, it also omits much useful information, especially information that can be perceived on the surface of the Earth. James Corner deems it necessary to conduct research on map-making methods so that the illustration contains more effective information and becomes more readable. The method raised by James Corner actively integrates the perceptible terrain landscape, draws a sectional map based on the ground map, and adds illustrations or photos indicating the terrain characteristics (Corner 1999). Therefore, it is more map-designing than map-drawing. Compared with the traditional map, the landscape map combining real-life information helps the reader to get a feel of the scene, where the human visual image displays an irreplaceable position in revealing the character of the location, e.g. the windmill topography (Corner and MacLean 2000: 83).

There are two issues that deserve our attention. First, Corner introduced the Human Visual Image into map-drawing. Second, Corner used many scales in the same map. Although this kind of representation method provides perceptual knowledge for the reader, the inclusion of photos is problematic in its reasonability and objectivity. Therefore, this representation method is more a personal choice by architects or urban planners than a universal map-making method; nor can it be used as a platform for analysis and research. Nevertheless, Corner's method is significant in that it closely connects the perceived landscape with the geological location. This purpose is not fully served due to the subjective connection of the information in the photos with the geological location. The key point of the problem is that the perceptual factors cannot display their essential spatial relationship.

1.2 Spatial characteristics and geological location

To really know a city, people need to know not only the location of the urban space but also the characteristics of such space. In fact, a combination of spatial characteristics and geological location has appeared in ancient maps that expressed not only the characteristics of the space and material status, but also the basic relationship of the objects in the map.

> In representing the geography of Paradise, medieval map-makers always emphasized the passage to a dimension different from the time and space of ordinary human experience. A survey of the iconography of Paradise on surviving maps dating from the sixth to the end of the fifteenth century reveals a common and perennial element in the cartography of Paradise: the use of a visual device to express the duality of relationships between the Garden of Eden and the known world, their separation and connection. (Scafi 1999:60)

The problem of such drawing is that the geometrical size and the scale could not be accurately drawn and proportionately expressed in the map, which accounted for the fact that it could only be used as a sketch map, and not as the basis for measurement or research. The reason the map could not be precisely drawn is that the interface expressing the spatial characteristics and that expressing the geological location are not in the same space. The former is on a vertical interface and the latter is on the horizontal interface. In addition, representing the spatial characteristics and expressing the geological location involve different scales, so it is necessary to seek a method for linking the macro scale and the micro scale.

The current drawing methods are unable to incorporate both vertical and horizontal interfaces into one map, and researchers often have to simplify the vertical spatial characteristics and transform them into illustrations or icons in order to insert them into the horizontal map. To increase information directly perceptible on the map, some researchers adopt the analytical and statistical method in which the pictures are first analysed and sorted and then the analysis results are added to the ground map by using colours or icons so that the geological location and the landscape are combined (Porta and Renne 2005). Due to the limitations of the ground plan, the factors of the spatial characteristics have to be made too abstract to read, which can only be useful for statistical and quantitative study. Consequently, the factors of the spatial characteristics are still absent.

The most direct working interface for the spatial characteristics is the vertical plans of the city where various heights of urban form are recorded. The vertical interface used now is the plan of sections, which is insufficient as a proper tool for the city since there are different sections in different places. Ultimately, the spatial relationships and physical dimensions of objects change with each viewpoint. For example, the view of walking on the street differs from running through the same street.

> The original purpose of the tripartite mode of notation (events, movements, spaces) was to introduce the order of experience, the order of time – moments, intervals, sequence –

for all inevitably intervene in the reading of city. It also proceeded from a need to question the modes of representation generally used by architects: plans, sections, axonometrics, perspectives. (Tschumi 1994)

For this purpose, we have to review the attributes of urban space, for which interpretations or diagrams of the urban space depend on the comprehension of it.

1.3 Attributes of the urban space

Since the early twentieth century, architectural spatial theory accepted the perceived ability of robust scientific models to capture 'time and space'. As a response to non-Euclidean geometry, the 'fourth dimension' is introduced, which opposes the traditional concepts of space as a static geometrical form. Sigfried Giedion, in his book *Space, Time and Architecture* (1941), conceived 'of space as relative to a moving point of reference, not as an absolute and static entity', which bridged architecture and physics. With this space/time concept, artists, architects and urbanists have for a long time sought to capture movement within the spatial framework of design. Therefore, renderings from fixed angles gradually died out in the representation of buildings, while drawings from multiple points, perspectives in a series and the moving image become the major representation methods.

Regarding the attributes of architecture and urban space, Shadrach Woods put it clearly:

We are concerned, not with 'architecture' or 'town planning', but with the creation of environment at every scale [...] We cannot think of planning in static terms – in three-dimensional space, when we live in a four-dimensional world. The realization, for instance, that the scene of action of reality is not a three-dimensional Euclidean space but rather a four-dimensional world, in which space and time are linked together indissolubly, sets our civilization apart from any others. (Woods 1964)

In the scientific sense, the theory of a four-dimensional world for architectural or urban space focuses on the spatial perception of people when they move in that space, rather than the four-dimensional attributes of the physical material urban space in itself. To be more specific, people's perception of the urban space in a dynamic status brings real value to the four-dimensional space theory. Therefore, the four-dimensional characteristics of the urban space are a combination of space and motion. Motion includes two concepts: the first is the movement of people and objects in the space, and the second refers to the changes in light and images over time. The functions of these two types of motion form the core of representing four-dimensional urban space.

If we consider this issue with the concept of four-dimensional space, we realize that developing a new tool and method is essential, since we cannot depend on improving the

original mapping method. This new method is made possible by introducing the moving image.

2. Space–time and film

2.1 Four-dimensional space and two-dimensional medium

The direct representation of four-dimensional space is a difficult task for people living in a three-dimensional world. The common medium of imaging the three-dimensional space is a two-dimensional surface. For instance, both the perspective drawing invented during the Renaissance and the axonometric drawing in ancient Chinese landscape painting are two-dimensional drawings made in a specific way for representing the three-dimensional world. Both perspective and the axonometric drawings represent three-dimensional images on the two-dimensional surface. This process not only relies on the reasonability of the images, but also on the resonance in the observers. The three-dimensional image is formed through the viewer's mind. (Petrin 2008)

There are two ways of experiencing four-dimensional space: The first is through the changing views of moving through three-dimensional space, and the second is experiencing the image changing by light going through time. People can perceive four-dimensional space only through the changing images. Consequently, we can believe that changing image is the 'imaging' of four-dimensional space in three-dimensional space. The perception of the urban space is made of a series of changing images, and is thus built by people and the urban space. The changing image of the urban space can be presented on the screen and regarded as the imaging of the observer's perception. Cinematography is the best way to acquire changing images.

2.2 Film and screen

As a technical method, cinematography directly records the material space in the city, and the movements of people and objects. The changes of light combine to form scene, location and time. The film camera can not only record the changes in the physical configuration characteristics arising from the relative movement (the film camera moving in the city), but also the changes in the light and shadow in the space resulting from the absolute movement (the film camera shooting in a fixed point). Consequently, cinematography is currently the most effective method of recording the spatial characteristics of the city; video provides the sense of time in urban space.

Considering the film and the screen, there are two viewpoints: the video in the screen and the video on the screen. We assume that 'in the screen' is related the sense of narrative while 'on the screen' is concerned with the configuration of the changing images. The former has

been used a lot in representing architectural and urban environments and the latter has not yet been fully researched. Since the spatial characteristics of the city have been recorded in video, the changes in the regular pattern of imaging should reflect the spatial characteristics to a certain extent. Therefore, it is necessary to explore the trace of the graphic changes on the screen, which could become a way for mapping urban space in human perceptions.

The difficulty lies in how to dissect the images with compressed times and spaces, and determining the systems for layering the information with space simultaneously. In order to do so, our research took the urban street spaces as paradigm and focused on perception of its spatial pattern. To simplify our task, this pilot study involved only buildings along the streets, even though trees, cars, people, sun and shadows are all important in real experience.

2.3 Decomposing the image

The images recorded by the film camera cannot be represented directly and must be analysed to extract the relevant components according to the research subjects. Technically, it is easy to get a still picture from video or film, but there are still two questions: how do you identify the spatial perception components; and how do you select the instantaneous frame with tits spatial elements.

Coming back to Lynch's research, it proved that 'road', 'landmark' and 'edge' are all components directly perceptible in the space of the urban streets with road providing the path in which people perceive the urban material space and the edge and landmark providing the geometrical form of the space and the objects that are perceived directly. In the city, the organization of architectural surfaces directly forms the perceptible condition of the street space – the buildings along both sides of the street form the components of the street space. When people are walking in the street, they are very sensitive to the form of the street and the height of the buildings along the street, and are also very sensitive to the changes in the height of the buildings. The experiment about people's perception of the city street proves that people walking in the urban space are most sensitive to the moving objects and the vertical objects. (Yang et al. 2007) Therefore, among the numerous components of the picture, the components that need extracting are the height of the buildings and the horizontal distance between the buildings on both sides of the street, so that we can identify the spatial figure of the street in time.

From the view of the space-time consistency, the observer and the scene the observer perceives could be seen at the same time-space point. (Putnam 1967) Therefore, the imaging in the film or video could be seen as the same as space perception of a person in the street. The advantage of the film or video is that it allows us to record and recognize each spatial segment linked with the original instant in time, in which space and time are tied together. This is important for further analysis.

3. Setting and cartography

3.1 The frame selection

It is necessary to cut a still picture from film for analysis; in the picture, the three-dimensional image was compressed into a two-dimensional interface. From the time point of view, the spatial form that exists in different instants of time is condensed. In order to separate instant spatial form, one has to decide on the frame, which might function as a selector. The effective scope of the image must be determined before setting the frame, which involves three issues: first, determining the visual distance in terms of the visual quality; second, determining the visible surface in terms of the best visual quality; and third, determining the street width in terms of the best visual quality.

The best visual quality depends on the accuracy of getting the observation details. If we focus on the profile and the material texture of the buildings, the best visual distance should be within 40 metres. Based on the best resolution and horizontal vision of the naked eye, we design a simulated vision sphere to simulate human vision[1] with a computer, so that

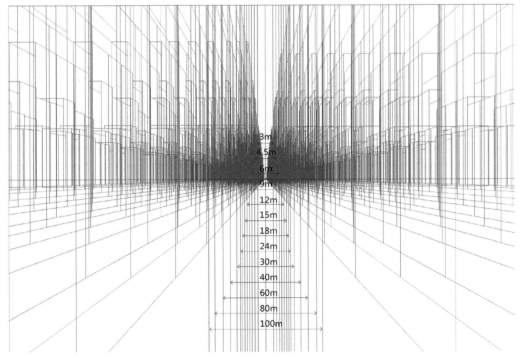

Figure 1.

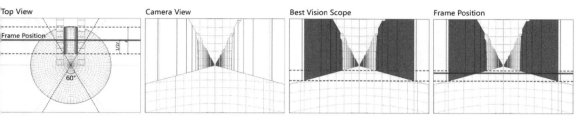

Figure 2.

the vision sphere can help us define the best visible surface. In the experiment, setting the radius of the vision sphere depends on the precision requirements of the focused point, and the radius needed for observation and perception is the best visual distance. To make assessments[2] for the best visible surface, the vision sphere is placed onto the street at various widths. Therefore, when the width of the street is larger than that of the vision sphere, the objects on both sides of the street are not within the scope of the best vision. Through the experiment, we can obtain the best vision scope (Figure 1) and select the visible surface within this scope (Figure 2).

Of course, if we only focus on the profile of the buildings and not on the material texture of the buildings, the best visible distance increases and the radius of the vision sphere will be enlarged correspondingly. Consequently, if human perception is taken as the reference point in discussion, the ground plan of the city is not the datum plane for studying urban perceptual space; the visual images replace it.

3.2 Linear classification

The best visible frame can separate the information in the picture and pick up the street's spatial configuration linked with each particular instant in time. Since there are buildings along the sides of the streets, their position decides the street's spatial form. To draw out the street's instant spatial configuration, if the middle point of the street is taken as the original point, there are four basic situations as follow:

1. If the buildings on both sides of the street are within the frame, the horizontal line indicating the street width can be fully identified, and this line is set as L or –L;
2. If the buildings on both sides of the street are not in the frame, or only one side in the frame (the buildings are set back or at the street crossroads), then the street width cannot be determined temporarily, and the undecided edge of the horizontal line of width is extended to the border of the picture. This line is set as L' or –L';
3. If the height of the buildings on the frame is visible, then this fully identified vertical line could be set as the height of the building, and is called Z;

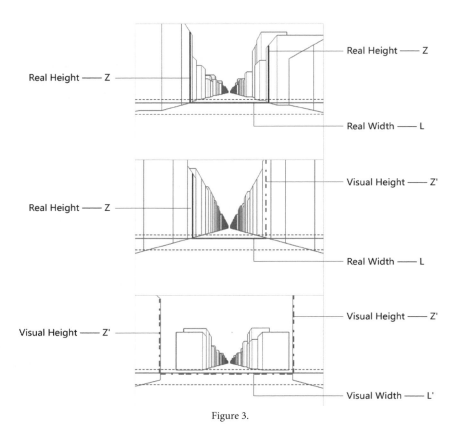

Figure 3.

4. If the height of the buildings on the frame exceeds the border of the picture, then this vertical line is set as Z'.

We use different colours to indicate these four lines, and their combination describes the street space on different occasions in the real perceptual experience (Figure 3).

3.3 The coordinate selection

Space, as we ordinarily conceive it, is a three-dimensional Euclidean space, a static space, whose cartography is based on a 2D or 3D Cartesian coordinate system. Space-time is a kind of four-dimensional space, which is hard to visualize in Euclidean space. It may help in the beginning to think simply in terms of changing coordinates. The space–time interval put forward by German mathematician Hermann Minkowski provides a different reference

system.[3] In the Minkowski space, three space coordinates and one time coordinate are needed to refer to a point at a particular instant in time. This point at a particular instant in time, specified by the four coordinates, is called an event. The distance between two different events is called the space-time interval.

Although the concept of Minkowski's space-time is still under discussion, we could incorporate his time coordinate axis into our coordinate system. Suppose we place the moving picture into Minkowski's coordinates; it will turn into a series of static pictures along the time axis, and the distance between the pictures will depend on the time intervals. If we separate the research subjects in the pictures, we will get the rule in which the subject varies with time.

The measurement unit used in the time coordinate differs from that in the space coordinate. If speed is taken into account, the measurement unit in the time dimension can also be converted into the measurement in the distance, thus unifying the measurement unit. In the process of operation, we can determine the basic measurement unit of the time axis in our new coordinates according to the needs of our research questions, and this will not affect the other measurement units originally used in the coordinates.

4. Experiment

4.1 Mapping coordinates

In order to present urban spatial forms linked with movement on the street, we have to discard the traditional Cartesian coordinate system and develop a coordinate system based on Minkowski's coordinates, which incorporate a time coordinate. What we want to express is the form of street space perception at the time of movement, and the relationship between velocity and the perceived pattern, and we want to map the perceptible street's spatial form. We recognize that human perception of the street spatial form varies with our moving speed, so we attempt to draw the map on the visibly perceived street space through the time-space coordinates. Based on this, we assume the vertical coordinate as the time axis – t and assume the horizontal coordinate as the street width axis – x. If the time axis is placed on the middle line of the street width, then it forms 't – x' Coordinates[4] (Figure 4).

One thing we have to clarify here is that the 't – x' Coordinate is only set for mapping the spatial pattern of the urban streets, so that the total length of the t axis is limited by the mapped distance of the street. This means that the same distance of the street, the same length of the t axis, from the filming point of view, multiplied by the speed of filming time is equal to the distance the film camera moved along the street. Therefore, the length of the t axis remains unchanged once the street is chosen, whatever the moving speed was, so that the units along the t axis are dependent on the interception of a screen by time. Consequently, on the same street if the moving speed is different and the interception of a screen by time remains the same, the density of scale marks will be different; the faster case

Figure 4.

will have sparse scale marks and the slower one will have denser marks. If we extract the pictures corresponding to each scale mark on the *t* axis, one could intercept more pictures from the film made by moving slowly. Then the pattern of spatial form of the street will be more detailed and consistent with people's perceptions. This coordinate system can not only map the changes in the width of the street over time, but also reflect the difference in the moving speed.

Figure 5.

Since all horizontal street width lines L or L' are linked to the height (or visual height) line of the buildings, we can easily add the height line of the building Z or Z' in the 't – x' Coordinates at the same time. What needs to be adapted is the rotation of Z and Z' (we temporarily set the rotation angle 45°to axis X) to make reading easier (**Figure 5**).

4.2 Mapping experiments[5]

We first establish two computer models of the urban street: Model A and Model B. The width of both streets is 12 metres, but the height of the buildings varies. Model A and B differ in building combinations along the street: in Model A, the buildings are aligned into a line, while in Model B they are in disorder (Figure 6).

In the first experiment, we place the vision sphere in both models and set the moving speed to normal walking speed lasting for 100 seconds. In the 100-second video clip, Model A and Model B are extracted by every five seconds and twenty frames are extracted (Figure 7).

In the second experiment, the vision sphere is placed in both models for an equal distance but at half the walking speed. In a 200-second video clip, they are extracted by every five seconds and 40 frames are extracted (Figure 8).

Obviously, in the first experiment due to physical differences we have two different streets' spatial patterns at the same moving speed, which reflect the changes in the location of the

Model A

Top View

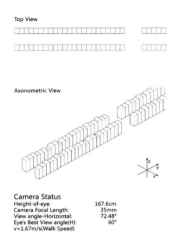

Axonometric View

Camera Status
Height-of-eye: 167.6cm
Camera Focal Length: 35mm
View angle-Horizontal: 72.48°
Eye's Best View angle(H): 60°
v=1.67m/s(Walk Speed)

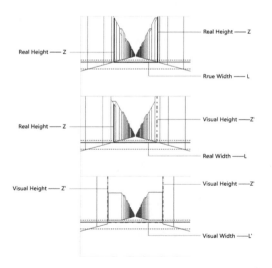

Model B

Top View

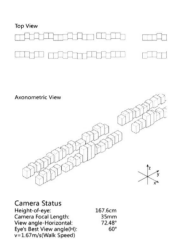

Axonometric View

Camera Status
Height-of-eye: 167.6cm
Camera Focal Length: 35mm
View angle-Horizontal: 72.48°
Eye's Best View angle(H): 60°
v=1.67m/s(Walk Speed)

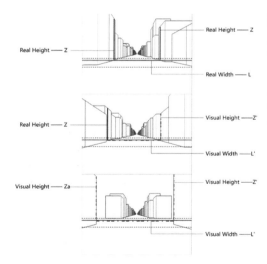

Figure 6.

Model B

Model A

Figure 7.

Model A

Model B

Figure 8.

buildings on both street sides directly affecting visual perception. In the second experiment, due to the different walking speed, the same streets' spatial patterns become different (especially in Model B), and reflect more details of visual perception. Both results are basically consistent with our experience of the street space. Therefore, we can preliminarily assume that such representation expresses the visually perceived space of the urban street space. This needs to be tested in a real street.

4.3 Mapping the street's spatial patterns[6]

To test the applicability of the '$t - x$' Coordinates and the mapping method, we have to select real streets with similar lengths in different cities. Based on street maps provided by Google Earth and the three-dimensional full-view photos of the same street provided by Google Maps, we have made a simulation of moving in the street. This kind of street simulation can be used as the sample for testing our mapping methods and process. We chose the street rue Cambon in Paris and another street with similar length in Tokyo. The length of the former street is 450 metres and the latter 440 metres. We made two films of about 3 minutes and the passing speed is about 2.5 metres per second.

There are three factors to verify: (1) the selection of best visual frame; (2) the setting rules of the streets' spatial configuration; and (3) the '$t - x$' Coordinates. First we extract a still picture from the film for every five seconds and get two sets of pictures of equal number for the two streets. Second, because the widths of both streets are less than 40 metres, the best visible frame used before is applied to abstract both streets' spatial configurations; we indicate the different conditions of the buildings and streets with different lines (L, -L, L', -L', Z and Z') and get another two sets of spatial patterns at different instants in time (Figure 9).

Finally, these two sets of pictures are put respectively in the '$t - x$' Coordinates and the time scale is 5 second (respectively 13 metres and 11 metres for the two streets). Thus we get the visually perceived map of these two streets. Obviously, in the ordinary ground plan, the shape of these two streets makes little difference (in terms of the width and length), however, their spatial patterns sharply contrast in the '$t - x$' Coordinates, which correspond to real experience on both streets (Figure 10).

These experiments have proved that the spatial perception on urban streets could be represented in a quantifiable way. In order to do so, filming along the street is the basic and the most efficient approach.

Tokyo

Paris

Figure 9.

Tokyo

Paris

Figure 10.

Conclusion

The problem of urban space has always been a focus of urban design. This problem lies not in the space itself, but in the relationship between the urban form and human perception. Since urban spatial perception depends on movements in space and changing scenes, urban space is no static space. Current research methods for the space still largely retain a classic technique that is based on a 2D or 3D Cartesian coordinate system. Addressing this methodological issue, our research tries to directly face the essence of spatial perception and to find proper tools for this issue.

The filming functions as the recording tool for a real-time scenario. Its significance is not only for representation but also for studying materials. Filming along urban streets, the camera could record the form of space that people saw at any particular instant. This has transferred 4D (the space-time scenario) to a 2D medium (screen) that can become the research platform. Based on Minkowski's coordinate theory, this research establishes the '$t - x$' Coordinates for mapping urban streets' spatial patterns at different speeds, which can simulate the spatial perception of the movement.

Although this research is only a preliminary attempt and needs improvement in many aspects and further exploration, the idea as well as the method introduced into urban research have already shown their potential. At least we know that cinematography can help to represent buildings and contribute to the architectural and urban research. In addition, this will initiate new direction in urban space research. In this sense, filming will be an irreplaceable tool and method.

References

Corner, J. (1999), 'The Agency of Mapping: Speculation, Critique and Invention', in D. Cosgrove (ed.), *Mappings*, London: Reaktion Books Ltd, pp. 213–252.

Corner, J. and MacLean, A. S. (2000), *Taking Measures Cross the American Landscape*, New Haven and London: Yale University Press.

Cosgrove, D. (1999), 'Introduction: Mapping Meaning', in D. Cosgrove (ed.), *Mappings*, London: Reaktion Books Ltd, pp. 1–23.

Feyerabend, P. (1975), *Against Method: Outline of an Anarchistic Theory of Knowledge*, London: NLB.

Giedion, S. (1941), *Space, Time & Architecture: The Growth of a New Tradition*, Cambridge: Harvard University Press.

Jacob, C. (2006), *The Sovereign Map: Theoretical Approaches in Cartography Throughout History*, Chicago & London: The University of Chicago Press.

Kostof, S. (1991), *The City Shaped: Urban Pattern and Meanings through History*, Boston, Toronto, London: A Bulfinch Press Book.

Lynch, K. (1960), *The Image of the City*, Boston: MIT Press.

Petrin, J. (2008), 'Stimulating the Second Space', in A. Thierstein and A. Foerser (eds), *The Image and the Region: Making Mega-City Regions Visible!*, Baden: Lars Muller Publish, pp. 155–167.

Porta, S. and Renne, J. L. (2005), 'Linking urban design to sustainability: formal indicators of social urban sustainability field research in Perth, Western Australia', *URBAN DESIGN International*, 10, pp. 52–64.

Putnam, H. (1967), 'Time and Physical Geometry', *The Journal of Philosophy*, 64:8, pp. 240–247.

Scafi, A. (1999), 'Mapping Eden: Cartographies of the Earthly Paradise', in D. Cosgrove (ed.), *Mappings*, London: Reaktion Books Ltd, pp. 50–70.

Tschumi, B. (1994), *The Manhattan Transcripts*, London: Academy Editions.

Whyte, W. H. (1980), *The Social Life of Small Urban Spaces*, New York: Project for Public Spaces.

Woods, S. (1964), 'Urban Environment the Search for System', J. Donat (ed.), *World Architecture 1*, London: Studio Vista, p. 151.

Yang, P. P.-J., Putra, S. Y. and Chaerani, M. (2007), 'Computing the sense of time in urban physical environment', *URBAN DESIGN International*, 12, pp. 115–29.

Notes

1. The basic data on the vision sphere: vision height-1676mm, camera focus-35 mm, camera horizontal angle-72.48, comfortable vision scope for left and right eyeballs-60°, vision sphere radius-about 35m.
2. The width values were set in 3m, 4.5m, 6m, 9m, 12m, 15m, 18m, 24m, 30m, 40m, 60m, 80m and 100m, which cover almost all road widths from pedestrian paths to vehicle lanes.
3. Minkowski built on mathematical approaches used in non-Euclidean geometry and on the mathematical work of Lorentz and Poincaré, and showed in 1908 that Einstein's new theory could also be explained by replacing the concept of a separate *space and time* with a four-dimensional continuum called *space–time*. This was a groundbreaking concept, and Roger Penrose has said that relativity was not truly complete until Minkowski reformulated Einstein's work.
4. The distance can be a negative value in the time–space coordinate; please refer to 'The Minkowski formulation: introduction of space–time', <http://schools-wikipedia.org/wp/i/Introduction_to_special_relativity.htm>
5. This exercise is conducted by Tao Liu, a master student at the School of Architecture at Nanjing University.
6. This exercise is conducted by Rui Chen, a master student at the School of Architecture at Nanjing University.

Chapter 17

The Moving Image of the City: Expressive Space/Inhabitation/ Narrativity: Intensive studio workshop on 'Continuity of Action in space'

Maureen Thomas

Although clarity or legibility is by no means the only important property to a beautiful city, it is of special importance when considering environments at the urban scale of size, time and complexity. To understand this, we must consider not just the city as a thing in itself, but the city being perceived by its inhabitants.

(Kevin Lynch, 1960. *The Image of the City:* 3)

Introduction: Architectural research and teaching, and the practice of digital media

Traditionally, the role of the University in culture and society changes with the needs, potentials and demands of people, philosophy, politics and economics. Equally, the ways in which cultural artefacts are produced and research is conducted change in response to new perspectives. In the twenty-first century, the value of practice-based and practice-led research in the field of architecture has increasingly been recognized (e.g. Rendell 2004; Rendell et al. 2007) and its relationship to research methodology in other areas of art, design, media and communications has become more and more apparent (Suchman and Trigg 1991; Reilly 2002; Biggs 2003; Hockey 2003; Stringer 2003; Gray and Malins 2004; Prophet 2004; Scrivener and Chapman 2004; Hannula 2005; Sullivan 2005; Barrett and Bolt 2007; Büchler et al. 2009). Underpinning all research, teaching and learning are the technologies available for carrying out the work, which affect methodology, research outcomes and the investigation and dissemination of new knowledge.

The rapid development of information and communications technologies and creative digital media in the twentieth century has had an enormous and far-reaching impact on traditional culture, society, philosophy, politics and the economics of the cultural industries, which include architecture. At its simplest, in the University environment, this development represents the transition from pencils, pens, paints and paper to computers, software, digital media and screens. Like pencils, pens and paper, digital input (such as camcorders), computing and display/playout devices can handle both graphics (diagrams, letters of the alphabet) and still photographic or drawn images. In addition, however, they can deal with moving images and sound. Mini digital-video cameras capable of high-resolution image-capture are widely available and relatively inexpensive. In areas such as lens media, visual arts, design and architecture, a single highly portable (e.g. notebook) computer with a standard range of software enables the user to perform a wide range of operations on site. For students of architecture and architects, some technical skills are incorporated into software programs

such as Word, CeltX, Photoshop, Final Cut or Adobe Premiere, Audition, After Effects, Flash, Director, Isadora or Max MSP/Jitter, as well as Maya, Virtools and 3D Autocad packages. This means that the arts and sciences of reading and writing print, looking at and incorporating images and also watching and making movies are accessible to many undergraduates on one handy machine – less cumbersome than combinations of the traditional artist's palette and easel, architect's drawing instruments and board, or 35mm film cameras, sound equipment and editing tables. Mobile phones and IPAs are sophisticated enough input/playout devices to support the production of interesting bite-sized and increasingly longer movies with new properties, such as interactivity, communicability and massively multiple authorship, on their miniscreens.

However, at the opening of the twenty-first century, standards of 'reading' the languages of digital media and communication are still appreciably higher than standards of 'speaking' or 'writing' them. Many people, including university students, with quite sophisticated digital resources, in fact tend to 'scribble' with them rather than *compose* with informed confidence. Yet young people communicate using electronic media far more than print media (witnessed by the very rapid expansion of the online resource, Wikipedia; the proliferation of video display and exchange Internet sites such as YouTube and Bitroad; systems like Skype, which enable (moving) picture, voice and text exchange in real time over broadband; and the integration of sms media messaging via mobile phone into daily life – all these accessible from mobile communication devices). Teaching and learning already rely heavily upon these media and forms of communication, although the longevity of electronic storage is as yet unknown. In the areas of both architecture and moving image media, the easy availability of digital tools means that undergraduates, MArch, MPhil, MFA, Diploma and Doctoral students are all using them heavily – with expertise where they are able; but often enough scribbling busily even where they are not. The lack of understanding of digital media 'writing' can produce very uneven work, and may use up large amounts of time and effort with disappointing results.

For some twenty years, for the teaching/learning and research groups with which I have been associated (both Art and Design Universities submitting to RAE Design panels, and Research Universities submitting only to academic panels) I have been developing and running cross-border workshops in creative digital media (Universities of Cambridge (Architecture and Screen Media and Cultures), London (Goldsmiths Digital Studios), Ulster (Visual Arts/Design and Architecture), Bath (Architecture and Engineering), National Film and Television School, UK; Aalto (Media Lab) Helsinki, Malmö (Interactive Narrativity Studio) Sweden and Norwegian Film School/Arts Fellowship Programme, Norway). The main aim of these workshops is to provide both the theoretical understanding and the practical know-how necessary to interpret and use digital media effectively for both creative and research purposes. Experience gained and lessons learnt from a practice-based and practice-led approach in developing ways of observing, analysing, theorizing, contextualizing and presenting both the objects of study and the outcomes of research, including the application of new knowledge to new design and creative projects and products, form

the basis for the three *CinemArchitecture* workshops on architecture and screen language – storytelling structures, *mise-en-scène* – staging action for the camera – and *mise-en-cadre* – framing in 2008, 2009 and 2010 – that inspire this chapter. The *CinemArchitecture* programme (<http://cinemarchitecture.arq.up.pt/presentation.html>) was developed by the Universities of Cambridge, Liverpool, Porto and the Estonian Academy of the Arts, Tallinn and supported by the EC's *Erasmus* programme (<http://ec.europa.eu/education/programmes/llp/structure/erasmus_en.html>).

Why were these workshops deemed necessary as part of the *CinemArchitecture* programme? There can be no doubt as to the special relationship between architecture and the moving image (Aronson 1977; Clarke 1997; Penz and Thomas 1997; Aitken 2001; Barber 2002; Bruno 2002; Mazierska and Rascaroli 2003; Shiel and Fitzmaurice 2003; Thomas and Penz 2003; Marcus and Neumann 2007; Mennel 2008; Webber and Wilson 2008). But cross-disciplinary and convergent activities while they excitingly and notoriously offer the potential for the discovery of new knowledge, also depressingly carry a high risk of indiscriminate and sometimes unfortunate intellectual hybridization. In the digital era, this extends to practice as well as theory: scholars, practitioners and students alike all too often wander into electronic supermarkets of colourful and attractive-looking images, documents, articles, books, websites and movies; throw them higgledy piggledy into the trolleys of their projects, theses, artworks or articles – and hope that with enough stirring, a delectable, palatable and sustaining meal will emerge. This method may have tempting results for the snack culture of entertainment: but how useful or genuinely intellectually and culturally nourishing is snacking to twenty-first-century universities, research studios and cultural industries?

The supermarket trolley/readysnack approach can easily be compounded by the crossovers between the humanities and the sciences, art and technology. During this transitional time, while digital media and technologies are being assimilated into the culture of research, teaching and learning as well as creativity, it is important to keep reviewing and modifying the methods by which creative researchers and scholarly practitioners are trained to analyse, produce and interpret both primary and secondary material using digital media. Recipes are not the answer – formulaic instruction rarely produces innovative thinking or creative exuberance. Researchers as well as students need to be familiar both with the fundamental properties of ingredients, and the skilful handling of the tools of creation and interpretation. For this reason, it was decided to incorporate an intensive two-part studio workshop on Architecture and the Moving Image into *CinemArchitecture*, giving participants the opportunity to explore hands-on how these creative disciplines influence and elucidate each other, and how the theories and praxis of each can be applied systematically, in such a way as to enable and support new ways of eliciting, presenting and evaluating research results. The 2008 workshop held at the department of Architecture, University of Porto (designed by Alvaro Siza) provides the case study here, but the same format was used at the Departments of Architecture, University of Liverpool in 2009 and Tallinn, 2010. Now the CinemArchitecture project is over, it is hoped that the lessons learnt, approach and methodology will be of wider interest.

The Workshop – content, method and outcomes

First, at the beginning of the workshop, using movie clips to exemplify 'screen language', which uses both, the concepts of 'plot' and 'shot' grammar were introduced. These terms were used throughout as part of a systematic approach which regards moviemaking, like architecture, as a process of 'design', 'expression' and 'communication' (compare Lawson 2006). *Plot Grammar* – the structure of the story – is dominant at the level of initial design (screenwriting). *Shot Grammar* – how the action is staged by the director (*mise-en-scène*) and captured for the screen by the camera (*mise-en-cadre*) comes to the fore during the shoot, at the level of expression. *Screen Language* (Thomas 2005: 386–387) is finalized during editing, when picture and sound are adjusted for the delivery medium. Traditionally, designing and scripting the *plot* means combining action (including characters) with time, place and narrative stance (including viewpoint). Moving from plot grammar to shot grammar includes characterization and performance, as well as *mise-en-scene* and *mise-en-cadre*, the camera taking a great deal of responsibility for narrative stance. Moving from plot grammar plus shot grammar to screen language requires the editor to analyse the script and the captured material, and to re-balance them into a successful combination of plot structure, performance and narrative stance, delivered with energy and engagement. An architectural movie entails, in addition, a grammar of space, and for the purposes of these workshops architectural theorist Kevin Lynch's parsing of the legible city was systematically combined with traditional screen grammars (Lynch 1960).

Plot grammar

The diagrammatical presentation of (classical tragic) dramatic/narrative structure extracted from philosopher, classicist, university teacher of rhetoric and writer of novels and plays, Gustav Freytag's, 1863 work, *Die Technik des Dramas* (*Technique of the Drama*) (Freytag, 1863, trans. MacEwan 1968), since known as 'Freytag's pyramid', goes in and out of fashion as an anatomy of narrative theatre; but it has consistently provided a useful basis for the description and production of theatre, film and television drama. Hollywood has consistently used it as a guide for scriptwriters, in a 3-Act version (e.g. Cowgill 1999: 2). Opposite (Figure 1), Freytag's pyramid diagram is updated, using this modern movie interpretation, combined with Philip Parker's useful approach to film genre and plotting as 'question and answer' (Parker 1998: 26–27).

It is usual in film, as in theatre, to ensure that the audience is aware (though not necessarily consciously) of the 'turning points' where each segment of a sequence starts and finishes. These are most often signalled through action rather than dialogue.

However, plot structure can also be viewed from a less character- or story-based perspective, and Todorov's restatement of the 5-stage development arc can be useful in developing the shape for an architectural movie that starts from formal, visual or spatial elements: (Branigan 1992: 4)

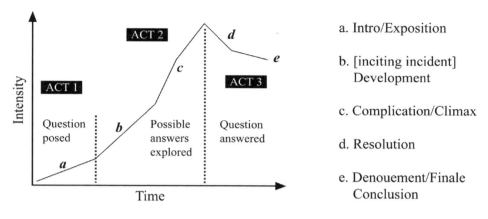

Figure 1: 5-Stage Development Arc, 3-Act structure.

Tzvetan Todorov argues that narrative in its most basic form is a causal transformation of a situation through five stages:

- a state of equilibrium at the outset
- a disruption of the equilibrium by some action
- a recognition that there has been a disruption
- an attempt to repair the disruption
- a reinstatement of the initial equilibrium

These changes of state are not random but are produced according to principles of cause and effect (e.g. principles that describe possibility, probability, impossibility, and necessity among the actions that occur) [...] this emergent form, or transformation, is a necessary feature of narrative because, as Christian Metz observes, 'A narrative is not a sequence of closed events, but a closed sequence of events'.

Brenda Laurel (following Todorov) (Laurel [1991] 1993: 70) illustrates 'plot' as a progression from the possible to the probable to the necessary, using a 'flying wedge' diagram (Figure 2):

The 'flying wedge' and 5-stage development arc put together with the 3-Act structure look like this (Figure 3):

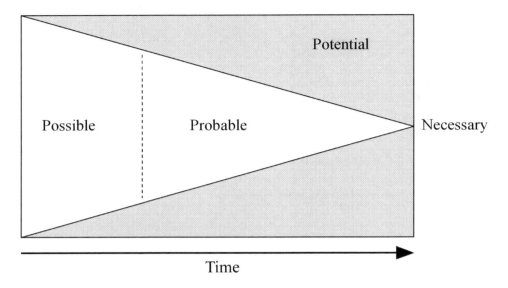

Figure 2: After Laurel ([1991] 1993: 70, Figure 3.1: Plot: possible to necessary). (Laurel notes that 'in the context of [...] drama [...] the terms *possibility*, *probability* and *necessity* have specific meanings that differ substantially from mathematical or scientific usage'. For dramatic connotations: Aristotle, Poetics, 1451a-b.)

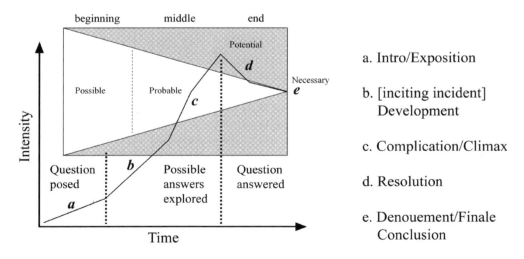

a. Intro/Exposition

b. [inciting incident] Development

c. Complication/Climax

d. Resolution

e. Denouement/Finale Conclusion

Figure 3: 'Flying Wedge' plot diagram plus 5-Stage development arc, within a 3-Act structure showing level of intensity and interest.

Table 1 shows how the traditional 'Aristotelian' analysis of effective dramatic plot-shaping matches the classical rhetorical approach to setting up and demonstrating an argument or thesis. This structure, knowingly or unknowingly, still forms the basis for most documentaries and moving-image essays (for example, in site analyses). Combining them in an architectural movie or digital media essay can be a helpful way of structuring communication.

DRAMA	Set-up/ Intro	Development	Complication/ Climax	Resolution	Denouement/ Finale
DOCUMENTARY	Exposition	Development	Summation	Resolution	Conclusion
'Ordo Naturalis'	*Exordium*	*Propositio*	*Nnarratio*	*Argumentatio*	*conclusio*

Table 1: Aristotelian analysis of plot or argument developed through a 5-stage Arc. [Aristotle tr. Freese, 1926; Burton 1996–2003; Heath 1996]

Spatial grammar

The following handout (prepared by Dr Julia Sussner, Department of Architecture, University of Cambridge) was handed out to all participants to accompany a presentation of Lynch's theories illustrated by slides.

WORKSHOP HANDOUT

In *The Image of the City*, Lynch highlights the importance of what he terms 'legibility': 'This book will assert that legibility is crucial in the city setting, will analyse it in some detail, and will try to show how this concept might be used today in rebuilding our city' (Lynch 1960: 3). To achieve this, Lynch parses the urban environment into five categories (Lynch 1960: 47–48):

1. *Paths.* Paths are the channels along which the observer moves. They may be streets, walkways, transit lines, canals, railroads. People observe the city while moving through it, and along these paths the other environmental elements are arranged and related.
2. *Edges.* They are boundaries between two phases, linear breaks in continuity. These edge elements, although probably not as dominant as paths, are for many people important organizing features, particularly in the role of holding together generalized areas, as in the outline of the city by water or wall.

3. *Districts*. Districts are recognizable as having some common, identifying character. Always identifiable from the inside, they are also used for exterior reference if visible from the outside. Most people structure their city to some extent in this way.

4. *Nodes*. Nodes are points, the strategic spots in a city into which an observer can enter, and which are the intensive foci or and from which he is travelling. Or the nodes may be simply concentrations, which gain their importance from being the condensation of some use or physical character, as a street-corner hangout or an enclosed square. The concept of node is related to the concept of path, since junctions are typically the convergence of paths, events on the journey. Some nodal points are to be found in almost every image, and in certain cases they may be the dominant feature.

5. *Landmarks*. Landmarks are another type of point-reference, but in this case the observer does not enter within them, they are external. Some landmarks are distant ones, typically seen from many angles and distances. They are frequently used [as] clues of identity and even of structure, and seem to be increasingly relied upon as a journey becomes more and more familiar.

In parsing the urban environment, Lynch emphasizes the importance of the shared knowledge of what it *feels* like to travel through various places. As Norberg-Schulz expresses it, the personal *experience* of archetypal locations is what converts them from spaces to *places*, underlining the importance of identification and orientation.

> *[T]he work of Lynch constitutes an essential contribution to the theory of place. Its importance also consists in the fact that his empirical studies of concrete urban structure confirm the general 'principles of organization' defined by Gestalt psychology without reducing the importance of orientation, we have to stress that dwelling above all presupposes identification with the environment.*
>
> (Norberg-Schulz 1986: 20)

Application of architectural analysis

As preparation for their moving image project, each participant was asked to make a sketch-map of a personal journey (in the campus where the workshop takes place) using Lynch's 5 basic structural categories in their analysis. Then each participant captures 5 KEY STILL IMAGES (stills-camera, phonecam or hand sketching) – one image for each stage of the story arc: and places them in the appropriate place on the map (handsketching or using PowerPoint or Photoshop), and submits the storymap to tutors for review. Each group, using all the storymaps from its members, agrees on one journey that makes sense to all participants, and creates a rapid storyboard of that journey, which then serves as the location-plot for a 3-minute movie on the general topic of 'Exchange'.

Example (see Figure 4 below):

Act 1
(1) Set-up/ Intro/Exposition [Landmark]
(2) Development

Act 2
(2) Complication [Pathway]
(3) Climax [Node]

Act 3
(4) Resolution [District]
(5) Finale/Denouement/Conclusion/ [Edge]

IMAGE OF THE CITY THROUGH NARRATIVITY:
PROMENADE ARCHITECTURALE
Space + Narrativity = Spatially Organised Narrative

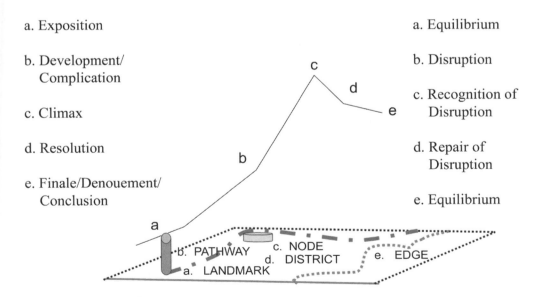

a. Exposition

b. Development/
 Complication

c. Climax

d. Resolution

e. Finale/Denouement/
 Conclusion

a. Equilibrium

b. Disruption

c. Recognition of
 Disruption

d. Repair of
 Disruption

e. Equilibrium

Figure 4: Dramatic development combined with architectural legibility.

Shot grammar

Basic shot types are identified and demonstrated at the outset of the workshop. Montage, where shots may be connected through theme or visual composition, rather than contiguity in space or connection through action (an approach commonly used in music videos and commercials, as well as in the classic 'City Symphony' films of the 1920's), relies heavily on formal visual characterisitics as well as the content of frames for its editing strategies. Part One of the *CinemArchitecture* hands-on workshop, led by Dr François Penz (Cambridge) and Dr Richard Koeck (Liverpool) focused for three days on montage; participants in the Part Two 'Continuity' workshop, described here, had thus already had some opportunity to work with image-capture and editing and spatial translation for video, using only montage techniques.

More familiar in twentieth- and twenty-first-century movie and television drama is the continuity shooting and editing practiced in the Part Two workshop, where the cinematic cuts between individual shots are disguised by the use of a screen language based on continuity of action, developed largely under the influence of Hollywood *mise-en-scène* and *mise-en-cadre* (Bordwell and Thompson 2006). The basic grammar of this language is familiar, and can be described as a set of rules for narrative comprehension and emotional expression (Arijon 1976; Rabiger 1998; Katz 1991; Block 2007). In the workshop, the emphasis was on the emotional and expressive connotations of shot-types. The examples below (Figures 5–12) were drawn and painted by Ricardo Sousa, a participant in the Porto workshop (2008) and the Liverpool workshop (2009), and are reproduced here with his kind permission.

Figure 5: Low-angle – increases power of figure; non-natural position of camera-eye suggests furtiveness, thriller genre (© Ricardo Sousa 2009).

Figure 6: Eye-level – 'natural' angle suggests this is really happening (rather than staged) (© Ricardo Sousa 2009).

Figure 7: High Angle: narrative stance not related to a character in the story (unless positioned at window or other location overlooking action, with POV down) gives sense of surveillance (or strong directorial control of narration) (© Ricardo Sousa 2009).

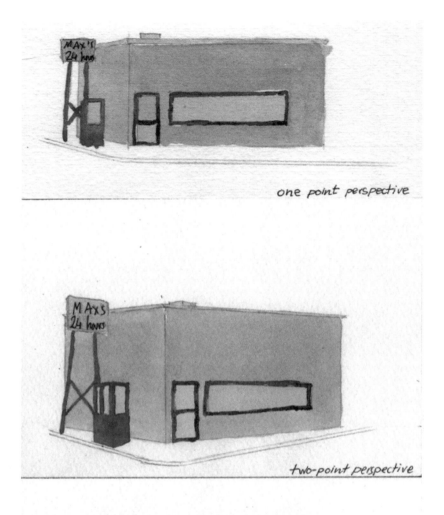

one point perspective

two-point perspective

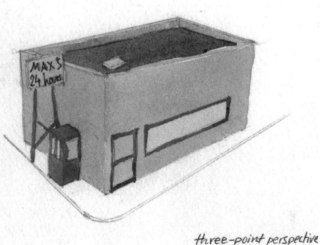

three-point perspective

Figure 8: 1 -, 2- and 3-point perspectives – illusory depth, increasing with number of vanishing points, can create a sense of claustrophobia/openness , danger/safety (© Ricardo Sousa 2009).

Figure 9: Deep Space – expressive of emotional distance (one point perspective, multiple planes, shape/size difference, textural diffusion, tonal separation, up/down position) (© Ricardo Sousa 2009).

Figure 10: Flat Space – expressive of trapped emotions (walls frontal; no longitudinal planes or converging lines; actors staged on same horizontal plane with similar textural detail) (© Ricardo Sousa 2009).

Figure 11: Limited Space – expressive of unresolved relationships & suspense (depth cues – size difference, textural diffusion, up/down position and tonal separation, but no longitudinal planes; actor's movement remains parallel to picture plane) (© Ricardo Sousa 2009).

Figure 12: Ambiguous Space – Expressive of lack of emotional resolution (absence of spatial cues to establish actual size and spatial relationships) (© Ricardo Sousa 2009).

In the workshop, participants were introduced to shot-grammar and given the opportunity to experiment with it hands-on, first analysing the architectural characteristics of the location, then staging action and deploying the camera to express and communicate them, using their screen language effectively in the service of architecture.

Overall aims and brief

In summary, the overall aims of the workshop were to:

- Familiarize participants with ways of analysing architecture and the built environment in terms of their effect upon the people inhabiting them
- Provide experience of matching architectural structure and flow with cinematic structure and flow
- Enable participants to understand and deploy basic moving image & sound language to join spaces together on the screen effectively and present a smooth flow through buildings/sites
- Familiarize participants with the basic practical skills necessary for the use of digital moving-image capture and editing equipment, and sound editing software, to support the design, expression and communication of architectural ideas

Learning experience & method of teaching:

Developing projects as a team, dividing the roles of Producer, Writer, Director, Cinematographer, Storyboard Artist and Editor amongst members (each participant taking a turn at each role if possible), under expert supervision, participants were asked to:

(Day One)
- Analyse and identify conventions and techniques for creating 'screen' landscapes on screen from captured images of real places; and evaluate techniques to create the illusion of continuous action in continuous space on screen (Tutor led)
- Reconnoitre location and start to develop story ideas combining Lynchian analysis of the components of a legible city with Aristotelian principles of dramatic narrativity (Student led)
- Develop a script for 3-minute exercise movie, 'Exchange' (Student led, Tutor supervised)
- Begin storyboarding the script (Student led, Tutor supervised)

(Day Two)
- Finalize script, shooting script and storyboards (Student led, Tutor supervised)
- Shoot 3-minute exercise (Student led, Tutor supervised)
- Transfer footage to editing workstation and begin to edit picture (Student led, Tutor supervised)

(Day Three)
- Finalize picture edit (Student led, Tutor supervised)
- Select music track and edit picture and music to final cut (Student led, Tutor supervised)
- Review exercise outcomes and workshop (Tutor led)

Learning outcomes:

On completion of the workshop, participants were expected to be able to:

- Analyse a location (site) according to Lynchian structural principles
- Identify the shooting and editing techniques and rationale for continuity shooting and editing
- Identify the elements and sequence of a five-stage 'story arc'
- Structure, script and storyboard a sequence for camera
- Use a mini-digital-video camera and Final Cut Pro or Premier Pro editing system to shoot and cut a 3-minute 2-character moving image 'promenade architecturale'
- Analyse the qualities and impact of *mise-en-scène* and point of view in presenting action and creating audience identification
- Define the effect of framing and lighting on the translation of a physical location to a moving image realization
- Evaluate the contribution of camera and editing strategies in producing aesthetic, dramatic, informative and engaging effects
- Evaluate the contribution of music to the aesthetic, dramatic, informative and engaging effect of moving image material

Content:

- Lecture/Presentation of underlying architectural and moving image theory
- Analysis of site informed by architectural and moving image theory
- Screening, analysis and discussion of selected scenes relevant to the workshop topic, with particular emphasis on historical precedent, *mise-en-cadre*, montage, *mise-en-scène*, continuity shooting, point of view and editing, sound design and music
- Familiarization with digital image capture and editing equipment, and sound editing software
- Shooting and cutting, using a digital video camera and editing system, a 3-minute moving-image narrative continuity-sequence using two characters on the topic: *Exchange*

Assessment:

- Formative assessment during all stages of the workshop by tutor team
- Summative assessment at final critical review of workshop process and productions by tutors and participants
- Written feedback from participants

Brief: continuity of action in space (making the 'artificial landscape' of the screen coherent). Topic: 'Exchange'

In the *CinemArchitecture* workshop 'continuity' drama exercise, the 36 participants (eight from each of the four participating universities) began by individually analysing the legibility of the site (location), with particular reference to the emotional responses it inspired in them. In groups of six, each group composed of members from all four universities and supervised by one tutor (from one of the universities), they then developed two characters and a scenario about *Exchange* (in the widest sense), inspired by the emotions evoked in them by the built environment, using their 'screen landscape' to help express the drama, under my overall guidance. Starting from the classic five-stage dramatic arc of '(1) *Set-up/ Intro*, (2) *Development* (3) *Climax* (4) *Resolution* (5) *Denouement/ Finale*' outlined above, participants were asked to structure their scenario in a simple 3-Act form, and devise the best *mise-en-scène* for conveying the dramatic narrative effectively, using the architectural features of the environment to underline the emotion of the drama.

Groups analysed the Siza FAUP campus site personally, according to Kevin Lynch's parsing of the legibility of a city (Lynch 1960: 47) into *landmarks, pathways, nodes, districts*, and *edges* – according to individual experience/reading of the campus.

Each group used a miniDV camera to capture footage for a three-minute sequence framed as a story of 'Exchange' (in its broadest sense) between two characters. Participants were asked to structure their scenario in a classic five-stage dramatic arc that works in three acts, paying particular attention to the continuity of space.

Example:

(1) *Set-up/ Intro* (e.g. What is the *landmark*? Where have I come from? Where am I going to?)
(2) *Development* (e.g. What is the best *pathway* towards the fi nal goal (edge) (via a *node*)?)
(3) *Climax [Summation]* (e.g. What is the significance of this *node*? Where have I come from? Where can I go to from here?)
(4) *Resolution* (e.g. What constitutes this *district*? Where are its *edges*? How can the journey be completed?)

(5) *Conclusion/Denouement/Finale* (e.g. Are the *edge* of the district and the end of the journey (at another *landmark*? *Node*? *Edge*?) clear?)

This five-stage dramatic arc structure was matched with the Lynchian analysis of the campus (not necessarily in the order exemplified above), to produce a narrative that was both spatially and dramatically organized.

Aim and parameters of exercise:

To prepare and shoot a 3-minute minimovie for two characters, creating the illusion of continuity between locations, with no dialogue, on digital video, on location (exteriors and interiors may both be used), in daylight (no movie lighting); and to edit it, using sound effects and through composed original music. No visible or audible on-screen dialogue.

Content:
The dramatic topic of the scene – EXCHANGE – may be interpreted as tightly or loosely as desired, but through the drama the scene should:

- Express the nature of the location clearly, using it to convey the drama
- Introduce two characters and tell a simple story about them, using locations as well as action to express mood, individuality, personality, intention, predicament/moments of drama and emotion

Overall questions of drama and architectural environment:

How can you use an encounter in a particular setting to express a relationship, as well as the individuality, personality, intention, of each character? How can place convey the predicament/moment of drama, and the emotion between the characters? How can movement and perspective suggest what has gone before, and make the viewer curious to see what comes next? In the context of an architectural movie, how can character, situation and action be used to express the key features, design approach, mood, atmosphere, form and function of a specific building or place in moving images?

Notes on characters and scenario

It was expected that students of architecture would have more technical knowledge of the theory and practice of designing the built environment than designing characters and plots, so brief notes were given to them to help with the process of making a movie using characters. These were designed to focus on translating the analysis of the site into a sequence of place-based action. The movie clips shown in the introduction to the workshop were used as reference in discussion.

> *Notes:* When you have very little time to introduce characters, it is most efficient to introduce them *doing something characteristic* of themselves and their particular pursuits. When you need to differentiate between two different characters, it is useful to have them both react, differently, to something (a place, an object, a sound, a situation) that allows an audience to perceive the contrasts in their natures, as well as something about the relationship between them. The screen can communicate a great deal of information directly, instantaneously and simultaneously, both visually and through sound. There is no need to ration actions so that they happen in a row, one after the other – many can happen at the same time, in a single scene, or a single shot. Three minutes can be dense with meaning and movement and convey an idea, characters and story very strongly (a typical TV commercial lasts only 30 seconds; in three minutes you can convey a great deal).

Some questions whose answers should help develop *characters* and *scenario*:

- What is the exchange that takes place? How can the use of the location focus it for the audience?
- Is the action between the characters (for example) collaboration, confrontation, conversation, pursuit, persuasion – or something else? How can the location and shooting strategy be used to signal this?
- What brings the characters together in this place at this time? How can *mise-en-scène*, camera movement, perspective and location be used to communicate this?
- What is the intention of each character in each scene in the sequence? How can this be underlined by use of location, *mise-en-scène* and *mise-en-cadre*?
- What does their interaction say about the characters' relationship now, in the past and in the future?
- What is the mood of this moment? How can it best be conveyed by the combination of location, use of space, camera strategy, framing, performance, point-of-view and music?
- What is the emotional focus of the meeting between these characters? How can the location emphasise this?

- What is the audience's relationship to the characters? (How do the characters feel, and how do you want the audience to feel?) How can the *mise-en-scène, mise-en-cadre* and locations communicate this?
- What is the narrative stance of your telling? How will you place the camera in relation to the action in order to keep this consistent?
- What actions mark the beginning (set-up), the middle (climax), and the end (finale) of each scene? How can you use the location and camera movement to underline these moments?
- What style or genre are you using? Why? How can the use of camera and location create this style?
- How do the five stages of your development arc fall in relation to location, character development and action?

Parameters for 3-minute movie

- Two characters only
- No dialogue (seen or heard!)
- No complicated costuming
- No more than four (hand-holdable) props
- No more than eighteen camera set-ups altogether
- Exterior location shoot as far as possible
- No movie lighting (location lighting only)
- Through-composed original music, plus sound effects if desired;
- Voice-Over narration may be used if there is time to write, record and edit it.

Team roles for the exercise

The **Producer** is responsible for managing the project, including all practical aspects such as scheduling, problem solving, crisis management and resolution, and ensuring that all parts of the production run smoothly and on time and no-one gets hurt. On this exercise, the Producer also ensures that all participants have the opportunity to take their turns at all the different production roles, though only one participant takes final responsibility for ensuring that the functions of each role are fulfilled (see: Light Honthaner 2003; Rabiger 1998).

The **Scriptwriter** is responsible for ensuring that the story has a clear, effective and appealing shape responding to the brief, and that the action and characters are fully realized, and clearly represented in the script (see Parker 1998).

The **Storyboard Artist** finalizes, in close collaboration with the rest of the team, but especially the Director and Cinematographer, sketches that communicate the structure of sequences, the framing for the shots, and the positioning and movement of the camera to capture the images (see Block 2007; Katz 1991).

The **Cinematographer** is responsible for camera and camera equipment (including keeping the batteries charged!) and, in close collaboration with the Director (with the Producer checking the logistics and scheduling of the shoot) of finalizing the shooting script, and (with the Editor and Director) checking that the storyboards are appropriate – as well as ensuring that all the material is shot (see: Arijon 1976; Bruce 2007).

The **Director** works very closely with the Producer and all other members of the team, and is responsible for ensuring that the script and storyboards represent a well-proportioned and visualized movie; for directing crew and performers on the shoot; for checking the edit and final cut and resolving team and artistic problems (see Rabiger 2003).

The **Editor**, in addition to ensuring that all sequences are edited and put together, is responsible for collecting the raw footage from the cinematographer, transferring it to the editing system and seeing that the picture lock-off on the schedule is observed. The Editor may also help the Cinematographer and Director finalize storyboards (see: Reisz and Millar 1968; Murch 2001).

The review for this workshop exercise concentrated on a discussion of the usefulness of Lynch's analysis in making place legible on screen, and identifying and formulating strategies for expressing the character and mood of a location using human figures and drama and story-structure communicated through the camera.

Additional material

Workshop **handouts** included the following list of titles recommended for viewing, which represents important moments in international film history as well as important city films:

Across the Universe (Julie Taymor, USA, 2007)
After Hours (Martin Scorsese, USA 1985)
Aldri annet enn bråk (Nothing but Trouble) (Edith Calmar, Norway, 1954)
L'ami de mon amie (My Girlfriend's Boyfriend) (Eric Rohmer, France 1987)
Anchors Aweigh (George Sidney, USA 1945)
Annie Hall (Woody Allen, USA 1977)
Au Bout de Souffle (Godard, France 1960)

'Beijing Trilogy' (Ning Jing, China 1993-2001): *For Fun* (1993)*; On the Beat* (1995)*; I love Beijing* (2001)

Das blaue Licht (The Blue Light) (Leni Riefenstahl, Germany 1932)

The Blot (Lois Weber, USA 1921)

Blow-Up (Michelangelo Antonioni, UK 1966)

Brick Lane (Sarah Gavron, UK 2007)

*Bride and Prejudice (*Gurinder Chadha, UK/USA 2004)

Bright Star (Jane Campion, UK/Australia/France)

Das Cabinet des Caligari (The Cabinet of Dr Caligari) (Robert Weine, Germany 1920)

Caramel (Nadine Labaki, France/Lebanon 2007)

Christopher Strong (Dorothy Arzner, USA 1933)

Chung Hing Sam lam (Chungking Express) (Wong Kar Wai, Hong Kong 1994)

The Cool World (Shirley Clarke, USA 1964)

Cookie (Susan Seidelman, USA 1989)

Dark City (Alex Proyas, Australia/USA, 1998)

Daughters of the Dust (Julie Dash, USA/UK 1991)

Demon Seed (Donald Cammell, USA 1977)

Desperately Seeking Susan (Susan Seidelman USA 1985)

Il dialogo di Roma (Marguerite Duras, Italy 1982)

A Dry White Season (Euzhan Palcy, USA 1989)

An Education (Lone Scherfig, UK 2009)

Den eneste ene (The One and Only) (Susanne Bier, Denmark 1999)

Eternal Sunshine of the Spotless Mind (Michel Gondry, USA 2005)

Face (Antonia Bird, UK 1997)

La fiancée du pirate (A very curious girl) (Nelly Kaplan, France 1969)

A Fish called Wanda (Charles Crichton, USA/UK 1988)

Fishtank (Andrea Arnold, UK, 2009) (124 mins)

Flying Down to Rio (Thornton Freeland, USA 1933)

Friends with Money (Nicole Holofcener, USA 2006)

Gabbeh (Mohsen Makhmalbaf, Iran/France, 1996)

Real Women Have Curves (Patricia Cardoso, USA 2002)

Hachi-gatsu no kyôshikyoku (Rhapsody in August) (Akira Kurosawa, Japan 1991)

La Haine (Hate) (Matthieu Kassovitz, France 1995)

Hasards ou Coincidences? (Chance or Coincidence ?) (Claude Lelouch, France 1998)

Hester Street (Joan Micklin Silver, USA 1975)

His Girl Friday (Howard Hawks, USA 1940)

The Hong Kong Tycoon (Tang Shu Shuen, Hong Kong 1979)

*How I Killed a Saint (*Teona Struga Mitevska, Macedonia 2004)

Humpday (Lynn Shelton, USA 2009)

Husbands (John Cassavetes, USA 1970)

I Could Never Be Your Woman (Amy Heckerling, USA 2007)

In Bruges (Martin McDonagh, UK 2008)

I've Heard the Mermaids Singing (Patricia Rozema, Canada 1987*)*

Jeanne Dielman 23 Quai du Commerce 1080 Bruxelles (Chantal Akerman, Belgium/France 1975)

Julie and Julia (Nora Ephron, USA 2009)

Koyaanisqatsi (Godfrey Reggio, USA 1982)

The Ladykillers (Alexander MacKendrick, UK 1955)

The Lavender Hill Mob (Charles Crichton, UK 1951)

Lisbon Story (Wim Wenders, Germany/Portugal 1994)

Little Dorrit (Christine Edzard, UK, 1988)

London Wakes Up (Ruby Grierson, UK 1936)

Lola (Jacques Demy, France 1961)

Lost in Translation (Sofia Coppola, USA 2003)

The Long Day Closes (Terence Davies, UK 1992)

Ma Vida Loca (My Crazy Life) (Allison Anders, USA 1993)

Man with a Movie Camera (Vertov, USSR, 1929)

The Matrix (Wachowski Bros, USA 1999)

Memento (Christopher Nolan, USA 2000)

Minority Report *(Steven Spielberg, USA 2002)*

Mona Lisa (Niel Jordan, 1986)

Mrs Dalloway (Marleen Gorris, UK/USA/Netherlands 1997)

Mulholland Drive (David Lynch, France/USA 2001)

New York, New York (Martin Scorsese, USA 1977)

Notorious (Alfred Hitchcock, USA 1946)

La Nuit Americaine (Day for Night) (François Truffaut, France/Italy, 1973)

Night on Earth (Jim Jarmusch, USA 1991)

101 Reykjavik (Baltasar Kormákur, Iceland/Denmark/France/Norway/Germany 2001)

Oliver Twist (David Lean, UK 1948)

On a Clear Day (Gaby Dellal, UK 2005)

Orlando (Sally Potter, UK/Russia/ France/ Italy/Netherlands 1992)

Panj é asr (5 in the Afternoon) (Samira Makhmalbaf, Iran/France, 2003)

Peeping Tom (Michael Powell, UK 1960)

Performance (Donald Cammell and Nicholas Roeg, UK 1970)

The Pillow Book (Peter Greenaway, France, UK, Netherlands, Luxembourg 1996)

Precious: Based on the Novel Push by Sapphire (Lee Daniels, USA 2009)

Professione: reporter (The Passenger) (Michaelangelo Antonioni, Italy/France/Spain 1975)

Pygmalion (Anthony Asquith, UK 1938)

Ratcatcher (Lynn Ramsay, UK/France, 1999)

Rattle of a Simple Man (Muriel Box, UK 1964)

Rear Window (Alfred Hitchcock, USA 1954) (112 mins)

Roma, Città Aperta (Rome, Open City) (Roberto Rossellini, Italy 1945)

*SABU, Good-bye to their Youth (*Tomoko Matsunashi, Japan 2003)

Salaam Bombay! (Mira Nair, UK/India/France, 1988)

Sans toit ni loi (Vagabonde) (Agnès Varda, France 1985)

Samt el qusur (Silences of the Palace) (Moufida Tlatli, France/Tunisia 1991)

Sedmikrásky (Daisies) (Věra Chytilová, Czechoslovakia 1966)

Shakespeare in Love (John Madden, UK 1998)

Shalosh Ima'ot (Three Mothers) (Dina Zvi-Riklis, Israel 2006)

Short Cuts (Robert Altman, USA 1993)

Shot in Bombay (Liz Mermin, UK 2008)

Singin' in the Rain (Stanley Donen & Gene Kelly, USA 1952)

Slumdog Millionaire (Danny Boyle, UK 2008)

Something New (Sanaa Hamri, USA 2006)

The Station Agent (Thomas McCarthy, USA 2003)

Strange Days (Kathryn Bigelow, USA 1995)

The Stranger Left no Card (Wendy Toye, 1953) and *Stranger in Town [Tales of the Unexpected* Season 5 episode 5] (Wendy Toye, UK, *Anglia Television,* 1979*)*

Street Corner (Muriel, Box UK 1953)

Sunrise (Frederic Murnau, USA, 1927)

Sunset Boulevard (Billy Wilder, USA 1950)

Sweeney Todd: the Demon Barber of Fleet Street (Tim Burton, USA/UK 2007)

Sweet Sixteen (Ken Loach, UK 2002)

That Night in Rio (Irving Cummings, USA 1941)

The Third Man (Carol Reed, UK 1949)

Timecode (Mike Figgis, USA 2000)

Tokyo Monogatari (Tokyo Story) Yasujiro Ozu, Japan 1953)

Top Hat (Mark Sandrich, USA 1935)

Under the Skin (Carine Adler, UK 1997)

Unstrung Heroes (Diane Keaton, USA 1998)

Das Versprechen (The Promise) (Margarethe von Trotta, Germany/France/Switzerland 1995)

Vertigo (Alfred Hitchcock, USA 1958)

Water (Deepa Mehta, Canada/India, 2005)

The Way We Live (Jill Craigie, UK 1946)

Whale Rider (Niki Caro, New Zealand/Germany 2002)

Wives (Hustruer) (Anja Breien, Norway 1975)

Y'aura t'il de la neige à Noël? (Will it Snow for Christmas?) (Sandrine Veysset, France 1997)

Zir-e poost-e shahr (Under the City's Skin) (Rakhshan Bani Etemad, Iran 2001)

Zuckerbaby (Sugarbaby) (Percy Adlon, Germany 1985)

Participants equipped with this list can continue their exploration of the relationship between cinema and architecture and at the same time acquire some first-hand knowledge of international film history.

Conclusion

It seems clear that the students from the four European universities that participated in the 'CinemArchitecture' experiment found it stimulating, enjoyable and also an unexpectedly revitalizing, effective and revealing learning experience.

A major reason for describing this workshop in some detail has been to give a realistic indication of the amount of preparation and the extent of expertise, time, resources and facilities necessary to provide such a learning experience. The University in the twenty-first century, galvanized by the development of electronic media and communications, is evolving towards integrating the cross-disciplinary and practice-based into its traditional academic framework (Duxbury et al. 2008; Baker et al. 2009). Cultural artefacts and professional practice reflect this tendency and architects as well as academics rely more and more on the language, production methodology and technical skills of digital moving-image arts. Increasingly, research in architecture shares perspectives and criteria with other areas of art, design, media and communications (McNiff 2008; Smith and Dean 2009; Biggs and Karlsson 2010; Rendell 2010). These in turn give rise to innovative and productive integrated approaches to teaching and learning (Trowler and Wareham 2007). 'CinemArchitecture' brings together the concepts and cultures of architectural and cinematic thinking and practice, to catalyse new departures.

The kind of workshop described here can be implemented over three days with limited – but appropriate – resources, and the necessary specialized tuition (as with any Studio in an architectural curriculum). Most universities in the twenty-first century have the resources and facilities to run such workshops, and students very often own suitable cameras and editing software. The exciting dimension of such a venture is that it leaves every participant not only with a new way of observing and carrying out site analysis, but also with the tools and the conceptual framework to nurture the seeds of truly contemporary ways of working creatively within their field and extending the range of the traditional skills they learn. The viewing-programme and reading-list leave them with material with which to develop their own original projects – and, even in three days, they can acquire a mindset, skillset and competence that provides the groundwork to push back the boundaries of research methodology as well as of professional practice.

References

Aitken, I. (2001), *European Film Theory and Cinema*, Edinburgh: Edinburgh University Press.

Arijon, D. (1976), *Grammar of the Film Language*, Los Angeles: Silman-James Press.

Aristotle (384–322 BC) (trans. by J. H. Freese) (1926), *Aristotle, The 'Art' of Rhetoric*, London and Cambridge, Mass: Harvard University Press (Loeb Classical Library)

Aronson, A. (1977), *The History and Theory of Environmental Scenography*, Ann Arbor: UMI.

Baker, S., Buckley, B. and Kett, G. (2009), *Creative Arts PhD: Future-Proofing the Creative Arts in Higher Education. Project Final Report.* Australian Learning and Teaching Council. Available to

download from: http://www.creativeartsphd.com/docs/ALTC_Report_Final.pdf [Final report of the 'Creative Arts PhD' project, funded by the Australian government and higher education institutions]. Accessed 27 February 2011.

Barber, S. (2002), *Projected Cities: Cinema and Urban Space*, London: Reaktion.

Barrett, E. and Bolt B. (eds) (2007), Practice as Research: Approaches to Creative Arts Enquiry, London: IB Tauris.

Biggs, M. (2003), 'The Role of "the Work" in Research', PARIP, University of Bristol, UK. http://www.bris.ac.uk/parip/biggs.htm. Accessed 15 July 2010.

Biggs, M. and Karlsson, H. (2010), *The Routledge Companion to Research in the Arts*, London and New York: Routledge.

Block, B. (2007), *The Visual Story: Creating the Structure of Film, TV and New Media*, 2nd ed., Boston & Oxford: Focal Press.

Bordwell, D. and Thompson, K. (2006), *Film Art: An Introduction*, 8th ed., New York: McGraw-Hill.

Branigan, E. (1992), *Narrative Comprehension and Film*, London/New York: Routledge.

Bruno, G. (2002), *Atlas of Emotions: Journeys in Art, Architecture and Film*, London and New York: Verso.

Büchler, D., Biggs, M. and Ståhl, L.-H. (2009), 'Areas of Design Practice as an Alternative Research Paradigm', *Design Principles and Practices: An International Journal*, 3:2, pp. 327–338.

Burton, G. O. (© 1996–2003), 'Silva Rhetoricae', Brigham Young University. <http://rhetoric.byu.edu/>. Accessed 27 February 2011.

Clarke, D. B. (ed.) (1997), *The Cinematic City*, London: Routledge.

Cowgill, L. (1999), *Secrets of Screenplay Structure*, Hollywood: Lone Eagle Publishing Co.

Duxbury, L., Grierson, E. M. and Waite, D. (2008), *Thinking Through Practice: Art as Research in the Academy*, Melbourne: RMIT Publishing.

Freytag, G. ([1863] 1968), *Technique of the Drama; An Exposition of Dramatic Composition and Art (An Authorized Translation from the 6th German ed. by Elias J. MacEwan)*, New York: B. Blom.

Gray, C. and Malins, J. (2004), *Visualizing Research: A Guide to the Research Process in Art and Design*, Aldershot: Ashgate.

Hannula, M. (ed.) (2005), *Artistic Research: Theories, Methods, and Practices* Helsinki: Academy of Fine Arts (purchase at <http://goart.gu.se/kf_publ/kf_publ.htm>). Accessed 27 February 2011.

Heath, M. (1996), *Aristotle: Poetics*, Harmondsworth: Penguin Classics.

Hockey, J. (2003), 'Practice–Based Research Degree Students in Art and Design: Identity and Adaptation', *Journal of Art & Design Education*, 22:1, pp. 82–91, Oxford: Blackwell Publishing (on behalf of the National Society for Education in Art and Design).

Katz, S. D. (1991), *Film Directing Shot by Shot*, Los Angeles: Michael Wiese Productions.

Laurel, Brenda. ([1991] 1993), *Computer as Theatre*, Reading, Massachusetts/ MenloPark, California/ New York/Don Mills, Ontario/Wokingham,England/Amsterdam/Bonn/ Sydney/Singapore/Tokyo/ Madrid/San Juan/Milan/Paris: Addison-Wesley Publishing Company.

Lawson, B. (2006), *How Designers Think: The Design Process Demystified*, 4th ed., London: Elsevier Architectural Press.

Light Honthaner, E. (2003), *The Complete Film Production Handbook*, 3rd ed., Book & CD-ROM), Boston & Oxford: Focal Press.

Lynch, K. (1960), *The Image of the City*, Cambridge, Mass: MIT Press.

Marcus, A. and Neumann, D. (ed.) (2007), *Visualizing the City*, London/New York: Routledge.

Mazierska, E. and Rascaroli, L. (2003), *From Moscow to Madrid: Postmodern Cities, European Cinema*, London and New York: I. B. Tauris.

McNiff, S. (2008), *Art-based Research*, London: Jessica Kingsley.

Mennel, B. (2008), *Cities and Cinema*, London/New York: Routledge.

Murch, W. (2001), *In the Blink of an Eye: A Perspective on Film Editing*, 2nd rev. ed., Los Angeles: Silman-James Press.

Norberg-Schulz, C. (1986), *Architecture: Meaning and Place*, New York: Electa/Rizzoli.

Parker, P. (1998), *The Art and Science of Screenwriting*, 2nd ed., Bristol: Intellect Books.

Penz, F. and Thomas, M. (ed.) (1997), *Cinema & Architecture*, London: British Film Institute.

Prophet, J. (2004). 'Re-addressing Practice based Research: Funding and Recognition', *Digital Creativity*, 15:1. pp. 2–7.

Rabiger, M. (1998), *Directing the Documentary*, Boston & Oxford: Focal Press.

—— (2003), *Directing: Film Techniques and Aesthetics*, Boston & Oxford: Focal Press.

Reilly, L. (2002), 'An Alternative Model of 'Knowledge' for the Arts', *Working Papers in Art and Design*, 2, http://www.herts.ac.uk/artdes1/research/papers/wpades/vol2/reillyfull.html. Accessed 15 July 2010.

Reisz, K. and Millar, G. (1968), *The Technique of Film Editing*, Boston & Oxford: Communication Arts Books/ Hastings House /Focal Press.

Rendell, J. (2004), 'Architectural Research and Disciplinarily', *Architectural Research Quarterly*, 8:4, pp. 141–147.

—— (2010), *Site-Writing: The Architecture of Art Criticism*. London: I.B. Tauris.

Rendell, J., Hill, J., Fraser, M. and Dorrian, M. (eds) (2007), *Critical Architecture*, London: Routledge.

Scrivener, S. and Chapman, P. (2004), 'The Practical Implications of Applying a Theory of Practice Based Research: A Case Study', *Working Papers in Art and Design*, 3. http://www.herts.ac.uk/artdes1/research/papers/wpades/vol3/ssfull.html. Accessed 15 July 2010.

Shiel, M. and Fitzmaurice, T. (ed.) (2003), *Screening the City*, London and New York: Verso.

Smith, H. and Dean, R. (2009), *Practice-led Research, Research-led Practice in the Creative Arts*, Edinburgh: Edinburgh UP.

Stringer, E. T. (2003), *Action Research in Education*, Harlow: Prentice Hall/Pearson.

Suchman, L. and Trigg, R. (1991), 'Understanding practice: Video as a medium for reflection and design', in J. Greenbaum and M. Kyng (ed.), *Design at Work: Cooperative Design of Computer Systems*, Hillsdale, N.J.: Erlbaum, pp. 65–90.

Sullivan, G. (2005), *Art Practice as Research: Inquiry in the Visual Arts*, Oaks, CA: Sage.

Thomas, M. (2005), 'Playing with Chance and Choice – Orality, Narrativity and Cinematic Media', in B. Bushoff (ed.), *Developing Interactive Narrative Content*, Munich: High Text, pp. 371–442.

Thomas, M. and Penz, F. (ed.) (2003), *Architectures of Illusion: From Motion Pictures to Interactive Navigable Environments*, Bristol: Intellect Books.

Trowler, P. and Wareham, T. (2007), 'Reconceptualising the Teaching-Research Nexus', *In HERDSA Proceedings of the Annual HERDSA Conference 2007: Enhancing Higher Education Theory and Scholarship*, 8–11 July 2007, Adelaide Australia.

Webber, A. and Wilson, E. (ed.) (2008), *Cities in Transition: The Moving Image and the Modern Metropolis*, London: Wallflower.

http://cinemarchitecture.arq.up.pt/presentation.html.

http://ec.europa.eu/education/programmes/llp/structure/erasmus_en.html

Contributors

Thom Andersen has lived in Los Angeles for most of his life. He teaches film/video composition at the California Institute of the Arts. In 1974 he completed *Eadweard Muybridge, Zoopraxographer*, an hour-long documentation of Muybridge's photographic work. In 1995, with Noël Burch, he completed *Red Hollywood*, a videotape about the filmwork created by the victims of the Hollywood Blacklist. Their work on the history of the Blacklist also produced a book, *Les Communistes de Hollywood: Autre chose que des martyrs*, published in 1994. In 2003 he completed *Los Angeles Plays Itself*, a video essay about the representation of Los Angeles in movies.

Marc Boumeester is a researcher and lecturer at the Delft School of Design, Delft University of Technology. His interests lie within the conceptual area enclosed by architectural conditions – unstable media – human perception. In earlier years he has worked for various major television- and film-producing companies and realized over sixty audio-visual products, varying from commercials and documentaries to drama-series and feature films. He is affiliated with the Royal Academy of Art in The Hague, has guest-lectured at a number of institutions around the globe, and participated in/organized various international projects in the fields of research and the arts.

Nicholas Bullock is Emeritus Reader in Architectural and Planning History in the Department of Architecture, Cambridge, a Fellow of King's College and teaches in the Graduate School of the Architectural Association. He has written on the housing reform movement in 19th and early 20th century Germany and France and on aspects of Modernism both between the wars and after 1945. His book, *Building the Post-War World, Modern Architecture and Reconstruction in Britain*, was published in 2002. He is currently researching a book on the architecture and the modernization of France in the thirty years after World War II.

Alison Butler is Head of the Department of Film, Theatre & Television, University of Reading, UK and Lecturer in Film. Her research interests are in alternative and artist's film, cinematic time and space, and women's cinema. She is the author of *Women's Cinema: The Contested Screen* (London: Wallflower, 2002).

Layla Curtis is an artist. She received her BA Fine Art from Edinburgh College of Art (1998) and her MA Fine Art from Chelsea College of Art (2000). Her work, included in the Tate Collection, the collection of the New Art Gallery Walsall and the Government Art Collection, encompasses a variety of media. She collages maps to create fictional hybrid cartographical works, creates drawings compiled of cartographic text taken from atlases, street maps and globes and uses technologies such as video, Global Positioning Systems (GPS) and thermal imaging cameras to create drawings and trace journeys. In 2005 Curtis was awarded an Arts Council England International Fellowship to Antarctica with the British Antarctic Survey. Solo exhibitions include those at Milton Keynes Gallery (2000), New Art Gallery Walsall (2006) and Ormeau Baths Gallery, Belfast (2008). Recently she was funded by Arts Council England to travel to the Borneo rainforest to develop a new body of work while walking and living with the indigenous semi-nomadic Penan.

Wowo Ding is Dean of the School of Architecture and Urban Planning at Nanjing University, China. She studied architecture at Nanjing Institute of Technology, China and the Swiss Federal Institute of Technology (ETH Zürich), and completed her doctorate at the ETH Zürich. She is a Professor in Urban Design and a practising architect. She has won the Nanjing Outstanding Design for the individual prize and the Jiangsu Provincial Urban and Rural Planning and Design Award. She was a member of the Holcim Awards jury for region Asia Pacific in 2008.

Celia Dunne is a Ph.D. candidate at the University of Cambridge's Centre of Latin American Studies. Her doctoral thesis examines tropes of the popular and the everyday in contemporary Mexican photography. Celia's research interests include twentieth- and twenty-first-century Latin American literary and visual culture, in particular that of Mexico and Central America.

Murray Grigor's films on architecture include award winners *Mackintosh, Space and Light, The Hand of Adam, Sean Connery's Edinburgh, The Architecture of Frank Lloyd Wright, Carlo Scarpa, Sir John Soane, Alexander Greek Thomson* and *John Lautner*. He directed *Pride of Place* Mobil's eight part series on American architecture with Robert A. M. Stern for PBS and the four part series *Edge of Britain* with A.J.P. Taylor. He became the first recipient of the Royal Television Society Reith Award for 'consistent and innovative effort in television' and was the first film-maker to be awarded the American Institute of Architects' Citation of Excellence.

Janet Harbord is Professor of Film Studies, School of Languages, Linguistics and Film, Queen Mary, University of London, UK. Her work engages with philosophies of screen media in a post-cinematic context. She has written on the subjects of memory, the image and archives; inertia, speed and energies of film; montage and cutting; spatial relations and film circulation; cultural translation and supplementation; affect, gesture and the image. She

is the author of *Chris Marker: La Jetée* (MIT Press, 2009), *The Evolution of Film: Rethinking Film Studies* (Polity Press, 2007), and *Film Cultures* (Sage Publications, 2002).

Mark Lewis, born in Ontario, is an artist who lives and works in London. Solo Exhibitions include: the Vancouver Art Gallery (Canada), Kunsthalle Winterther (Switzerland), Hamburger Kunstverein (Germany), Musée d'art Moderne (Luxembourg), BFI Southbank (London) and Museo Marino Marini (Italy), Forte di Bard (Italy). In 2009 Mark represented Canada at the 53rd Venice Biennale with his exhibition Cold Morning. Lewis' films have been shown at a number of International film festivals including: Rotterdam International Film Festival 2010 (The Netherlands), Toronto International Film Festival 2009 (Canada) and Berlin International Film Festival 2010 (Germany).

Andong Lu studied architecture at Tsinghua University, China and the University of Cambridge, and completed his doctorate at Cambridge. He is now a Research Fellow of Wolfson College. His research interests include narrative organization of space, cinematic aided research, and Chinese urbanism. He has taught post-graduate courses at Nanjing University and Cambridge University, coordinated a series of research workshops in the UK and China, and written widely on architecture and urbanism journals, including the *Journal of Architecture* (UK), *arq: Architectural Research Quarterly* (UK), *The Architect* (China) and *World Architecture* (China). He has guest-edited the *Cinematic Architecture* (special issue of *The Architect* (China), profile no. 136).

Rachel Moore is Lecturer in International Media, Goldsmiths, University of London, UK. She is interested in the crossovers between anthropology and film theory, most recently writing on Jean Epstein's Breton films. This interest extends to film practice, as with the study of the treatment of dead bodies in film and in magical ritual in a forthcoming essay entitled, 'Magical Death: the international Comedies of Re-burial'. Her current book project, based on earlier research around film and contact across time and space conducted during her Guggenheim Fellowship, is called *In the Film Archive of Natural History*. She is the author of *Savage Theory: Cinema as Modern Magic* (Duke University Press, 2000) and *Hollis Frampton: Nostalgia* (MIT Press, 2006).

Roger Odin is Emeritus Professor of 'Sciences de la Communication' at the Paris University 3-Sorbonne Nouvelle where he directed the Institut de Recherche en Cinéma et Audiovisuel for twenty years (1983–2003). A theoretician of the semio-pragmatic approach (*Cinéma et production de sens*, A. Colin, 1990, *De la fiction*, De Boeck, 2000, *Les espaces de communication*, PUG, 2011, forthcoming), he is also interested in documentary cinema (*L'âge d'or du cinéma documentaire: Europe années 50*, 2 volumes, L'Harmattan, 1997), amateur productions (*Le film de famille*, Méridiens-Klincksieck, 1995; *Le cinéma en amateur*, Communications n°68, Seuil, 1999), the relationship between cinema and the city (committee member of the research network MSH, Paris 3) and more recently

he became interested in mobile phone movie productions (see 'Il cinema nell'epoca del videofonino', *Bianco et Nero* n° 568, 2011).

Andrew Otway, born in Lancaster, has a degree in French (1980) from Kingston Polytechnic (now Kingston University) and an M.A. in European Languages and Cultures (2008) from Lancaster University. He is currently studying part-time for a Ph.D. at Lancaster University researching the area of Urban Rhythmanalysis, referring to the work of Henri Lefebvre; this is supervised by the University's Department of European Languages and Cultures and Department of Sociology. Andrew is also interested in Cultural Geography, Marxism and radical environmental politics and Sociology as they apply to the urban.

François Penz, an architect by training, teaches in the Department of Architecture at the University of Cambridge where he is a Reader in Architecture and the Moving Image. He co-founded Cambridge University Moving Image Studio (CUMIS, 1998-2005) and more recently the Digital Studio for Research in Design, Visualisation and Communication (DIGIS – www.expressivespace.org) where he runs the PhD programme. His research focuses on the narrative organization of space and the expressive use of digital media as an aid to design and communications in architectural and city related issues. He is a fellow of Darwin College and a founder Director of the company ScreenSpace.

Maria Hellström Reimer, visual artist and senior lecturer, received her PhD in Landscape Architecture at the Swedish University of Agricultural Sciences, Alnarp, Sweden, in 2006, with a dissertation entitled *Steal This Place – The 'Free Town of Christiania' and the Aesthetics of Tactical Formlessness* (Alnarp: Acta Universitatis Sueciae, 2006), an interdisciplinary study on the border between aesthetics, urbanism and landscape studies. Apart from her affiliation with the landscape department at Alnarp, Hellström Reimer has been a visiting scholar at Massachusetts Institute of Technology, Cambridge, MA; she has conducted interdisciplinary and arts-based research at The Interactive Institute Space and Virtuality Studio, Sweden; and she has held a post-doc at Malmö University, School of Arts and Communication. Her main focus within the field of landscape design research is performativity, spatial activism, and visual rhetorics.

Patrik Sjöberg is Assistant Professor in Film Studies at Karlstad University in Sweden. He has published on various aspects of documentary media, more specifically on the shared grounds between documentary media and different experimental strategies found in art and media in general. Topics of research include: the use of archival images; expanded cinema; film and video as evidence in a court of law; forensic animation; cinema, modernity and the conceptualization of place/site/city, and, more recently, the speaking subject in documentary media.

Maureen Thomas is a dramatist, screenwriter and integrated media director who, with Dr François Penz, co-founded what is now the Digital Studio for Research in Design, Visualisation and Communication (DIGIS – www.expressivespace.org) at the Martin Centre, Department of Architecture, University of Cambridge. They developed and directed an MPhil in Architecture and the Moving Image (50% of examinable work in moving-image form); from this, the Screen City, Interactive Narrativity and Location-Drama Workshop modules were incorporated into a new cross-discipline 'Screen Media and Cultures' MPhil, on which Maureen is a core tutor. She is a Senior Research Fellow of Churchill College, where her practice-based research focuses on the spatial organization of narrative; the integration of 3D, 2D and performance media; and interactive storytelling.

Hing Tsang is an independent film-maker and lecturer at the University of Surrey, Department of Dance, Film and Theatre. His current research interests include Chinese Cinema, evolutionary theory, Peircean sign-theory, and documentary cinema. He is currently completing a monograph on Peirce's notion of the self and its relevance to documentary practice and theory, with special reference to the work of Jon Jost, Van der Keuken, and Rithy Panh.

Helmut Weihsmann completed his studies in architecture at the Technical University in Vienna in 1980. Since his graduation he has been working as a freelance historian, critic and teacher at many international institutions i.e., University of Applied Arts in Vienna, I.T.Ü. in Istanbul, FU-Berlin, etc. He has been a honorary guest professor, lecturer and/ or coaching workshops at American, Turkish and West European colleges and universities such as Columbia University, Yale School of Architecture, Rhode Island School of Design, SUNY-Buffalo, Forum des Images in Paris and at the Getty Center in Santa Monica. He is the founding member of the bi-annual *Film.Arch Festival* in Graz (1993) and since 1999 director of the successful film-series 'Urbanity and Aesthetics' at many international institutions. He is currently managing the monthly film program *Arch.Film-Matinée* at the Filmcasino since 2005 in Vienna.

Index